POLLOCK AND AFTER:

THE CRITICAL DEBATE

POLLOCK
AND AFTER
THE CRITICAL DEBATE

Edited by
Francis Frascina

Icon Editions

1817

HARPER & ROW, PUBLISHERS, New York

Cambridge, Philadelphia, San Francisco, London
Mexico City, São Paulo, Singapore, Sydney

FIRST U.S. EDITION

LIBRARY OF CONGRESS CATALOG CARD
NUMBER: 84-48596

ISBN 0-06-433126-1
ISBN 0-06-430147-8 (pbk.)

85 86 87 88 89 10 9 8 7 6 5 4 3 2 1

Typeset by Book Ens, Saffron Walden, Essex
Printed and bound by Butler & Tanner Ltd,
Frome and London

Contents

Preface vii

I The Critical Debate and its Origins 1

Introduction 3

1 *Clement Greenberg:* Avant-Garde and Kitsch 21

2 *Clement Greenberg:* Towards a Newer 35
Laocoon

3 *T. J. Clark:* Clement Greenberg's Theory of 47
Art

4 *Michael Fried:* How Modernism Works: A 65
Response to T.J. Clark

5 *T. J. Clark:* Arguments about Modernism: 81
A Reply to Michael Fried

II History: Representation and 89
Misrepresentation – The Case of
Abstract Expressionism

Introduction 91

6 *Max Kozloff:* American Painting During the 107
Cold War

7 *Eva Cockcroft*: Abstract Expressionism, 125
Weapon of the Cold War

8 *David and Cecile Shapiro*: Abstract 135
 Expressionism: The Politics of Apolitical
 Painting

9 *Serge Guilbaut*: The New Adventures of the 153
 Avant-Garde in America

10 *Fred Orton and Griselda Pollock*: *Avant-* 167
 Gardes and Partisans Reviewed

III Modernism: History, Criticism and Explanation

III Modernism: History, Criticism 185
and Explanation

Introduction 187

11 *Michael Baldwin, Charles Harrison and Mel* 191
 Ramsden: Art History, Art Criticism and
 Explanation

12 *Charles Harrison*: Modernism and the 217
 'Transatlantic Dialogue'

13 *Thomas Crow*: Modernism and Mass Culture 233
 in the Visual Arts

Preface

This anthology is designed as a resource for those interested in recent debates and controversies in the history and criticism of modern art. As such it provides an historical and theoretical complement to the two other anthologies in this area published by Harper & Row: *Modern Art and Modernism: A Critical Anthology* (1982), edited by Francis Frascina and Charles Harrison; *Modernism, Criticism, Realism* (1984), edited by Charles Harrison and Fred Orton. Each of these three anthologies covers related but distinct aspects.

The three sections of this book are so organized that recent debate on art history and art criticism, exemplified by that between Clark and Fried from 1982 to 1983 (represented in Section I), can be seen to have considerable origins in those issues which were perceived as central to the discussion of art and culture in the late 1930s and 1940s in the USA. These issues also concern the authors of articles offering a critique of the conventional Modernist explanation and history of Abstract Expressionism and its legacy, which are represented in Section II. The introductions to these two sections should be seen as closely related in terms of theoretical and historical context. The third section contains three essays which deal with the problems of theory and history introduced in earlier texts.

It will be seen that the writings of Clement Greenberg form a substantial subject of study here. This is inevitable if we regard Modernism as the dominant form of explanation and history of modern art in the post-war years. This book does not include texts associated with any continental approaches, such as the structuralism, semiology and *nouveau mélange* of the 1970s. This is deliberate. Any critique of a dominant form of explanation and history requires that 'the dominant form' – the critical theory, the ideology – is adequately characterized and defensibly criticized. Continental theory and American notions of 'post-Modernism' are beyond the aims and scope of this anthology.

Where texts have been edited, excised material is indicated thus [. . .]. Reference to texts reprinted in this book is made thus *[00]*.

I

THE CRITICAL DEBATE AND ITS ORIGINS

Introduction

During the 1970s and the 1980s there have been several critiques of conventional art history and major debates on the methods and procedures of art historians and art critics concerned with the 'modern period'. Informed by the interests and analytical tools of other disciplines, certain historians and critics began to consider questions and issues raised some time ago but submerged in the 1950s and 1960s by the dominance of Modernist critical theory and history. The sorts of questions and issues raised would not seem novel to *some* art historians of earlier art or to other types of historians who had been working in the post-war period. However, to many practitioners of Modernism, and to those who received their education from a generation, or two, of teachers and academics steeped in the Modernist tradition, conventional art history and criticism seemed authoritative and 'objective'; it formed the consensus.

For those concerned with art, art criticism and art history produced since the mid-thirties, the questions and issues can be seen to fall into separable but *not* mutually exclusive areas. One is general and philosophical, the other is specific and political. The first area centres on questions of 'historical interpretation' and the 'interested writing of history', on which Popper has written.[1] Are the judgements of art historians and critics 'completely objective' or 'absolutely compelling'?; if no history is disinterested are the interpretations and evaluations of art historians and critics not so much knowledge but ideological desiderata, wishes and ideals which the author would like to be realized? Arnold Hauser has written in his more robust work on the philosophy of art history on these issues:

Are [such] interpretations correct or incorrect? Is one more correct than another? Is a later interpretation always more correct than an earlier? Or has the temporal sequence of judgments in this case nothing whatever to do with progress, with any progressive discovery of truth? Is relativism in art history inevitable and unobjectionable? Or have we in the last resort to do with assertions that are not to be distinguished as true or false, but to some quite different criteria, such as the degree of

3

relevance of the connections pointed out, or the extent of the deepening and enrichment of our aesthetic experience which may result? It certainly seems clear that the course not merely of art, but of art history also – that is, not only of the practice but also of the interpretation of art – is subject to the laws of something like Alfred Weber's 'cultural development', which is not a strictly progressive movement, unlike the continuous process of cumulative achievement which he terms 'civilization'.[2]

Are the evaluations and revaluations of art history governed by ideology or by logic? What are the criteria for distinguishing between a truthful statement about a painting and an ideological one? These are not simple issues. Nor is the distinction which can be seen to follow from Hauser's comments. The historian of art needs to be concerned with a consciously defined history of how and why works of art were produced *and* a history of the ideas and ideological formations that produced the most characteristic, or conventional, histories.

Also central to this area is debate on the concept of representation: works of art as representations – whether or not resemblance to the 'real' world was of interest to their producers – and works of history and explanation as representations. Writing in 1937, partly as a response to the work of Alfred H. Barr Jr, *Cubism and Abstract Art*, published in 1936,[3] Meyer Schapiro made the following important points, explicitly on representation in art and implicitly on representation in art history. They still hold for recent debates.

> The logical opposition of realistic and abstract art by which Barr explains the more recent change rests on two assumptions about the nature of painting, common in writing on abstract art: that representation is a passive mirroring of things and therefore essentially non-artistic, and that abstract art, on the other hand, is a purely aesthetic activity, unconditioned by objects and based on its own internal laws . . .
>
> These views are thoroughly one-sided and rest on a mistaken idea of what a representation is. There is no passive, 'photographic' representation in the sense described; the scientific elements of representation in older art – perspective, autonomy, light and shade – are ordering principles and expressive means as well as devices of rendering. All rendering of objects, no matter how exact they seem, even photographs, proceed from values, methods and viewpoints which somehow shape the image and often determine its contents. On the other hand, there is no 'pure art', unconditioned by experience; all fantasy and formal construction, even the random scribbling of the hand, are shaped by experience and by nonaesthetic concerns.[4]

As Schapiro implies, painting is a practice of representation. Artists work within changing systems and codes, as do practitioners of other disciplines. These systems and codes are the means by which people represent some kind of *cognition* of their world. Individual works of art, therefore, do not provide transparent illusions of 'reality', or of the 'world', but constitute determined and produced allusions to it. Such allusions are specific combinations of the formal and thematic elements of a picture and may be seen as an expression of the way people relate their lives to the conditions of their existence. This is to regard paintings as produced images of, ideas about, and positions on the world; as forms of ideology which represent systems of ideas, values and beliefs. And it should be realized that as mediated, or worked, representations of reality, they are not self-evident or transparent.

It can also be argued that art history is a practice of representation. In painting,

particular signifying systems, codes and expressive means are used; in art history, or art criticism, the system is language with all its power. Thus, to gain any knowledge of a specific society or of its history requires that we understand its systems of representation, though neither the signifying systems nor that which is signified should be considered as reducible to simplistic models – both are complex. For the practice of art or the practice of art history entails a process of transforming given and inherited raw materials – the socially determined signifying systems of practices and institutions – into a definite product. The transformation is a *practice* – using social/intellectual labour within the constraints and expressive and productive possibilities of socially determined means of production ('ordering principles and expressive means as well as devices of rendering'). This is to acknowledge that whatever is perceived as reality or is offered as history should not necessarily be considered as innocent, disinterested, self-evident or transparent.

The second area where questions and issues have been raised is in the consideration of the nature of the ideological formation which has produced the most dominant history of modern art in general, and of post-war American art in particular. The critical theory we now call 'Modernism' was elaborated at the same time that Abstract Expressionism was produced and ratified. Its influence on art history, art criticism and other forms of explanation has been as great as the 'art boom', to use Greenberg's phrase, in art dealing and curatorship since the late 1940s. The dominance of Modernism, the massive growth in entrepreneurial dealership, the status and function of museums in the mould of the Museum of Modern Art New York, the idea and reality of the 'Cold War', the role of imperialist ideology in the formation of a particular social matrix and culture in America and its perceived allies; these have been the sorts of connections made by those seeking a critique of conventional art history and criticism. The breadth of these connections may be seen as consistent with a claim for Modernism made in 1961 by Clement Greenberg, the most competent exponent of this convention. He asserted that: 'Modernism includes more than just art and literature. By now it includes almost the whole of what is truly alive in our culture.'[5] He went on, in this classic statement, to explain that:

> The essence of Modernism lies, as I see it, in the use of the characteristic methods of a discipline itself – not in order to subvert it, but to entrench it more firmly in its area of competence.

> [. . .] Realistic, illusionist art had dissembled the medium, using art to conceal art. Modernism used art to call attention to art. The limitations that constitute the medium of painting – the flat surface, the shape of the support, the properties of the pigment – were treated by the Old Masters as negative factors that could be acknowledged only implicitly or indirectly. Modernist painting has come to regard these same limitations as positive factors that are to be acknowledged openly. Manet's paintings became the first Modernist ones by virtue of the frankness with which they declared the surfaces on which they were painted . . .

> It was the stressing, however, of the ineluctable flatness of the support that remained most fundamental in the processes by which pictorial art criticized and defined itself under Modernism . . . Flatness, two-dimensionality, was the only condition painting

5

shared with no other art, and so Modernist painting orientated itself to flatness as it did to nothing else.[6]

As an art critic, art theorist and commentator on social and political issues, Greenberg belongs to the intelligentsia, which Noam Chomsky identifies as a social class in a 'society like ours'.[7] As professionals, members of this class see their job as the analysis and presentation of some picture of social reality. As Chomsky says, 'by virtue of their analyses and interpretations, they serve as mediators between the social facts and the mass of the population: they create the ideological justification for social practice'.[8] He goes on to suggest that to compare the work of specialists in contemporary affairs, their interpretations, with 'the events', the 'world of fact', often reveals a 'great and fairly systematic divergence'. The critiques of Modernism during the 1970s and 1980s were started, in part, by those who recognized a systematic divergence between Modernists' explanation, interpretation and history of art, and more materialist representations of 'events' and the 'world of fact'. This can be said to have happened in two major areas. The first was effected by work produced on the nineteenth century by T. J. Clark with the publication of two of his books in 1973: *The Absolute Bourgeois: Artists and Politics in France, 1848–1851* and *Image of the People: Gustave Courbet and the 1848 Revolution.*[9] The second was the appearance of articles which questioned the Modernist explanation of, and influence on, art from the late 1940s onwards. Some of these are collected in Sections II and III of this anthology.

Chomsky suggests that the explanation of systematic divergences needs to take into account the class position of the intelligentsia:

> With a little industry and application, anyone who is willing to extricate himself from the system of shared ideology and propaganda will readily see through the modes of distortion developed by substantial segments of the intelligentsia. Everybody is capable of doing that. If such an analysis is often carried out poorly, that is because, quite commonly, social and political analysis is produced to defend special interests rather than to account for the actual events.[10]

The last sentence of Chomsky's quote is a salutary warning to those interested in the 'social history of art'. He may, however, also underestimate the difficulty of the project. It is certainly true that many critiques of Modernism have been poorly argued and inadequately theorized. One reason for this is the danger of special interest leading to reductionism or reflectionism: works of art, or of art history, or of art criticism 'reflecting' ideologies, social relations or wider histories; history as 'background' to that which is produced; the determinist argument of economic base causing an automatic response in superstructural forms.[11] However, there are problems facing historians who view conventional Modernism as a 'set of ideas' or as an 'ideology'. As Kolakowski writes, the problem facing the 'historian of ideas'

> ... does not consist in comparing the 'essence' of a particular idea with its practical 'existence' in terms of social movements. The question is rather how, and as the result of what circumstances, the original idea came to serve as a rallying-point for so many different and mutually hostile forces; or what were the ambiguities and conflicting tendencies in the idea itself which led to its developing as it did?[12]

And for those historians who view mainstream Modernism as part of the system of shared ideology which is inextricable from American imperialism in the post-war period (examples will be found in Section II), Chomsky makes a series of points:

> The resources of imperialist ideology are quite vast. It tolerates – indeed encourages – a variety of forms of opposition . . . It is permissible to criticize the lapses of the intellectuals and of government advisers, and even to accuse them of an abstract desire for 'domination', again a socially neutral category, not linked in any way to concrete social and economic structures. But to relate that abstract 'desire for domination' to the employment of force by the United States government in order to preserve a certain system of world order, specifically, to ensure that the countries of the world remain open insofar as possible to exploitation by U.S.-based corporations – that is extremely impolite, that is to argue in an unacceptable way.[13]

Art history, art criticism and art itself may seem marginal in the context of the principles that 'guide US foreign policy, and its concern to create a global economic order that conforms to the needs of the US economy and its masters'.[14] Yet, for many critics of Modernism who see that theory as a misrepresentation of the causal conditions of Abstract Expressionism and as ideologically dominating the critical debate on art since the 1950s, it is deeply embedded in the strategies and rhetoric of the Cold War. For them, the history of the ideas and ideological formations that produced the most characteristic, or conventional, history of art in the post-war period is a history intersected by the forces and resources of the 'imperialist ideology'.

There is a good case for seeing the major debates of the 1970s and 1980s as having their roots in the 1930s and 1940s in the USA, where Modernism became elaborated and entrenched in subsequent decades. Certainly many of the texts in this anthology discuss the historical and theoretical significance of two essays by Clement Greenberg written for *Partisan Review* when it was an important forum for Marxist debate in the late 1930s and early 1940s. These two essays, 'Avant-Garde and Kitsch' (1939) and 'Towards a Newer Laocoon' (1940),[15] are as much concerned with culture as they are with forms of art in bourgeois society. So too is Meyer Schapiro's 'The Nature of Abstract Art' published in *Marxist Quarterly* in 1937.[16] The texts by Serge Guilbaut and by Thomas Crow consider the contribution made by this essay not only to our understanding of debates in the 1930s but also to the competences of those interested in early critiques of the shifts and developments in the tradition of Modernism. Schapiro's point of departure was Alfred H. Barr Jr's *Cubism and Abstract Art*, published by the Museum of Modern Art as the guide to and catalogue of the exhibition, of the same name, held by the museum in the spring of 1936. On the jacket of Barr's book appeared a diagram of lines of influence in modern art (Plate A). This diagram represents a discernible shift in the premises for the discussion of modern art and its history. Implicitly or explicitly Barr's model, a linear and intentionalist flow diagram, informs much subsequent conventional history and explanation of modern art. That is not to say that there were no sources or critical traditions on which Barr drew. He would have been aware of the tradition we now recognize as forming the basis of Modernism: certain *aspects* of criticism by Zola and other late

7

nineteenth-century critics, and by Denis, Fry, Bell, Wilenski, etc.[17] Though it is fair to say, I think, that Barr's position was *particular*.

As the director of a new and prestigious museum, established in 1929 and funded by the financially élite families of East Coast entrepreneurial capitalism,[18] Barr wished to organize major retrospective exhibitions of modern art. As a scholar, he also wished to write well-researched art history. In 1926, he had been appointed Assistant Professor of Art History at Wellesley College, where he taught the first college course to be devoted exclusively to twentieth-century art history. Painting since the *Fauves* and the Cubists had received little *systematic* attention of a similar intellectual and historical seriousness as works of art produced in, say, Mediaeval and Renaissance Europe had by, in particular, German academics. Barr's ambition was to provide explanations of modern art which were as scholarly as academic work on earlier art; he was, therefore, researching in an area ripe for authoritative and pioneering 'history'. But first he had to be clear about what he was constructing a history *of*.

Barr was active when explanations as seemingly diverse as those by Worringer, Fry, Bahr, Cheney, Breton and Trotsky were available.[19] It should also be remembered that Barr had travelled in Europe, including Soviet Russia where he had met artists and writers concerned with debates on Russian Formalism. For Barr such explanations would have shown the failure of modern criticism *systematically* to account for the range of modern art and modern art practices. Many of the debates were historically specific, as were the art works discussed. However, one function of a museum, and therefore of its director, is to collect elements of different cultures – at best to represent their relevant cognitive systems and social beliefs, but at worst to construct curatorial histories – histories which may have more to do with the ideals and projected status of the representatives of the institution and its apologists within a particular society than they do with adequate historical representation.

As an art historian *and* exhibition organizer, Barr needed to establish a coherent explanation of diverse productions in modern art. He split up his explanation into two complementary parts. One was represented by 'Cubism and Abstract Art', the other by the exhibition 'Fantastic Art, Dada and Surrealism' held in the Museum of Modern Art in late 1936. As with the former this was a substantial pioneering exhibition with an accompanying catalogue in which Barr explained that, unlike the rational and abstract tendencies displayed in the earlier show, these works represented human interest in the irrational, the spontaneous, the enigmatic and the dreamlike – art which was defined as romantic, often figurative and naturalistic. With these two shows Barr constructed what appeared to be a dialectic in modern art; a dialectic of exhaustion and reaction between styles which emanated from Cubism. This 'style', represented as the largest and most influential in Barr's 'flow diagram', is seen as having been caused by selected aspects of late nineteenth-century French art.

Barr's general thesis rests on two major premises. First, he makes the intellectual error of distinguishing between 'representational' and 'non-representational' art. As Schapiro suggested in 1937, this is a mistaken distinction. *All* works of art represent or signify, something. For Barr 'representation' is associated with art

that appears to be concerned with the world of 'facts', or with what more theoretically robust authors have called 'resemblance'.[20] Yet, any informed consideration of art produced at different times and in different cultures will confirm that there is a wide range of ways in which a picture represents its subject or theme or conveys knowledge. Often combinations of symbols and signifiers convey shifting or ambiguous meanings which may not appear consistent with what a picture *resembles*. If representations are constructed from conventions, references, symbols, and signifiers then the characteristics of an art work in which there is little evident concern with resemblance may still *represent* something or be symbolic. Plainly without knowledge of the conventions implicit in abstract works references or symbols may be difficult to 'read' or to 'translate'. However, as it is essential to Modernist aesthetics for the history of modern art to be one stressing a move toward autonomy, and disinterestedness they characterise abstract art, as 'non-representational'. They are blind to considering pictorial representations as actively constructed from conventions available as the resources of a culture or sub-culture. Hence, with Cubism, Barr sees an exhaustion of 'representational' art and an inevitable move to what he identifies as the two major trends in the twentieth century.

Second, he sees art as essentially explainable in terms of certain formal interests. He identifies what appear to be formal similarities between works produced in different cultures and circumstances; formal similarity is used as a key for unlocking historical complexity. He constructs a systematic model which seeks to explain diversity, to provide a history which is essentially *historicist* – a retrospective curatorial validation for certain forms of 'Non-Geometric Abstract Art' and 'Geometric Abstract Art'. This 'history' and explanation of modern art, which Barr developed and elaborated in further catalogues and publications, became enormously influential despite criticism such as that by Meyer Schapiro in 1937:

> . . . if the book is largely an account of historical movements, Barr's conception of abstract art remains essentially unhistorical. He gives us, it is true, the dates of every stage in the various movements, as if to enable us to plot a curve, or to follow the emergence of the art year by year, but no connection is drawn between the art and the conditions of the moment. He excludes as irrelevant to its history the nature of the society in which it arose, except as an incidental obstructing or accelerating atmospheric factor. The history of modern art is presented as an internal, immanent process among the artists; abstract art arises because, as the author says, representational art had been exhausted. Out of boredom with 'painting facts', the artists turned to abstract art as a pure aesthetic activity. 'By a common and powerful impulse they were driven to abandon the imitation of natural appearance' just as the artists of the fifteenth century 'were moved by a passion for imitating nature'. The modern change, however, was 'the logical and inevitable conclusion toward which art was moving'.[21]

Barr's emphasis on the theory of exhaustion and reaction reduces history, as Schapiro observes, to the 'pattern of popular ideas on changes in fashion'. Yet despite such dissent, Barr's critical model seemed to offer a plausible 'explanation'. He relegated problematic issues such as that of 'realism' in Cubism by emphasizing one aspect of Picasso's and Braque's interests, namely formal and

technical radicalism, as though it was the motive force of their practice. To give priority to formal concerns provided Barr with a critical model which not only allowed him to discuss particular paintings in scholarly detail, but also to construct a systematic history of modern art, in which developments appeared self-winding and independent of extrapictorial forces. And, more importantly, it could be both elaborated and extended to account for 'new developments'. Here is Barr in 1939, developing the vocabulary and conceptual framework of his model:

> *Les Demoiselles d'Avignon* is the masterpiece of Picasso's Negro period, but it may also be called the first cubist picture for the breaking up of natural forms, whether figures, still-life or drapery, into a semi-abstract allover pattern of tilting shifting planes is already cubism; cubism in a rudimentary stage, it is true, but closer to the developed early cubism of 1909 than are most of the intervening 'Negro' works. *Les Demoiselles* is a transitional picture, a laboratory, or, better, a battlefield of trial and experiment; but it is also a work of formidable, dynamic power unsurpassed in European art of its time. Together with Matisse's *Joie de vivre* of the same year it marks the beginning of a new period in the history of modern art.[22]

We can get a better idea of the implications of Barr's critical model by seeing it as a paradigm, in a similar way to that proposed by Thomas S. Kuhn, the historian of science. In 1962 Kuhn published an influential book, *The Structure of Scientific Revolutions*,[23] the general thesis of which is useful for art history. Kuhn argues that change or 'progress' in scientific theory consists of *shifts* in paradigms; it is not a linear series of revolutions, or a disinterested development of knowledge. A paradigm is a model by which the practitioners of any discipline, for our purposes art historians and critics, define *their* field of problems, a 'field' is that which any group of practitioners needs to circumscribe in order to do any productive *work*. The paradigm may be 'metaphysical', based on 'values', 'beliefs' or an organizing principle governing perception itself; it may be 'sociological' as a set of intellectual, verbal, behavioural or institutional *habits*; it may be dominated by a 'classic' or hegemonic work. Importantly, Kuhn's sociological notion of a paradigm means that the paradigm can function *prior to theory*. I am not suggesting that art criticism, art history or art practice is the *same* as the procedures, interests and demands of scientific research. Rather, that to apply Kuhn's general model of scientific change to explain change in art criticism and art history helps us to understand the nature and success of Modernist criticism and history, particularly that which has dominated post-war debates on art.

> What then is the nature of the more professional and esoteric research that a group's [i.e. art critics/historians] reception of a single paradigm permits? If the paradigm represents work that has been done once and for all, what further problems does it leave the united group to resolve?
>
> . . . We must recognize how very limited in both scope and precision a paradigm can be at the time of its first appearance. Paradigms gain their status because they are more successful than their competitors in solving a few problems that the group of practitioners has come to recognize as acute. To be more successful is not, however, to be either completely successful with a single problem or notably successful with any large number. The success of a paradigm . . . is at the start largely a success discoverable in selected and still incompatible examples. Normal [art history/criticism] . . . consists in the actualization of that promise, an actualization achieved

by extending the knowledge of those facts [i.e. about characteristics of works of art] that the paradigm displays as particularly revealing, by increasing the extent of the match between those facts and the paradigm's predictions, and by further articulations of the paradigm itself.[24]

According to Kuhn, a new paradigm becomes dominant when, in comparison with its competitors, it promises to explain selected and seemingly incompatible examples which the old paradigm cannot. Within the new model certain 'facts' are selected as particularly revealing. By successfully matching those 'facts' against the paradigm's predictions the paradigm can be elaborated.

For Barr the existing paradigm for modern art history and art criticism would have been under stress because it could not *systematically* account for modern developments. (In Kuhnian terms the situation before Barr may even be characterized as *pre*-paradigmatic.) So, by emphasizing formal characteristics of paintings as especially revealing, he could construct a particular history of modern art. His paradigm could be not only elaborated and *theorized* but also extended to account for new paintings. Clement Greenberg had a major influence on both these kinds of development. He refined and elaborated Barr's explanation and history of modern art in his gradual emphasis on 'modern specialization' and the rigours of formalism; his 1958 essay on Cubist 'Collage',[25] is an example of his sophisticated analysis of particular works, while his 1961 essay, 'Modernist Painting',[26] provides the theoretical rationalizations. Greenberg is also the major figure in the extension of the paradigm to account for new developments in terms of its formal predictions. He could account for Abstract Expressionism in general, and Jackson Pollock in particular, within the paradigm's narrowly circumscribed set of problems. An introduction to the conditions in which Greenberg's criticism developed and shifted within the paradigm's 'resources' and 'tolerances of opposition' can be found at the beginning of Section II.

Schapiro's early critique of Barr's model is powerful in both its historical and theoretical arguments. Yet the paradigm took off because it seemed to solve problems within the practice of *criticism* itself. By defining the 'field', the 'model' of problems for criticism, it misrepresented the problems for modern art *practices*. As Kuhn says, the success of a paradigm does not mean that it is *true*:

> ... one of the things ... [an artistic or art historical/critical] community acquires with a paradigm is a criterion for choosing problems that, while the paradigm is taken for granted, can be assumed to have solutions. To a great extent these are the only problems that the community will admit as ... [artistic, art historical or art critical] or encourage its members to undertake. Other problems, including many that had previously been standard, are rejected as metaphysical, as the concern of another discipline, or sometimes as just too problematic to be worth the time. A paradigm can, for that matter, even insulate the community from those socially important problems that are not reducible to the puzzle form, because they cannot be stated in terms of the conceptual and instrumental tools the paradigm supplies.[27]

By 1961 the paradigm was well entrenched; it had been elaborated and refined to account for the history of art since Manet and had seemed to account for new and seemingly incompatible examples. Pollock's work of the 1940s and

particularly his 'drip paintings', were explained in terms of an extension of Barr's model; Pollock was characterized as essentially taking on the formal and technical problems of both the 'abstract and rational' trend and the 'surrealist and irrational', which also included aspects of expressionism. His art, therefore, could be explained in terms of a synthesis of styles which itself established a new heading in the extended model. His art could also be seen not only as a 'reaction' to previous styles but also as an 'exhaustion' of them. Greenberg's writings during the 1950s and 1960s are conventionally regarded as exhibiting his 'art for art's sake' and 'modern specialization' theories, as demonstrated in 'Modernist Painting'. However, as the Kuhnian notion of paradigm suggests, the critical theory refined in 'Modernist Painting' had its roots in Greenberg's criticism of the late 1930s, when the community of art critics had acquired Barr's paradigm. Here is Greenberg in 1939:

> Picasso, Braque, Mondrian, Miró, Kandinsky, Brancusi, even Klee, Matisse and Cézanne, derive their chief inspiration from the medium they work in. The excitement of their art seems to lie most of all in its pure preoccupation with the invention and arrangement of spaces, surfaces, shapes, colours etc., to the exclusion of whatever is not necessarily implicated in these factors.[28]

and in 1940,

> The arts lie safe now, each within its 'legitimate' boundaries, and free trade has been replaced by autarchy. Purity in art consists in the acceptance, willing acceptance, of the limitations of the medium of the specific art . . .
> It is by virtue of its medium that each art is unique and strictly itself. To restore the identity of an art the opacity of its medium must be emphasized.[29]

These two essays, included in Section I of this anthology, contain elements recognizable in the critical debates on Pollock and his legacy. Yet, they also contribute to the debates on culture and society which preoccupied Marxists during the 1930s and 1940s. As T. J. Clark notes, when Greenberg reprinted 'Avant-Garde and Kitsch' as the opening collection of critical essays, *Art and Culture* (1961), he made 'no attempt to tone down its mordant hostility to capitalism'.[30] Greenberg offered a critique of bourgeois culture under capitalism from the nineteenth century to the late 1930s. For him the contemporary era was one in which there seemed to be little possibility of a critical art, only 'an academicism in which the really important issues are left untouched because they involve controversy, and in which creative activity dwindles to virtuosity in the small details of form . . .'.[31] And he concluded this essay with a view which *seems* incompatible with his later elaboration of formalism: 'Capitalism in decline finds that whatever of quality it is still capable of producing becomes almost invariably a threat to its own existence . . . Here, as in every other question today, it becomes necessary to quote Marx word for word . . . Today we look to socialism *simply* for the preservation of whatever living culture we have right now.'[32]

'Towards a Newer Laocoon' is a defence of abstract art without the same attention to a social and cultural critique. And even though the content of both essays has provided some of the origins of current debates about Modernism, and about art practice, art history and art criticism since Pollock, they are essentially

within the same paradigm. This is clear if we compare them to the essays by Meyer Schapiro from the late 1930s, particularly 'The Social Bases of Art' (1936) and 'The Nature of Abstract Art' (1937).[33] As permission for their inclusion in this anthology could not be obtained from the author, it is necessary to quote from them at length.

Much recent debate on Pollock and after has centred on 'the social history of art'. And if, as I argue, there is a good case for seeing the origins of conventional post-war Modernism rooted in the 1930s then there is as strong a case for examining early critiques from Marxists of the same period.

'The Social Bases of Art' provides us with a more lucid and more historically informed analysis of art and culture from ca. 1850 to the 1930s than much else on offer at the time. It also discusses many of the issues which concern those historians and critics active in debates on art practice, art historical practice and critical practice since Pollock. It starts with a clear awareness of what has been called the 'relative autonomy' of art:

> When we speak in this paper of the social bases of art we do not mean to reduce art to economics or sociology or politics. Art has its own conditions which distinguish it from other activities. It operates with its own special materials and according to general psychological laws. But from these physical and psychological factors we could not understand the great diversity of art, why there is one style at one time, another style a generation later, why in certain cultures there is little change for hundreds of years, in other cultures not only a mobility from year to year but various styles at the same moment, although physical and psychological factors are the same . . .[34]

Schapiro goes on to identify 'the common character' which unites the art of individuals at any one time and place: it is as members of a society,

> . . . with its special traditions, its common means and purposes, prior to themselves, that individuals learn to paint, speak and act in the current manner. And it is in terms of changes in their immediate common world that individuals are impelled together to modify their no longer adequate conceptions.[35]

Schapiro is here arguing from within a particular aspect of the Marxist tradition. Leon Trotsky had written that a 'work of art, should in the first place, be judged by its own law, that is, by the law of art',[36] therein lies its 'relative autonomy' (the specific phrase is attributed by some to French Marxists of the 1960s and 1970s, particularly to Althusser).[37] However, we need to explain why and how a 'given tendency in art has originated in a given period of history; in other words, who it was who made a demand for such an artistic form and not for another, and why'.[38] The answer for Trotsky lay within the materialist conception of history, according to which the *ultimately* determining element in history is the production and reproduction of real life. Engels wrote in 1894:

> Political, juridical, philosophical, religious, literary, artistic, etc., development is based on economic development. But all these react upon one another and also upon the economic basis. It is not that the economic situation is *cause, solely active*, while everything else is only passive effect. There is, rather, interaction on the basis of economic necessity, which *ultimately* always asserts itself . . . So it is not, as people try here and there conveniently to imagine, that the economic situation produces an automatic effect. No. Men make their histories themselves, only they do so in a

> given environment, which conditions it, and on the basis of actual relations already existing, among which the economic relations, however much they may be influenced by the other – the political and ideological – relations, are still ultimately the decisive ones, forming the keynote which runs through them and alone leads to understanding.[39]

This letter restates a similar position made clear in an earlier one to J. Bloch where Engels stated that 'the economic situation is the basis, but the various elements of the superstructure . . . also exercise their influence upon the course of the historical struggles and in many cases preponderate in determining their *form*'.[40] That is to say that art, as a superstructural form, is produced from all kinds of causes – *as are* art history and art criticism. The interaction or the relationship between the two sets of causes is often inadequately discussed, as is pointed out by Baldwin, Harrison and Ramsden in Text 11. Importantly, as Engels states, elements of the superstructure have a relative autonomy, so it is clear, for example, that ideas can be determinants on modes of production and activities, and have a revolutionary potential. Yet, although ideas, beliefs and forms of representation may not be subject to exhaustive causal explanation by reference to 'the material conditions of life' – they have some life of their own – ultimately social and economic relations are the decisive influences.

> If modern art seems to have no social necessity, it is because the social has been narrowly identified with the collective as the anti-individual, and with repressive institutions and beliefs, like the church or the state or morality, to which most individuals submit. But even those activities in which the individual seems to be unconstrained and purely egotistic depend upon socially organized relationships. Private property, individual competitive business enterprise or sexual freedom, far from constituting non-social relationships, presuppose specific, historically developed forms of society.
>
> . . . if we examine attentively the objects a modern artist paints and the psychological attitudes evident in the choice of these objects and their forms, we will see how intimately his art is tied to the life of modern society.
>
> . . . elements drawn from the professional surroundings and activity of the artist; situations in which we are consumers and spectators; objects which we confront intimately, but passively or accidentally, or manipulate idly and in isolation – these are typical subjects of modern painting.
>
> . . . The preponderance of objects drawn from a personal and artistic world does not mean that pictures are now more pure than in the past, more completely works of art. It means simply that the personal and aesthetic contexts of secular life now condition the formal character of art . . .[41]

Schapiro's account of modern art is consistent with a materialist conception of history. He considers what works of art in the modern period may be seen as representations *of*, and offers a history and explanation which address similar social concerns to those which exercised Greenberg in 'Avant-Garde and Kitsch' only three years later. Schapiro recognized, as had Barr at the same period, that the existing paradigm for the explanation of modern art could not systematically account for the range of its forms, practices and justifications – whether by artists or contemporary critics. 'The Social Bases of Art' is obviously also the result of an informed consideration of what a history of modern art should be a history *of*.

Barr's consideration led to a different construction, to the formation of what we now call the Modernist paradigm. If Schapiro also provides the criterion for selecting problems, that is a paradigm, it was conspicuously unsuccessful in the light of Modernism's subsequent ideological dominance.

In retrospect, though, critics of Modernism see Schapiro's texts of 1936 and 1937 as demonstrating some of the historical resources for a revision of the dominant paradigm. This is particularly so as there are areas of agreement in the social analysis underlying both these texts and Greenberg's 'Avant-Garde and Kitsch'; yet they come to different conclusions. As Thomas Crow observes:

> Both see the commodification of culture as the negation of the real thing, that is, the rich and coherent symbolic dimension of collective life in earlier times; both see beneath the apparent variety and allure of the modern urban spectacle only the 'ruthless and perverse' laws of capital; both posit modernist art as a direct response to that condition, one which will remain in force until a new, socialist society is achieved. [42]

This last point may be open to debate where Greenberg is concerned, though on a quick reading it would be difficult to identify the author of the following:

> The conception of art as purely aesthetic and individual . . . in its most advanced form . . . is typical of the *rentier* leisure class in modern capitalist society, and is most intensely developed in centers like Paris, which have a large *rentier* group and considerable luxury industries. Here the individual is no longer engaged in a struggle to attain wealth; he has no direct relation to work, machinery, competition; he is simply a consumer, not a producer. [43]

It is Schapiro, not Greenberg; perhaps it is the emphasis on 'producer' which distinguishes the text as incompatible with the notion of 'purity' as strong in Greenberg's essays of 1939 and 1940 as is his hostility to capitalism. Further examination reveals fundamental difference in each author's view of 'mass culture'. For Greenberg, as with Adorno, there is a strong sense of moral judgement underlying his concept of 'kitsch' and his emphasis on formal 'purity in art', representing the preservation of a living Western culture. This prevents him from making an *historical* analysis of the avant-garde's engagement with particular subjects and images from urban leisure and 'mass culture'. Fundamentally, I think this is because even in his early essays, as impressive as they are, there is a concern with the notion of 'quality' (the *disinterested* discriminations of value) which is inseparable from the other aspects of the Modernist paradigm, even in its unelaborated form. Hence, it is Schapiro who carries through his materialist concept of history to claim that:

> The social origins of such forms of modern art do not in themselves permit one to judge this art as good or bad; they simply throw light upon some aspects of their character and enable us to see more clearly that the ideas of modern artists, far from describing eternal and necessary conditions of art, are simply the results of recent history. In recognizing the dependence of his situation and attitudes on the character of modern society, the artist acquires the courage to change things, to act on his society and for himself in an effective manner.
>
> . . . An individual art in a society where human beings do not feel themselves to be most individual when they are inert, dreaming, passive, tormented or uncontrolled,

15

would be very different from modern art. And in a society where all men can be free individuals, individuality must lose its exclusiveness and its ruthless and perverse character.[44]

An analysis of the reasons why the Barr paradigm became so successfully elaborated and internalized within the seemingly incompatible social analysis of early 'Trotskyist' Greenberg cannot be dealt with here. Some of the reasons are covered in the next section of this anthology but a full account will be covered elsewhere. However, recalling Chomsky's comments on the 'intelligentsia' as a 'social class', we can see from Schapiro's own essay that the production of a successful form of criticism may be seen as a form of 'ideological justification for social practice':

> Of course, only a small part of this [*rentier*] class is interested in painting, and only a tiny proportion cultivates the more advanced modern art . . . the common character of this class affects to some degree the tastes of its most cultivated members. We may observe that these consist mainly of young people with inherited incomes, who finally make art their chief interest, either as artists and decorators, or as collectors, dealers, museum officials, writers on art and travellers. Active businessmen and wealthy professionals who occasionally support this art tend to value the collecting of art as a higher activity than their own daily work.[45]

I do not wish to suggest that Schapiro's writings of the 1930s are somehow revealed as more ideologically sound than the early work of Greenberg or Barr.[46] Rather they shed light on the context of the 1930s debates which, in many respects, are similar to the ones that occupy us now. To be consistent we need to examine the social, intellectual and political conditions of the late 1930s in order to begin to explain the extent of the differences between their respective analyses, histories; their writings as forms of representation. However, it would be disingenuous not to admit that Schapiro's texts, despite their weaknesses in certain areas, have a powerful explanatory force, particularly in the context of art history in the 1930s. It is a pity that they could not be included in this anthology.

Schapiro's texts, especially 'The Nature of Abstract Art', also owe their strength to the fact that they address Modernist heroes – they do not *avoid* them. As T. J. Clark states in Text 5:

> . . . the critique of modernism will not proceed by demotion of heroes, but by having heroism come to be less and less the heart of the matter. We should not be trying to puncture holes in the modernist canon (we shall anyway usually fail at that) but rather to have canon replaced by other, more intricate, more particular orders and relations. Naturally, new kinds of value judgement will result from this: certain works of art will come to seem more important, others less interesting than before; but above all the *ground* of valuation will shift.[47]

It is clear that one of the major debates within the 'history of modern art' concerns the art critic's and art historian's function as a disseminator, or 'mediator' of 'truth', of 'knowledge', of 'history', of 'ideology'. In an interview held in June 1981, which formed the basis for a television programme, 'Greenberg on Art Criticism' for the Open University course *Modern Art and Modernism: Manet to Pollock*, Greenberg distances himself from recent work produced by younger academics:

. . . you young ones, you think there's always more there than there is. You have to write out the rest . . . the value judgements come *first*. You young ones, you want to fill in, fill in the pages . . . You want to think, and there's nothing wrong with that, but cut, cut . . .[48]

By 'cut' Greenberg means 'edit out' all that which is not relevant to value judgements and aesthetic questions. For Greenberg historians such as T. J. Clark and others represented in this anthology 'want to fill in, fill in the pages'. By this he means burrowing into the past, dishing up facts, even if presented in a well-substantiated and theorized way. He said something similar to Charles Harrison in an interview published in *Art Monthly* in 1984,[49] though Harrison would *not* characterize himself as a 'social historian of art'. Here, though, there are the grounds for a debate on the work to be done by art historians and art critics concerned with a critique of Modernism: as it can be seen as a misrepresentation of the possible cognitive and historical meanings of art, and of how and why works of art are *produced* in particular causal conditions; as a dominant post-war ideology in which debate on Pollock and later artists was contained within the insulated paradigm. This last point can be illustrated by the seemingly substantial debate between the 'abstractionists' and 'literalists' in the 1960s on the 'legacy of Pollock'.[50] Michael Fried, further elaborating Greenberg, most clearly expressed the 'abstractionist' case, while Don Judd and Robert Morris favoured the 'literalist'. For those locked within the Modernist critical paradigm such a debate may seem, in the context of 'modern specialization' etc., to be interesting, productive and a contribution to human knowledge. Others may consider the debate as doctrinal squabbles, as the paradigm's tolerance and indeed as encouragement of a variety of forms of opposition – albeit 'opposition' as defined by the criterion of problems for the group of practitioners.

For Harrison and members of Art & Language, as represented by Text 11, Modernism and the 'social history of art' need, and have needed, one another in order to justify their existence. For them also the 'Left' has 'failed' systematically to counter the cultural and theoretical claims of the former.[51] Whether or not both these observations are true, they see a major project to be a consideration of what a clash of Modernism – its emphasis on aesthetic judgement, on 'intuition', on autonomy, on 'quality' – and the social history of art – its historical materialism – will bring to an art history and an art criticism informed by the rigours of scientific inquiry and the legacy of British philosophy which follows in the tradition of philosophical rationalism. For other critics of Modernism, historical materialism has no truck with 'intuition' unless it is considered as the historical product of bourgeois individualism. For them, Modernism as a critical theory has all the dangers of closure on inquiry, ideologically determined, that characterizes the considerable limits of a paradigm, as considered by Thomas Kuhn. And as an account of modern art it is rank bad history; Modernism is an ideology which systematically misrepresents the real relations between the meaning of art and its practices and how and why works of art are and were *produced.*

What at least needs to be recognized is that there are jobs of work to be done. Rigorous engagement with theoretical problems is one, the practice and continual testing of the social history of art – historical materialism – is another. The con-

tinual testing, though, requires that critiques are based on an adequate characterization and defensible criticism of the work produced by other historical materialists. The *historian* of art needs to be concerned with a consciously defined history of how and why works of art were, and are, produced *and* a history of the ideas and ideological formations that produced the most characteristic, or paradigmatic, histories.

Notes

1 See *The Poverty of Historicism* (London, Routledge & Kegan Paul, 1957). An important extract, 'Situational Logic in History. Historical Interpretation', is reprinted in *Modern Art and Modernism: A Critical Anthology*, edited by Francis Frascina and Charles Harrison (London, Harper & Row, 1982, pp. 11–13).

2 'The Sociological Approach: The Concept of Ideology in the History of Art', *The Philosophy of Art History* (London, Routledge & Kegan Paul, 1959). This quote from the edited reprint in Frascina and Harrison, op. cit., p. 237. See also Frederick Antal's essays published under the title of *Classicism and Romanticism* (London, Routledge & Kegan Paul, 1966).

3 Published by The Museum of Modern Art, New York.

4 'The Nature of Abstract Art', *Marxist Quarterly*, vol. 1, no. 1, January 1937, pp. 77–98; this quote from the essay as reprinted in Schapiro, *Modern Art: 19th and 20th Centuries* (London, Chatto and Windus, 1978, pp. 195–196).

5 *Arts Yearbook* 4, 1961, pp. 109–116; this quote from the essay reprinted in Frascina and Harrison, op. cit., p. 5.

6 Ibid., pp. 5–6.

7 'Politics' in *Language and Responsibility*, based on conversations with Mitsou Ronat (Sussex, The Harvester Press, 1979, p. 4).

8 Ibid.

9 Both published by Thames and Hudson.

10 Op cit., p. 4.

11 For a discussion of these 'taboos' see T. J. Clark's 'On the Social History of Art', *Image of the People*, op. cit., pp. 9–20; edited reprint in Frascina and Harrison, op. cit., pp. 249–258.

12 Leszek Kolakowski, *Main Currents of Marxism: Its Origins, Growth and Dissolution*, Vol. 1, *The Founders*, translated from the Polish by P. S. Falla (Oxford, Oxford University Press, 1981, p. 3).

13 Op. cit., pp. 40–41.

14 Ibid., p. 41. He goes on: 'I'm referring, for example, to the crucial documentation contained in the *Pentagon Papers*, covering the late 1940s and early 1950s when the basic policies were clearly set, or the documents on global planning for the post war period produced in the early 1940s by the War-Peace Studies groups of the Council on Foreign Relations, to mention only two significant examples'.

15 See Texts 1 and 2.

16 See note 4.

17 For a representative selection of texts see Frascina and Harrison, op. cit. For

a further discussion of the origins of, typical debates within, and resources for a critique of Modernism, see the Open University course A315 *Modern Art and Modernism: Manet to Pollock* (Milton Keynes, The Open University Press, 1983).

18 See Russell Lynes, *Good Old Modern: An Intimate Portrait of the Museum of Modern Art* (New York, Atheneum, 1973).

19 See Frascina and Harrison, op. cit.

20 See, for example, M. Baldwin, C. Harrison, M. Ramsden, 'Art History, Art Criticism and Explanation' (Text 11) and other work by Art & Language.

21 Loc. cit., pp. 187–188.

22 *Picasso: Forty Years of his Art* (New York, The Museum of Modern Art, 1939, p. 60). See also Barr's *Picasso: Fifty Years of his Art* (New York, The Museum of Modern Art, 1946, p. 56).

23 The University of Chicago Press, Chicago. See also the second enlarged edition (1970), from which all quotations are taken. Important also for this discussion is Margaret Masterman, 'The Nature of a Paradigm' in *Criticism and the Growth of Knowledge*, ed. I. Lakatos and A. Musgrave (Cambridge University Press, Cambridge, 1970, pp. 59–89).

24 Ibid., pp. 23–24.

25 First published as 'The pasted-paper revolution', *Art News*, **LVII**, September 1958, pp. 46–49 and p. 60. See reprint in Frascina and Harrison, op. cit., pp. 105–108. Revised and expanded it appeared as 'Collage' in Greenberg's *Art and Culture: Critical Essays* (Boston, Beacon Press, 1961).

26 See note 5.

27 Op. cit., p. 37.

28 'Avant-Garde and Kitsch', p. 37 *[23]*. See Text 1 p. 21 for full reference.

29 'Towards a Newer Laocoon', p. 305 *[41–42]*. See Text 2 p. 35 for full reference.

30. 'Clement Greenberg's Theory of Art' p. 139 *[47]*. See Text 3 for full reference p. 47.

31. Op. cit., p. 35 *[22]*.

32 Ibid., pp. 48–49 *[31–32]*.

33 The former: the *First American Artists' Congress against War and Fascism* (New York, 1936, pp. 31–37). Reprinted in *Social Realism: Art as a Weapon*, edited and introduced by David Shapiro (New York, Frederick Ungar Publishing Co., 1973, pp. 118–127) from which all quotations are taken.) The latter: see note 4.

34 Loc. cit., p. 118.

35 Ibid.

36 *Literature and Revolution*, translated by Rose Strunsky (Ann Arbor Paperbacks, The University of Michigan Press, 1960, p. 178). This was written in the summers of 1922 and 1923, first appearing in English translation in 1925.

37 See Louis Althusser, *For Marx* (Harmondsworth, Penguin, 1969; French original, 1966).

38 Trotsky, op. cit., p. 178.

39 Friedrich Engels to W. Borgius, 25 January 1894, in *Selected Works*, Vol. III (London, Lawrence and Wishart, pp. 502–503).

40 Engels to J. Bloch, 21–22 September 1890, *Selected Works*, Vol. III

(London, Lawrence and Wishart, p. 487).

41 'The Social Bases of Art', loc. cit., pp. 120–123.

42 'Modernism and Mass Culture in the Visual Arts', p. 227 *[242]*. See Text 13 for full reference.

43 'The Social Bases of Art', loc. cit., p. 123.

44 Ibid., pp. 126–127.

45 Ibid., p. 124.

46 For an analysis of Schapiro's career and interests see O. K. Werckmeister's review of Schapiro's *Romanesque Art, Art Quarterly*, new series **11** (Spring 1979), pp. 211–218.

47 See 'Arguments about Modernism', Text 5, p. 84.

48 Television Programme 29, see note 17.

49 April 1984, No. 75, p. 6.

50 For a sample of Michael Fried taking issue with the 'literalists' see his 'Art and Objecthood', *Artforum*, June 1967, reprinted in *Minimal Art: A Critical Anthology*, edited by Gregory Battcock (New York, 1968). And for a resumé of the rival positions see Philip Leider, 'Abstraction and Literalism: Reflections on Stella at the Modern', *Artforum*, April 1970, pp. 44–51.

51 See the Introduction to Charles Harrison and Fred Orton (eds) *Modernism, Criticism, Realism* (London and New York, Harper & Row, 1984).

1 Avant-Garde and Kitsch

Clement Greenberg

One and the same civilization produces simultaneously two such different things as a poem by T. S. Eliot and a Tin Pan Alley song, or a painting by Braque and a *Saturday Evening Post* cover. All four are on the order of culture, and ostensibly, parts of the same culture and products of the same society. Here, however, their connection seems to end. A poem by Eliot and a poem by Eddie Guest – what perspective of culture is large enough to enable us to situate them in an enlightening relation to each other? Does the fact that a disparity such as this within the frame of a single cultural tradition, is and has been taken for granted – does this fact indicate that the disparity is a part of the natural order of things? Or is it something entirely new, and particular to our age?

The answer involves more than an investigation in aesthetics. It appears to me that it is necessary to examine more closely and with more originality than hitherto the relationship between aesthetic experience as met by the specific – not generalized – individual, and the social and historical contexts in which that experience takes place. What is brought to light will answer, in addition to the question posed above, other and perhaps more important ones.

I

A society, as it becomes less and less able, in the course of its development, to justify the inevitability of its particular forms, breaks up the accepted notions upon which artists and writers must depend in large part for communication with their audiences. It becomes difficult to assume anything. All the verities involved by religion, authority, tradition, style, are thrown into question, and the writer or artist is no longer able to estimate the response of his audience to the symbols and

Source: 'Avant-Garde and Kitsch', *Partisan Review*, vol. vi, no. 5, Fall 1939, pp. 34–49.

references with which he works. In the past such a state of affairs has usually resolved itself into a motionless Alexandrianism, an academicism in which the really important issues are left untouched because they involve controversy, and in which creative activity dwindles to virtuosity in the small details of form, all larger questions being decided by the precedent of the old masters. The same themes are mechanically varied in a hundred different works, and yet nothing new is produced: Statius, mandarin verse, Roman sculpture, Beaux Arts painting, neo-republican architecture.

It is among the hopeful signs in the midst of the decay of our present society that we – some of us – have been unwilling to accept this last phase for our own culture. In seeking to go beyond Alexandrianism, a part of Western bourgeois society has produced something unheard of heretofore: avant-garde culture. A superior consciousness of history – more precisely, the appearance of a new kind of criticism of society, an historical criticism – made this possible. This criticism has not confronted our present society with timeless utopias, but has soberly examined in the terms of history and of cause and effect the antecedents, justifications and functions of the forms that lie at the heart of every society. Thus our present bourgeois social order was shown to be, not an eternal, "natural" condition of life, but simply the latest term in a succession of social orders. New perspectives of this kind, becoming a part of the advanced intellectual conscience of the fifth and sixth decades of the nineteenth century, soon were absorbed by artists and poets, even if unconsciously for the most part. It was no accident, therefore, that the birth of the avant-garde coincided chronologically – and geographically too – with the first bold development of scientific revolutionary thought in Europe.

True, the first settlers of Bohemia – which was then identical with the avant-garde – turned out soon to be demonstratively uninterested in politics. Nevertheless, without the circulation of revolutionary ideas in the air about them, they would never have been able to isolate their concept of the "bourgeois" in order to define what they were *not*. Nor, without the moral aid of revolutionary political attitudes would they have had the courage to assert themselves as aggressively as they did against the prevailing standards of society. Courage indeed was needed for this, because the avant-garde's emigration from bourgeois society to Bohemia meant also an emigration from the markets of capitalism, upon which artists and writers had been thrown by the falling away of aristocratic patronage. (Ostensibly, at least, it meant this – meant starving in a garret – although, as will be shown later, the avant-garde remained attached to bourgeois society precisely because it needed its money.)

Yet it is true that once the avant-garde had succeeded in "detaching" itself from society, it proceeded to turn around and repudiate revolutionary politics as well as bourgeois. The revolution was left inside society, a part of that welter of ideological struggle which art and poetry find so unpropitious as soon as it begins to involve those "precious," axiomatic beliefs upon which culture thus far has had to rest. Hence it was developed that the true and most important function of the avant-garde was not to "experiment," but to find a path along which it would be possible to keep culture *moving* in the midst of ideological confusion and

violence. Retiring from public altogether, the avant-garde poet or artist sought to maintain the high level of his art by both narrowing and raising it to the expression of an absolute in which all relativities and contradictions would be either resolved or beside the point. "Art for art's sake" and "pure poetry" appear, and subject matter or content becomes something to be avoided like a plague.

It has been in search of the absolute that the avant-garde has arrived at "abstract" or "non-objective" art – and poetry, too. The avant-garde poet or artist tries in effect to imitate God by creating something valid solely on its own terms in the way nature itself is valid, in the way a landscape – not its picture – is aesthetically valid; something *given*, increate, independent of meanings, similars, or originals. Content is to be dissolved so completely into form that the work of art or literature cannot be reduced in whole or in part to anything not itself.

But the absolute is absolute, and the poet or artist, being what he is, cherishes certain relative values more than others. The very values in the name of which he invokes the absolute are relative values, the values of aesthetics. And so he turns out to be imitating, not God – and here I use "imitate" in its Aristotelian sense – but the disciplines and processes of art and literature themselves. This is the genesis of the "abstract."[1] In turning his attention away from subject-matter or common experience, the poet or artist turns it in upon the medium of his own craft. The non-representational or "abstract," if it is to have aesthetic validity, cannot be arbitrary and accidental, but must stem from obedience to some worthy constraint or original. This constraint, once the world of common, extraverted experience has been renounced, can only be found in the very processes or disciplines by which art and literature have already imitated the former. These themselves become the subject matter of art and literature. If, to continue with Aristotle, all art and literature are imitation, then what we have here is the imitation of imitat*ing*. To quote Yeats:

> Nor is there singing school but studying
> Monuments of its own magnificence.

Picasso, Braque, Mondrian, Miró, Kandinsky, Brancusi, even Klee, Matisse and Cézanne, derive their chief inspiration from the medium they work in.[2] The excitement of their art seems to lie most of all in its pure preoccupation with the invention and arrangement of spaces, surfaces, shapes, colors, etc., to the exclusion of whatever is not necessarily implicated in these factors. The attention of poets like Rimbaud, Mallarmé, Valéry, Eluard, Pound, Hart Crane, Stevens, even Rilke and Yeats, appears to be centered on the effort to create poetry and on the "moments" themselves of poetic conversion rather than on experience to be converted into poetry. Of course, this cannot exclude other preoccupations in their work, for poetry must deal with words, and words must communicate. Certain poets, such as Mallarmé and Valéry,[3] are more radical in this respect than others – leaving aside those poets who have tried to compose poetry in pure sound alone. However, if it were easier to define poetry, modern poetry would be much more "pure" and "abstract." . . . As for the other fields of literature – the definition of avant-garde aesthetics advanced here is no Procrustean bed. But aside from the fact that most of our best contemporary novelists have gone to school

with the avant-garde, it is significant that Gide's most ambitious book is a novel about the writing of a novel, and that Joyce's *Ulysses* and *Finnegan's Wake* seem to be above all, as one French critic says, the reduction of experience to expression for the sake of expression, the expression mattering more than what is being expressed.

That avant-garde culture is the imitation of imitat*ing* – the fact itself – calls for neither approval nor disapproval. It is true that this culture contains within itself some of the very Alexandrianism it seeks to overcome. The lines quoted from Yeats above referred to Byzantium, which is very close to Alexandria; and in a sense this imitation of imitat*ing* is a superior sort of Alexandrianism. But there is one most important difference: the avant-garde moves, while Alexandrianism stands still. And this, precisely, is what justifies the avant-garde's methods and makes them necessary. The necessity lies in the fact that by no other means is it possible today to create art and literature of a high order. To quarrel with necessity by throwing about terms like "formalism," "purism," "ivory tower" and so forth is either dull or dishonest. This is not to say, however, that it is to the *social* advantage of the avant-garde that it is what it is. Quite the opposite.

The avant-garde's specialization of itself, the fact that its best artists are artists' artists, its best poets, poets' poets, has estranged a great many of those who were capable formerly of enjoying and appreciating ambitious art and literature, but who are now unwilling or unable to acquire an initiation into their craft secrets. The masses have always remained more or less indifferent to culture in the process of development. But today such culture is being abandoned by those to whom it actually belongs – our ruling class. For it is to the latter that the avant-garde belongs. No culture can develop without a social basis, without a source of stable income. And in the case of the avant-garde this was provided by an elite among the ruling class of that society from which it assumed itself to be cut off, but to which it has always remained attached by an umbilical cord of gold. The paradox is real. And now this elite is rapidly shrinking. Since the avant-garde forms the only living culture we now have, the survival in the near future of culture in general is thus threatened.

We must not be deceived by superficial phenomena and local successes. Picasso's shows still draw crowds, and T. S. Eliot is taught in the universities; the dealers in modernist art are still in business, and the publishers still publish some "difficult" poetry. But the avant-garde itself, already sensing the danger, is becoming more and more timid every day that passes. Academicism and commercialism are appearing in the strangest places. This can mean only one thing: that the avant-garde is becoming unsure of the audience it depends on – the rich and the cultivated.

Is it the nature itself of avant-garde culture that is alone responsible for the danger it finds itself in? Or is that only a dangerous liability? Are there other, and perhaps more important, factors involved?

II

Where there is an avant-garde, generally we also find a rearguard. True enough –

simultaneously with the entrance of the avant-garde, a second new cultural phenomenon appeared in the industrial West: that thing to which the Germans give the wonderful name of *Kitsch*: popular, commercial art and literature with their chromeotypes, magazine covers, illustrations, ads, slick and pulp fiction, comics, Tin Pan Alley music, tap dancing, Hollywood movies, etc., etc. For some reason this gigantic apparition has always been taken for granted. It is time we looked into its whys and wherefores.

Kitsch is a product of the industrial revolution which urbanized the masses of Western Europe and America and established what is called universal literacy.

Previous to this the only market for formal culture, as distinguished from folk culture, had been among those who in addition to being able to read and write could command the leisure and comfort that always goes hand in hand with cultivation of some sort. This until then had been inextricably associated with literacy. But with the introduction of universal literacy, the ability to read and write became almost a minor skill like driving a car, and it no longer served to distinguish an individual's cultural inclinations, since it was no longer the exclusive concomitant of refined tastes. The peasants who settled in the cities as proletariat and petty bourgeois learned to read and write for the sake of efficiency, but they did not win the leisure and comfort necessary for the enjoyment of the city's traditional culture. Losing, nevertheless, their taste for the folk culture whose background was the countryside, and discovering a new capacity for boredom at the same time, the new urban masses set up a pressure on society to provide them with a kind of culture fit for their own consumption. To fill the demand of the new market a new commodity was devised: ersatz culture, kitsch, destined for those who, insensible to the values of genuine culture, are hungry nevertheless for the diversion that only culture of some sort can provide.

Kitsch, using for raw material the debased and academicized simulacra of genuine culture, welcomes and cultivates this insensibility. It is the source of its profits. Kitsch is mechanical and operates by formulas. Kitsch is vicarious experience and faked sensations. Kitsch changes according to style, but remains always the same. Kitsch is the epitome of all that is spurious in the life of our times. Kitsch pretends to demand nothing of its customers except their money – not even their time.

The pre-condition for kitsch, a condition without which kitsch would be impossible, is the availability close at hand of a fully matured cultural tradition, whose discoveries, acquisitions and perfected self-consciousness kitsch can take advantage of for its own ends. It borrows from it devices, tricks, strategems, rules of thumb, themes, converts them into a system and discards the rest. It draws its life blood, so to speak, from this reservoir of accumulated experience. This is what is really meant when it is said that the popular art and literature of today were once the daring, esoteric art and literature of yesterday. Of course, no such thing is true. What is meant is that when enough time has elapsed the new is looted for new "twists," which are then watered down and served up as kitsch. Self-evidently, all kitsch is academic, and conversely, all that's academic is kitsch. For what is called the academic as such no longer has an independent exis-

tence, but has become the stuffed-shirt "front" for kitsch. The methods of industrialism displace the handicrafts.

Because it can be turned out mechanically, kitsch has become an integral part of our productive system in a way in which true culture could never be except accidentally. It has been capitalized at a tremendous investment which must show commensurate returns; it is compelled to extend as well as to keep its markets. While it is essentially its own salesman, a great sales apparatus has nevertheless been created for it, which brings pressure to bear on every member of society. Traps are laid even in those areas, so to speak, that are the preserves of genuine culture. It is not enough today, in a country like ours, to have an inclination towards the latter; one must have a true passion for it that will give him the power to resist the faked article that surrounds and presses in on him from the moment he is old enough to look at the funny papers. Kitsch is deceptive. It has many different levels, and some of them are high enough to be dangerous to the naive seeker of true light. A magazine like the *New Yorker*, which is fundamentally high-class kitsch for the luxury trade, converts and waters down a great deal of avant-garde material for its own uses. Nor is every single item of kitsch altogether worthless. Now and then it produces something of merit, something that has an authentic folk flavor; and these accidental and isolated instances have fooled people who should know better.

Kitsch's enormous profits are a source of temptation to the avant-garde itself, and its members have not always resisted this temptation. Ambitious writers and artists will modify their work under the pressure of kitsch, if they do not succumb to it entirely. And then those puzzling border-line cases appear, such as the popular novelist, Simenon, in France, and Steinbeck in this country. The net result is always to the detriment of true culture, in any case.

Kitsch has not been confined to the cities in which it was born, but has flowed out over the countryside, wiping out folk culture. Nor has it shown any regard for geographical and national-cultural boundaries. Another mass product of Western industrialism, it has gone on a triumphal tour of the world, crowding out and defacing native cultures in one colonial country after another, so that it is now by way of becoming a universal culture, the first universal culture ever beheld. Today the Chinaman, no less than the South American Indian, the Hindu, no less than the Polynesian, have come to prefer to the products of their native art magazine covers, rotogravure sections and calendar girls. How is this virulence of kitsch, this irresistible attractiveness, to be explained? Naturally, machine-made kitsch can undersell the native handmade article, and the prestige of the West also helps, but why is kitsch a so much more profitable export article than Rembrandt? One, after all, can be reproduced as cheaply as the other.

In his last article on the Soviet cinema in the *Partisan Review*, Dwight Macdonald points out that kitsch has in the last ten years become the dominant culture in Soviet Russia. For this he blames the political regime – not only for the fact that kitsch is the official culture, but also that it is actually the dominant, most popular culture; and he quotes the following from Kurt London's *The Seven Soviet Arts*: ". . . the attitude of the masses both to the old and new art styles probably remains essentially dependent on the nature of the education afforded

them by their respective states." Macdonald goes on to say: Why after all should ignorant peasants prefer Repin (a leading exponent of Russian academic kitsch in painting) to Picasso, whose abstract technique is at least as relevant to their own primitive folk art as is the former's realistic style? No, if the masses crowd into the Tretyakov (Moscow's museum of contemporary Russian art: kitsch) it is largely because "they have been conditioned to shun 'formalism' and to admire 'socialist realism'."

In the first place it is not a question of a choice between merely the old and merely the new, as London seems to think – but of a choice between the bad, up-to-date old and the genuinely new. The alternative to Picasso is not Michelangelo, but kitsch. In the second place, neither in backward Russia nor in the advanced West do the masses prefer kitsch simply because their governments condition them towards it. Where state educational systems take the trouble to mention art, we are told to respect the old masters, not kitsch; and yet we go and hang Maxfield Parrish or his equivalent on our walls, instead of Rembrandt and Michelangelo. Moreover, as Macdonald himself points out, around 1925 when the Soviet regime was encouraging avant-garde cinema, the Russian masses continued to prefer Hollywood movies. No, "conditioning" does not explain the potency of kitsch. . . .

All values are human values, relative values, in art as well as elsewhere. Yet there does seem to have been more or less of a general agreement among the cultivated of mankind over the ages as to what is good art and what bad. Taste has varied, but not beyond certain limits: contemporary connoisseurs agree with eighteenth century Japanese that Hokusai was one of the greatest artists of his time; we even agree with the ancient Egyptians that Third and Fourth Dynasty art was the most worthy of being selected as their paragon by those who came after. We may have come to prefer Giotto to Raphael, but we still do not deny that Raphael was one of the best painters of his *time*. There has been an agreement then, and this agreement rests, I believe, on a fairly constant distinction made between those values only to be found in art and the values which can be found elsewhere. Kitsch, by virtue of rationalized technique that draws on science and industry, has erased this distinction in practice.

Let us see for example what happens when an ignorant Russian peasant such as Macdonald mentions stands with hypothetical freedom of choice before two paintings, one by Picasso, the other by Repin. In the first he sees, let us say, a play of lines, colors and spaces that represent a woman. The abstract technique – to accept Macdonald's supposition, which I am inclined to doubt – reminds him somewhat of the icons he has left behind him in the village, and he feels the attraction of the familiar. We will even suppose that he faintly surmises some of the great art values the cultivated find in Picasso. He turns next to Repin's picture and sees a battle scene. The technique is not so familiar – as technique. But that weighs very little with the peasant, for he suddenly discovers values in Repin's picture which seem far superior to the values he has been accustomed to finding in icon art; and the unfamiliar technique itself is one of the sources of those values: the values of the vividly recognizable, the miraculous and the sympathetic. In Repin's picture the peasant recognizes and sees things in the way in which he

recognizes and sees things outside of pictures – there is no discontinuity between art and life, no need to accept a convention and say to oneself, that icon represents Jesus because it intends to represent Jesus, even if it does not remind me very much of a man. That Repin can paint so realistically that identifications are self-evident immediately and without any effort on the part of the spectator – that is miraculous. The peasant is also pleased by the wealth of self-evident meanings which he finds in the picture: "it tells a story." Picasso and the icons are so austere and barren in comparison. What is more, Repin heightens reality and makes it dramatic: sunset, exploding shells, running and falling men. There is no longer any question of Picasso or icons. Repin is what the peasant wants, and nothing else but Repin. It is lucky, however, for Repin that the peasant is protected from the products of American capitalism, for he would not stand a chance next to a *Saturday Evening Post* cover by Norman Rockwell.

Ultimately, it can be said that the cultivated spectator derives the same values from Picasso that the peasant gets from Repin, since what the latter enjoys in Repin is somehow art too, on however low a scale, and he is sent to look at pictures by the same instincts that send the cultivated spectator. But the ultimate values which the cultivated spectator derives from Picasso are derived at a second remove, as the result of reflection upon the immediate impression left by the plastic values. It is only then that the recognizable, the miraculous and the sympathetic enter. They are not immediately or externally present in Picasso's painting, but must be projected into it by the spectator sensitive enough to react sufficiently to plastic qualities. They belong to the "reflected" effect. In Repin, on the other hand, the "reflected" effect has already been included in the picture, ready for the spectator's unreflective enjoyment.[4] Where Picasso paints *cause*, Repin paints *effect*. Repin pre-digests art for the spectator and spares him effort, provides him with a short cut to the pleasure of art that detours what is necessarily difficult in genuine art. Repin, or kitsch, is synthetic art.

The same point can be made with respect to kitsch literature: it provides vicarious experience for the insensitive with far greater immediacy than serious fiction can hope to do. And Eddie Guest and the *Indian Love Lyrics* are more poetic than T. S. Eliot and Shakespeare.

III

If the avant-garde imitates the processes of art, kitsch, we now see, imitates its effects. The neatness of this antithesis is more than contrived; it corresponds to and defines the tremendous interval that separates from each other two such simultaneous cultural phenomena as the avant-garde and kitsch. This interval, too great to be closed by all the infinite gradations of popularized "modernism" and "modernistic" kitsch, corresponds in turn to a social interval, a social interval that has always existed in formal culture as elsewhere in civilized society, and whose two termini converge and diverge in fixed relation to the increasing or decreasing stability of the given society. There has always been on one side the minority of the powerful – and therefore the cultivated – and on the other the great

mass of the exploited and poor – and therefore the ignorant. Formal culture has always belonged to the first, while the last have had to content themselves with folk or rudimentary culture, or kitsch.

In a stable society which functions well enough to hold in solution the contradictions between its classes the cultural dichotomy becomes somewhat blurred. The axioms of the few are shared by the many; the latter believe superstitiously what the former believe soberly. And at such moments in history the masses are able to feel wonder and admiration for the culture, on no matter how high a plane, of its masters. This applies at least to plastic culture, which is accessible to all.

In the Middle Ages the plastic artist paid lip service at least to the lowest common denominators of experience. This even remained true to some extent until the seventeenth century. There was available for imitation a universally valid conceptual reality, whose order the artist could not tamper with. The subject matter of art was prescribed by those who commissioned works of art, which were not created, as in bourgeois society, on speculation. Precisely because his content was determined in advance, the artist was free to concentrate on his medium. He needed not to be philosopher or visionary, but simply artificer. As long as there was general agreement as to what were the worthiest subjects for art, the artist was relieved of the necessity to be original and inventive in his "matter" and could devote all his energy to formal problems. For him the medium became, privately, professionally, the content of his art, even as today his medium is the public content of the abstract painter's art – with that difference, however, that the medieval artist had to suppress his professional preoccupation in public – had always to suppress and subordinate the personal and professional in the finished, official work of art. If, as an ordinary member of the Christian community, he felt some personal emotion about his subject matter, this only contributed to the enrichment of the work's public meaning. Only with the Renaissance do the inflections of the personal become legitimate, still to be kept, however, within the limits of the simply and universally recognizable. And only with Rembrandt do "lonely" artists begin to appear, lonely in their art.

But even during the Renaissance, and as long as Western art was endeavoring to perfect its technique, victories in this realm could only be signalized by success in realistic imitation, since there was no other objective criterion at hand. Thus the masses could still find in the art of their masters objects of admiration and wonder. Even the bird who pecked at the fruit in Zeuxes' picture could applaud.

It is a platitude that art becomes caviar to the general when the reality it imitates no longer corresponds even roughly to the reality recognized by the general. Even then, however, the resentment the common man may feel is silenced by the awe in which he stands of the patrons of this art. Only when he becomes dissatisfied with the social order they administer does he begin to criticize their culture. Then the plebeian finds courage for the first time to voice his opinions openly. Every man, from Tammany aldermen to Austrian house-painters, finds that he is entitled to his opinion. Most often this resentment towards culture is to be found where the dissatisfaction with society is a reactionary dissatisfaction which

expresses itself in revivalism and puritanism, and latest of all, in fascism. Here revolvers and torches begin to be mentioned in the same breath as culture. In the name of godliness or the blood's health, in the name of simple ways and solid virtues, the statue-smashing commences.

IV

Returning to our Russian peasant for the moment, let us suppose that after he has chosen Repin in preference to Picasso, the state's educational apparatus comes along and tells him that he is wrong, that he should have chosen Picasso – and shows him why. It is quite possible for the Soviet state to do this. But things being as they are in Russia – and everywhere else – the peasant soon finds that the necessity of working hard all day for his living and the rude, uncomfortable circumstances in which he lives do not allow him enough leisure, energy and comfort to train for the enjoyment of Picasso. This needs, after all, a considerable amount of "conditioning." Superior culture is one of the most artificial of all human creations, and the peasant finds no "natural" urgency within himself that will drive him towards Picasso in spite of all difficulties. In the end the peasant will go back to kitsch when he feels like looking at pictures, for he can enjoy kitsch without effort. The state is helpless in this matter and remains so as long as the problems of production have not been solved in a socialist sense. The same holds true, of course, for capitalist countries and makes all talk of art for the masses there nothing but demagogy.[5]

Where today a political regime establishes an official cultural policy, it is for the sake of demagogy. If kitsch is the official tendency of culture in Germany, Italy and Russia, it is not because their respective governments are controlled by philistines, but because kitsch is the culture of the masses in these countries, as it is everywhere else. The encouragement of kitsch is merely another of the inexpensive ways in which totalitarian regimes seek to ingratiate themselves with their subjects. Since these regimes cannot raise the cultural level of the masses – even if they wanted to – by anything short of a surrender to international socialism, they will flatter the masses by bringing all culture down to their level. It is for this reason that the avant-garde is outlawed, and not so much because a superior culture is inherently a more critical culture. (Whether or not the avant-garde could possibly flourish under a totalitarian regime is not pertinent to the question at this point.) As matter of fact, the main trouble with avant-garde art and literature, from the point of view of Fascists and Stalinists, is not that they are too critical, but that they are too "innocent," that it is too difficult to inject effective propaganda into them, that kitsch is more pliable to this end. Kitsch keeps a dictator in closer contact with the "soul" of the people. Should the official culture be one superior to the general mass-level, there would be a danger of isolation.

Nevertheless, if the masses were conceivably to ask for avant-garde art and literature, Hitler, Mussolini and Stalin would not hesitate long in attempting to satisfy such a demand. Hitler is a bitter enemy of the avant-garde, both on doc-

trinal and personal grounds, yet this did not prevent Goebbels in 1932–33 from strenuously courting avant-garde artists and writers. When Gottfried Benn, an Expressionist poet, came over to the Nazis he was welcomed with a great fanfare, although at that very moment Hitler was denouncing Expressionism as *Kultur-bolschewismus*. This was at a time when the Nazis felt that the prestige which the avant-garde enjoyed among the cultivated German public could be of advantage to them, and practical considerations of this nature, the Nazis being the skilful politicians they are, have always taken precedence over Hitler's personal inclinations. Later the Nazis realized that it was more practical to accede to the wishes of the masses in matters of culture than to those of their paymasters; the latter, when it came to a question of preserving power, were as willing to sacrifice their culture as they were their moral principles, while the former, precisely because power was being withheld from them, had to be cozened in every other way possible. It was necessary to promote on a much more grandiose style than in the democracies the illusion that the masses actually rule. The literature and art they enjoy and understand were to be proclaimed the only true art and literature and any other kind was to be suppressed. Under these circumstances people like Gottfried Benn, no matter how ardently they support Hitler, become a liability; and we hear no more of them in Nazi Germany.

We can see then that although from one point of view the personal philistinism of Hitler and Stalin is not accidental to the political roles they play, from another point of view it is only an incidentally contributory factor in determining the cultural policies of their respective regimes. Their personal philistinism simply adds brutality and double-darkness to policies they would be forced to support anyhow by the pressure of all their other policies – even were they, personally, devotees of avant-garde culture. What the acceptance of the isolation of the Russian Revolution forces Stalin to do, Hitler is compelled to do by his acceptance of the contradictions of capitalism and his efforts to freeze them. As for Mussolini – his case is a perfect example of the *disponibilité* of a realist in these matters. For years he bent a benevolent eye on the Futurists and built modernistic railroad stations and government-owned apartment houses. One can still see in the suburbs of Rome more modernistic apartments than almost anywhere else in the world. Perhaps Fascism wanted to show its up-to-datedness, to conceal the fact that it was a retrogression; perhaps it wanted to conform to the tastes of the wealthy élite it served. At any rate Mussolini seems to have realized lately that it would be more useful to him to please the cultural tastes of the Italian masses than those of their masters. The masses must be provided with objects of admiration and wonder; the latter can dispense with them. And so we find Mussolini announcing a "new Imperial style." Marinetti, Chirico, et al. are sent into the outer darkness, and the new railroad station in Rome will not be modernistic. That Mussolini was late in coming to this only illustrates again the relative hesitancy with which Italian fascism has drawn the necessary implications of its role. . . .

Capitalism in decline finds that whatever of quality it is still capable of producing becomes almost invariably a threat to its own existence. Advances in culture no less than advances in science and industry corrode the very society under

31

whose aegis they are made possible. Here, as in every other question today, it becomes necessary to quote Marx word for word. Today we no longer look towards socialism for a new culture – as inevitably as one will appear, once we do have socialism. Today we look to socialism *simply* for the preservation of whatever living culture we have right now.

Notes

1 The example of music, which has long been an abstract art, and which avant-garde poetry has tried so much to emulate, is interesting. Music, Aristotle said curiously enough, is the most imitative and vivid of all arts because it imitates its original – the state of the soul – with the greatest immediacy. Today this strikes us as the exact opposite of the truth, because no art seems to us to have less reference to something outside itself than music. However, aside from the fact that in a sense Aristotle may still be right, it must be explained that ancient Greek music was closely associated with poetry, and depended upon its character as an accessory to verse to make its imitative meaning clear. Plato, speaking of music, says: "For when there are no words, it is very difficult to recognize the meaning of the harmony and rhythm, or to see that any worthy object is imitated by them." As far as we know, all music originally served such an accessory function. Once, however, it was abandoned, music was forced to withdraw into itself to find a constraint or original. This is found in the various means of its own composition and performance.

2 I owe this formulation to a remark made by Hans Hofmann, the art teacher, in one of his lectures. From the point of view of this formulation, Surrealism in plastic art is a reactionary tendency which is attempting to restore "outside" subject matter. The chief concern of a painter like Dali is to represent the processes and concepts of his consciousness, not the processes of his medium.

3 See Valéry's remarks about his own poetry.

4 T. S. Eliot said something to the same effect in accounting for the shortcomings of English Romantic poetry. Indeed the Romantics can be considered the original sinners whose guilt kitsch inherited. They showed kitsch how. What does Keats write about mainly, if not the effect of poetry upon himself?

5 It will be objected that such art for the masses as folk art was developed under rudimentary conditions of production – and that a good deal of folk art is on a high level. Yes, it is – but folk art is not Athene, and it's Athene whom we want: formal culture with its infinity of aspects, its luxuriance, its large comprehension. Besides, we are now told that most of what we consider good in folk culture is the static survival of dead formal, aristocratic, cultures. Our old English ballads, for instance, were not created by the "folk," but by the post-feudal squirearchy of the English countryside, to survive in the mouths of the folk long after those for whom the ballads were composed had gone on to other forms of literature.... Unfortunately, until the machine-age, culture was the exclusive prerogative of a society that lived by the labor of serfs or slaves. They were the real symbols of culture. For one man to spend time and energy creating or listening to poetry meant that another man had to produce enough to keep himself alive and the former in comfort. In Africa today we

find that the culture of slave-owning tribes is generally much superior to that of the tribes that possess no slaves.

(Editor's note: When this text appeared in the author's *Art and Culture: Critical Essays* (Beacon Press, 1961), Greenberg included the following note when the volume was reprinted:

P.S. To my dismay I learned years after this saw print that Repin never painted a battle scene; he wasn't that kind of painter. I had attributed some one else's picture to him. That showed my provincialism with regard to Russian art in the nineteenth century. [1972])

2 Towards a Newer Laocoon

Clement Greenberg

The dogmatism and intransigence of the "non-objective" or "abstract" purists of painting today cannot be dismissed as symptoms merely of a cultist attitude towards art. Purists make extravagant claims for art, because usually they value it much more than any one else does. For the same reason they are much more solicitous about it. A great deal of purism is the translation of an extreme solicitude, an anxiousness as to the fate of art, a concern for its identity. We must respect this. When the purist insists upon excluding "literature" and subject matter from plastic art, now and in the future, the most we can charge him with off-hand is an unhistorical attitude. It is quite easy to show that abstract art like every other cultural phenomenon reflects the social and other circumstances of the age in which its creators live, and that there is nothing inside art itself, disconnected from history, which compels it to go in one direction or another. But it is not so easy to reject the purist's assertion that the best of contemporary plastic art is abstract. Here the purist does not have to support his position with metaphysical pretentions. And when he insists on doing so, those of us who admit the merits of abstract art without accepting its claims in full must offer our own explanation for its present supremacy.

Discussion as to purity in art and, bound up with it, the attempts to establish the differences between the various arts are not idle. There has been, is, and will be, such a thing as a confusion of the arts. From the point of view of the artist engrossed in the problems of his medium and indifferent to the efforts of theorists to explain abstract art *completely*, purism is the terminus of a salutory reaction against the mistakes of painting and sculpture in the past several centuries which were due to such a confusion.

Source: 'Towards a Newer Laocoon', *Partisan Review*, July–August, 1940, vol. vii, no. 4, pp. 296–310. © Clement Greenberg. This material has been slightly revised by the author. Most revisions are to punctuation.

I

There can be, I believe, such a thing as a dominant art form; this was what literature had become in Europe by the 17th century. (Not that the ascendancy of a particular art always coincides with its greatest productions. In point of achievement, music was the greatest art of this period.) By the middle of the 17th century the pictorial arts had been relegated almost everywhere into the hands of the courts, where they eventually degenerated into relatively trivial interior decoration. The most creative class in society, the rising mercantile bourgeoisie, impelled perhaps by the iconoclasm of the Reformation (Pascal's Jansenist contempt for painting is a symptom) and by the relative cheapness and mobility of the physical medium after the invention of printing, had turned most of its creative and acquisitive energy towards literature.

Now, when it happens that a single art is given the dominant role, it becomes the prototype of all art: the others try to shed their proper characters and imitate its effects. The dominant art in turn tries itself to absorb the functions of the others. A confusion of the arts results, by which the subservient ones are perverted and distorted; they are forced to deny their own nature in an effort to attain the effects of the dominant art. However, the subservient arts can only be mishandled in this way when they have reached such a degree of technical facility as to enable them to pretend to conceal their *mediums*. In other words, the artist must have gained such power over his material as to annihilate it seemingly in favor of *illusion*. Music was saved from the fate of the pictorial arts in the 17th and 18th centuries by its comparatively rudimentary technique and the relative shortness of its development as a formal art. Aside from the fact that in its nature it is the art furthest removed from imitation, the possibilities of music had not been explored sufficiently to enable it to strive for illusionist effects.

But painting and sculpture, the arts of illusion par excellence, had by that time achieved such facility as to make them infinitely susceptible to the temptation to emulate the effects, not only of illusion, but of other arts. Not only could painting imitate sculpture, and sculpture, painting, but both could attempt to reproduce the effects of literature. And it was for the effects of literature that 17th and 18th century painting strained most of all. Literature, for a number of reasons, had won the upper hand, and the plastic arts – especially in the form of easel painting and statuary – tried to win admission to its domain. Although this does not account completely for the decline of those arts during this period, it seems to have been the form of that decline. Decline it was, compared to what had taken place in Italy, Flanders, Spain and Germany the century before. Good artists, it is true, continue to appear – I do not have to exaggerate the depression to make my point – but not good *schools* of art, not good followers. The circumstances surrounding the appearance of the individual great artists seem to make them almost all exceptions; we think of them as great artists "in spite of." There is a scarcity of distinguished small talents. And the very level of greatness sinks by comparison to the work of the past.

In general, painting and sculpture in the hands of the lesser talents – and this is what tells the story – become nothing more than ghosts and "stooges" of litera-

ture. All emphasis is taken away from the medium and transferred to subject matter. It is no longer a question even of realistic imitation, since that is taken for granted, but of the artist's ability to interpret subject matter for poetic effects and so forth.

We ourselves, even today, are too close to literature to appreciate its status as a dominant art. Perhaps an example of the converse will make clearer what I mean. In China, I believe, painting and sculpture became in the course of the development of culture the dominant arts. There we see poetry given a role subordinate to them, and consequently assuming their limitations: the poem confines itself to the single moment of painting and to an emphasis upon visual details. The Chinese even require visual delight from the handwriting in which the poem is set down. And by comparison to their pictorial and decorative arts doesn't the later poetry of the Chinese seem rather thin and monotonous?

Lessing, in his *Laokoon* written in the 1760s, recognized the presence of a practical as well as a theoretical confusion of the arts. But he saw its ill effects exclusively in terms of literature, and his opinions on plastic art only exemplify the typical misconceptions of his age. He attacked the descriptive verse of poets like James Thomson as an invasion of the domain of landscape painting, but all he could find to say about painting's invasion of poetry was to object to allegorical pictures which required an explanation, and to paintings like Titian's "Prodigal Son," which incorporate "two necessarily separate points of time in one and the same picture."

II

The Romantic Revival or Revolution seemed at first to offer some hope for painting, but by the time it departed the scene, the confusion of the arts had become worse. The Romantic theory of art was that the artist feels something and passes on this feeling – not the situation or thing which stimulated it – to his audience. To preserve the immediacy of the feeling it was even more necessary than before, when art was imitation rather than communication, to suppress the role of the medium. The medium was a regrettable if necessary physical obstacle between the artist and his audience, which in some ideal state would disappear entirely to leave the experience of the spectator or reader identical with that of the artist. In spite of the fact that music considered as an art of pure feeling, was beginning to win almost equal esteem, this attitude represents a final triumph for poetry. All feeling for the arts as métiers, crafts, disciplines – of which some sense had survived until the 18th century – was lost. The arts came to be regarded as nothing more or less than so many powers of the personality. Shelley expressed this best when in his *Defense of Poetry* he exalted poetry above the other arts because its medium came closest, as Bosanquet puts it, to being no medium at all. In practice this aesthetic encouraged that particular and widespread form of artistic dishonesty which consists in the attempt to escape from the problems of the medium of one art by taking refuge in the effects of another. Painting is the most suscep-

tible to evasions of this sort, and painting suffered most at the hands of the Romantics.

At first it did not seem so. As a result of the triumph of the burghers and of their appropriation of all the arts a fresh current of creative energy was released into every field. If the Romantic revolution in painting was at first more a revolution in subject matter than in anything else, abandoning the oratorical and frivolous literature of 18th century painting in search of a more original, more powerful, more sincere literary content, it also brought with it a greater boldness in pictorial means. Delacroix, Géricault, even Ingres, were enterprising enough to find new form for the new content they introduced. But the net result of their efforts was to make the incubus of literature in painting even deadlier for the lesser talents who followed them. The worst manifestations of literary and sentimental painting had already begun to appear in the painting of the late 18th century – especially in England, where a revival which produced some of the best English painting was equally efficacious in speeding up the process of degeneration. Now the schools of Ingres and Delacroix joined with those of Morland and Greuze and Vigée-Lebrun to become the official painting of the 19th century. There have been academies before, but for the first time we have academicism. Painting enjoyed a revival of activity in 19th century France such as had not been seen since the 16th century, and academicism could produce such good painters as Corot and Theodore Rousseau, and even Daumier – yet in spite of this the academicians sank painting to a level that was in some respects an all-time low. The name of this low is Vernet, Gérôme, Leighton, Watts, Moreau, Böcklin, the Pre-Raphaelites, etc., etc. That some of these painters had real talent only made their influence the more pernicious. It took talent – among other things – to lead art that far astray. Bourgeois society gave these talents a prescription, and they filled it – with talent.

It was not realistic imitation in itself that did the damage so much as realistic illusion in the service of sentimental and declamatory literature. Perhaps the two go hand in hand. To judge from Western and Graeco-Roman art, it seems so. Yet it is true of Western painting that in so far as it has been the creation of a rationalist and scientifically-minded city culture, it has always had a bias towards a realism that tries to achieve illusion by overpowering the medium, and is more interested in exploiting the practical meanings of objects than in savoring their appearance.

III

Romanticism was the last great tendency flowing *directly* from bourgeois society that was able to inspire and stimulate the profoundly responsible artist – the artist conscious of certain inflexible obligations to the standards of his craft. By 1848 Romanticism had exhausted itself. After that the impulse, although indeed it had to originate in bourgeois society, could only come in the guise of a denial of that society, as a turning away from it. It was not to be an about-face towards a new society, but an emigration to a Bohemia which was to be art's sanctuary from

capitalism. It was to be the task of the avant-garde to perform in opposition to bourgeois society the function of finding new and adequate cultural forms for the expression of that same society, without at the same time succumbing to its ideological divisions and its refusal to permit the arts to be their own justification. The avant-garde, both child and negation of Romanticism, becomes the embodiment of art's instinct of self-preservation. It is interested in, and feels itself responsible to, only the values of art; and, given society as it is, has an organic sense of what is good and what is bad for art.

As the first and most important item upon its agenda, the avant-garde saw the necessity of an escape from ideas, which were infecting the arts with the ideological struggles of society. Ideas came to mean subject matter in general. (Subject matter as distinguished from content: in the sense that every work of art must have content, but that subject matter is something the artist does or does not have in mind when he is actually at work.) This meant a new and greater emphasis upon form, and it also involved the assertion of the arts as independent vocations, disciplines and crafts, absolutely autonomous, and entitled to respect for their own sakes, and not merely as vessels of communication. It was the signal for a revolt against the dominance of literature, which was subject matter at its most oppressive.

The avant-garde has pursued, and still pursues, several variants, whose chronological order is by no means clear, but can be best traced in painting, which as the chief victim of literature brought the problem into sharpest focus. (Forces stemming from outside art play a much larger part than I have room to acknowledge here. And I must perforce be rather schematic and abstract, since I am interested more in tracing large outlines than in accounting for and gathering in all particular manifestations.)

By the second third of the 19th century academic painting had degenerated from the pictorial to the picturesque. Everything depends on the anecdote or the message. The painted picture occurs in blank, indeterminate space; it just happens to be on a square of canvas and inside a frame. It might just as well have been breathed on air or formed out of plasma. It tries to be something you imagine rather than see – or else a bas-relief or a statue. Everything contributes to the denial of the medium, as if the artist were ashamed to admit that he had actually painted his picture instead of dreaming it forth.

This state of affairs could not be overcome at one stroke. The campaign for the redemption of painting was to be one of comparatively slow attrition at first. Nineteenth century painting made its first break with literature when in the person of the Communard, Courbet, it fled from spirit to matter. Courbet, the first real avant-garde painter, tried to reduce his art to immediate sense data by painting only what the eye could see as a machine unaided by the mind. He took for his subject matter prosaic contemporary life. As avant-gardists so often do, he tried to demolish official bourgeois art by turning it inside out. By driving something as far as it will go you often get back to where it started. A new flatness begins to appear in Courbet's painting, and an equally new attention to every inch of the canvas, regardless of its relation to the "centers of interest." (Zola, the Goncourts and poets like Verhaeren were Courbet's correlatives in literature. They too were "experimental"; they too were trying to get rid of ideas and "literature," that is, to

establish their art on a more stable basis than the crumbling bourgeois oecumene.) If the avant-garde seems unwilling to claim naturalism for itself it is because the tendency failed too often to achieve the objectivity it professed, i.e. it succumbed to "ideas."

Impressionism, reasoning beyond Courbet in its pursuit of materialist objectivity, abandoned common sense experience and sought to emulate the detachment of science, imagining that thereby it would get at the very essence of painting as well as of visual experience. It was becoming important to determine the essential elements of each of the arts. Impressionist painting becomes more an exercise in color vibrations than representation of nature. Manet meanwhile, closer to Courbet, was attacking subject matter on its own terrain by including it in his pictures and exterminating it then and there. His insolent indifference to his subject, which in itself was often striking, and his flat color-modeling were as revolutionary as Impressionist technique proper. Like the Impressionists he saw the problems of painting as first and foremost problems of the medium, and he called the spectator's attention to this.

IV

The second variant of the avant-garde's development is concurrent in time with the first. It is easy to recognize this variant, but rather difficult to expose its motivation. Tendencies go in opposite directions, and cross-purposes meet. But tying everything together is the fact that in the end cross-purposes indeed do meet. There is a common effort in each of the arts to expand the expressive resources of the medium, not in order to express ideas and notions, but to express with greater immediacy sensations, the irreduceable elements of experience. Along this path it seemed as though the avant-garde in its attempt to escape from "literature" had set out to treble the confusion of the arts by having them imitate every other art except literature.[1] (By this time literature had had its opprobrious sense expanded to include everything the avant-garde objected to in official bourgeois culture.) Each art would demonstrate its powers by capturing the effects of its sister arts or by taking a sister art for its subject. Since art was the only validity left, what better subject was there for each art than the procedures and effects of some other art? Impressionist painting, with its progressions and rhythmic suffusions of color, with its moods and atmospheres, was arriving at effects to which the Impressionists themselves gave the terms of Romantic music. Painting, however, was the least affected by this new confusion. Poetry and music were its chief victims. Poetry – for it too had to escape from "literature" – was imitating the effects of painting and sculpture (Gautier, the Parnassians, and later the Imagists) and, of course, those of music (Poe had narrowed "true" poetry down to the lyric). Music, in flight from the undisciplined, bottomless sentimentality of the Romantics, was striving to describe and narrate (program music). That music at this point imitates literature would seem to spoil my thesis. But music imitates painting as much as it does poetry when it becomes representational; and besides, it seems to me that Debussy used the program more as a pretext for experiment than as an

end in itself. In the same way that the Impressionist painters were trying to get at the structure beneath the color, Debussy was trying to get at the "sound underneath the note."

Aside from what was going on inside music, music as an art in itself began at this time to occupy a very important position in relation to the other arts. Because of its "absolute" nature, its remoteness from imitation, its almost complete absorption in the very physical quality of its medium, as well as because of its resources of suggestion, music had come to replace poetry as the paragon art. It was the art which the other avant-garde arts envied most, and whose effects they tried hardest to imitate. Thus it was the principal agent of the new confusion of the arts. What attracted the avant-garde to music as much as its power to suggest was, as I have said, its nature as an art of immediate sensation. When Verlaine said, "De la musique avant toute chose," he was not only asking poetry to be more suggestive – suggestiveness, after all, was a poetic ideal foisted upon music – but also to affect the reader or listener with more immediate and more powerful sensations.

But only when the avant-garde's interest in music led it to consider music as a *method* of art rather than as a kind of effect did the avant-garde find what it was looking for. It was when it was discovered that the advantage of music lay chiefly in the fact that it was an "abstract" art, an art of "pure form." It was such because it was incapable, objectively, of communicating anything else than a sensation, and because this sensation could not be conceived in any other terms than those of the sense through which it entered consciousness. An imitative painting can be described in terms of non-visual identities, a piece of music cannot, whether it attempts to imitate or not. The effects of music are the effects, essentially, of pure form; those of painting and poetry are too often incidental to the formal natures of these arts. Only by accepting the example of music and defining each of the other arts solely in the terms of the sense or faculty which perceived its effects and by excluding from each art whatever is intelligible in the terms of any other sense or faculty would the non-musical arts attain the "purity" and self-sufficiency which they desired; which they desired, that is, in so far as they were avant-garde. The emphasis, therefore, was to be on the physical, the sensorial. "Literature's" corrupting influence is only felt when the senses are neglected. The latest confusion of the arts was the result of a mistaken conception of music as the only immediately sensuous art. But the other arts can also be sensuous, if only they will look to music, not to ape its effects, but to borrow its principles as a "pure" art, as an art which is abstract because it is almost nothing else except sensuous.[2]

V

Guiding themselves, whether consciously or unconsciously, by a notion of purity derived from the example of music, the avant-garde arts have in the last fifty years achieved a "purity" and a radical de-limitation of their fields of activity for which there is no previous example in the history of culture. The arts lie safe now, each

41

within its "legitimate" boundaries, and free trade has been replaced by autarchy. Purity in art consists in the acceptance, willing acceptance, of the limitations of the medium of the specific art. To prove that their concept of purity is something more than a bias in taste, painters point to Oriental, primitive and children's art as instances of the universality and naturalness and objectivity of their ideal of purity. Composers and poets, although to a much lesser extent, may justify their efforts to attain purity by referring to the same precedents. Dissonance is present in early and non-Western music, "unintelligibility" in folk poetry. The issue is, of course, focussed most sharply in the plastic arts, for they, in their non-decorative function, have been the most closely associated with imitation, and it is in their case that the ideal of the pure and the abstract has met the most resistance.

The arts, then, have been hunted back to their mediums, and there they have been isolated, concentrated and defined. It is by virtue of its medium that each art is unique and strictly itself. To restore the identity of an art the opacity of its medium must be emphasized. For the visual arts the medium is discovered to be physical; hence pure painting and pure sculpture seek above all else to affect the spectator physically. In poetry, which, as I have said, had also to escape from "literature" or subject matter for its salvation from society, it is decided that the medium is essentially psychological and sub- or supra-logical. The poem is to aim at the general consciousness of the reader, not simply his intelligence.

It would be well to consider "pure" poetry for a moment, before going on to painting. The theory of poetry as incantation, hypnosis or drug – as psychological agent then – goes back to Poe, and eventually to Coleridge and Edmund Burke with their efforts to locate the enjoyment of poetry in the "Fancy" or "Imagination." Mallarmé, however, was the first to base a consistent practice of poetry upon it. Sound, he decided, is only an auxiliary of poetry, not the medium itself; and besides, most poetry is now read, not recited: the sound of words is a part of their meaning, not the vessel of it. To deliver poetry from the subject and to give full play to its true affective power it is necessary to free words from logic. The medium of poetry is isolated in the power of the word to evoke associations and to connote. Poetry subsists no longer in the relations between words as meanings, but in the relations between words as personalities composed of sound, history and possibilities of meaning. Grammatical logic is retained only in so far as it is necessary to set these personalities in motion, for unrelated words are static when read and not recited aloud. Tentative efforts are made to discard metric form and rhyme, because they are regarded as too local and determinate, too much attached to specific times and places and social conventions to pertain to the essence of poetry. There are experiments in poetic prose. But as in the case of music, it was found that formal structure was indispensable, that some such structure was integral to the medium of poetry as an aspect of its resistance. . . . The poem still offers possibilities of meaning – but only possibilities. Should any of them be too precisely realized, the poem would lose the greatest part of its efficacy, which is to agitate the consciousness with infinite possibilities by approaching the brink of meaning and yet never falling over it. The poet writes, not so much to *express*, as to create a thing which will operate upon the reader's consciousness to produce the emotion of poetry. The content of the poem is what

it does to the reader, not what it communicates. The emotion of the reader derives from the poem as a unique object – pretendedly – and not from referents outside the poem. This is "pure" poetry as ambitious contemporary poets try to define it by the example of their work. Obviously, it is an impossible ideal, yet one which most of the best poetry of that last fifty years has tried to reach, whether it is poetry about nothing or poetry about the plight of contemporary society.

It is easier to isolate the medium in the case of the plastic arts, and consequently avant-garde painting and sculpture can be said to have attained a much more radical "purity" than avant-garde poetry. Painting and sculpture can become more completely nothing but what they do; like functional architecture and the machine, they *look* what they *do*. The picture or statue exhausts itself in the visual sensation it produces. There is nothing to identify, connect or think about, but everything to feel. "Pure" poetry strives for infinite suggestion, "pure" plastic art for the minimum. If the poem, as Valéry claims, is a machine to produce the emotion of poetry, the painting and statue are machines to produce the emotion of "plastic sight." The purely plastic or abstract qualities of the work of art are the only ones that count. Emphasize the medium and its difficulties, and at once the purely plastic, the proper, values of visual art come to the fore. Overpower the medium to the point where all sense of its resistance disappears, and the adventitious uses of art become more important.

The history of avant-garde painting is that of a progressive surrender to the resistance of its medium; which resistance consists chiefly in the flat picture plane's denial of efforts to "hole through" it for realistic perspectival space. In making this surrender, painting not only got rid of imitation – and with it, "literature" – but also of realistic imitation's corollary confusion between painting and sculpture. (Sculpture, on its side, emphasizes the resistance of its material to the efforts of the artist to ply it into shapes uncharacteristic of stone, metal, wood, etc.) Painting abandons chiaroscuro and shaded modelling. Brush strokes are often defined for their own sake. The motto of the Renaissance artist, *Ars est artem celare*, is exchanged for *Ars est artem demonstrare*. Primary colors, the "instinctive," easy colors, replace tones and tonality. Line, which is one of the most abstract elements in painting since it is never found in nature as the definition of contour, returns to oil painting as the third color between two other color areas. Under the influence of the rectangular shape of the canvas, forms tend to become geometrical – and simplified, because simplification is also a part of the instinctive accommodation to the medium. But most important of all, the picture plane itself grows shallower and shallower, flattening out and pressing together the fictive planes of depth until they meet as one upon the real and material plane which is the actual surface of the canvas; where they lie side by side or interlocked or transparently imposed upon each other. Where the painter still tries to indicate real objects their shapes flatten and spread in the dense, two-dimensional atmosphere. A vibrating tension is set up as the objects struggle to maintain their volume against the tendency of the real picture plane to re-assert its material flatness and crush them to silhouettes. In a further stage realistic space cracks and splinters into flat planes which come forward, parallel to the plane surface. Sometimes this advance to the surface is accelerated by inserting a piece of printed

paper, or by painting a segment of wood or texture *trompe l'oeil,* or by drawing exactly printed letters, and placing them so that they destroy the partial illusion of depth by slamming the various planes together. Thus the artist deliberately emphasizes the illusoriness of the illusions which he pretends to create. Sometimes these elements are used in an effort to preserve an illusion of depth by being placed on the nearest plane in order to drive the others back. But the result is an optical illusion, not a realistic one, and only emphasizes further the impenetrability of the plane surface.

The destruction of realistic pictorial space, and with it, that of the object, was accomplished by means of the travesty that was cubism. The cubist painter eliminated color because, consciously or unconsciously, he was parodying, in order to destroy, the academic methods of achieving volume and depth, which are shading and perspective, and as such have little to do with color in the common sense of the word. The cubist used these same methods to break the canvas into a multiplicity of subtle recessive planes, which seem to shift and fade into infinite depths and yet insist on returning to the surface of the canvas. As we gaze as at a cubist painting of the last phase we witness the birth and death of three-dimensional pictorial space.

And as in painting the pristine flatness of the stretched canvas constantly struggles to overcome every other element, so in sculpture the stone figure appears to be on the point of relapsing into the original monolith, and the cast seems to narrow and smooth itself back to the original molten stream from which it was poured, or tries to remember the texture and plasticity of the clay in which it was first worked out.

Sculpture hovers finally on the verge of "pure" architecture, and painting, having been pushed up from fictive depths, is forced through the surface of the canvas to emerge on the other side in the form of paper, cloth, cement and actual objects of wood and other materials pasted, glued or nailed to what was originally the transparent picture plane, which the painter no longer dares to puncture – or if he does, it is only to dare. Artists like Hans Arp, who begin as painters, escape eventually from the prison of the single plane by painting on wood or plaster and using molds or carpentry to raise and lower planes. They go, in other words, from painting to colored bas-relief, and finally – so far must they fly in order to return to three-dimensionality without at the same time risking illusion – they become sculptors and create objects in the round, through which they can free their feelings for movement and direction from the increasing ascetic geometry of pure painting. (Except in the case of Arp and one or two others, the sculpture of most of these metamorphosed painters is rather unsculptural, stemming as it does from the discipline of painting. It uses color, fragile and intricate shapes and a variety of materials. It is construction, fabrication.)

The French and Spanish in Paris brought painting to the point of the pure abstraction, but it remained, with a few exceptions, for the Dutch, Germans, English and Americans to realize it. It is in their hands that abstract purism has been consolidated into a school, dogma and credo. By 1939 the center of abstract painting had shifted to London, while in Paris the younger generation of French and Spanish painters had reacted against abstract purity and turned back to a con-

fusion of literature with painting as extreme as any of the past. These young orthodox Surrealists are not to be identified, however, with such pseudo- or mock Surrealists of the previous generation as Miró, Klee and Arp, whose work, despite its apparent intention, has only contributed to the further deployment of abstract painting pure and simple. Indeed, a good many of the artists – if not the majority – who contributed importantly to the development of modern painting came to it with the desire to exploit the break with imitative realism for a more powerful expressiveness, but so inexorable was the logic of the development that in the end their work constituted but another step towards abstract art, and a further sterilization of the expressive factors. This has been true, whether the artist was Van Gogh, Picasso or Klee. All roads led to the same place.

VI

I find that I have offered no other explanation for the present superiority of abstract art than its historical justification. So what I have written has turned out to be an historical apology for abstract art. To argue from any other basis would require more space than is at my disposal, and would involve an entrance into the politics of taste – to use Venturi's phrase – from which there is no exit – on paper. My own experience of art has forced me to accept most of the standards of taste from which abstract art has derived, but I do not maintain that they are the only valid standards through eternity. I find them simply the most valid ones at this given moment. I have no doubt that they will be replaced in the future by other standards, which will be perhaps more inclusive than any possible now. And even now they do not exclude all other possible criteria. I am still able to enjoy a Rembrandt more for its expressive qualities than for its achievement of abstract values – as rich as it may be in them.

It suffices to say that there is nothing in the nature of abstract art which compels it to be so. The imperative comes from history, from the age in conjunction with a particular moment reached in a particular tradition of art. This conjunction holds the artist in a vise from which at the present moment he can escape only by surrendering his ambition and returning to a stale past. This is the difficulty for those who are dissatisfied with abstract art, feeling that it is too decorative or too arid and "inhuman," and who desire a return to representation and literature in plastic art. Abstract art cannot be disposed of by a simple-minded evasion. Or by negation. We can only dispose of abstract art by assimilating it, by fighting our way through it. Where to? I do not know. Yet it seems to me that the wish to return to the imitation of nature in art has been given no more justification than the desire of certain partisans of abstract art to legislate it into permanency.

Notes

1 This is the confusion of the arts for which Babbitt made Romanticism responsible.

2 The ideas about music which Pater expresses in *The School of Giorgione* reflect this transition from the musical to the abstract better than does any single work of art.

3 Clement Greenberg's Theory of Art

T. J. Clark

In the issue of *Partisan Review* for Fall 1939 appeared an article by Clement Greenberg entitled "Avant-Garde and Kitsch." It was followed four issues later, in July–August 1940, by another wide-ranging essay on modern art, "Towards a Newer Laocoon."[1] These two articles, I believe, stake out the ground for Greenberg's later practice as a critic and set down the main lines of a theory and history of culture since 1850 – since, shall we say, Courbet and Baudelaire. Greenberg reprinted "Avant-Garde and Kitsch," making no attempt to tone down its mordant hostility to capitalism, as the opening item of his collection of critical essays, *Art and Culture*, in 1961. "Towards a Newer Laocoon" was not reprinted, perhaps because the author felt that its arguments were made more effectively in some of his later, more particular pieces included in *Art and Culture* – the essays on "Collage" or "Cézanne," for example, or the brief paragraphs on "Abstract, Representational, and So Forth." I am not sure that the author was right to omit the piece: it is noble, lucid, and extraordinarily balanced, it seems to me, in its defense of abstract art and avant-garde culture; and certainly its arguments are taken up directly, sometimes almost verbatim, in the more famous theoretical study which appeared in *Art and Literature* (Spring 1965) with the balder title "Modernist Painting."*

 The essays of 1939 and 1940 argue already for what were to become Greenberg's main preoccupations and commitments as a critic. And the arguments adduced, as the author himself admits at the end of "Towards a Newer Laocoon," are largely historical. "I find," Greenberg writes there, "that I have

*First published in *Arts Yearbook*, **4**, 1961, pp. 109–116 (Ed.).

Source: 'Clement Greenberg's Theory of Art', *Critical Inquiry*, September 1982, vol. 9, no. 1, pp. 139–156. © T. J. Clark. This was a special issue of the journal entitled *The Politics of Interpretation*, based on a symposium of the same name sponsored by *Critical Inquiry*, and held at the University of Chicago's Center for Continuing Education, October 30th–November 1st 1981. T. J. Clark was a speaker at that conference.

offered no other explanation for the present superiority of abstract art than its historical justification. So what I have written has turned out to be an historical apology for abstract art" ("NL," p. 310) *[45]*. The author's proffered half-surprise at having thus "turned out" to be composing an apology in the historical manner should not of course be taken literally. For it was historical consciousness, Greenberg had argued in "Avant-Garde and Kitsch," which was the key to the avant-garde's achievement – its ability, that is, to salvage something from the collapse of the bourgeois cultural order. "A part of Western bourgeois society," Greenberg writes, "has produced something unheard of heretofore: – avant-garde culture. A superior consciousness of history – more precisely, the appearance of a new kind of criticism of society, an historical criticism – made this possible. . . . It was no accident, therefore, that the birth of the avant-garde coincided chronologically – and geographically, too – with the first bold development of scientific revolutionary thought in Europe" ("AK," p. 35) *[22]*. By this last he means, need I say it, preeminently the thought of Marx, to whom the reader is grimly directed at the end of the essay, after a miserable and just description of fascism's skill at providing "art for the people," with the words: "Here, as in every other question today, it becomes necessary to quote Marx word for word. Today we no longer look toward socialism for a new culture – as inevitably as one will appear, once we do have socialism. Today we look to socialism *simply* for the preservation of whatever living culture we have right now" ("AK," p. 49) *[32]*.

It is not intended as some sort of revelation on my part that Greenberg's cultural theory was originally Marxist in its stresses and, indeed, in its attitude to what constituted explanation in such matters. I point out the Marxist and historical mode of proceeding as emphatically as I do partly because it may make my own procedure later in this paper seem a little less arbitrary. For I shall fall to arguing in the end with these essays' Marxism and their history, and I want it understood that I think that to do so *is* to take issue with their strengths and their main drift.

But I have to admit there are difficulties here. The essays in question are quite brief. They are, I think, extremely well written: it was not for nothing that *Partisan Review* described Clement Greenberg, when he first contributed to the journal early in 1939, as "a young writer who works in the New York customs house" – fine, redolent avant-garde pedigree, that! The language of these articles is forceful and easy, always straightforward, blessedly free from Marxist conundrums. Yet the price paid for such lucidity, here as so often, is a degree of inexplicitness – a certain amount of elegant skirting round the difficult issues, where one might otherwise be obliged to call out the ponderous armory of Marx's concepts and somewhat spoil the flow of the prose from one firm statement to another. The Marxism, in other words, is quite largely implicit; it is stated on occasion, with brittle and pugnacious finality, *as* the essays' frame of reference, but it remains to the reader to determine just how it works in the history and theory presented – what that history and theory depend on, in the way of Marxist assumptions about class and capital or even base and superstructure. That is what I intend to do in this paper: to interpret and extrapolate from the texts, even at the risk of making their Marxism declare itself more stridently than the "young

writer" seems to have wished. And I should admit straight away that there are several points in what follows where I am genuinely uncertain as to whether I am diverging from Greenberg's argument or explaining it more fully. This does not worry me overmuch, as long as we are alerted to the special danger in this case, dealing with such transparent yet guarded prose, and as long as we can agree that the project in general – pressing home a Marxist reading of texts which situate themselves within the Marxist tradition – is a reasonable one.[2]

I should therefore add a word or two to conjure up the connotations of "Marxism" for a writer in 1939 in *Partisan Review*. I do not need to labour the point, I hope, that there *was* a considerable and various Marxist culture in New York at this time; it was not robust, not profound, but not frivolous or flimsy either, in the way of England in the same years; and it is worth spelling out how well the pages of *Partisan Review* in 1939 and 1940 mirrored its distinction and variety and its sense of impending doom. The issue in which the "Newer Laocoon" was published began with an embattled article by Dwight MacDonald entitled "National Defense: The Case for Socialism," whose two parts were headed "Death of a World" and "What Must We Do to Be Saved?" The article was a preliminary to the "Ten Propositions on the War" which MacDonald and Greenberg were to sign jointly a year later, in which they argued – still in the bleak days of 1941 – for revolutionary abstention from a war between capitalist nation-states. It was a bleak time, then, in which Marxist convictions were often found hard to sustain, but still a time characterized by a certain energy and openness of Marxist thought, even in its moment of doubt. MacDonald had just finished a series of articles – an excellent series, written from an anti-Stalinist point of view – on Soviet cinema and its public. (It is one main point of reference in the closing sections of "Avant-Garde and Kitsch.") Edmund Wilson in Fall 1938 could be seen pouring scorn on "The Marxist Dialectic," in the same issue as André Breton and Diego Rivera's "Manifesto: Towards a Free Revolutionary Art." Philip Rahv pieced out "The Twilight of the Thirties" or "What Is Living and What Is Dead" in Marxism. Victor Serge's *Ville Conquise* was published, partly, in translation. Meyer Schapiro took issue with *To the Finland Station*, and Bertram Wolfe reviewed Boris Souvarine's great book on Stalin.

And so on. The point is simply that this *was* a Marxist culture – a hectic and shallow-rooted one, in many ways, but one which deserved the name. Its appetite for European culture – for French art and poetry in particular – is striking and discriminate, especially compared with later New York French enthusiasms. This was the time when Lionel Abel was translating Lautréamont, and Delmore Schwartz, *A Season in Hell*. The pages of *Partisan Review* had Wallace Stevens alongside Trotsky, Paul Eluard next to Allen Tate, "East Coker" – I am scrupulous here – following "Marx and Lenin as Scapegoats." No doubt the glamour of all this is misleading; but at least we can say, all reservations made, that a comparable roster of names and titles from any later period would look desultory by contrast, and rightly so.

Greenberg's first contribution to the magazine, in early 1939, was a review of Bertolt Brecht's *Penny for the Poor*, the novel taken from *The Threepenny Opera*. In it he discussed, sternly but with sympathy, the "nerve-wracking" formal

monotony which derived, so he thought, from Brecht's effort to write a parable – a *consistent* fiction – of life under capitalism. In the same issue as "Avant-Garde and Kitsch" there appeared an account of an interview which Greenberg had had, the previous year, with Ignazio Silone. The interviewer's questions told the tale of his commitments without possibility of mistake: "What, in the light of their re-lations to political parties," he asked, "do you think should be the role of revolutionary writers in the present situation?"; and then, "When you speak of liberty, do you mean *socialist* liberty?"; and then, "Have you read Trotsky's pamphlet, *Their Morals and Ours?* What do you think of it?"[3]

I am aware of the absurdity of paying more heed to Greenberg's questions than to Silone's grand replies; but you see the point of all this for anyone trying in the end to read between the lines of the "Newer Laocoon." And I hope that when, in a little while, I use the phrase "Eliotic Trotskyism" to describe Greenberg's stance, it will seem less forced a coinage. Perhaps one should even add Brecht to Eliot and Trotsky here, since it seems that the example of Brecht was especially vivid for Greenberg in the years around 1940, representing as he did a difficult, powerful counterexample to all the critic wished to see as the main line of avant-garde activity: standing for active engagement in ideological struggle, not detach-ment from it, and suggesting that such struggle was not necessarily incompatible with work on the *medium* of theatre, making that medium explicit and opaque in the best avant-garde manner. (It is a pity that Greenberg, as far as I know, wrote only about Brecht's novels and poetry.[4] Doubtless he would have had critical things to say also about Brecht's epic theatre, but the nature of his criticism – and especially his discussion of the tension between formal concentration and political purpose – might well have told us a great deal about the grounds of his ultimate settling for "purity" as the only feasible artistic ideal.)

All this has been by way of historical preliminary: if we are to read Green-berg's essays of 1939 and 1940, it is necessary, I think, to bear this history in mind.

Let me begin my reading proper, then, by stating in summary form what I take to be the arguments of "Avant-Garde and Kitsch" and the "Newer Laocoon." They are, as I have said, historical explanations of the course of avant-garde art since the mid-nineteenth century. They are seized with the strangeness of the avant-garde moment – that moment in which "a part of Western bourgeois society . . . produced something unheard of heretofore"; seized with its strange-ness and not especially optimistic as to its chances of survival in the face of an ongoing breakdown of bourgeois civilization. For that *is* the context in which an avant-garde culture comes to be: it is a peculiar, indeed unique, reaction to a far from unprecedented cultural situation – to put it bluntly, the decadence of a society, the familiar weariness and confusion of a culture in its death throes. "Avant-Garde and Kitsch" is explicit on this: Western society in the nineteenth century reached that fatal phase in which, like Alexandrian Greece or late Mandarin China, it became "less and less able . . . to justify the inevitability of its particular forms" and thus to keep alive "the accepted notions upon which artists and writers must depend in large part for communication with their audiences" ("AK," p. 34) *[21]*. Such a situation is usually fatal to seriousness in art. At the

end of a culture, when all the verities of religion, authority, tradition, and style –
all the ideological cement of society, in other words – are either disputed or doubted
or believed in for convenience' sake and not held to *entail* anything much – at
such a moment "the writer or artist is no longer able to estimate the response of
his audience to the symbols and references with which he works." In the past that
had meant an art which therefore left the really important issues to one side and
contented itself with "virtuosity in the small details of form, all larger questions
being [mechanically, listlessly] decided by the precedent of the old masters"
("AK," pp. 34–35) *[22]*.

Clearly, says Greenberg, there has been a "decay of our present society" –
the words are his – which corresponds in many ways to all these gloomy prece-
dents. What is new is the course of art in this situation. No doubt bourgeois
culture is in crisis, more and more unable since Marx "to justify the inevitability
of its particular forms"; but it has spawned, half in opposition to itself, half at its
service, a peculiar and durable artistic tradition – the one we call modernist and
which Greenberg then called, using its own label, avant-garde. "It was to be the
task of the avant-garde to perform in opposition to bourgeois society the function
of finding new and adequate cultural forms for the expression of that same society,
without at the same time succumbing to its ideological divisions and its refusal to
permit the arts to be their own justification" ("NL," p. 301) *[39]*.

There are several stresses here worth distinguishing. First, the avant-garde is
"part of Western bourgeois society" and yet in some important way estranged
from it: needing, as Greenberg phrases it, the revolutionary gloss put on the very
"concept of the 'bourgeois' in order to define what they were *not*" ("AK," p. 35)
[22] but at the same time performing the function of finding forms "for the ex-
pression" of bourgeois society and tied to it "by an umbilical cord of gold." Here
is the crucial passage: "it is to the [ruling class] that the avant-garde belongs. No
culture can develop without a social basis, without a source of stable income. [We
might immediately protest at this point at what seems to be the text's outlandish
economism: "social basis" is one thing, "source of income" another; the sentence
seems to elide them. But let it pass for the moment.] In the case of the avant-garde
this [social basis] was provided by an elite among the ruling class of that society
from which it assumed itself to be cut off, but to which it has always remained
attached by an umbilical cord of gold" ("AK," p. 38) *[24]*.

That is the first stress: the contradictory belonging-together-in-opposition of
the avant-garde and its bourgeoisie; and the sense – the pressing and anxious
sense – of that connection-in-difference being attenuated, being on the point of
severance. For "culture is being abandoned by those to whom it actually belongs
– our ruling class" ("AK," p. 38) *[24]*: the avant-garde, in its specialization and
estrangement, *had always been* a sign of that abandonment, and now it seemed as
if the breach was close to final.

Second, the avant-garde is a way to protect art from "ideological divisions."
"Ideological confusion and violence" are the enemies of artistic force and con-
centration: art seeks a space of its own apart from them, apart from the endless
uncertainty of meanings in capitalist society ("AK," p. 36) *[22–23]*. It is plain
how this connects with my previous wondering about Greenberg on Brecht, and I

shall not press the point here, except to say that there is a special and refutable move being made in the argument: to compare the conditions in which, in late capitalism, the meanings of the ruling class are actively disputed with those in which, in Hellenistic Egypt, say, established meanings stultified and became subject to skepticism – this is to compare the utterly unlike. It is to put side by side a time of economic and cultural dissolution – an epoch of weariness and unconcern – and one of articulated and fierce class struggle. Capital may be uncertain of its values, but it is not weary; the bourgeoisie may have no beliefs worth the name, but they will not admit as much: they are hypocrites, not skeptics. And the avant-garde, I shall argue, has regularly and rightly seen an *advantage* for art in the particular conditions of "ideological confusion and violence" under capital; it has wished to take part in the general, untidy work of negation and has seen no necessary contradiction (rather the contrary) between doing so and coming to terms once again with its "medium."

But I shall return to this later. It is enough for now to point to this second stress, and to the third: the idea that one chief purpose of the avant-garde was to oppose bourgeois society's "refusal to permit the arts to be their own justification." This is the stress which leads on to the more familiar – and trenchant – arguments of the essays in question, which I shall indicate even more briefly: the description of the ersatz art produced for mass consumption by the ruling classes of late capitalism as part of their vile stage management of democracy, their pretending – it becomes perfunctory of late – "that the masses actually rule"; and the subtle account of the main strands in the avant-garde's history and the way they have all conspired to narrow and raise art "to the expression of an absolute" ("AK," p. 36) *[23]*. The pursuit has been purity, whatever the detours and self-deceptions. "The arts lie safe now, each within its 'legitimate' boundaries, and free trade has been replaced by autarchy. Purity in art consists in the acceptance . . . of the limitations of the medium. . . . The arts, then, have been hunted back [the wording is odd and pondered] to their mediums, and there they have been isolated, concentrated and defined" ("NL," p. 305) *[41–42]*. The logic is ineluctable, it "holds the artist in a vise," and time and again it overrides the most impure and ill-advised intentions:

> A good many of the artists – if not the majority – who contributed importantly to the development of modern painting came to it with the desire to exploit the break with imitative realism for a more powerful expressiveness, but so inexorable was the logic of the development that in the end their work constituted but another step towards abstract art, and a further sterilization of the expressive factors. This has been true, whether the artist was Van Gogh, Picasso or Klee. All roads led to the same place. ["NL," pp. 309–10] *[45]*

This is enough of summary. I do not want now, whatever the temptation, to pitch in with questions about specific cases (Is that *true* of van Gogh? What is the balance in collage between medium and illusion? etc.) Greenberg's argument of course provokes such questions, as arguments should do, but I want to restrict myself, if I can, to describing its general logic, inexorable or not, choosing my examples for their bearing on the author's overall gist.

Let me go back to the start of "Avant-Garde and Kitsch." It seems to be an

unstated assumption of that article – and an entirely reasonable one, I believe – that there once was a time, before the avant-garde, when the bourgeoisie, like any normal ruling class, possessed a culture and an art which were directly and recognizably its own. And indeed we know what is meant by the claim: we know what it means, whatever the provisos and equivocations, to call Chardin and Hogarth bourgeois painters or Samuel Richardson and Daniel Defoe novelists of the middle class. We can move forward a century and still be confident in calling Balzac and Stendhal likewise, or Constable and Géricault. Of course there are degrees of difference and dissociation always – Balzac's politics, Géricault's alienation, Chardin's royal clientele – but the bourgeoisie, we can say, in some strong sense *possessed* this art: the art enacted, clarified, and criticized the class's experiences, its appearance and values; it responded to its demands and assumptions. There was a distinctive bourgeois culture; this art is part of our evidence for just such an assertion.

But it is clear also that from the later nineteenth century on, the distinctiveness and coherence of that bourgeois identity began to fade. "Fade" is too weak and passive a word, I think. I should say that the bourgeoisie was obliged to dismantle its focused identity, as part of the price it paid for maintaining social control. As part of its struggle for power over other classes, subordinate and voiceless in the social order but not placated, it was forced to dissolve its claim to culture – and in particular forced to revoke the claim, which is palpable in Géricault or Stendhal, say, to take up and dominate and preserve the absolutes of aristocracy, the values of the class it displaced. "It's Athene whom we want," Greenberg blurts out in a footnote once, "formal culture with its infinity of aspects, its luxuriance, its large comprehension" ("AK," p. 49 n.5) *[32]*. Add to those qualities intransigence, intensity and risk in the life of the emotions, fierce regard for honour and desire for accurate self-consciousness, disdain for the commonplace, rage for order, insistence that the world cohere: these are, are they not, the qualities we tend to associate with art itself, at its highest moments in the Western tradition. But they are specifically feudal ruling-class superlatives: they are the ones the bourgeoisie believed they had inherited and the ones they chose to abandon because they became, in the class struggles after 1870, a cultural liability.

Hence what Greenberg calls kitsch. Kitsch is the sign of a bourgeoisie contriving to lose its identity, forfeiting the inconvenient absolutes of *Le Rouge et le noir* or *The Oath of the Horatii*. It is an art and a culture of instant assimilation, of abject reconciliation to the everyday, of avoidance of difficulty, pretence to indifference, equality before the image of capital.

Modernism is born in reaction to this state of affairs. And you will see, I hope, the peculiar difficulty here. There had once been, let me say again, a bourgeois identity and a classic nineteenth-century bourgeois culture. But as the bourgeoisie built itself the forms of mass society and thereby entrenched its power, it devised a massified pseudoart and pseudoculture and destroyed its *own* cultural forms – they had been, remember, a long time maturing, in the centuries of patient accommodation to and difference from aristocratic or absolutist rule. Now, Greenberg says, I think rightly, that some kind of connection exists between this bourgeoisie and the art of the avant-garde. The avant-garde is engaged

in finding forms for the expression of bourgeois society: that is the phrase again from the "Newer Laocoon." But what could this mean, exactly, in the age of bourgeois decomposition so eloquently described in "Avant-Garde and Kitsch"? It seems that modernism is being proposed as bourgeois art in the absence of a bourgeoisie or, more accurately, as aristocratic art in the age when the bourgeoisie abandons its claims to aristocracy. And how will art keep aristocracy alive? By keeping *itself* alive, as the remaining vessel of the aristocratic account of experience and its modes; by preserving its own means, its media; by proclaiming those means and media *as* its values, as meanings in themselves.

This is, I think, the crux of the argument. It seems to me that Greenberg is aware of the paradox involved in his avant-garde preserving *bourgeoisie*, in its highest and severest forms, for a bourgeoisie which, in the sense so proposed, no longer existed. He points to the paradox, but he believes the solution to it has proved to be, in practice, the density and resistance of artistic values per se. They are the repository, as it were, of affect and intelligence that once inhered in a complex form of life but do so no longer; they are the concrete form of intensity and self-consciousness, the only one left, and therefore the form to be preserved at all costs and somehow kept apart from the surrounding desolation.

It is a serious and grim picture of culture under capitalism, and the measure of its bitterness and perplexity seems to me still justified. Eliotic Trotskyism, I called it previously; the cadencies shifting line by line from "Socialism or Barbarism" to "Shakespeare and the Stoicism of Seneca." (And was Greenberg a reader of *Scrutiny*, I wonder? It was widely read in New York at this time, I believe.)[5] From his Eliotic stronghold he perceives, and surely with reason, that much of the great art of the previous century, including some which had declared itself avant-garde and anti-bourgeois, had depended on the patronage and mental appetites of a certain fraction of the middle class. It had in some sense *belonged* to a bourgeois intelligentsia – to a fraction of the class which was self-consciously "progressive" in its tastes and attitudes and often allied to the cause not just of artistic experiment but of social and political reform. And it is surely also true that in late capitalism this independent, critical and progressive intelligentsia was put to death by its own class. For late capitalism – by which I mean the order emerging from the Great Depression – is a period of cultural uniformity: a leveling-down, a squeezing-out of previous bourgeois élites, a narrowing of distance between class and class *and* between fractions of the same class. In this case, the distance largely disappears between bourgeois intelligentsia and unintelligentsia: by our own time one might say it is normally impossible to distinguish one from the other.

(And lest this be taken as merely flippant, let me add that the kind of distance I have in mind – and distance here does not mean detachment but precisely an active, uncomfortable difference from the class one belongs to – is that between Walter Lippmann's salon, say, and the American middle class of its day; or that between the circle around Léon Gambetta and the general ambience of Ordre Moral. This last is especially to the purpose, since its consequences for culture were so vivid: one has only to remember the achievement of Antonin Proust in his brief tenure of the Direction des Beaux-Arts or Georges Clemenceau's patronage

of and friendship with Claude Monet.)[6]

This description of culture is suitably grim, as I say, and finds its proper echoes in Eliot, Trotsky, F. R. Leavis, and Brecht. And yet – and here at last I modulate into criticism – there seem to me things badly wrong with its final view of art and artistic value. I shall offer three, or perhaps four, kinds of criticism of the view: first, I shall point to the difficulties involved in the very notion of art itself becoming an independent source of value; second, I shall disagree with one of the central elements in Greenberg's account of that value, his reading of "medium" in avant-garde art; and third, I shall try to recast his sketch of modernism's formal logic in order to include aspects of avant-garde practice which he overlooks or belittles but which I believe are bound up with those he sees as paramount. What I shall point to here – not to make a mystery of it – are *practices of negation** in modernist art which seem to me the very form of the practices of purity (the recognitions and enactments of medium) which Greenberg extols. Finally, I shall suggest some ways in which the previous three criticisms are connected: in particular, the relation between those practices of negation and the business of bourgeois artists making do without a bourgeoisie. I shall be brief, and the criticisms may seem schematic. But my hope is that because they are anyway simple objections to points in an argument where it appears palpably weak, they will, schematic or not, seem quite reasonable.

The first disagreement could be introduced by asking the following (Wittgensteinian) question: What would it be *like*, exactly, for art to possess its own values? Not just to have, in other words, a set of distinctive effects and procedures but to have them somehow be, or provide, the standards by which the

*Author's note, 1984: This phrase in my essay seems to have given rise to some misunderstanding, among those who approved of it as much as those who thought it a dreadful slur. Let me offer a further brief explanation. By "practice of negation" I meant some form of decisive innovation, in method or materials or imagery, whereby a previously established set of skills or frame of reference – skills and references which up till then had been taken as essential to art-making of any seriousness – are deliberately avoided or travestied, in such a way as to imply that only *by* such incompetence or obscurity will genuine picturing get done.

For example: – The various attacks on centred and legible composition, from the *Burial at Ornans* onwards. The distortion or reversal of perspective space. The refusal of simple equivalences between particular aspects of a representation and aspects of the thing represented: the Impressionists' broken handling, Cézanne's discarding of the usual indicators of different surface textures, the Fauves' mismatching of colour on canvas with colour in the world out there. Deliberate displays of painterly awkwardness, or facility in kinds of painting that were not supposed to be worth perfecting. Primitivisms of all shapes and sizes. The use of degenerate or trivial or "inartistic" materials. Denial of full conscious control over the artefact; automatic or aleatory ways of doings things. A taste for the margins and vestiges of social life; a wish to celebrate the "insignificant" or disreputable in modernity. The rejection or parody of painting's narrative conventions. The false reproduction of painting's established *genres* (Manet was a past master at this). The parody of previous powerful styles (Abstract Expressionism in the hands of Johns or Lichtenstein). And so on.

effects and procedures are held to be of worth? I may as well say at once that there seem, on the face of it, some insuperable logical difficulties here, and they may well stand in the way of ever providing a coherent reply to the Wittgensteinian question. But I much prefer to give – or to sketch – a kind of *historical* answer to the question, in which the point of asking it in the first place might be made more clear.

Let us concede that Greenberg may be roughly right when he says in "Avant-Garde and Kitsch" that "a fairly constant distinction" has been made by "the cultivated of mankind over the ages" "between those values only to be found in art and the values which can be found elsewhere" ("AK," p. 42) *[27]*. But let us ask how that distinction was actually made – made and maintained, as an active opposition – in practice, in the first heyday of the art called avant-garde. For the sake of vividness, we might choose the case of the young speculator Dupuy, whom Camille Pissarro described in 1890 as "mon meilleur amateur" and who killed himself the same year, to Pissarro's chagrin, because he believed he was faced with bankruptcy. One's picture of such a patron is necessarily speculative in its turn, but what I want to suggest is nothing very debatable. It seems clear from the evidence that Dupuy was someone capable of savouring the *separateness* of art, its irreducible difficulties and appeal. That was what presumably won him Pissarro's respect and led him to buy the most problematic art of his day. (This at a time, remember, when Pissarro's regular patrons, and dealers, had quietly sloped off in search of something less odd.) But I would suggest that he also saw – and in some sense insisted on – a kind of consonance between the experience and value that art had to offer and those that belonged to his everyday life. The consonance did not need to be direct and, indeed, could not be. Dupuy was not in the market for animated pictures of the Stock Exchange – the kind he could have got from Jean Béraud – or even for scenes à la Degas in which he might have been offered back, dramatically, the shifts and upsets of life in the big city. He purchased landscapes instead and seems to have had a taste for those painted in the neo-impressionist manner – painted, that is, in a way which tried to be tight, discreet, and uniform, done with a disabused orderliness, seemingly scientific, certainly analytic. And all of these qualities, we might guess, he savoured and required as the signs of art's detachment.

Yet surely we must also say that his openness to such qualities, his ability to understand them, was founded in a sense he had of some play between those qualities occurring in art and the same occurring in life – occurring in his life, not on the face of it a happy one, but one at the cutting edge of capitalism still. And when we remember what capitalism *was* in 1890, we are surely better able to understand why Dupuy invested in Georges Seurat. For this was a capital still confident in its powers, if shaken; and not merely confident, but scrupulous: still in active dialogue with science; still producing distinctive rhetorics and modes of appraising experience; still conscious of its own values – the tests of rationality, the power born of observation and control; still, if you wish, believing in the commodity as a (perplexing) form of freedom.

You see my point, I hope. I believe it was the interplay of these values and the values of art which made the distinction between them an active and possible one

– made it a distinction at all, as opposed to a rigid and absolute disjunction. In the case of Dupuy, there was difference-yet-consonance between the values which made for the bourgeois' sense of himself in practical life and those he required from avant-garde painting. The facts of art and the facts of capital were in active tension. They were still negotiating with each other; they could still, at moments, in particular cases like Dupuy's, contrive to put each other's categories in doubt.

This, it seems to me, is what is meant by "a fairly constant distinction [being] made between those values only to be found in art and the values which can be found elsewhere." It is a negotiated distinction, with the critic of Diderot's or Baudelaire's or Félix Fénéon's type the active agent of the settlement. For critics like these, and in the art they typically address, it is true that the values a painting offers are discovered, time and again and with vehemence, as different and irreducible. And we understand the point of Fénéon's insistence; but we are the more impressed by it precisely because the values are found to be different as part of a real cultural dialectic, by which I mean that they are visibly under pressure, in the text, from the demands and valuations made by the ruling class in the business of ruling – the meanings it makes and disseminates, the kinds of order it proposes as its own. It is this pressure – and the way it is enacted in the patronage relation or in the artist's imagining of his or her public – which keeps the values of art from becoming a merely academic canon.

I hope it is clear how this account of artistic standards – and particularly of the ways in which art's separateness as a social practice is secured – would call into question Greenberg's hope that art could become a provider of value in its own right. Yet I think I can call that belief in question more effectively simply by looking at one or another of the facts of art which Greenberg takes to have become a value, in some sense: let me look, for simplicity's sake, at the notorious fact of "flatness." Now it is certainly true that the literal flatness of the picture surface was recovered at regular intervals as a striking fact by painters after Courbet. But I think that the question we should ask in this case is *why* that simple, empirical presence went on being interesting for art. How could a fact of effect or procedure stand in for value in this way? What was it that made it vivid?

The answer is not far to seek. I think we can say that the fact of flatness was vivid and tractable – as it was in the art of Cézanne, for example, or that of Matisse – because it was made to stand for something: some particular and resistant set of qualities, taking its place in an articulated account of experience. The richness of the avant-garde, as a set of contexts for art in the years between 1860 and 1918, say, might thus be redescribed in terms of its ability to give flatness such complex and compatible values – values which necessarily derived from elsewhere than art. It could stand, that flatness, as an analogue of the "popular" – something therefore conceived as plain, workmanlike, and emphatic. Or it could signify "modernity," with flatness meant to conjure up the mere two dimensions of posters, labels, fashion prints, and photographs. Equally, unbrokenness of surface could be seen – by Cézanne, for example – as standing for the truth of *seeing*, the actual form of our knowledge of things. And that very claim was repeatedly felt, by artist and audience, to be some kind of aggression on the latter: flatness

appeared as a barrier to the ordinary bourgeois' wish to enter a picture and dream, to have it be a space apart from life in which the mind would be free to make its own connections.

My point is simply that flatness in its heyday *was* these various meanings and valuations; they were its substance, so to speak; they were what it was seen *as*. Their particularity was what made it vivid – made it a matter to be painted over again. Flatness was therefore in play – as an irreducible, technical "fact" of painting – with all of these totalizations, all of these attempts to make it a metaphor. Of course in a sense it resisted the metaphors, and the painters we most admire insisted also on it as an awkward, empirical quiddity; but the "also" is the key word here: there was no fact without the metaphor, no medium without its being the vehicle of a complex act of meaning.

This leads me directly to my third criticism of Greenberg's account. It could be broached most forcefully, I think, by asking the question: How does the medium most often *appear* in modernist art? If we accept (as we ought to, I feel) that avant-garde painting, poetry, and music are characterized by an insistence on medium, then what kind of insistence has it been, usually? My answer would be – it is hardly an original one – that the medium has appeared most characteristically as the site of negation and estrangement.

The very way that modernist art has insisted on its medium has been by negating that medium's ordinary consistency – by pulling it apart, emptying it, producing gaps and silences, making it stand as the opposite of sense or continuity, having matter be the synonym for resistance. (And why, after all, should matter be "resistant"? It is a modernist piety with a fairly dim ontology appended.) Modernism would have its medium be *absence* of some sort – absence of finish or coherence, indeterminacy, a ground which is called on to swallow up distinctions.

These are familiar avant-garde strategies; and I am not for a moment suggesting that Greenberg does not recognize their part in the art he admires. Yet he is notoriously uneasy with them and prepared to declare them extrinsic to the real business of art in our time – the business of each art "determin[ing], through the operations peculiar to itself, the effects peculiar and exclusive to itself."[7] It is Greenberg's disdain for the rhetoric of negation which underlies, one supposes, the ruefulness of his description of Jackson Pollock as, after all, a "Gothic" whose art harked back to Faulkner and Melville in its "violence, exasperation and stridency."[8] It is certainly the same disdain which determines his verdict on Dada, which is only important, he feels, as a complaisant topic for journalism about the modern crisis (or the shock of the new). And one does know what he means by the charge; one does feel the fire of his sarcasm, in 1947, when, in the middle of dealing well with Pollock's unlikely achievement, he writes: "In the face of current events, painting feels, apparently, that it must be more than itself: that it must be epic poetry, it must be theatre, it must be an atomic bomb, it must be the rights of Man. But the greatest painter of our time, Matisse, preeminently demonstrated the sincerity and penetration that go with the kind of greatness particular to twentieth century painting by saying that he wanted his art to be an armchair for the tired business man."[9]

It is splendid, it is salutary, it is congenial. Yet surely in the end it will not quite do as description. Surely it is part of modernism's problem – even Matisse's – that the tired businessman be so weary and vacant and so little interested in art as his armchair. It is this situation – this lack of an adequate ruling class to address – which goes largely to explain modernism's negative cast.

I think that finally my differences with Greenberg centre on this one. I do not believe that the practices of negation which Greenberg seeks to declare mere *noise* on the modernist message can be thus demoted. They are simply inseparable from the work of self-definition which he takes to be central: inseparable in the case of Pollock, for certain, or Miró or Picasso or, for that matter, Matisse. Modernism is certainly that art which insists on its medium and says that meaning can henceforth only be found in *practice*. But the practice in question is extraordinary and desperate: it presents itself as a work of interminable and absolute decomposition, a work which is always pushing "medium" to its limits – to its ending – to the point where it breaks or evaporates or turns back into mere unworked material. That is the form in which medium is retrieved or reinvented: the fact of Art, in modernism, *is* the fact of negation.

I believe that this description imposes itself: that it is the only one which can include Mallarmé alongside Rimbaud, Schoenberg alongside Webern, or (dare I say it?) Duchamp beside the Monet of the *Nymphéas*. And surely that dance of negation has to do with the social facts I have spent most of my time rehearsing – the decline of ruling-class élites, the absence of a "social base" for artistic production, the paradox involved in making bourgeois art in the absence of a bourgeoisie. Negation is the sign inside art of this wider decomposition: it is an attempt to *capture* the lack of consistent and repeatable meanings in the culture – to capture the lack and make it over into form.

I should make the extent of this, my last disagreement with Greenberg, clear. The extent is small but definite. It is not, of course, that Greenberg fails to recognize the rootlessness and isolation of the avant-garde; his writing is full of the recognition, and he knows as well as anyone the miseries inherent in such a loss of place. But he does believe – the vehemence of the belief is what is most impressive in his writing – that art can substitute *itself* for the values capitalism has made valueless. A refusal to share that belief – and that is finally what I am urging – would have its basis in the following three observations. First, to repeat, negation is inscribed in the very practice of modernism, as the form in which art appears to itself as a value. Second, that negativity does not appear as a practice which guarantees meaning or opens out a space for free play and fantasy – in the manner of the joke, for example, or even of irony – but, rather, negation appears as an absolute and all-encompassing fact, something which once begun is cumulative and uncontrollable; a fact which swallows meaning altogether. The road leads back and back to the black square, the hardly differentiated field of sound, the infinitely flimsy skein of spectral colour, speech stuttering and petering out into etceteras or excuses. ("I am obliged to believe that these are statements having to do with a world, . . . but you, the reader, need not. . . . And I and You, oh well. . . . The poem offers a way out of itself, hereabouts. . . . But do not take it, wholly. . . ." And so on.) On the other side of negation is always emptiness: that is

a message which modernism never tires of repeating and a territory into which it regularly strays. We have an art in which ambiguity becomes infinite, which is on the verge of proposing – and does propose – an Other which is comfortably ineffable, a vacuity, a vagueness, a mere mysticism of sight.[10]

There is a way – and this again is something which happens *within* modernism or at its limits – in which that empty negation is in turn negated. And that brings me back finally to the most basic of Greenberg's assumptions; it brings me back to the essays on Brecht. For there is an art – a modernist art – which has challenged the notion that art stands only to suffer from the fact that now all meanings are disputable. There is an art – Brecht's is only the most doctrinaire example – which says that we live not simply in a period of cultural decline, when meanings have become muddy and stale, but rather in a period when one set of meanings – those of the cultivated classes – is fitfully contested by those who stand to gain from their collapse. There is a difference, in other words, between Alexandrianism and class struggle. The twentieth century has elements of both situations about it, and that is why Greenberg's description, based on the Alexandrian analogy, applies as well as it does. But the end of the bourgeoisie is not, or will not be, like the end of Ptolemy's patriciate. And the end of its art will be likewise unprecedented. It will involve, and has involved, the kinds of inward turning that Greenberg has described so compellingly. But it will also involve – and has involved, as part of the practice of modernism – a search for another place in the social order. Art wants to address someone, it wants something precise and extended to do; it wants *resistance*, it needs criteria; it will take risks in order to find them, including the risk of its own dissolution.[11] Greenberg is surely entitled to judge that risk too great and, even more, to be impatient with the pretense of risk so dear to one fringe of modernist art and its patrons – all that stuff about blurring the boundaries between art and life and the patter about art being "revolutionary." Entitled he is; but not in my opinion right. The risk is large and the patter odious; but the alternative, I believe, is on the whole worse. It is what we have, as the present form of modernism: an art whose object is nothing but itself, which never tires of discovering that that self is pure as only pure negativity can be, and which offers its audience that nothing, tirelessly and, I concede, adequately made over into form. A verdict on such an art is not a matter of taste – for who could fail to admire, very often, its refinement and ingenuity – but involves a judgment, still, of cultural possibility. Thus while it seems to me right to expect little from the life and art of late capitalism, I still draw back from believing that the best one can hope for from art, even *in extremis*, is its own singular and perfect disembodiment.

Notes

1 See Clement Greenberg, "Avant-Garde and Kitsch," *Partisan Review* 6 (Fall 1939): 34–49 [see Text 1], and "Towards a Newer Laocoon," *Partisan Review* 7 (July–August 1940): 296–310 [see Text 2]; all further references to these essays, abbreviated "AK" and "NL" respectively, will be included in the text.

2 This carelessness distinguishes the present paper from two recent studies of Greenberg's early writings, Serge Guilbaut's "The New Adventures of the

Avant-Garde in America," *October* 15 (Winter 1980) [see Text 9], and Fred Orton and Griselda Pollock's "*Avant-Gardes* and Partisans Reviewed," *Art History* 3 (September 1981) [see Text 10]. I am indebted to both these essays and am sure that their strictures on the superficiality – not to say the opportunism – of Greenberg's Marxism are largely right. (Certainly Mr. Greenberg would not now disagree with them.) But I am nonetheless interested in the challenge offered to most Marxist, and non-Marxist, accounts of modern history by what I take to be a justified, though extreme, pessimism as to the nature of established culture since 1870. That pessimism is characteristic, I suppose, of what Marxists call an ultraleftist point of view. I believe, as I say, that a version of some such view is correct and would therefore wish to treat Greenberg's theory *as if* it were a decently elaborated Marxism of an ultra-leftist kind, one which issues in certain mistaken views (which I criticize) but which need not so issue and which might still provide, cleansed of those errors, a good vantage for a history of our culture.

3 Greenberg, "An Interview with Ignazio Silone," *Partisan Review* 6 (Fall 1939): 23, 25, 27.

4 See Greenberg, "Bertolt Brecht's Poetry" (1941), *Art and Culture* (Boston, 1961).

5 Mr. Greenberg informs me the answer here is yes and points out that he even once had an exchange with F. R. Leavis, in *Commentary*, on Kafka – one which, he says, "I did not come out of too well!" ("How Good Is Kafka?," *Commentary* 19 (June 1955).

6 I think this state of affairs lies at the root of those ills of present-day Marxist criticism to which Edward Said refers in "Opponents, Audiences, Con-stituencies, and Community." [*Critical Inquiry*, September 1982, vol. 9, no. 1, pp. 1–26.] In the years around 1910, for example, it was possible for Marxist intellectuals to identify a worthwhile enemy within the ranks of the academy – there was a group of progressive bourgeois intellectuals whose thought and action had some real effect in the polity. That state of things was fortunate in two regards. It enabled middle-class Marxist intellectuals to attain to some kind of lucidity about the limits of their own enterprise – to see themselves as bourgeois, lacking roots in the main earth of class struggle. It meant they did not spend much of their time indulging in what I regard as the mainly futile breast-beating represented so characteristically by Terry Eagleton's bathetic question, which Said quotes: " 'How is a Marxist-structuralist analysis of a minor novel of Balzac to help shake the foundations of capitalism?' " (p. 15). Those earlier Marxists did not need this rhetoric, this gasping after class positions which they did not occupy, because there was an actual job for them to do, one with a measure of importance, after all – the business of opposing the ideologies of a bourgeois élite and of pointing to the falsity of the seeming contest between that élite and the ordinary, power-wielding mass of the class. (I am thinking here, e.g., of the simple, historical *ground* to Georg Lukács' battle with positivism in science, Kantianism in ethics, and Weberianism in politics. It was the evident link between that cir-cuit of ideas and an actual, cunning practice of social reform that gave Lukács' essays their intensity and also their sense of not having to apologize for intellectual work.) I believe it is the absence of any such bourgeois intelligentsia, goading and supplying the class it belongs to – the absence, in other words, of a bourgeoisie worth attacking in the realm of cultural pro-

duction – that lies behind the quandary of Eagleton et al. And let me be clear: the quandary seems to me at least worth being in, which is more than I can say for most other academic dilemmas. I just now applied the adjective "bathetic" to Eagleton's question, and perhaps it will have seemed a dismissive choice of word. But bathos implies an attempt at elevation and a descent from it; and of the general run of contemporary criticism – the warring solipsisms and scientisms, the exercises in spot-the-discourse or discard-the-referent – I think one can fairly say that it runs no such risk. Its tone is ludicrously secure.

7 Greenberg, "Modernist Painting," *Art and Literature* 4 (Spring 1965): 194.

8 Greenberg, "The Present Prospects of American Painting and Sculpture," *Horizon* 16 (October 1947): 26.

9 Greenberg, "Art," *Nation* 8 (March 1947): 284.

10 The editor of *Critical Inquiry* suggested that I say a little more about the negative cast I ascribe to modernism and give an example or two. Too many examples crowd to mind, and I ought to avoid the more glamorous, since what I am referring to is an *aspect* or *moment* of modernist art, most often mixed up with other purposes or techniques, though often, I would argue, dominating them. Nevertheless a phrase from Leavis' *New Bearings* occurs, in which the critic describes T. S. Eliot's "effort to express formlessness itself as form," and the lines (among others) which that phrase applies to: "Shape without form, shade without colour,/Paralysed force, gesture without motion." Yet we would do best to descend from these obvious heights and, if glamour is what is wanted, contemplate Ad Reinhardt's description of his own black painting in 1962:

> A square (neutral, shapeless) canvas, five feet wide, five feet high, as high as a man, as wide as a man's outstretched arms (not large, not small, sizeless), trisected (no composition), one horizontal form negating one vertical form (formless, no top, no bottom, directionless), three (more or less) dark (lightless) non-contrasting (colorless) colors, brushwork brushed out to remove brushwork, a matt, flat, free-hand painted surface (glossless, textureless, non-linear, no hard-edge, no soft-edge) which does not reflect its surroundings – a pure, abstract, non-objective, timeless, spaceless, changeless, relationless, disinterested painting – an object that is self-conscious (no unconsciousness), ideal transcendent, aware of no thing but art (absolutely no anti-art). [*Art, USA, Now* (New York, 1963), p. 269]

This pretends to be ironical, of course, and the art it gives rise to is negligible now, I dare say, even by received modernist standards; but the passage only puts into words a kind of attitude and practice which is by no means eccentric since Baudelaire and which has often issued in art of peculiar forcefulness and gravity.

11 This is not to smuggle in a demand for realism again by the back door; or at least, not one posed in the traditional manner. The weakness or absence I have pointed to in modern art does not derive, I think, from a lack of grounding in "seeing" (for example) or a set of realist protocols to go with that; rather, it derives from its lack of grounding in some (any) specific practice of representation, which would be linked in turn to other social practices – embedded in them, constrained by them. The question is not, therefore, whether modern

art should be figurative or abstract, rooted in empirical commitments or not so rooted, but whether art is now provided with sufficient constraints of any kind – notions of appropriateness, tests of vividness, demands which bring with them measures of importance or priority. Without constraints, representation of any articulateness and salience cannot take place. (One might ask if the constraints which modernism declares to be its own and sufficient – those of the medium or of an individual's emotions and sense of inner truth – are binding or indeed coherent; or, to be harsh, if the areas of practice which it points to as the *sites* of such constraint – medium, emotion, even "language" [sacred cow] – are existents at all, in the way that is claimed for them.)

4 How Modernism Works: A Response to T. J. Clark

Michael Fried

In the remarks that follow, I challenge the interpretation of modernism put forward in T. J. Clark's provocative essay, "Clement Greenberg's Theory of Art." As will become clear, my aim in doing so is not to defend Greenberg against Clark's strictures. On the contrary, although my own writings on recent abstract art are deeply indebted to the example of Greenberg's practical criticism (I consider him the foremost critic of new painting and sculpture of our time), I shall suggest that Clark's reading of modernism shares certain erroneous assumptions with Greenberg's, on which indeed it depends. I shall then go on to rehearse an alternative conception of the modernist enterprise that I believe makes better sense of the phenomena in question than does either of theirs, and, in an attempt to clinch my case, I shall conclude by looking briefly at an interesting phase in the work of the contemporary English sculptor Anthony Caro, whose achievement since 1960 I take to be canonical for modernism generally.

I

At the center of Clark's essay is the claim that the practices of modernism in the arts are fundamentally practices of negation. This claim is false.

Not that there is nothing at all to the view he espouses. In the first place, there is a (Gramscian?) sense in which a given cultural expression may be thought of as occupying a social space that might otherwise be occupied by another and, therefore, as bearing a relation to that other that might loosely be characterized as one of negation. Furthermore, particular modernist developments in the arts have

Source: 'How Modernism Works: A Response to T. J. Clark', *Critical Inquiry*, September 1982, vol. 9, no. 1, pp. 217–234. © 1982 The University of Chicago. All rights reserved. Michael Fried was the respondent to T. J. Clark at the conference where Text 3 was delivered.

often involved a negative "moment" in which certain formal and expressive possibilities were implicitly or indeed explicitly repudiated in favor of certain others, as when, for example, Edouard Manet in the early 1860s rejected both dramatic mise-en-scène and traditional sculptural modelling as vehicles of pictorial coherence, or as when Caro almost a century later came to feel the inadequacy to a dawning vision of sculptural possibility of the techniques of modelling and casting in which he had been trained.[1]

It is also true that entire episodes in the history of modern art – Dada, for example, or the career of Marcel Duchamp – can be construed as largely negative in motivation, and it is part of Clark's critique that Greenberg gives those episodes short shrift, treating them, Clark says, as mere noise on the surface of the modernist message. But Clark goes far beyond these observations to insist that "negation is inscribed in the very practice of modernism, as the form in which art appears to itself as a value," or, as he more baldly puts it, "the fact of Art, in modernism, *is* the fact of negation" (p. 154) *[59]*. And these claims, to the extent that I find them intelligible, seem to me mistaken.

Now it is a curious feature of Clark's essay that he provides no specific examples for his central argument. Instead, he merely cites the names Mallarmé, Rimbaud, Schoenberg, Webern, Duchamp, and Monet (of the *Nymphéas*), and in footnote 10, added, we are told, at the request of the editor, he quotes (irrelevantly in my view) a phrase of F. R. Leavis' on two lines by T. S. Eliot, along with a description by Ad Reinhardt – a distinctly minor figure who cannot be taken as representative of modernism – of his own black paintings. (The latter are evidently the "black square" to which, Clark asserts, "the road leads back and back" – except it doesn't [p. 154] *[59]*.)

How are we to understand this refusal to discuss specific cases? In an obvious sense, it makes Clark's position difficult to rebut: one is continually tempted to imagine what he would say about particular works of art – Manet's *Déjeuner sur l'herbe* (Plate C), or Cézanne's *Gulf of Marseilles Seen from L'Estaque,* or Matisse's *Blue Nude*, or Picasso's *Ma Jolie*, or Jackson Pollock's *Lavender Mist*, or David Smith's *Zig IV*, or Caro's *Prairie* – and then to argue against those invented descriptions. I found myself doing this again and again in preliminary drafts of this response until I realized that it was pointless. For the burden of proof is Clark's, the obligation is his, to establish by analyzing one or more indisputably major works of modernist art (I offer him the short list I have just assembled) that negation functions in those works as the radical and all-devouring principle he claims it is. And here it is worth stipulating that it will not be enough to say of Manet's *Déjeuner* (I'm anticipating Clark again) that it represents a situation or an action that is psychologically and narratively unintelligible; not enough because it would still be possible to argue, as I would wish to argue, that unintelligibility in Manet, far from being a value in its own right as mere negation of meaning, is in the service of aims and aspirations that have in view a new and profound and, for want of a better word, positive conception of the enterprise of painting.[2] I would make the same sort of argument about the violation of ordinary spatial logic in Cézanne, or the distorted drawing and bizarre color in Matisse, or the near dissolution of sculptural form in Picasso, or the embracing of abstraction

and the exploration of new means of picture-making in Pollock, or the use of industrial materials and techniques in Smith and Caro. In all these instances of "mainstream" modernism – a notion Clark is bound to reject as reinstituting the very distinction he wishes to collapse – there is at most a negative "moment," the significance of which can only be understood (and the form of that understanding can only be historical, which is to say, provisional or at any rate not final) in terms of a relation to a more encompassing and fundamental set of positive values, conventions, sources of conviction.[3] If Clark disagrees with this, and I'm sure he does, let him accept the challenge and offer examples that prove his point. Otherwise his sweeping generalizations lack all force.

II

Clark's essay stages itself as a critique of Greenberg's theory of modernism; yet the gist of Clark's argument, his equation of modernism with negation, involves a largely uncritical acceptance of Greenberg's account of how modernism works.

The story Greenberg tells is this.[4] Starting around the middle of the nineteenth century, the major arts, threatened for the first time with being assimilated to mere entertainment, discovered that they could save themselves from that depressing fate "only by demonstrating that the kind of experience they provided was valuable in its own right and not to be obtained from any other kind of activity." (The crucial figure in painting is Manet, whose decisive canvases belong to the early 1860s.)

> Each art, it turned out, had to effect this demonstration on its own account. What had to be exhibited and made explicit was that which was unique and irreducible not only in art in general but also in each particular art. Each art had to determine, through the operations peculiar to itself, the effects peculiar and exclusive to itself. By doing this, each art would, to be sure, narrow its area of competence, but at the same time it would make its possession of this area all the more secure.
>
> It quickly emerged that the unique and proper area of competence of each art coincided with all that was unique to the nature of its medium. The task of self-criticism became to eliminate from the effects of each art any and every effect that might conceivably be borrowed from or by the medium of every other art. Thereby each art would be rendered "pure," and in its "purity" find the guarantee of its standards of quality as well as of its independence. "Purity" meant self-definition, and the enterprise of self-criticism in the arts became one of self-definition with a vengeance.[5]

As described by Greenberg, the enterprise in question involved testing a wide range of norms and conventions in order to determine which were inessential, and therefore to be discarded, and which on the contrary constituted the timeless and unchanging essence of the art of painting. (Greenberg doesn't use either of the last two adjectives, but both are implicit in his argument.) By the early 1960s, the results of this century-long project, Greenberg's famous modernist "reduction," appeared to be in:

It has been established by now, it would seem, that the irreducibility of pictorial art consists in but two constitutive conventions or norms: flatness and the delimitation of flatness. In other words, the observance of merely these two norms is enough to create an object which can be experienced as a picture: thus a stretched or tacked-up canvas already exists as a picture – though not necessarily as a *successful* one.[6]

Greenberg may have been somewhat uneasy with this conclusion; at any rate, he goes on to state that Barnett Newman, Mark Rothko, and Clyfford Still, three of the most advanced painters of the postwar period, "have swung the self-criticism of Modernist painting in a new direction by dint simply of continuing it in its old one. The question now asked in their art is no longer what constitutes art, or the art of painting, as such, but what constitutes *good* art as such. What is the ultimate source of value or quality in art?" (The answer he gives, or finds their art to give, is "conception.")[7] But here, too, the governing notion is one of reduction to an essence, to an absolute and unchanging core that in effect has been there all along and which the evolution of modernist painting has progressively laid bare.

I don't say that Clark swallows Greenberg whole. In particular he refuses to accept the proposition that with the advent of modernism art becomes or is revealed to be "a provider of value in its own right" (p. 151) *[57]*, arguing instead that modernist art has always reflected the values of modern society (more on this presently). But I do suggest that Clark's insistence that modernism proceeds by ever more extreme and dire acts of negation is simply another version of the idea that it has evolved by a process of radical reduction – by casting off, negating, one norm or convention after another in search of the bare minimum that can suffice. Indeed I believe that it is because Clark accepts Greenberg's reductionist and essentialist conception of the modernist enterprise that he is led to characterize the medium in modernism as "the site of negation and estrangement" – as pushed continually "to the point where it breaks or evaporates or turns back into mere unworked material" – and to assert that in modernism "negation appears as an absolute and all-encompassing fact, something which once begun is cumulative and uncontrollable" (pp. 152, 153–4, 154) *[58, 59, 59]*. From this perspective, Clark's attitude towards the developments to which he alludes is less important than the assumptions underlying his interpretation of those developments. His attitude, of course, is the reverse of Greenberg's, but his assumptions derive directly from Greenberg's schema.

III

As long ago as 1966–67 I took issue with what I called a reductionist conception of modernism. In an essay on a group of paintings by Frank Stella, I wrote:

I take a reductionist conception of modernist painting to mean this: that painting roughly since Manet is seen as a kind of cognitive enterprise in which a certain quality (e.g., literalness), set of norms (e.g., flatness and the delimiting of flatness), or core of problems (e.g., how to acknowledge the literal character of the support) is progressively revealed as constituting the *essence* of painting – and, by implication, as having done so all along. This seems to me gravely mistaken, not on the grounds

that modernist painting is *not* a cognitive enterprise, but because it radically misconstrues the *kind* of cognitive enterprise modernist painting is. What the modernist painter can be said to discover in his work – what can be said to be revealed to him in it – is not the irreducible essence of *all* painting, but rather that which, at the present moment in painting's history, is capable of convincing him that it can stand comparison with the painting of both the modernist and the pre-modernist past whose quality seems to him beyond question.[8]

And in another essay written later that year I quoted Greenberg's remarks about a tacked-up canvas already existing as a picture though not necessarily as a successful one and commented:

> It is not quite enough to say that a bare canvas tacked to a wall is not "necessarily" a successful picture; it would, I think, be more accurate to say that it is not *conceivably* one. It may be countered that future circumstances might be such as to *make* it a successful painting; but I would argue that, for that to happen, the enterprise of painting would have to change so drastically that nothing more than the name would remain. . . . Moreover, seeing something as a painting in the sense that one sees the tacked-up canvas as a painting, and being convinced that a particular work can stand comparison with the painting of the past whose quality is not in doubt, are altogether different experiences: it is, I want to say, as though unless something compels conviction as to its quality it is no more than trivially or nominally a painting. . . . This is not to say that painting *has no* essence; it *is* to claim that essence – i.e., that which compels conviction – is largely determined by, and therefore changes continually in response to, the vital work of the recent past. *The essence of painting is not something irreducible*. Rather, the task of the modernist painter is to discover those conventions which, at a given moment, alone are capable of establishing his work's identity as painting.[9]

My aim in quoting these passages is not to spare myself the trouble of formulating afresh the thoughts they express but rather to show that a sharply critical but emphatically pro-modernist reading of Greenberg's reductionism and essentialism has been available for some considerable time. And my aim in showing *this* is not to suggest that Clark ought to have felt obliged to come to grips with or at least to acknowledge that reading (though I tend to think he should have) so much as to underscore his dependence on Greenberg's theory of modernism, even perhaps his solidarity with Greenberg in the face of certain criticisms of the latter's ideas. In any case, I hope it is evident that the conception of modernism adumbrated in the passages just quoted is consistent with the arguments I have already mounted against Clark's essay. The following observations will help spell this out.

1. The less inclined we are to accept the view that modernism proceeds by discarding inessential conventions in pursuit of a timeless constitutive core, the more improbable we are bound to find the claim that negation in modernism is "cumulative and uncontrollable," that (to quote Clark in full) "the road leads back and back to the black square, the hardly differentiated field of sound, the infinitely flimsy skein of spectral colour, speech stuttering and petering out into etceteras and excuses" (p. 154) *[59]*. There is no road, if by that one means a track laid down in advance and ending in a predetermined destination, which is to say that there are no theoretical grounds for believing (or inclining to believe) that the evolution of modernist painting or sculpture or any other art will be from

greater to lesser complexity, from differentiation to nondifferentiation, from articulateness to inarticulateness, and so on. (Nor are there theoretical grounds for believing the reverse.) Of course, it may simply be the case that some such evolution has occurred, but that is precisely what I dispute. Try understanding the history of Impressionism in those terms, or the art of Picasso and Braque between 1906 and 1914, or the emergence in the past seventy years of a tradition of constructed sculpture culminating in Smith and Caro, or the sequence of recent modernist painters Pollock – Helen Frankenthaler – Morris Louis – Kenneth Noland – Jules Olitski – Larry Poons (more challenges to Clark). My point here, however, is not that Clark's account of modernism belies the facts so much as that it is captive to an idea of how modernism works that all but screens the facts from view.

2. To the extent that we acknowledge the need for a putative work of modernist art to sustain comparison with previous work whose quality or level, for the moment anyway, is not in doubt, we repudiate the notion that what at bottom is at stake in modernism is a project of negation. For it is plainly not the case that the art of the old masters – the ultimate term of comparison – can usefully be seen as negative in essence: and implicit in my account is the claim that the deepest impulse or master convention of what I earlier called "mainstream" modernism has never been to overthrow or supersede or otherwise break with the premodernist past but rather to attempt to equal its highest achievements, under new and difficult conditions that from the first were recognized by a few writers and artists as stacking the deck against the likelihood of success.[10] (For Baudelaire in 1846, those conditions included the disappearance of the great schools of painting that in the past had sustained relatively minor talents and, more broadly, the advent of an extreme form of individualism that in effect threw the modern artist solely on his personal resources and thereby ensured that only the most gifted and impassioned natures could hope to create lasting art.)[11] Here too, of course, someone might wish to argue that the various measures and strategies by which the modernist arts have sought to measure up to the great works of the past have been cumulatively and overwhelmingly negative in import. But this would require serious discussion of specific works, careers, movements, and so on, and once again I would bet heavily against the persuasiveness of the result.

3. The interpretation of modernism that I have been propounding implies a view of the relation of the artistic enterprise to the wider culture in which it is situated that differs from both Greenberg's and Clark's. According to Greenberg, modernism gets started at least partly in response to sociopolitical developments, but once under way its evolution is autonomous and in the long run even predetermined.[12] According to Clark, on the other hand, artistic modernism must be understood as something like a reflection of the incoherence and contradictoriness of modern capitalist society. In his words, "Negation is the sign inside art of this wider decomposition: it is an attempt to *capture* the lack of consistent and repeatable meanings in the culture – to capture the lack and make it over into form" (p. 154) *[59]*.

Now it may seem that my own views on this topic are closer to Greenberg's than to Clark's, and in a sense they are. I find Clark's thumbnail analysis of the

sociopolitical content of modernism both crude and demeaning, quite apart from the absurdity of the idea that this culture or any culture can be said to lack "consistent and repeatable meanings." What on earth can he be thinking of? Furthermore, the modernist artist – say, the modernist painter – is represented in my account as primarily responsible to an exalted conception or at any rate to an exacting practice of the enterprise of painting. And this, in addition to perhaps striking some readers as elitist and inhumane (their problem, not mine),[13] may appear to commit me to a view of art and society as mutually exclusive, forever sealed off from one another without possibility of interpenetration or even communication. But this would be wrong: in the first place because my argument expressly denies the existence of a distinct *realm* of the pictorial – of a body of suprahistorical, non-context-specific, in that sense "formalist," concerns that define the proper aims and limits of the art of painting – maintaining on the contrary that modernist painting, in its constantly renewed effort to discover what it must be, is forever driven "outside" itself, compelled to place in jeopardy its very identity by engaging with what it is not. (The task of understanding modernism politically is itself misunderstood if it is thought of as constructing a bridge over an abyss.)[14] And in the second place because my emphasis on the utterly crucial role played in modernism by conviction or its absence invites inquiry into what might be called the politics of conviction, that is to say, the countless ways in which a person's deepest beliefs about art and even about the quality of specific works of art have been influenced, sometimes to the point of having been decisively shaped, by institutional factors that, traced to their limits, merge imperceptibly with the culture at large. In a particular instance this may result in the undermining of certain beliefs and their replacement by others (a state of no belief is impossible). But it doesn't follow merely from the recognition of influence, even powerful influence, that the original beliefs are not to be trusted. A host of institutional factors must have collaborated long ago to incline me to take Manet seriously; but I can no more imagine giving up my conviction about the greatness of his art than I can imagine losing interest in painting altogether. (Both events could happen and perhaps will, but if they do I will scarcely be the same person. Some convictions are part of one's identity.)

4. To repeat: my insistence that the modernist painter seeks to discover not the irreducible essence of all painting but rather those conventions which, at a particular moment in the history of the art, are capable of establishing his work's nontrivial identity as painting leaves wide open (in principle though not in actuality) the question of what, should he prove successful, those conventions will turn out to be. The most that follows from my account, and I agree that it is by no means negligible, is that those conventions will bear a perspicuous relation to conventions operative in the most significant work of the recent past, though here it is necessary to add (the relation of perspicuousness consists precisely in this) that significant new work will inevitably transform our understanding of those prior conventions and moreover will invest the prior works themselves with a generative importance (and isn't that to say with a measure of value or quality?) that until that moment they may not have had. Thus the evolution since the early 1950s of what is often called color-field painting has entailed a continual

reinterpretation of Pollock's allover drip paintings of 1947–50 as well as an ever more authoritative identification of those pictures as the fountainhead of an entire tradition of modernist painting.[15]

So intensely perspectival and indeed so circular a view of the modernist enterprise – both the meaning and the value of the present are conceived as underwritten by a relation to a past that is continually being revised and reevaluated by the present – has close affinities with modern antifoundationalist thought both in philosophy proper and in theory of interpretation. (Recent discussions of Wittgenstein's treatment in the *Philosophical Investigations* of "following a rule," with its problematizing of how we "go on in the same way" – e.g., making objects capable of eliciting conviction as paintings – are pertinent here.) But what I want to emphasize at this juncture is that insofar as the practice I have just described involves something like radical self-criticism, the nature of that self-criticism is altogether different from what Greenberg means by the term; and insofar as the process in question may be figured as a version of the dialectic, it throws into relief just how *un*dialectical Clark's reading of modernism is.[16]

IV

Toward the close of his essay, Clark writes that the end (in the sense of death) of the art of the bourgeoisie will involve, in fact has already involved (he is thinking of Brecht), "a search for another place in the social order." He continues: "Art wants to address someone, it wants something precise and extended to do; it wants *resistance*, it needs criteria; it will take risks in order to find them, including the risk of its own dissolution" (p. 155) *[60]*. And in a footnote to this he adds:

> This is not to smuggle in a demand for realism again by the back door; or at least, not one posed in the traditional manner. The weakness or absence I have pointed to in modern art does not derive, I think, from a lack of grounding in "seeing" (for example) or a set of realist protocols to go with that; rather, it derives from its lack of grounding in some (any) specific practice of representation, which would be linked in turn to other social practices – embedded in them, constrained by them. The question is not, therefore, whether modern art should be figurative or abstract, rooted in empirical commitments or not so rooted, *but whether art is now provided with sufficient constraints of any kind* – notions of appropriateness, tests of vividness, demands which bring with them measures of importance or priority. Without constraints, representation of any articulateness and salience cannot take place. [Pp. 155–56 n. 11; my emphasis] *[62–63]*

Here as elsewhere Clark's argument is unpersuasive. For one thing, to personify art itself as "wanting" to do certain things that are now not being done is palpably absurd. (Need I add that it is also alien to a materialist view of the subject?) For another, Clark's use of notions like resistance and criteria is obscure. Is it his considered view that in modernist art literally anything goes? Does he simply dismiss the insistence by Greenberg and others on the need to distinguish between the large mass of ostensibly difficult and advanced but in fact routine and meretricious work – the product, according to those critics, of an ingratiating and

empty avant-gardism – and the far smaller and often less obviously extreme body of work that really matters, that can survive comparison with what at that juncture they take to be the significant art of the past?[17] True, the distinction is not enforced by appeal to objective criteria – but are those what Clark is asking for? Does he think, against Kant and Wittgenstein, that such criteria have a role to play in the arts? In any case, despite his disclaimers, the whole passage bears witness to an uneasiness with abstract art that makes Clark a dubious guide to the events of the past century or more.

My strongest objection to his remarks, however, is that they fail to recognize not just the magnitude of the achievement of modernist painters and sculptors I admire but also, more to the point, the formative importance in their art of what can only be called constraints. I shall conclude with a brief example.

In 1966 Caro, who had been making abstract sculptures in welded steel since 1960, became interested in making *small* sculptures – pieces that would extend no more than a foot or two in any dimension and thus would tend to be placed on a table or other convenient locus for small portable objects rather than directly on the ground, the compulsory (i.e., the only right) siting for his abstract pieces until that moment.[18] Now it may seem that this ought not to have presented a problem: Why not simply make small (i.e., tabletop) versions of the larger sculptures that normally would have been placed on the bare ground, and let it go at that? But the fact of the matter is that such a solution was unacceptable to Caro, by which I mean that even without giving it a try he knew with perfect certainty that it would not do, that it was incapable of providing the basis for proceeding that he sought. But why?

Here I want to say, because it failed to respond to the *depth of Caro's need* for something, call it a convention,[19] that would articulate smallness in a manner consistent with the prior logic of his art, that would be faithful to his commitment to a particular mode of thinking, feeling, and willing sculpture, in short that would not run counter to his acceptance (but that is too contractual a term: his internalization, his appropriation) of a particular set of constraints, the initial and at first only partial unearthing of which roughly six years before had been instrumental in his sudden emergence as a major artist (itself a characteristically modernist phenomenon).[20] I associate those constraints with a radical notion of *abstractness*, which I contrast not with *figurativeness*, an uninteresting opposition, but rather with *literalness*, in the present context a compelling one.[21] Reformulated in these terms, the problem of smallness that Caro found so challenging may be phrased quite simply. How was he to go about making pieces whose modest dimensions would strike the viewer not as a contingent, quantitative, in that sense merely literal fact about them but rather as a crucial aspect of their identity as abstract works of art – as internal to their "form," as part of their very essence as works of sculpture? To put this another way, by what means was he to make small sculptures that could not be seen, that would effectively defeat being perceived, either as models for or as reduced versions of larger ones? In obvious respects, the task he faced involved departing from norms that had been operative in his art up to that time. More importantly, however, his task was one of remaining responsible to a particular vision of his art (may we not lift a phrase from Clark and say to

73

a particular vision of "cultural possibility"?) according to which a sculpture's scale – indeed all its features that matter, including its mode of self-presentation – must be secured abstractly, made part of its essence, in order to convince the viewer (in the first instance the sculptor) of their necessity or at any rate their lack of arbitrariness.

Caro's solution to this problem involved two distinct steps, the first of which soon proved dispensable. First, he incorporated handles of various sorts in a number of pieces in an attempt to key the "feel" of each work to that of graspable and manipulable objects. The chief precedent for this was Picasso's *Glass of Absinthe* (1914), a small painted bronze sculpture that incorporates a real silver sugar strainer. (Recognizable handles disappear from Caro's art around 1968.) Second, as in *Table Piece XXII* of 1967 (Plate D), Caro ran at least one element in every piece *below* the level of the tabletop or other elevated plane surface on which it was to be placed. This had the effect of precluding the transposition of the sculpture, in fact or in imagination, to the ground – of making the placement of the sculpture on (i.e., partly off) the tabletop a matter not of arbitrary choice but of structural necessity. And it at once turned out that tabling or precluding grounding the sculptures in this way was tantamount to establishing their smallness in terms that are not a function of actual size. More precisely, the distinction between tabling and grounding, determined as it is by the sculptures themselves, makes itself felt as equivalent to a qualitative as opposed to quantitative, essential as opposed to contingent, or abstract as opposed to literal difference in scale. (Not only did the abstract smallness of the table sculptures later prove compatible with surprising largeness of actual size; it soon became apparent that a certain minimum size, on the order of feet rather than inches, was required for their tabling to be experienced in these terms.)[22]

Caro's table sculptures thus embody a sense of scale for which there is no obvious precedent in earlier sculpture. And although it seems clear that our conviction on this score relates intimately to the fact that in everyday life smallish objects of the sort we grasp, manipulate, and shift casually from place to place tend to be found on tables, within easy reach, rather than on the ground, it is also true that we encounter nothing quite like the abstract smallness of Caro's table sculptures in our ordinary dealings with the world. From this point of view, an ontological one, the table sculptures are endlessly fascinating. And the source of that fascination could not have less to do with everything Clark means by negation, decomposition, absence, emptiness – the entire battery of concepts by means of which he tries to evoke the futility of modernism as he sees it.

A further glance at *Table Piece XXII* and I am done. The sculpture consists of three primary elements – a section of curved, broad-diameter pipe, a longer section of straight, narrow-diameter pipe, and a handle – welded together in a configuration, a structure of relations, that subtly, abstractly, asserts not only the disparateness but also the separateness of the two sections of pipe. (The pipe sections strike us as above all *disjoined* from one another by the handle that runs between them.) And one consequence of this is that, far from being tempted to reach out and grasp the handle, we sense as if subliminally that we are being invited to take hold of a gap, a spacing, and we draw back. In short, the everyday, literal

function of a handle is here eclipsed by *this* handle's abstract function of enforcing a separation and thereby attuning us all the more finely to apprehending *Table Piece XXII* abstractly rather than literally, as a work of art and not, or not merely, a physical object. A Marxist critic might wish to say that this last distinction and indeed my larger advocacy of abstractness versus literalness are epitomes of bourgeois ideology. But he would have to grant that my analysis of Caro's table sculptures could hardly be further from Clark's fantasy of the medium in modernism reverting to the state of "mere unworked material."

Finally, beyond and embracing the considerations I have so far invoked, the convincingness of *Table Piece XXII* as art depends on something that defies exhaustive analysis, namely, the sheer rightness of *all* the relevant relations at work in it, including the appropriateness of its color, a metallic gray-green, to everything else. Intuition of that rightness is the critic's first responsibility as well as his immediate reward, and if Clark shared more than a fraction of that intuition, about this Caro or any Caro, or any Smith, Pollock, Frankenthaler, Louis, Noland, Olitski, or Poons, not to mention the antecedent masters whose painting and sculptures, continually reinterpreted, stand behind theirs, his understanding of the politics of modernism would be altogether different from what it is.

Notes

1 Clark writes in his n. 10 (p. 154) *[62]* that "what I am referring to is an *aspect* or *moment* of modernist art, most often mixed up with other purposes or techniques, though often, I would argue, dominating them." This introduces a hint of qualification, almost of moderation, that can be found nowhere else in his essay. The present response addresses the hard, unqualified position taken by his essay as a whole, which stands virtually as it was read aloud at the "Politics of Interpretation" conference in Chicago. Perhaps I ought to add, inasmuch as my assessment of his views on modernism will be severe, that I think highly of his studies of French art during the Second Republic, *Image of the People* (Princeton, N.J., 1973) and *The Absolute Bourgeois* (Princeton, N.J., 1973).

2 I associate those aims and aspirations with the search for a new and more perspicuous mode of pictorial unity as well as with the desire to achieve a specific relation between painting and beholder (two aspects of the same undertaking). This is not the place for a detailed discussion of these matters, but I will simply note that the unintelligibility of the action or situation promotes an effect of *instantaneousness*, not of the action itself so much as of one's perception of the scene, the painting, as a whole. For more on Manet's aims in the first half of the 1860s, see my "Manet's Sources: Aspects of His Art, 1859–1865," *Artforum* 7 (March 1969): 28–82. In that essay I suggest that the *Déjeuner* combines elements of several genres of painting (e.g., landscape, portraiture, still life) and that this too is to be understood in terms of Manet's pursuit of a more radical and comprehensive mode of unification than was provided by the pictorial culture of his day.

3 On the distinction between "mainstream" modernism and its shadow, the phenomenon Greenberg calls avant-gard*ism*, see n. 17 below.

4 My presentation of Greenberg's theory of modernism is based chiefly on two of his later essays, "Modernist Painting" (1961), in *The New Art: A Critical Anthology*, ed. Gregory Battcock (New York, 1966), pp. 100–110, and "After Abstract Expressionism" (1962), in *New York Painting and Sculpture: 1940–1970*, ed. Henry Geldzahler (New York, 1969), pp. 360–71.

5 Greenberg, "Modernist Painting," p. 102.

6 Greenberg, "After Abstract Expressionism," p. 369.

7 Ibid. Greenberg spells out what he means by "conception" when he says of Newman's paintings: "The onlooker who says his child could paint a Newman may be right, but Newman would have to be there to tell the child *exactly* what to do" (p. 370).

8 Fried, "Shape as Form: Frank Stella's New Paintings" (1966), in *New York Painting and Sculpture*, p. 422.

9 Fried, "Art and Objecthood" (1967), in *Minimal Art: A Critical Anthology*, ed. Battcock (New York, 1968), pp. 123–24 n. 4 (with a few minor changes). The Wittgensteinian view of essence and convention propounded in these passages and indeed the basic conception of the modernist enterprise outlined in them were worked out during a period of close intellectual comradeship with Stanley Cavell; see, e.g., Cavell, "The Availability of Wittgenstein's Later Philosophy," "Music Discomposed," and "A Matter of Meaning It," *Must We Mean What We Say?* (New York, 1969), as well as his *The Claim of Reason: Wittgenstein, Skepticism, Morality, and Tragedy* (New York, 1979), esp. pp. 86–125. For a highly intelligent, at once sympathetic and deconstructive, reading of my account of modernism, see Stephen Melville, "Notes on the Reemergence of Allegory, the Forgetting of Modernism, the Necessity of Rhetoric, and the Conditions of Publicity in Art and Criticism," *October* 19 (Winter 1981): 55–92.

10 That the historical mission of modernism has been to preserve the standards of the high art of the past is one of Greenberg's major themes. The closing words of "Modernist Painting" are these: "Nothing could be further from the authentic art of our time than the idea of a rupture of continuity. Art is, among many other things, continuity. Without the past of art, and without the need and compulsion to maintain past standards of excellence, such a thing as Modernist art would be impossible" (p. 110).

11 See Charles Baudelaire, "The Salon of 1846," *Art in Paris 1845–1862: Salons and Other Exhibitions*, trans. and ed. Jonathan Mayne (Ithaca, N.Y., 1981), pp. 115–16. What the great schools chiefly provided to artists belonging to them was "faith" or, as Baudelaire shrewdly goes on to say, "the impossibility of doubt" (p. 115). In the same vein, Baudelaire writes of Delacroix more than a decade later: "He is as great as the old masters, in a country and a century in which the old masters would not have been able to survive" ("The Salon of 1859," p. 168).

12 Let me emphasize that I am speaking here of the implications of his theoretical essays (or of primarily theoretical passages in essays like "After Abstract Expressionism"); as a practical critic, Greenberg is at pains to eliminate all suggestion of predetermination and in fact would surely claim that he wished to do so in his theoretical writings as well. As we have seen, however, the terms of his analysis – reduction to an essence – make such a suggestion unavoidable.

13 I say that it is their problem because it is based on unexamined assumptions

or simply wishful thinking about what art (and life) should be like. This is perhaps the place to mention that in a lecture at a conference on art criticism and social theory held at Blacksburg, Virginia (9–11 October 1981), Donald Kuspit of the State University of New York at Stony Brook (author of a study of Greenberg) characterized my views on modernism as "authoritarian" and even as "fascistic." These are hard words. Presumably what justifies them is my insistence that some art is better than other art and my claim to know, to be able to tell, which is which. (Sometimes, of course, what I am able to tell is that previously I was wrong.) But what would be the use of a critic who regarded all art as equally indifferent, or who claimed not to be able to distinguish good from bad, or who considered all such questions beside the point? Moreover, my emphasis on the primacy of conviction means precisely that the reader of my criticism is barred from being persuaded, simply by reading me, of the rightness (or wrongness) of the judgments I make; rather, he *must* test those judgments against his firsthand experience of the works in question if he is to arrive at a view of the matter that is truly his. Is this authoritarianism? Fascism? Only, it seems to me, if we are prepared to characterize in those terms the assertion that while "the doors of the temple stand open, night and day, before every man, and the oracles of this truth cease never, it is guarded by one stern condition; this namely; It is an intuition. It cannot be received at second hand" (Ralph Waldo Emerson, "The Divinity School Address," *Nature, Addresses, and Lectures*, ed. Robert E. Spiller and Alfred R. Ferguson [Cambridge, Mass., 1979], p. 80).

14 Early in his essay, Clark cites Bertolt Brecht as a modern artist for whom "active engagement in ideological struggle . . . was not necessarily incompatible with work on the *medium* of theatre, making that medium explicit and opaque in the best avant-garde manner" (p. 143), and again toward the end he mentions Brecht with approval. This is true as far as it goes, but it fails to consider the possibility that it was precisely Brecht's prior concern with problems and issues relating to what might be called the inescapable theatricality of the theatrical arts that enabled him to make an engagement in ideological struggle *count* artistically. Brecht himself describes his discovery of Marx as that of an ideal audience: "When I read Marx's *Capital* I understood my plays. . . . It wasn't of course that I found I had unconsciously written a whole pile of Marxist plays; but this man Marx was the only spectator for my plays I'd ever come across" (*Brecht on Theater*, trans. and ed. John Willett [New York, 1964], pp. 23–24). (A similar line of argument might be pursued in connection with Godard.) The question as regards modernist painting and sculpture is therefore whether the present state of those arts is such as to facilitate an analogous development. I think the answer is no, but not because of any fact of *closure*.

15 See, e.g., my *Morris Louis* (New York, 1970), pp. 13–22 and passim.

16 Two further ramifications of my account of modernism should at least be mentioned. First, it implies that the conviction of quality or value is always elicited by putative paintings and sculptures and not by putative works of art as such. The way I put this in "Art and Objecthood" was to claim that "the concepts of quality and value – and to the extent that these are central to art, the concept of art itself – are meaningful . . . only *within* the individual arts. What lies *between* the arts is theatre" (p. 142). (See n. 18 below, and cf. Greenberg, "Intermedia," *Arts* 56 [October 1981]: 92–93.) Second, the

situation of the critic is analogous to that of the modernist artist in that criticism has no neutral, context-free, in that sense suprahistorical, descriptive categories at its disposal (not even, or especially not, "painting" and "sculpture") but rather must seek to elicit the conviction that the concepts it finds itself motivated to deploy actually illuminate the works under discussion. Moreover, as the context changes, largely as the result of subsequent artistic developments, even the concepts in widest use will require modification. For example, during the past fifteen or twenty years the concept "flatness" that at least since the late nineteenth century had been indispensable to the construal of modernist painting has lost much of its urgency; which is not to say that ambitious painting in our time has been freed from the demand that it come to terms with issues of *surface* – if anything the pressure there is more intense than before. Larry Poons' recent "pour" paintings incorporating bits and pieces of polyurethane, shown at the Emmerich Gallery in New York in April 1982, are a case in point.

17 In a lecture delivered at the University of Sydney in 1968, Greenberg distinguishes between the authentic avant-garde, which he sees as dedicated to preserving the values of the high art of the past, and the "popular" avant-garde – the invention of Duchamp and Dada – which he characterizes as seeking to evade the issue of quality altogether (see Greenberg, "Avant-Garde Attitudes: New Art in the Sixties," The John Power Lecture in Contemporary Art, 17 May 1968 [Sydney, 1969], pp. 10–11). (One recurrent tactic of evasion has been to raise the pseudoquestion of art as such.) In that lecture too Greenberg notes the emergence in the 1960s of what he calls "novelty" art, in which the "easiness" of the work – its failure to offer a significant challenge to advanced taste – "is . . . knowingly, aggressively, extravagantly masked by the guises of the difficult" (p. 12). And in a subsequent essay, Greenberg substitutes the pejorative term "avant-gardism" for that of the "popular" avant-garde ("Counter Avant-Garde," *Art International* 15 [May 1971]: 16–19).

In my "Art and Objecthood" I argue that the best contemporary painting and sculpture seek an ideal of self-sufficiency and what I call "presentness" whereas much seemingly advanced recent work is essentially *theatrical*, depending for its effects of "presence" on the staging, the conspicuous manipulation, of its relation to an audience. (In the years since "Art and Objecthood" was written, the theatrical has assumed a host of new guises and has acquired a new name: post-modernism.) Recently Melville has challenged the hardness of this distinction, arguing, for example, that the desire to defeat the theatrical can find satisfaction only in a theatrical space, or at any rate in circumstances that cannot wholly escape the conditions of theater (I make this point in my writings on pre-modernist art), and going on to claim that today "the field we call 'painting' includes, and cannot now be defined without reference to, its violations and excesses – performance work in particular" ("Notes," p. 80). In this connection he cites figures such as Rauschenberg and Acconci, whose endeavors I continue to see as trivial. But the fact that I am unimpressed by his exemplary artists by no means deflects the force of his general argument, which compels an awareness that, as he puts it, neatly paraphrasing me on Diderot, the art of painting is inescapably addressed to an audience that must be gathered (see p. 87). On the other hand, as Melville is aware, the impossibility of a pure or absolute mode of

antitheatricality by no means implies that I am mistaken in my assessment of the best work of our time or even, by and large, in the terms in which I have described it. (Effects of presentness can still amount to grace.)

On theatricality as an issue for pre-modernist art, see my *Absorption and Theatricality: Painting and Beholder in the Age of Diderot* (Berkeley, 1980); "Thomas Couture and the Theatricalization of Action in Nineteenth-Century French Painting," *Artforum* 8 (June 1970): 36–46; "The Beholder in Courbet: His Early Self-Portraits and Their Place in His Art," *Glyph* 4 (1978): 85–129; "Representing Representation: On the Central Group in Courbet's *Studio*," in *Allegory and Representation: Selected Papers from The English Institute, 1979–80*, ed. Stephen J. Greenblatt (Baltimore, 1981), pp. 94–127, rpt. in *Art in America* 69 (September 1981): 127–33, 168–73; and "Painter into Painting: On Courbet's *After Dinner at Ornans* and *Stonebreakers*," *Critical Inquiry* 8 (Summer 1982): 619–49. Theatricality in Manet is discussed in my "Manet's Sources," pp. 69–74.

18 On Caro, see, e.g., my introduction to the exhibition catalog, *Anthony Caro*, Hayward Gallery, London, 1969; Richard Whelan et al., *Anthony Caro* (Baltimore, 1974); and William Rubin, *Anthony Caro* (New York, 1975). The Whelan book contains additional texts by Greenberg, John Russell, Phyllis Tuchman, and myself. The following discussion of Caro's table sculptures is based on my essay in the catalog to the travelling exhibition, *Anthony Caro: Table Sculptures, 1966–77*, British Council, 1977–78 (rpt. in *Arts* 51 [March 1977]: 94–97).

19 "It is as if this expressed the essence of form. – I say, however: if you talk about *essence* –, you are merely noting a convention. But here one would like to retort: there is no greater difference than that between a proposition about the depth of the essence and one about – a mere convention. But what if I reply: to the *depth* that we see in the essence there corresponds the *deep* need for the convention" (Ludwig Wittgenstein, *Remarks on the Foundations of Mathematics*, ed. G. H. Von Wright, R. Rhees, and G. E. M. Anscombe, trans. Anscombe [Oxford, 1956], p. 23e).

20 See my discussion of Louis' "breakthrough" to major achievement in *Morris Louis*, pp. 10–13.

21 The opposition between abstractness and literalness is developed in my essays "Shape as Form" and "Art and Objecthood," as well as in two short reviews, "Two Sculptures by Anthony Caro" and "Caro's Abstractness," both available in Whelan et al., *Anthony Caro*, pp. 95–101 and 103–10; see also in this collection Greenberg's remarks on Caro's abstractness or "radical unlikeness to nature" ("Anthony Caro," pp. 87–93, esp. p. 88).

22 Between 1966 and 1974, Caro made roughly two hundred table sculptures of this type. Around 1974–75, however, he began making table sculptures that no longer dipped below the level of the tabletop, without loss of quality. It is as though by then Caro had acquired a mastery of what might be called table scale that enabled him to give up anchoring the pieces to the tabletop and nevertheless to establish abstractly the specificity of their dimensions and mode of presentation. (On the other hand, many of these pieces also "work" on the ground and in that sense are presentationally looser than the earlier pieces.)

5 Arguments about Modernism: A Reply to Michael Fried

T. J. Clark

1 The argument about negation

I think that the thesis of my paper Michael Fried chooses mainly to attack –
namely, that there is a strong negative cast to modernism, one that characterizes it
as an episode in art – is, if banal, pretty well supported by the evidence. Attempts
to contradict it always end up seeming strained and over-ingenious (which is not
always the case with refutations of the commonplace). Fried's attempts seem to
me no exception and not much better in their present form than in the previous
ones he wonders I did not mention.

But obviously I should have been clearer about what I took the argument to
be; that I was not allows Fried to run rings round various imaginary opponents.
First of all, it is hardly likely that I should agree with the later Clement Greenberg
on some version of essentialism, for example, "that modernism proceeds by dis-
carding inessential conventions in pursuit of a timeless constitutive core" (p. 228)
[72]. To the extent that Fried's self-quotations are disputes with some such
notion – and I cannot see that they are much more – I can cordially agree with
them and pass on. My argument is about historical cases and how best to interpret
them, or how best to interpret the overall sequence they make.

Of course it was a large part of my case in the paper that the same was true of
Greenberg's argument in its original form. Both the articles of 1939–40 in
Partisan Review, "Avant-Garde and Kitsch" and "Towards a Newer Laocoon,"
depended on a picture – quite a powerful picture, I still think – of the social cir-
cumstances of late capitalism, and the discussion of medium in "Towards a
Newer Laocoon" was largely free of the a priori reasoning characteristic of
Greenberg later in his career. Fried is evidently very little interested in the
Trotskyite writer of 1939–40. I can see why. But if he wants to pass judgement on

Source: 'Arguments about Modernism: A Reply to Michael Fried' in W. J. T. Mitchell
(Ed.) *The Politics of Interpretation*, The University of Chicago Press, Chicago and
London, 1983, pp. 239–248. © T. J. Clark.

how much or how little of Greenberg I have swallowed, it might help to get clear which Greenberg we are talking about.

Hereabouts another misunderstanding seems to creep in. For to say of a series of artworks that they show modernist art proceeding by leaps and bounds of negation is not to say that these negations result continually in *nothing*, or next to nothing, or even that modernism is habitually nay-saying or nihilistic. It is not to make the claim – which I would find as absurd as Fried does – that modernism has left behind it no complex account of experience and its modes, or no viable work on the means and materials of representation. Of course it has. The argument is rather (1) that it should strike us as important that these accounts depended on such a "casting off of norms and conventions," one which in the end included most of the kinds of descriptive work which had previously given art its *raison d'être*, and (2) that this process progressively tended to overwhelm modernist practice and become a peculiar end in itself, or at least to obscure all others. So that the "new conception of the enterprise of painting" became, in my view, more and more etiolated and self-obsessed.[1]

Thus to describe Pollock's *Lavender Mist* – it would take, of course, quite a long discussion of its peculiar place in the sequence of Pollock's drip canvases – as representing a delectable *impasse* of painting, from which its author sought to escape, months later, by means of a desperate backtrack to figuration – this would not be to call the picture empty or insubstantial but to point to the unrepeatable, incorrigible nature of its wholeness. (The account could be supported by reference to the artist's own doubts and hesitations about abstraction, for which there is a remarkable and poignant body of evidence; for this kind of reason and others, Fried's remarks about my "uneasiness with abstract art" making me "a dubious guide to the events of the past century" [p. 230] *[73]* have an anachronistic ring.) Or to place Picasso's *Ma Jolie* (Plate E) in a series of pictures from 1909 onward in which the female body seems pulled out of shape or dispersed by the very act of representing it, to say that painting itself is seen here as a form of doleful violence against the nude, to point to the grim and obvious irony of the picture's title, inscribed as it is on the scaffold of monochrome shards – none of this would be to say that there *is* no body in *Ma Jolie* but rather that painting here seems obliged to push toward an area in which every vestige of integrity or sensual presence is done to death – every vestige but that of "paint itself," put on with such delicate, sober virtuosity – in the belief, apparently, that only there would some genuine grasp of the body be possible.[2] Fried and I may disagree in either case about whether the grasp or the wholeness is achieved; but I simply want us to be struck again by the violence with which the normal repertoire of likeness is annihilated and to wonder if any other ground for representation had been secured, or could possibly be secured, in the process.

Why is it, I wonder, that modernist critics (Fried is typical here), when they encounter a history of modernism in which its masterpieces are not all pictured as triumphant openings on to fullness and positivity, are so ready to characterize that history as merely hostile, telling a story of "futility" and waste? Part of the problem may simply be this: for me a strategy of negation and refusal is not an unreasonable response to bourgeois civilization since 1871, and indeed it is the

ruthlessness of negation which lies at the root of what I admire – certainly what I feel is still usable – in modern art. The line of wit is replaced by the line of dissolution: there is no modernism to speak of, as far as I am concerned, apart from *Mauvais Sang* and *Ecce Homo*, from *The Cloud in Trousers* and the *Dictionnaire des idées reçues*, from the black square (Malevich's not Ad Reinhardt's) and the *Wooden Horse* (Plate F). "I consider *The Cloud in Trousers* a catechism for modern art," said its author, V. Mayakovsky. "It is in four parts, with four rallying cries: 'Down with your Love!'; 'Down with your Art!'; 'Down with your Social Order!'; 'Down with your Religion!' "[3] "Voilà les forces qui se sont déployées," as an old book has it, "pour introduire dans les consciences des hommes un peu de la moississure des valeurs pourissantes."[4] The problem remains, however, whether art on its own has anything to offer *but* the spectacle of decomposition.

I find myself swapping lists of favourite works. This is a pity. For let it be said that no decent historical account of modern art can be framed solely round a selected set of its "masterpieces." (Though if a contrary account can only be managed by excluding those masterpieces or admitting them all as exceptions, that account is equally in trouble.)[5] I think that my reading of modernism could make various sense of the works Fried cites and put them in contact with a host of others that are now declared, by modernist fiat not by any process of historical enquiry, to be irrelevant to them. To take the example Fried mentions: I still find it striking that modernist writers so confidently outlaw the real impulse of Dada and early Surrealism from their account of twentieth-century art, while giving such weight to artists – like Arp or Miró or Pollock – who were profoundly affected by it. Nor is the problem solved, I think, by claiming that what Pollock and Miró took from the Surrealists, by some miracle of probity, was a set of techniques which they quickly cleansed and turned to higher purpose, rather than a whole strategy of release, exacerbation, emptying, and self-splitting. Some such description might just apply to Arp's way with his masters, but that it does is the key to his limitations as an artist. It is what puts him outside the "modern tradition," if such a contradiction in terms is conceivable.

These points could be pursued further. It is particularly in its treatment of the period between 1910 and 1930 that modernist art history is inadequate, because it is faced most dramatically there with the break-up of its received tradition, the end of Parisian hegemony over the arts, and the emergence of a set of competing art practices in which the limits and autonomy of art are at stake. The question is not whether one approves of or dislikes Marcel Duchamp, who in any case is largely the entrepreneur of "anti-art" attitudes in the period, giving them commodity form. The question is how one should deal with the whole decentering of art after 1917. A history which has nothing to say about the November Group and the Russian Productivists, about VKhUTEMAS and *Der Ventilator*, while lavishing attention on the dispirited efforts of Matisse and Kandinsky in the same decade, should flinch, I would have thought, from too confident a trading of examples.*

*Author's note, 1984: Since this sentence was written, the Guggenheim Museum has put on its irrefutable show, *Kandinsky: Russian and Bauhaus Years*. No doubt an exhibition

2 The argument about consistent meanings

This can be dealt with briefly. I am surprised that Fried finds the idea that modern culture lacks "consistent and repeatable meanings" absurd. I used the phrase as a shorthand for *patterns* of meaning, systems of belief and instantiation, by which a culture fixes – and opens to refutation – some complex account of its central experiences and purposes. The word "consistent" was meant to suggest both coherence and substance – a power to convince, a seeming depth. The word "repeatable" has that pattern of belief surviving through time, dealing with new evidence without coming apart, becoming something like a tradition or a mythology.

The idea that modern culture is characterized by the absence of such forms of knowledge goes back at least as far as the Jena school or the English writers of the same period and does not seem to me absurd then or later. It has certainly been an important idea for modernist art. To adopt Fried's own tactic for a moment, I should be interested to hear a plausible account of *Bouvard et Pécuchet*, say, or *The Trial* or *The Waste Land* (no minor figures now) which did not take such doubts and uncertainties to be somewhere near the heart of things.

As for Fried's further claim that it makes no sense to picture *any* culture as lacking "consistent and repeatable meanings," I recommend a good read of social anthropology – say, the literature on cargo cults.

3 The argument about cases

My answer to Fried is bound to be as inconclusive as responses-to-replies-to-rejoinders normally are, because really there is so little common ground between us on which to argue. This comes out most clearly in Fried's exultant pointing to cases and his certainty that in doing so he poses a serious challenge to my main account.

The reader is entitled to feel a bit baffled. So Fried finds my analyses crude

Footnote (*cont.*)

of Matisse in the 1920s could be arranged that would leave me looking similarly silly. In the knockabout of argument one tends to lose hold of the main point: that the critique of modernism will not proceed by demotion of heroes, but by having heroism come to be less and less the heart of the matter. We should not be trying to puncture holes in the modernist canon (we shall anyway usually fail at that) but rather to have canon replaced by other, more intricate, more particular orders and relations. Naturally, new kinds of value judgement will result from this: certain works of art will come to seem more important, others less interesting than before; but above all the *ground* of valuation will shift. At the moment our sorting is all *ex cathedra*: history proceeds by random exclusions and inclusions: we have a way, for example, of admitting (late in the day) that Diego Rivera was one of the greatest Cubist painters, but no way of reworking our view of his Social Realism in that light; we want Tatlin, but only bits of him; Derain, but not after 1910; Hopper but not Benton; Futurism minus the Fascism; El Lissitsky but not in his Stalinist mode. This is a mess. And the mess affects our account of the heroes, I think: the breathless, repetitive, fawning quality of so much writing on modern art is the result, it seems to me, of our not having a history in which even the masterpieces might make sense.

and demeaning, and I find his fulsome and aggrandizing. Apart from the usual academic *corrida*, what does this exchange of courtesies amount to? I do not think it turns on contrary intuitions of Anthony Caro; intuitions about Caro (and so forth) do not seem to me tests of anything very important. Of course their not seeming so derives in a sense from judgements of Caro's work, but these derive from other (primary) interests and commitments. The point at issue is this, I think: Fried is interested in preserving a certain set of practices and sensibilities (let's call them those of "art" or "sculpture"); the set is specific; at the heart of it I detect a form of pristine experience had by an individual in front of an object, an "intuition of rightness" if you like. The relation of this experience to the normal identities and relations of history is obscure, but the language of Fried's actual descriptions, here and elsewhere, suggests that it somehow abrogates them and opens on to a ground or plenitude of knowledge which is normally closed to us. Caro's sculpture provides such experiences (Fried says); the experience seems valuable (to him). And no doubt it does and is; or rather, since there is no rational ground *for* doubt, let's talk about something else – for instance, about why one person should be interested in preserving this kind of experience and the talk that goes with it and another be interested in its destruction.

Let me put the point another way. I take it that many of Fried's disagreements with me centre or depend on a version of the priority-of-perception thesis. Differences on this subject seem to me largely unresolvable, because behind them lie commitments and interests which are not susceptible of proof or disproof; but nonetheless I shall have my brief say. The priority-of-perception thesis in criticism owes its appeal, surely, to its uncontroversial insistence on the special nature of artistic statements, its reminding us that we are very often dealing with complex and self-conscious cases of description or enunciation, ones which admit the odd materiality of the means they employ. Art is a practice – or at least can be a practice, in certain historical circumstances – in which the mismatching of beliefs and instances can be recognised and played with. Thus artistic statements are likely to be specially demanding on the viewer or reader's attention.

The priority-of-perception thesis therefore insists on close reading, quite properly I think. The mistake it makes is in its notion of what close reading *is*: the question being whether it is an exclusive and intensive focusing, a bracketing of knowledge, a giving-over of consciousness to its object, or whether successful reading is a mobilization of complex assumptions, commitments, and skills, in which the object is always being seen against (as *part* of) a ground of interest and argument. I certainly think the latter is the case. In the critics whose close reading I most admire (and my preferences are not eccentric; I have in mind T. S. Eliot or F. R. Leavis, or for that matter Diderot and Coleridge), objects are attended to as instances of a certain history. They are construed from a political point of view. And these perspectives and commitments are present in the reading, shaping and informing it; they are what gives it precision and substance; the writing of the reading admits as much. The same is true of Greenberg's criticism, or was true in its active and fruitful first period from 1939 to 1948. Again, this was one of the things I tried to suggest in my paper; but perhaps I should state more clearly here

that it seems to me Greenberg's best years as a critic were these, when his readings were still openly worked by wider historical concerns and partisanship. Why these were eventually abandoned, and why he retreated to a notoriously intransigent version of the primacy-of-perception thesis, is another story. The Cold War and McCarthyism are not our subject at present.

4

One of the reasons I cannot see Caro's or Jules Olitski's work very well any longer is that I have become more aware over time of the ground of interests and arguments it serves – and that, woodenly. I find them so uncongenial and boring that I cannot now perceive anything much. (I don't intuit the work's rightness: Is that it? I think I'm still capable of noticing that a Caro is small, but I fail to see why I should take facts of this kind very seriously. And as to accepting them as *constraints*, in the sense I gave the word! . . .) This will seem critical gain to some and loss to others; doubtless the real hardliners will want to say that I never could have genuinely *seen* in the first place if I am thrown off track thus easily by ideology. My hard line in return would be that "seeing" in such statements seems to me nothing – I mean that more or less literally – but the instrumentation of a different ideology.

There is a danger that all this talk of interests and arguments will seem obscure, and rather than have it remain so I shall spell out what I mean quite crudely (no doubt demeaningly too). The bourgeoisie has a small but considerable interest, I believe, in preserving a certain myth of the aesthetic consciousness, one where a transcendental ego is given something appropriate to contemplate in a situation essentially detached from the pressures and deformities of history. The interest is considerable because the class in question has few other areas (since the decline of the sacred) in which its account of consciousness and freedom can be at all compellingly phrased.

It is not enough, in this connection, for Fried to deny that he posits "a distinct *realm* of the pictorial," since his critical practice so insistently reinstates one; in the same sentence we find him saying that painting's engagement "with what it is not," though inevitable, "place[s] in jeopardy its very identity" (p. 226) *[71]*. But why on earth should it? And isn't an account of painting which sees it as *gaining* its various identities through engagement with what it is not automatically foreclosed by Fried's formulations? Won't he rule out my account of Picasso, say, on the ground that it does not grasp how separate and sustaining the "enterprise of painting" was for the artist in question? In critical practice, isn't *any* account of modern art's engagement with what it is not dismissed as being beside the great ontological point? And when it comes to ontology, all the nods to Merleau-Ponty cannot save Fried's prose from sounding like old-time religion.

One is reminded, if I too can quote from a founding text, of the climax of "Art and Objecthood" (1967), where Fried draws a distinction between the theatrical, literalist modes of the sculpture he dislikes – preeminently Morris' and Judd's – and the "presentness" of a Caro, its being at every moment "wholly manifest." "It is this continuous and entire presentness, amounting, as it were, to the per-

petual creation of itself, that one experiences as a kind of *instantaneousness*: as though if only one were infinitely more acute, a single infinitely brief instant would be long enough to see everything, to experience the work in all its depth and fullness, to be forever convinced by it." The essay concludes famously: "More generally, however, I have wanted to call attention to the utter pervasiveness – the virtual universality – of the sensibility or mode of being which I have characterized as corrupted or perverted by theater. We are all literalists most or all of our lives. Presentness is grace."[6]

I do not mean to insinuate, finally, that a religious point of view is indefensible in criticism; how could I, with Eliot as reminder? It may even be that a religious perspective is the only possible one from which a cogent defence of modernism in its recent guise can be mounted. But the view is not defended here, it seems to me, just noised abroad in an odd manner; and that is its usual status in such writing.[7] If on the contrary a defence *were* offered, arguments about modernism, other than the name-calling kind, would be made much easier.

Notes

1 The core of this argument is commonplace, as I say; in no sense is it Greenberg's special property, still less mine. For a more elegant and emphatic phrasing of it, apropos the nineteenth-century invention of "literature," see Michel Foucault's *Les Mots et les choses* (Paris, 1966), p. 313:

> De la révolte romantique contre un discours immobilisé dans sa cérémonie, jusqu'à la découverte mallarméenne du mot en son pouvoir impuissant, on voit bien quelle fut, au XIXe siècle, la fonction de la littérature par rapport au mode d'être moderne du langage. Sur le fond de ce jeu essentiel, le reste est effet: la littérature se distingue de plus en plus du discours d'idées, et s'enferme dans une intransitivité radicale; elle se détache de toutes les valeurs qui pouvaient à l'âge classique le faire circuler (le goût, le plaisir, le naturel, le vrai), et elle fait naître dans son propre espace tout ce qui peut en assurer la dénégation ludique (le scandaleux, le laid, l'impossible); elle rompt avec toute définition de "genres" comme formes ajustées à un ordre de représentations, et devient pure et simple manifestation d'un langage qui n'a pour loi que d'affirmer – contre tous les autres discours – son existence escarpée: elle n'a plus alors qu'à se recourber dans un perpétuel retour sur soi.

I am not suggesting, by the way, that Foucault sees no advantages in this round of negation and intransitivity – any more than I do.

2 Interested readers might like to compare *Ma Jolie* with the further extremes of reduction and schematization of the female body in several canvases done some months before, in spring 1911, e.g., *La Mandoliniste* (P. Daix, *Le Cubisme de Picasso*, no. 390), *La Violiniste* (393), *Tête* (395), *Soldat et fille* (394), and the ultimate *Tête de jeune fille* (376; the title is firmly accredited). In comparison *Ma Jolie* does represent a return to a less desolate and rebarbative mode, but only in comparison.

In other paintings by Picasso from this time the presence of a guitar or mandolin gives rise to a play of analogy – it may anyway strike us as per-

functory – between the shape of the instrument and that of the woman. *Ma Jolie* is apparently playing a zither, and its rectilinear form does not allow even this much of metaphor.

3 V. Mayakovsky, foreword to the second edition of his *Cloud in Trousers* as cited in his *Bedbug and Selected Poetry* (New York, 1960), p. 306.

4 R. Vaneigem, *Traité de savoir-vivre à l'usage des jeunes générations* (Paris, 1967), p. 182.

5 Since so much of Michael Fried's argument turns on my reluctance to address particular works of modern art and discuss their negations in detail, I suppose I have to state the obvious here: I do not admit to any such reluctance, and of course I agree that detailed study of particular instances – pictures and their circumstances – is part of the business of understanding modernism. (Readers can now judge for themselves whether my *The Painting of Modern Life: Paris in the Art of Manet and His Followers* (New York and London, 1985) does that job or not.)

6 Fried, "Art and Objecthood," *Artforum* 5 (Summer 1967): 22, 23.

7 There is a curious twofold structure to Fried's writing at this point and others like it, which again seems to me typical of a certain discourse on the arts. The metaphysical buzzwords – "presentness," "perpetual creation of itself," "infinitely," "depth and fullness," "forever convinced," "grace," etc. – seem to provide the ground on which the more persistent, not to say strident, appeals to "intuition" rest. But what is it in the text that gives the metaphysics substance apart from the category, "intuition," which it appears to validate? The intuition *is* the religion – not a very satisfactory one, I should imagine, and certainly unlike Eliot's or Coleridge's. For in their kind of criticism, religious commitments are articulated in the form of full-fledged histories. It is clear that these writers possess a test of truth which to their minds exceeds the historical and puts the mere sequence of human events in question; but nonetheless that perspective *constructs* a history – not just a sequence of "great works" – in which art takes a special, subordinate place. (Consider the duties performed by descriptions of Shakespeare in *Biographia Literaria*, or the nature of the close reading of *Rameau's Nephew* offered by Hegel in the *Phenomenology*.) There is an essay to be written on when and how the religious attitude in criticism declines from this complex building and questioning of the past into a set of merely metaphysical episodes in an earth-bound, present-bound discussion of cases.

II

HISTORY: REPRESENTATION AND MIS-REPRESENTATION – THE CASE OF ABSTRACT EXPRESSIONISM

Introduction

Since the early 1970s the agenda for debate on art produced in the United States from the WPA[1] onwards has been revised. The appearance of Max Kozloff's 'American Painting During the Cold War' (Text 6) in 1973 initiated a number of articles and books which placed together 'Abstract Expressionism' with such concepts as the 'Cold War', 'Art and Politics', 'American Power', 'Suppression' and 'Freedom'.[2] Such juxtapositions were not those generally made by art critics and art historians during the 1950s and 1960s, a time when Greenberg conspicuously refined his 'modern specialization'[3] and when the norms for scholarly work were still those which had been set by the books of Alfred Barr and John Rewald.[4] In these decades explanations of Pollock's works and those produced by other 'Abstract Expressionists' mostly stressed not only *formal* similarities and connections with particular examples of European art but also with the Americans' 'development beyond'.[5] A typical example is the four-part article 'Jackson Pollock and the Modern Tradition' by William Rubin, published in *Artforum* between February and May 1967.[6] In it Rubin attempted to make formal links between characteristics of Pollock's paintings and those by: the Impressionists; particular works by Matisse and Mondrian; Picasso's 'Analytic' Cubist works and the legacy of Cubism; and finally the automatism of Surrealism. By concentrating on similarities in formal or technical *appearances*, Rubin constructed an historicist validation for Pollock's works while relegating the meanings of both European and American paintings as *representations* produced in distinct historical, ideological conditions. His article can be seen as a further elaboration of the then successful Modernist paradigm of art historical and art critical interpretation.

An earlier and more 'notorious' text is Michael Fried's *Three American Painters: Kenneth Noland, Jules Olitski, Frank Stella* of 1965.[7] In pursuit of a refined formal criticism Fried is interested in making 'convincing discriminations of value among the works of a particular artist'. He claims that:

> For twenty years or more all the best new painting and sculpture has been done in America; notably the work of artists such as de Kooning, Frankenthaler, Gorky, Gottlieb, Hofmann, Kline, Louis, Motherwell, Newman, Pollock, Rothko, Smith and Still – apart from those in the present exhibition – to name only some of the best.
>
> . . . the development over the past hundred years of what Greenberg calls "modernist" painting must be considered, because the work of the artists mentioned above represents, in an important sense, the extension in this country of a kind of painting that began in France with the work of Edouard Manet . . .
>
> Roughly speaking, the history of painting from Manet through Synthetic Cubism and Matisse may be characterized in terms of the gradual withdrawal of painting from the task of representing reality – or of reality from the power of painting to represent it – in favor of an increasing preoccupation with problems intrinsic to painting itself. . . . in this century it often happens that those paintings that are most full of explicit human content can be faulted on formal grounds – Picasso's *Guernica* is perhaps the most conspicuous example – in comparison with others virtually devoid of such content. (It must be granted that this says something about the limitations of formal criticism as well as about its strengths. Though precisely *what* it is taken to say will depend on one's feelings about *Guernica*, etc.)[8]

Within the parentheses Fried comes clean about what is gained and what may be lost by the application of formal criticism. In a footnote he also acknowledges that even with Manet, Modernism only offers an interpretation; for Fried it is more able than any other approach to throw light upon Manet's work but,

> What one takes to be the salient features of his situation is open to argument; an uncharacteristically subtle Marxist could, I think, make a good case for focussing on the economic and political situation in France after 1848.[9]

If this is possible for Manet then what one takes to be the salient features of Pollock's situation is also open to argument. There may be a good case for focussing on the economic and political situation in America from the mid-thirties onwards. However, for Fried, approaches other than formalist ones are essentially procedures for *reading in* the 'content' of paintings in an arbitrary and illogical way. Modernism defines its interests within containable and, in its terms, testable limits. In Fried's contribution to the Modernist critical tradition he provides 'explanation' for paintings and their changes in terms of a discussion of particular complex relationships between traditions, artistic sources, aspects of contemporary consciousness and art criticism. Most other social, political and cultural causal conditions or influences are excluded as being beyond the limits of usefulness or appropriateness. So, explanation of Pollock's work goes like this:

> In a painting such as *Number One* [1948] there is only a pictorial field so homogeneous, overall and devoid both of recognizable objects and of abstract shapes that I want to call it *optical*, to distinguish it from the structured, essentially tactile pictorial field of previous modernist painting from Cubism to de Kooning and even Hans Hofmann. Pollock's field is optical because it addresses itself to eyesight alone. The materiality of his pigment is rendered sheerly visual, and the result is a new kind of space – if it still makes sense to call it space – in which conditions of seeing prevail rather than one in which objects exist, flat shapes are juxtaposed or physical events transpire.[10]

The outlined figure on the left of *Number One 1948* (Plate B), or the series of Pollock's hand prints which appear top right of the painting, are of little or no interest to Fried.

In the 1970s and 1980s a number of articles appeared which questioned the Modernist account of American art since the 1930s, particularly the emphasis on stylistic analysis and the conventional presentation of Abstract Expressionism as the epitome of 'individualism', creative freedom and revolutionary avant-gardism.[11] This revision of historical interpretation is represented here by a selection of such texts.

The views and interests of these authors differ greatly from those which inform the approach of Greenberg, Fried, Rubin and Sandler – the most competent exponents of Modernist criticism and history. A major area of difference concerns their respective criteria of *relevance*. The 'revisionists' of the 1970s and 1980s regard as relevant to the explanation and interpretation of works of art and their conditions of production issues and concerns similar to those discussed by social, political and cultural historians of the period from Roosevelt's 'New Deal' to the Vietnam War; historians and commentators such as Joyce and Gabriel Kolko, Christopher Lasch, Richard M. Freeland and Noam Chomsky.[12]

Early essays such as those by Kozloff and Cockcroft began to pose questions hitherto neglected by art historians and art critics, whom we now link with the Modernist tradition of interpretation and explanation. Basically they queried the conventional history of linear artistic progression which explained Abstract Expressionism as a development within an essentially autonomous discipline. The Modernist arguments are well rehearsed and fundamentally propose that Abstract Expressionism, along with Cubism which is seen as its underlying formal influence,[13] is 'socially autonomous' because it is supposedly disengaged from the demands of signifying realistic intent or meaning; it is 'technically autonomous' because it is characterized as an art concerned primarily with purely formal compositions and 'experiments'; and it is 'conceptually autonomous' because the aim of the works is to evoke concerns confined to a notion of the artist's conceptualized vision, which is 'pure' and 'disinterested', and to communicate the 'essentials' of experience through the expressive use of form, colour, surface and the means for the illusion of shallow space/depth and 'relative flatness'. This explanation of Abstract Expressionism was refined retrospectively. It was produced in specific ideological circumstances in which issues of a social, cultural, political or economic nature – other than those compatible with Cold War rhetoric – were deemed as irrelevant to the experience, and hence to the explanation, of the 'work itself'. The 'work itself' and the beholder's experience of it are, it is argued, separable from the work's conditions of production and reception and from whatever determinants there may be upon the nature of the beholder's 'experience'.

Greenberg still argues that discriminations of 'value' are the only questions left open to the modern critic.[14] The concept of 'intuition' is the main area of investigation; aesthetics becomes a subject akin to the supposedly insulated problems of those scientific investigations pursued for the academic demands of the specialism.[15] Greenberg has not always held these views. Some of the

'revisionists' consider why Greenberg, and many other intellectuals of his generation, moved from Leftist,[16] if not Trotskyist, positions in the late 1930s and early 1940s to rabid anti-Communism during the 1950s onwards. As many of the essays in this anthology testify, Greenberg was associated with a 'Marxist culture' of sorts in New York while writing for *Partisan Review* in the late thirties and early forties. From the late forties onwards he became a leading anti-Communist liberal:

> As an editor of *Commentary* from 1945 to 1957, he helped shape the anti-Soviet attitudes of his fellow conservative intellectuals.
>
> In one of the more bizarre convergences in American history, Dondero, the man who found a Communist conspiracy behind modernist painting, endorsed Greenberg's campaign against liberals with alleged pro-Soviet sympathies. This strange alliance took place in 1951 during a controversy over Communist infiltration of political news magazines. An anti-Communist group, the American Committee for Cultural Freedom, led this effort to expose Soviet sympathizers on the staff of the *Nation*. Once a contributor to this journal, Greenberg made the first public charges against his former editors. Delighted with Greenberg's accusations, Dondero immediately reprinted them in the *Congressional Record*.[17]

Congressman George A. Dondero from Michigan is famous for his speech 'Modern Art Shackled to Communism' (1949).[18] For him modern artists of the '-isms' threatened American culture and the American way of life because the 'doctrine of "-isms" is Communist-inspired and Communist-connected'. While Greenberg was championing Abstract Expressionism as the most advanced form of painting encapsulating 'the main premises of Western art' because it was detached from representing political and social issues and engaged in going 'beyond' the formal aspects of Cubism, Dondero attacked Cubism as a potential instrument and weapon of American destruction, aiming 'to destroy by designed disorder'. As Christopher Lasch points out,

> Especially in the fifties, American intellectuals, on a scale that is only beginning to be understood, lent themselves to purposes having nothing to do with the values they professed – purposes, indeed, that were diametrically opposed to them.[19]

The Kuhnian notion of a successful paradigm can offer an explanation of the *form* of anti-Marxism in a particular discipline during this period. However, it does not provide *reasons why* anti-Marxism came about during the 1940s and 1950s.

At the most basic level the question posed by the 'revisionists' as represented by the five texts in this section is: notwithstanding the relative autonomy of art, do Modernist explanations provide historically adequate and theoretically defensible reasons for separating consideration of the *appearance* of Abstract Expressionist works from consideration of them as *produced* things; the material and ideological conditions in which, and out of which, they were made and received? These conditions are represented for these authors by the nature and substance of contemporary debates and ideological forms. Hence their concern is not with, say, documenting the formal links between European and Abstract Expressionist paintings which happen to *appear* similar but with considering the question: what sort of world was it in which 'drip paintings' were produced as a cogent form of representation? This leads to the consideration of those issues

from the 1930s to the 1950s which are regarded as uninformative within the Modernist paradigm. Some of these issues include: the cultural implications of the fall of Paris into the hands of the German army; debates and allegiances within 'artistic' and 'literary' sub-groups for whom the threats of Fascism could only be withstood by Communism; contemporary discussions of the New World as the only place where 'modern culture' could be safeguarded; the move from US isolationism to internationalism in the 1940s with all its imperialist implications embodied in the Marshall Plan; the US world role as perceived by its ruling class and as represented by the atomic explosions at Hiroshima and Nagasaki and the tests at the Bikini atoll; post-war entrenchment of a 'New Liberalism' and McCarthyite anti-Communism replacing pre-war dialogues on the axis which coupled 'New Deal' politics and Trotskyism. Such issues necessarily need to be located within debates on 'outdated' Regionalism, on Social Realism and on the expressive potential for a mural art in the 1940s which evoked a 'subject' purged of Social Realism, part of the discredited allegiances of the 1930s, and the 'subjective', a notion which painters 'borrowed' from European Surrealism.

As is indicated by material in the texts by Kozloff, the Shapiros and Guilbaut, while many artists in the USA in the early 1940s rejected Stalinist and Popular Front aesthetics, they nonetheless sought a political engagement. In the catalogue to the third annual exhibition, which included Gottlieb and Rothko, of the Federation of American Painters and Sculptors, established in 1940 after the Trotskyists seceded from the American Artists' Congress because it became associated with a pro-Stalinist 'line', there was a proclamation of aims:

> At our inception three years ago we stated 'We condemn artistic nationalism which negates the world tradition of art at the base of modern art movements'. Historic events which have since taken place have eminently confirmed this. Today America is faced with the responsibility either to salvage and develop, or to frustrate western creative capacity . . . Since no one can remain untouched by the impact of the present world upheaval, it is inevitable that values in every field of human endeavour will be affected. As a nation we are being forced to outgrow our narrow political isolationism. Now that America is recognized as the center where art and artists of all the world must meet, it is time for us to accept cultural values on a truly global plane.[20]

For those painters aware of the competences established by European artists the problem was how to achieve an art which avoided the traps of 'social' and 'realist' propaganda, an art independent of political affiliations of the 1930s, but which was rooted in contemporary experience and its representations. Abstract Expressionist paintings were produced out of conversations and practices in which a major concern was the *means* by which artists could represent their experience as members of an historically specific *avant-garde*. As Orton and Pollock point out, in Text 10, the late 1930s and early 1940s in New York are characterized by the establishment of a new discursive framework

> . . . that enabled some of the artists and intellectuals who gathered there to construct an identity for themselves which was simultaneously an opposition to, and extension of, available American and European traditions. It provided them with the consciousness of a role and function through which they could engage with, and disengage from, the current social turmoil and ideological crisis.[21]

In an article for *Partisan Review*, 'The Situation at the Moment', in January 1948, Greenberg described the problem in terms of private and social, cabinet picture and mural, artist and audience,

> Thus, while the painter's relation to his art has become more private than ever before because of a shrinking appreciation on the public's part, the architectural and presumably social location for which he destines his product has become, in inverse ratio, more public. This is the paradox, the contradiction, in the master-current of painting.[22]

For these artists their work had to address the 'social turmoil and ideological crisis' as perceived by New York-based painters, intellectuals and critics; their *representations* must not be merely fictions. Important, therefore, was the possibility for 'realism', albeit framed in a confusion of notions of the 'social' and the 'subjective', which was regarded as crucial as any practical and critical understanding of 'art itself'; or what more theoretically robust authors have meant by the 'relative autonomy' of art as a superstructural form.[23]

For artists of Pollock's generation greater access to Picasso's and Braque's Cubism confirmed the establishment of a new paradigm in art *practice*. For those artists who saw themselves as *avant-garde*, the Renaissance convention of illusionism had been replaced as the most successful form of pictorial representation. In its place was Cubism's assertion of an explicit dialectic between the *means* of representation and an expressive imagery or signifying system. Significantly, for consideration of critical debates in the late 1930s and early 1940s, authors such as Trotsky and Benjamin had argued that *part* of art's search for 'truth' is its fidelity to its 'own laws' – rules and principles.[24] Both argued that for art to take part actively and consciously in the pursuit of knowledge and revolution, art practice and political practice have to combine. For Trotsky, art as a revolutionary force must be bound to the society in which it is produced but not constrained by society's forces from pursuing a development of its own principles. By doing so it has the potential for providing a critical lead, in as much as it has a liberating role in culture and consciousness. Benjamin too declared in 'The Author as Producer' (1934) that:

> ... technical progress is for the author as producer the foundation of his political progress. In other words: only by transcending the specialization in the process of production which, in the bourgeois view, constitutes its order, is this production made politically valuable; and the limits imposed by specialization must be breached jointly by both the productive forces that they were set up to divide. ... A political tendency is the necessary, never the sufficient condition of the organizing function of a work. This further requires a directing, instructing stance on the part of the writer. And today this is to be demanded more than ever before. *An author who teaches writers nothing, teaches no one.*[25]

Trotsky and Benjamin are instructive not least for drawing attention to the necessity for any adequate history of art – here of Abstract Expressionism – to map out and account for those forces which moulded the consciousness of the artists and defenders (critics, curators, ideologists of various professions) responsible for its production and ratification. Recent work by historians of Abstract Expressionism such as Guilbaut and Cox has shown that the resources for what I characterize as 'realism' were not disinterested developments 'beyond' the

technical and formal specialisms or competences of European styles. Artists' and critics' consciousness may be characterized in part by examination of the nature of their statements. These show that a major resource for their art was a concern with 'alienation'.[26] So notions of 'alienation', 'anxiety' and 'metaphysics of despair' were current not only in the writings of artists and critics (in Greenberg's too, though in a less theatrical manner than Rosenberg's 'existentialism') but also in more public forms of print. Here is Greenberg in 1947 and 1948:

> In painting today such an urban art can be derived only from Cubism. Significantly and peculiarly, the most powerful painter in contemporary America, and the only one who promises to be a major one is a Gothic, morbid, and extreme disciple of Picasso's Cubism and Miró's post-Cubism, tinctured also with Kandinsky and Surrealist inspiration. His name is Jackson Pollock . . .

> For all its Gothic quality, Pollock's art is still an attempt to cope with urban life; it dwells entirely in the lonely jungle of immediate sensations, impulses and notions, therefore is positivist, concrete. Yet its Gothic-ness, its paranoia and resentment narrow it, large though it may be in ambition – large enough to contain inconsistencies, ugliness, blind spots and monotonous passages – it nevertheless lacks breadth.[27]

> Balance, largeness, precision, enlightenment, contempt for nature in all its particularity – that is the great and absent art of our age.

> The task facing culture in America is to create a milieu that will produce such an art – and literature – and free us (at last!) from the obsession with extreme situations and states of mind. We have had enough of the wild artist – he has by now been converted into one of the standard self-protective myths of our society: if art is wild it must be irrelevant.[28]

> Their isolation is inconceivable, crushing, unbroken, damning. That anyone can produce art on a respectable level in this situation is highly improbable. What can fifty do against a hundred and forty million?[29]

> In the face of current events painting feels, apparently, that it must be epic poetry, it must be theatre, it must be an atomic bomb, it must be the rights of Man. But the greatest painter of our time, Matisse, preeminently demonstrated the sincerity and penetration that go with the kind of greatness particular to twentieth century painting by saying that he wanted his art to be an armchair for the tired businessman.[30]

> Isolation, or rather the alienation that is its cause, is the truth – isolation, alienation, naked and revealed unto itself, is the condition under which the true reality of our age is experienced. And the experience of this true reality is indispensable to any ambitious art.[31]

These texts require careful analysis and the appropriate context but they at least suggest, as recent scholarly work reveals, that the informed reader will see the *history* of the years in which Pollock's drip paintings were produced as incompatible with either the hagiographical accounts or with the Modernism of Michael Fried where 'opticality' and 'positive/negative figuration' characterize a self-protective critical paradigm. Greenberg's criticism of the 1940s testifies to the inadequacy of an emphasis on formal 'specialization' alone. His own criticism from these years is historically misrepresented by the refined formalism of later Modernism – including his own writings from the 1950s onwards which seek to relegate the importance of his pre-1948 work.

The strength of Greenberg's and of some of Fried's criticism and history, particularly from the 1960s, is, so some would argue, that they attend to the objectively observable characteristics of Abstract Expressionist works described. They are systematically restricted by strong criteria of formal and technical *relevance*. The information and discussions represented by the texts in this section are thus ruled out as worthy but irrelevant to the discussion of quality. We may regard it as defensible to claim, as is again and again rehearsed by Greenberg, that the art critic – if not the art historian – should be true to his or her responses and be open to the 'intuition of quality', however unlikely the source of that intuition may be. However, such a position needs to be treated sceptically insofar as it can be demonstrated as historically determined and insofar as we can claim that no concept of quality can be truly disinterested.

Greenberg is reluctant to receive praise or even much respect for his pre-1948 work. Yet, that is where his criticism testifies to the difficulty of characterizing art and its practices in the modern period and particularly in an era of developed capitalism. In an attempt to sustain a critical practice in such a socioeconomic system there are social, political, moral, artistic and intellectual contradictions. It is the same for art practice. Historians such as those included here are interested in these contradictions rather than in seeking to replicate the seamless and insulated accounts of conventional Modernism.

Greenberg is of course aware of the material which recent history of the period emphasizes. However, as is clear from interviews and publications, he has well-marshalled defences against any attempts to expose those contradictions which existed in his writings and interests of the late thirties and the forties. Sometimes, though, he acknowledges the importance of history to those who find themselves unwittingly entertained by *his* desire to talk of a safely defined and socially insulated area of aesthetics. When revising an article, 'New York Painting Only Yesterday', from *Art News* in 1957, for his collected essays *Art and Culture* (1961), Greenberg added a parenthesis

> Abstract art was the main issue among the painters I knew then [the late 1930s]; radical politics was on many people's minds but for them Social Realism was as dead as the American Scene. (Though that is not all, by far, that there was to politics in art in those years; someday it will have to be told how 'anti-Stalinism', which started out more or less as 'Trotskyism', turned into art for art's sake, and thereby cleared the way, heroically, for what was to come.)[32]

This is quoted by some of the authors included here for it has been their aim to account for the transformation to which Greenberg refers. For him 'art for art's sake' became entrenched after 1948. Significantly, for those interested in a materialist history, Greenberg wrote in 'The Decline of Cubism' in *Partisan Review* in March of that year on a twofold transformation:

> If artists as great as Picasso, Braque and Léger have declined so grievously, it can only be because the general social premises that used to guarantee their functioning have disappeared in Europe. And when one sees, on the other hand, how much the level of American art has risen in the last five years, with the emergence of new talents so full of energy and content as Arshile Gorky, Jackson Pollock, David Smith . . . then the conclusion forces itself, much to our own surprise, that the main

premises of Western Art have at last migrated to the United States, along with the center of gravity of industrial production and political power.[33]

This correlation between artistic issues and economic and political conditions is seen as historically significant by those interested in accounting for the development of modern art in terms other than autonomous with respect to social and economic forces. As with much of Greenberg's criticism there are complex issues underlying what appears to be a simple but daring claim in 'The Decline of Cubism'. He openly challenges the supremacy of Parisian art, announcing the decline in power and importance of Cubist-derived works produced in Europe. For him the cultural supremacy of European art had been replaced by the works of Americans who are seen as having revitalized the 'main premises' of Western art. Painters who were later labelled 'Abstract Expressionists' were seen as having assumed the mantle of the international avant-garde. Yet Greenberg, as in 'Avant-Garde and Kitsch' in 1939, is still conscious of art's relationship with 'general social premises'; that the history and changes in art practice are somehow implicated in the histories and forces of 'industrial production and political power'. In 1939 it may be that his analysis of bourgeois culture and of capitalism was more adequately theorized although, as authors such as Guilbaut and Orton and Pollock suggest, there may be a degree of superficiality and opportunism to Greenberg's Marxism. For the 'revisionists' attempts to account for Greenberg's characterization of contemporary art lead them to consider the relationships which the critic himself suggests: were the causal conditions for the practice of art and of criticism in these years solely related to the specialism, or were wider issues, values and beliefs – and the economic structures which produce and sustain them – determining factors?

Certainly, however wary we must be in citing them as rigorously informative, artists' statements give support to the project that recent art historians have undertaken: they do not always fit the Modernist rationalization. What are we to make of Pollock's statement from 1950?

> Modern art to me is nothing more than the expression of contemporary aims of the age that we're living in . . .

> My opinion is that new needs need new techniques. And the modern artists have found new ways and new means of making their statements. It seems to me that the modern painter cannot express this age, the airplane, the atom bomb, the radio, in the old forms of the Renaissance or of any other past culture. Each age finds its own technique.[34]

It has surely been demonstrated that Abstract Expressionism was produced out of a desire to produce art which was competent in European terms, but how can it be accounted for as expressive of contemporary times – how do we account for particular works as *representations*?

The essays in this section represent the main points in the history of debates and controversies about the status and conditions of the production and the ratification of Abstract Expressionist paintings. They are presented in chronological order and have been edited to remove unnecessary overlap or substantial quotations from the two essays by Clement Greenberg included in Section I. The

debate began with articles which considered issues concerned with the ratification of Abstract Expressionism. They are thus focused on the fifties and to some extent the sixties. Kozloff's article posed the question:

> ... if we seem to have explored everything about this art technically, we have not yet asked sufficiently well what past interests have made it so official.[35]

Himself an early apologist for the Modernist characterization of Abstract Expressionism, Kozloff suggests a new context for the consideration of American painting since 1945, that of 'American political ideology, national self images, and even the history of the country' – 'the burgeoning claims of American world hegemony'.[36] Subsequent articles concentrated on these aspects of the Cold War rather than on the forties: Kozloff raises some issues but he is aware of the then lack of historical work on the period. After quoting Clyfford Still, speaking of the artist's role in the 1940s, he writes: 'How one might relate such an overwrought mood to the prevailing fear of atomic destruction is a baffling and disturbing question.'[37] It is a question which interests Guilbaut particularly, and to some extent the Shapiros, though the latter historians are as concerned with defending the interests of Social Realism, 'art as a weapon'. All of the texts, though, are a response to the art-historical myth making of institutions such as the Museum of Modern Art, New York, in the 1950s and 1960s and by articles in influential American journals such as *Artforum* in the 1960s. When Kozloff became an editor of that journal in the 1970s, articles which implicitly criticized its Modernist stance of the decade before were published. And as an indication of the depth of revisions in interpretations of the art produced during and since the 1940s and of the types of historical work being done by Americans, there is the substantial exhibition *Realism and Realities: The Other Side of American Painting 1940–1960* held in 1982 in the USA (Rutgers University Art Gallery; Montgomery Museum of Fine Arts; and the Art Gallery, University of Maryland).[38]

Clearly major debates and revisions centre on the interpretation of: the causal conditions and status of the range of paintings produced in the 1940s and 1950s (and to some extent here with the 1960s); the social, cultural and artistic conditions in which painters such as Pollock produced their work; the critical entrenchment of Abstract Expressionism in the 1950s and the possible interests of the agents of that entrenchment; the origins and characteristics of Modernist criticism, particularly that offered by Barr in the 1930s and 1940s, by Greenberg from the later 1930s onwards and by later critics/historians such as Fried and Rubin in the 1960s and 1970s.

For the two articles which more closely address the 1940s, those by the Shapiros and by Guilbaut, a major aim is to take up Greenberg's challenge: 'Someday it will have to be told how "anti-Stalinism", which started out more or less as "Trotskyism", turned into art for art's sake'.[39] In the 1930s Pollock was a Communist of sorts, interested in Social Realist mural art and Regionalism. By the mid-1940s he, along with many other radicals, found such commitments of the thirties inappropriate to contemporary reality. Their dilemmas are vividly represented by Dwight MacDonald's discussion of the 'impossible alternatives'

which faced the radicals and Trotskyists of the 1930s in post-1945 America.[40] What was responsible for these changes, dilemmas and impossible alternatives?

> I intend to paint large movable pictures which will function between the easel and mural. I have set a precedent in this genre in a large painting for Miss Peggy Guggenheim which was installed in her house and was later shown in the 'Large-Scale Paintings' show at the Museum of Modern Art. It is at present on loan at Yale University.
>
> I believe the easel picture to be a dying form, and the tendency of modern feeling is towards the wall picture or mural. I believe the time is not yet ripe for a *full* transition from easel to mural. The pictures I contemplate painting would constitute a halfway state, and an attempt to point the direction of the future, without arriving there completely.[41]

This is Pollock from 1947. His statement suggests, for some historians, that it is necessary to account for artists' wishes to draw on the public potential for, and ideological power of, large-scale mural art – the legacy of the thirties – but in a way which expressed their 'unconscious', 'Gothicness', 'alienation', 'morbidness', 'metaphysics of despair' or whatever term is used. Did they emphasize the 'subjective' in the format of Social Realist mural art of the 1930s in order to make a 'critical statement'? As we have seen, explicit Social Realism or any art which appeared obviously associated with a particular tendency had been discredited for the politically interested avant-garde because of its links with the failure of Communism and the Popular Front to withstand European Fascism. By painting large-scale 'abstract' works artists in the forties can also be seen to have been interested in a public convention and so to be demonstrating their rejection of the small-scale precious art object – the traditional consumable commodity of the bourgeoisie. This is to see Greenberg's 'Crisis of the Easel Picture'[42] in terms other than formalist, and to consider the possible social meaning of Pollock's belief that 'the time is not yet ripe for a *full* transition from easel to mural'.

The work done by Guilbaut, by the Shapiros and by other historians not represented here contributes to our understanding of the social, political, cultural and artistic conditions not only of the production of Abstract Expressionism but also of the elaboration of Modernist critical theory and its role in the ratification of Abstract Expressionism in ways which misrepresented its causal conditions. Orton and Pollock analyse the context in which Greenberg's early writings had the 'effect of clearing a space' in a specific ideological terrain. In doing so they claim that Greenberg offered a 'special sense of group identity for some painters' and defined 'a function for a specific kind of painting' – Abstract Expressionism.

Modernism may be seen as the ideology of particular class interests and institutional structures in the USA. These interests and structures are in part considered in this section, but it is primarily those texts by Kozloff, Cockcroft and the later part of the Schapiros' text which consider the 1950s when the Museum of Modern Art (MOMA), New York, adopted a promotion and ratification of Abstract Expressionism. Though it needs to be acknowledged that the material used and the arguments proposed are of a provisional nature. Not only were these essays produced in a critical climate which encouraged the critique of Modernism in terms either of innuendo or of reductionism, but also they reveal that competent

art-historical work as rigorous as that by social or political historians needed to be done. Examples such as work by Cox, de Hart Mathews, Guilbaut, Orton and Pollock have improved the competences of historians of art since the thirties. However, much still needs to be done.

Recent work on the 1930s and 1950s has been a prerequisite for anyone wishing to develop the schematic analyses of Kozloff and Cockcroft, and particularly the reductionism of the latter. This is not only so as to produce cogent history but also because we need to understand the role and power of such institutions as MOMA in order better to understand our own culture and history. For a good case can be argued that the histories of MOMA, as an institution, of contemporary art and of its Modernist history were intersected by other histories – the histories, for example, of class fraction and of imperialism. Almost as a ratification of Greenberg's claim in 'The Decline of Cubism' (1948), MOMA was involved in the 1950s in exporting Abstract Expressionism to Europe *and* in bringing it back home to New York, to MOMA, not only as 'the triumph of American painting' but also as the manifestation of *the* avant-garde form. This needed to be seen as the most recent, up-to-date and securely mapped position of the historically identifiable avant-garde 'mainstream' of modern art. For Greenberg the 'central' position of Abstract Expressionism was secured by the 'logic of Modernism', a self-fulfilling, and self-criticizing formal and aesthetic development. Between 1939 and 1961 Greenberg radically altered his view of 'relative autonomy'; by 1961 the crucial adjective had been stripped away. For the 'revisionists' the 'logic of Modernism' appears as the ideal projection of art representing the needs, desires, pleasures, aspirations and self-images of the literate hereditary bourgeoisie.[43]

There are problems in the projects tackled by those who are interested in critiques of Modernist histories and forms of explanation. A major one is the discussion of particular paintings, especially the characteristics of certain Pollocks. The problem is how to show that the wider issues discussed by these historians uncover meaning for and in Pollock's work. This general problem is discussed by T. J. Clark in Texts 3 and 5. To produce a cogent social history of art with respect to nineteenth-century artists and art practices is one thing, but to do the same with paintings seemingly devoid of explicit conventional subject matter or imagery is fraught with more pitfalls. Arguments which discuss 'resistance' and 'critical art' with respect to a drip painting need to be substantiated not only by strong evidence but also by adequate theory. The task is an extremely *difficult* one, not least because the language of description and explanation of Abstract Expressionism is so dominated by Modernist terms and references. Modest but well-theorized historical work needs to be produced.

Despite the limitations of some of the texts in this section they do chart a history of sorts – a history of resistance to Modernist dogma and ideology; a resistance which needs to address Modernism's strengths as an ideological force and as a theory which emphasizes the discipline of *relevance*. Yet, there is much material here which Modernists find extremely uncomfortable – as also in the books by Cox and by Guilbaut – and which extends the debates and competences of those critics of conventional Modernism who wish to establish a cogent historical

materialist account of modern art. We can learn from these articles by arguing with their premises, details and misconceptions. Unlike further elaborations of Modernism which close off inquiry, they can be seen to open up debate and contribute to our knowledge of the conditions in which artists such as Pollock and critics such as Greenberg produced forms of representation in the modern period, in an era of developed capitalism.

Notes

1 The Works Progress Administration (WPA), later called the Work Projects Administration, was part of President Roosevelt's 'New Deal' which aimed to stimulate national recovery and to provide a programme of work for those made unemployed as a result of the 'Great Depression'. Between 1935 and 1942 eight-and-a-half million people had worked on the WPA – one out of five able-bodied workers. The WPA's Federal Art Project (FAP) was started in 1935. It lasted until July 1943, and one of the main reasons for its winding up was recurrent criticism from conservatives in Congress who attacked what they called 'socialism' in the WPA. In fact the Dies Committee, which was similar to the anti-Communist McCarthy Committee of the Cold War, questioned members of Federal Project Number One about radical and Communist affiliations. The whole period of the WPA's life was fraught with such difficulties. Pollock joined the FAP's mural division (where some 2566 murals were produced) in 1935 and in 1936 moved to the easel division (where 108,099 works were produced). His allegiances at this time were to artists associated with the Mexican muralists (Orozco, Rivera, Siqueros) and with Communism, though his politics were probably an untheorized affiliation with the 'left' – a common position in the 1930s. The history and details of this whole period are complex politically, socially and culturally. The standard works are those by Francis V. O'Connor, *Federal Support for the Visual Arts: The New Deal and Now* (Greenwich, Conn., 2nd ed., 1971), and *Arts for the Millions: Essays from the 1930s by Artists and Administrators of the W.P.A. Federal Art Project* (Greenwich, Conn., 1973). Also see Greta Berman, *The Lost Years, Mural Painting in N.Y. City under the W.P.A. Federal Art Project 1935–1943* (Columbia University PhD, 1975; Garland Press, 1978).

2 The main articles are: Max Kozloff, 'American Painting During the Cold War', *Artforum*, **XI**, no. 9, May 1973, pp. 43–54 (see Text 6); William Hauptman, 'The Suppression of Art in the McCarthy Decade', *Artforum*, **XII**, no. 2, October 1973, pp. 48–52; Eva Cockcroft, 'Abstract Expressionism, Weapon of the Cold War', *Artforum*, **XII**, no. 10, June 1974, pp. 39–41 (see Text 7); John Tagg, 'American Power and American Painting: The Development of Vanguard Painting in the United States since 1945', *Praxis*, 1975, pp. 59–79; Jane de Hart Mathews, 'Art and Politics in Cold War America', *American Historical Review*, **81**, October 1976, pp. 762–787; Victor Burgin, 'Modernism in the *Work* of Art', *Twentieth Century Studies*, December 1976, no. 15/16, pp. 34–55; David and Cecile Shapiro, 'Abstract Expressionism: The Politics of Apolitical Painting', *Prospects*, **3**, 1977, pp. 175–214 (see Text 8); Serge Guilbaut, 'Création et développement d'une

Avant-Garde: New York 1946–1951', *Histoire et critique des arts*, 'Les Avant-Gardes', July 1978, pp. 29–48; Serge Guilbaut, 'The New Adventures of the Avant-Garde in America', *October*, **15**, Winter 1980, pp. 61–78 (see Text 9); Fred Orton and Griselda Pollock, '*Avant-Gardes* and Partisans Reviewed', *Art History*, **4**, no. 3, September 1981, pp. 303–327 (see Text 10); Frances K. Pohl, 'An American in Venice: Ben Shahn and American Foreign Policy at the 1954 Venice Biennale', *Art History*, **4**, no. 1, March 1981, pp. 80–113; T. J. Clark, 'Clement Greenberg's Theory of Art', *Critical Inquiry*, September 1982, **9**, no. 1, pp. 139–156 (see Text 3). Two major books are: Annette Cox, *Art-as-Politics: The Abstract Expressionist Avant-Garde and Society* (Ann Arbor, Michigan, UMI Research Press, 1982); Serge Guilbaut, *How New York Stole the Idea of Modern Art: Abstract Expressionism, Freedom, and the Cold War*, translated by Arthur Goldhammer (Chicago and London, The University of Chicago Press, 1983).

3 For a selection of his essays see Clement Greenberg, *Art and Culture: Critical Essays* (Boston, Beacon Press, 1961). See also his 'Modernist Painting', *Arts Yearbook*, **4**, 1961, pp. 109–116, reprinted in *Modern Art and Modernism: A Critical Anthology*, edited by Francis Frascina and Charles Harrison (London, Harper & Row, 1982, pp. 5–10); and his 'After Abstract Expressionism', *Art International*, **VI**, no. 8, October 1962, revised reprint in *New York Painting and Sculpture: 1940–1970*, edited by Henry Geldzhaler (London, Pall Mall Press Ltd, and New York, Metropolitan Museum of Art, 1969, pp. 360–371). For a sympathetic intellectual biography see Donald B. Kuspit, *Clement Greenberg: Art Critic* (Madison and London, The University of Wisconsin Press, 1979).

4 Alfred H. Barr Jr: such works as *Cubism and Abstract Art* (New York, The Museum of Modern Art, 1936); *Picasso: Fifty Years of His Art* (New York, The Museum of Modern Art, 1946); *Matisse: His Art and His Public* (New York, The Museum of Modern Art, 1951). John Rewald: such works as *The History of Impressionism* (New York, The Museum of Modern Art, 1946), and subsequent revised editions; *Post-Impressionism – From Van Gogh to Gauguin* (New York, The Museum of Modern Art, 1956), and subsequent revised editions.

5 Greenberg's criticism is paradigmatic, for example: 'Jackson Pollock was at first almost as much a late Cubist and a hard and fast easel-painter as any of the abstract expressionists I have mentioned . . . Pollock has an instinct for bold oppositions of dark and light, and the capacity to bind the canvas rectangle and assert its ambiguous flatness and quite unambiguous shape as a single and whole image concentrating into one the several images distributed over it. Going further in this direction, he went beyond late Cubism in the end'. ' "American-Type" Painting', *Partisan Review*, **XXII**, no. 2, Spring 1955, pp. 186–187. Reprinted in Frascina and Harrison (eds), op. cit., p. 97.

6 February 1967, pp. 14–22; March 1967, pp. 28–37; April 1967, pp. 18–31; May 1967, pp. 28–31.

7 Fogg Art Museum, Harvard University.

8 Ibid., pp. 4–5.

9 Ibid., p. 50, note 3.

10 Ibid., p. 14.

11 See Irving Sandler, *Abstract Expressionism: The Triumph of American Painting* (New York, Praeger, and London, Pall Mall Press, 1970); and his later *The New York School: The Painters and Sculptors of the Fifties* (New York and London, Harper & Row, 1978).

12 See Gabriel Kolko, *The Roots of American Foreign Policy* (Boston, Beacon Press, 1969) and his *Wealth and Power in America: An Analysis of Social Class and Income Distribution* (New York, Praeger, 1969); Gabriel and Joyce Kolko, *The Politics of War, 1943–45* (New York, Random House, 1968) and *The Limits of Power: The World and United States Foreign Policy* (New York, Harper & Row, 1972); Christopher Lasch, 'The Cultural Cold War: A Short History of the Congress for Cultural Freedom' in *Towards a New Past: Dissenting Essays in American History*, edited by Barton J. Bernstein (New York, Pantheon Books, 1968), and his *The New Radicalism in America: The Intellectual as a Social Type* (New York, Knopf, 1965), and his *The Agony of the American Left* (New York, Random House, 1968); Richard M. Freeland, *The Truman Doctrine and the Origins of McCarthyism* (New York, Schocken, 1971); Noam Chomsky, *American Power and the New Mandarins* (New York, Pantheon Books, 1969), and his *Problems of Knowledge and Freedom* (New York, Pantheon Books, 1971), and his *For Reasons of State* (New York, Pantheon Books, 1973).

13 See note 5.

14 See 'A Conversation with Greenberg' published in three parts in *Art Monthly*, February 1984, no. 73, pp. 3–9; March 1984, no. 74, pp. 10–14; April 1984, no. 75, pp. 4–6.

15 See the Kuhnian notion of paradigms in his *The Structure of Scientific Revolutions* (Chicago, The University of Chicago Press, 2nd edition, 1970) for a critique of such a view.

16 See, for example, the histories by: Daniel Aaron, *Writers on the Left* (Oxford, Oxford University Press, 1977, first published 1961); James Gilbert, *Writers and Partisans: A History of Literary Radicalism in America* (New York, John Wiley and Sons, 1968).

17 Annette Cox, op. cit., p. 142.

18 Given in the United States House of Representatives, 16 August 1949, *Congressional Record*, First Session, 81st Congress. On Dondero see Jane de Hart Mathews, op. cit., and William Hauptman, op. cit.

19 'The Cultural Cold War', loc. cit., pp. 322–323.

20 From a letter sent to the newspapers, including the *New York Times*, by the Federation on the occasion of their third show at the Wildenstein Gallery, June 2–26, 1943. Quoted in Guilbaut, *How New York Stole the Idea of Modern Art*, op. cit., pp. 73–74.

21 Op. cit., p. 306 *[168]*.

22 *Partisan Review*, **XV**, no. 1, p. 83.

23 See earlier discussion, p. 13ff.

24 Trotsky, *Literature and Revolution*, translated by Rose Strunsky (Ann Arbor Paperbacks, The University of Michigan Press, 1960), first English translation, 1925; Benjamin, 'The Author as Producer', address delivered at the Institute for the Study of Fascism, Paris, 27 April, 1934. First published in German in 1966, edited reprint of translation by Edmund Jephcott in Frascina and Harrison, op. cit., pp. 213–216.

25 Loc. cit., pp. 215–216.

26 See Guilbaut, *How New York Stole the Idea of Modern Art*, op. cit.
27 'The Present Prospects of American Painting and Sculpture', *Horizon*, London, **16**, nos. 93–94, October 1947, pp. 25–26.
28 Ibid., p. 28.
29 Ibid., p. 30.
30 'Jane Street Group, Rufino Tamayo', *Nation*, March 8, 1947, p. 284.
31 'The Situation at the Moment', loc. cit., p. 82.
32 'New York Painting Only Yesterday', *Art News,* **56**, Summer 1957, p. 58; material in parenthesis from the revised reprint titled 'The Late Thirties in New York', *Art and Culture*, op. cit., p. 230.
33 *Partisan Review*, **XV**, no. 3, March 1948, p. 369.
34 From a taped interview with William Wright, an East Hampton neighbour, who was planning a radio programme. Taped in 1950 it was broadcast for the first time on radio station WERI in Westerly, RI, in 1951. Quoted in Francis V. O'Connor and Eugene Victor Thaw (eds), *Jackson Pollock: A Catalogue Raisonné of Paintings, Drawings and Other Works, Vol. 4* (New Haven and London, Yale University Press, pp. 248–249).
35 Op. Cit., p. 43; see Text 6, p. 107.
36 Ibid., pp. 43–45; see Text 6, p. 108.
37 Ibid., p. 46; see Text 6, p. 112.
38 Catalogue by Greta Berman and Jeffrey Wechster published by Rutgers University, 1981.
39 See note 32.
40 See Guilbaut, Text 9.
41 Statement made in 1947 when applying for a Guggenheim Fellowship, quoted in O'Connor and Thaw, op. cit., p. 238.
42 *Partisan Review*, **XV**, no. 4, April 1948, pp. 481–484, reprinted in *Art and Culture*, op. cit., pp. 154–157.
43 See Text 11.

6 American Painting During the Cold War

Max Kozloff

More celebrated than its counterparts in letters, architecture, and music, American postwar art has become a success story that begs, not to be retold, but told freshly for this decade. The most recent as well as most exhaustive book on Abstract Expressionism is Irving Sandler's *The Triumph of American Painting*, a title that sums up the self-congratulatory mood of many who participated in its career. Three years ago, the Metropolitan Museum enshrined 43 artists of the New York School, 1940–1970, as one pageant in the chapter of its own centennial. Though elevated as a cultural monument of an unassailable but also a fatiguing grandeur, the virtues of this painting and sculpture will survive the present period in which they are taken too much for granted. Yet, if we seem to have explored everything about this art technically, we have not yet asked sufficiently well what past interests have made it so official.

The reputation of the objects themselves has been taken out of the art world's hands by money and media. But this accolade reflects rather than explains a social allure that has been far more seductive overall than even the marvelous formal achievements of the work. I am convinced that this allure stems from an equivocal yet profound glorifying of American civilization. We are not so careless as to assume that such an ideal was consciously articulated by artists, or, always directly perceived by their audiences. [. . .] Their international reputations should not preclude our acknowledgment that a Clyfford Still or a Kenneth Noland, an Andy Warhol or a Roy Lichtenstein, among many others are quintessentially American artists, more meaningful here than anywhere else. It is less evident, though reasonable that they have acquired their present blue-

Source: 'American Painting During the Cold War', *Artforum* vol. xi, no. 9, May 1973, pp. 43–54. This article is a somewhat revised version of the introduction to the catalogue of the exhibition *Twenty-five Years of American Painting 1948–1973* at the Des Moines Art Center, March 6th–April 22nd, 1973. This text has been edited. The original article included sixteen illustrations, all of which have been omitted. Reprinted by permission of the author and *Artforum*.

chip status partly through elements in their work that affirm our most recognizable norms and mores. For all the comment on the "triumph of American painting," this aspect of it has been the one least studied, a fact that in itself has historical interest.

If we are to account for this omission, and correct it, we are inevitably led to ask what, after all, can be said of American painting since 1945 in the context of American political ideology, national self-images, and even the history of the country? Such a question has not been seriously raised by our criticism, I think, for two reasons. One is the respectable but unproven suspicion that such an outlying context is too porous and nonexclusive for anything meaningful to be said. The other is the simplistic assumption that avant-garde art is in deep conflict with its social, predominantly middle-class setting. The liberal esthete otherwise variably critical of American attitudes, has been loathe to witness them celebrated in the art he admires, even though this is to subtract from its humanity as art. (The radical philistine correctly senses systems support in American art, but reads its coded signals far too crassly as direct statement.) Professional avant-garde ideology exhibits a great distaste for the mixing of political evaluations with artistic "purity." Yet modernist accolades dam up the continuing psychological resonance of American art and reinforce the outdated piety with which it is regarded.

Two facts immediately distinguish ambitious American painting from all predecessors in modern art. Before the Second World War, this country had exerted no earlier genuine leadership nor had it any significant cultural prestige in visual art. Distinguished painters were active – Georgia O'Keeffe, Mark Tobey, Edward Hopper, and Stuart Davis – but their example was considered too parochial in coloration, and thus too "unmodern" to provide models for mainstream work. The complete transformation of this state of affairs, the switching of the art capital of the West from Paris to New York, coincided with the recognition that the United States was the most powerful country in the world. In 25 years, no one could doubt that this society was determined from the first to use that power, economic and military, to extend it everywhere so that there would be no corner of the earth free from its influence. The most concerted accomplishments of American art occurred during precisely the same period as the burgeoning claims of American world hegemony. It is impossible to imagine the esthetic advent without, among several internal factors, this political expansion. The two phenomena offer parallels we are forced to admit, but may find hard to specify. Just as the nations of Western Europe were reduced to the level of dependent client and colonized states, so too was their art understood here to be adjunct, at best, to our own. Everywhere in the New York art world there were such easy assumptions of self-importance and natural superiority as not to find their match in any of the Western democracies. Never for one moment did American art become a conscious mouthpiece for any agency as was, say, the Voice of America. But it did lend itself to be treated as a form of benevolent propaganda for foreign intelligentsia. Many critics, including this one, had a significant hand in that treatment. How fresh in memory even now is the belief that American art is the sole trustee of the avant-garde "spirit," a belief so reminiscent of the U.S.

government's notion of itself as the lone guarantor of capitalist liberty. In these phenomena above all, our record ascribes to itself an incontrovertible "modernity." [. . .]

In 1945, the United States emerged intact and unbombed from a devastating world war that had left its allies traumatized and its enemies prostrate. We were a country, according to Dean Acheson, still at an adolescent stage of emotional development, yet burdened with vast adult responsibilities of global reconstruction and leadership.[1] Compared to Soviet Russia's overwhelming armed might on the ground, America possessed a terrifyingly counterweighted superweapon, the atomic bomb. We had also a heavy war industry whose reconversion to peacetime needs was being urged by public opinion and economic good sense.

In the worldview of the untried president, Truman, the European civil war had removed a buffer that had hitherto stood against the eruptive forces of Euro-Asiatic communism. Comparable to Axis enslavement, these forces clearly had no legitimate aim in establishing for themselves a security zone in Eastern Europe. Here was a situation that called for the stepping up rather than the relaxation of the American militancy that had just proved itself with such effectiveness in actual combat. It was necessary to alert the idealist spirit of the Americans to a new danger when they were feeling their first relief from war weariness and pleading for widespread demobilization. At Truman's disposal, significantly, were two important psychological levers: the recent illusion of national omnipotence, and the conviction, no less illusory, that all the world's peoples wanted to be, indeed had a right to be, like Americans. "We will lift Shanghai up and up, ever up, until it is just like Kansas City," a U.S. Senator once remarked.[2]

To galvanize such attitudes, and to justify the allocation of funds that would contain the communist menace, Truman dramatized world politics as a series of perpetual crises instigated by a tightly coordinated, monolithic Red conspiracy. He made his point graphically in Iran, Greece, Berlin, and eventually Korea. "It must be," he said, "the policy of the United States to support free peoples who are resisting subjugation by armed minorities or by outside pressures."[3] The Marshall Plan, Truman Doctrine, the Atlantic Alliance and Point Four, and above all, National Security Council paper 68 were measures, infused sometimes with extraordinary generosity and always with extreme boldness, to strengthen economies whose weakness made them vulnerable to "subjugation," and not incidentally to invest in their resources and to improve their position to buy American products, the better to ensure our political dominance. Thus when these activities were countered by the Russians, was initiated the era of mounting interventions, "atomic diplomacy," the arms race, and increasing international scares – the era known to us as the Cold War.

The generation of painters that first came of age during this period – whose tension, in retrospect, was so favorable to the development of all the American arts – felt united on two issues. They knew what they had to reject in terms of past idioms and mentality. At the same time, they were aware that achievement depended on a new and pervasive creative principle. Pollock, Still, Rothko, de Kooning, Newman, Gottlieb, and Gorky were prideful, enormously knowledge-

able men who had passed through the government-sponsored WPA phase of their careers and now knew themselves, no longer charity cases, to be cast out on their own. During and shortly after the war, they were still semi-underground personalities with first one-man shows ahead of them, although they were on the average forty years old. For them, regionalist painting, rigid geometric abstraction, and politically activist art were very infertile breeding grounds for new, breakthrough ideas. On the hostile American scene in general, they counted not at all.

In 1943 some of them contributed to a statement which, in part, reads:

> As a nation we are now being forced to outgrow our narrow political isolationism. Now that America is recognized as the center where art and artists of all the world meet, it is time for us to accept cultural values on a global scale.[4]

No doubt the remark reflects the personal and quite natural impact of the leaders of modern European art, temporarily present in New York as emigrés from the war. That their tradition had been blasted apart does not seem so much to have depressed as excited the Americans. Jealous understudies were preparing to take over the roles of those whom they considered failing stars. Above all, there was to be no convergence of immediate aims or repeating of European "mistakes," such as Surrealist illusionism or Neoplastic abstraction. Where artists like Léger and Mondrian deeply sympathized with the urban vitality of America, this was precisely the motif – especially in its accent on machined rhythms – that the Abstract Expressionists thought deadening to the human soul and had to escape.

It is remarkable that art searching to give form to emotional experience immediately after the most cataclysmic war in history should have been completely lacking in overt reference to the hopes or the absurdities of modern industrial power. These Americans were neither enthusiasts of the modern age nor nihilist victims of it. None of them had been physically involved in the great bloodletting. The violence and exalted, tragic spirit of their work internalized consciousness of the war and found a striking synthesis in expressive brushwork contained by increasingly generalized and reductive masses. Theirs came also to be a most spacious, enveloping art, its spontaneity or sheer willfulness writ large and innocent of the mockery and despair, the charnel elements in such Europeans of their own generation as Francis Bacon and Jean Dubuffet, whose works flared with atrocious memories.

The native rhetoric, rather, was an imperious toughness, a hardboiled aristocracy. In 1949, William Baziotes wrote: "when the demagogues of art call on you to make the social art, the intelligible art, the good art – spit on them and go back to your dreams. . . ."[5] All the ideas of the New York School were colored by antagonism to the practical mind, not as to some disembodied attitude, but as an inimically lowbrow and literalist obstacle to an authentic understanding of their work in America. Nothing was more irrelevant and foreign to their conception of terror in the world than American "knowhow," exactly at the moment when that "knowhow" was to provide a backup in concerted U.S. tactics of saber-rattling.

On the contrary, in choosing primitive icons from many cultures, Southwest

Indian or Imperial Roman, for example, they attempted to find "universal" symbols for their own alienation. Their art was suffused with totems of atavistic faith raised in protection of man against unknowable, afflicting nature.

Yet, it was as if their relish for the absolute inextricably blended with the demands of the single ego, claiming solidarity with the pioneering modernism of European art, and compensating for the inability to establish contact with social experience. Robert Motherwell was the only one among them to express written regrets on this score. The modern artists "value personal liberty because they do not find positive liberties in the concrete character of the modern state."[6] Not being able to identify with debased social values, they paint only for their colleagues, even if this is to condemn them to formalism remote from

> a social expression in all its public fullness . . . Modern art is related to the problem of the modern individual's freedom. For this reason the history of modern art tends at certain moments to become the history of modern freedom.[7]

In a very curious backhanded way, Motherwell was by implication honoring his own country. Here, at least, the artist was allowed, if only through indifference, to be at liberty and to pursue the inspired vagaries of his own conscience. Elsewhere in the world, where fascist or communist totalitarianism ruled, or where every energy had been spent in fighting them, the situation was otherwise. Modern American art, abandoning its erstwhile support for left-wing agitation during the '30s, now self-propagandized itself as champion of eternal humanist freedom. [. . .]

It is impossible to escape the impression that the simple latitude they enjoyed as artists became for this first generation, part of the necessary content of their work, a theme they reiterated with more intensity, purpose, and at greater length than in any other prior movement. Where Dadaism, a postwar art 30 years earlier, had utilized license for hilarious disdain, the New Yorkers charged "freedom" with a new, sober responsibility, even with a grave sense of mission. Each of their creative decisions had to be supremely exemplary in the context of a spiritual privilege denied at present to most of their fellow men. "The lone artist did not want the world to be different, he wanted his canvas to be a world."[8] Here were radical artists who, at the very inception of their movement, purged themselves of the radical politics in their own background. They did this not because they perceived less domestic need for protest in the late '40s (on the contrary), but because serious politics would drain too much from the courage needed for their own artistic tasks. That they heroicized these tasks in a way suggestive of American Cold War rhetoric was a coincidence that must surely have gone unnoticed by rulers and ruled alike.

Information about these preceptors of American painting would be incomplete without dealing with their understanding of themselves as practitioners of the "sublime." "The large format, at one blow, destroyed the century-long tendency of the French to domesticize modern painting, to make it intimate. We replaced the nude girl and the French door with a modern Stonehenge, with a sense of the sublime and the tragic that had not existed since Goya and Turner."[9] Going further than even Motherwell here, stressing the need for an unqualified

111

and boundless art, beyond beauty and myth, Newman, personally a very thought-ful anarchist, wrote "We are reasserting men's natural desire for the exalted, for a concern with our relationship to the absolute emotions."[10] Hence was revealed the positive value, an inevitably doomed quest for unlimited power, to which painters of high resources bent their backs. Nothing less would satisfy them than the imposition of a roughhewn grand manner. Avant-gardes are not strangers to self-righteousness. And the unusual feature here was not the assertion of sovereignty over the French tradition, the claim that art history was now definitively being made on these shores – correct, as it turned out. It was, rather, the declaration of total moral monopoly, the separation of the tiny minority in possession of the absolute from the unwashed materialist multitudes.

To be sure, the question for sublimity invariably emerged as a call *against institutional authoritarianism and was always considered to be a meaningful gesture of defiance against repression.* "There," said Clyfford Still, speaking of his role in the '40s, "I had made it clear that a single stroke of paint, backed by work and a mind that understood its potency and implications, could restore to man the freedom lost in twenty centuries of apologies and devices for sub-jugation."[11] How one might relate such an overwrought mood to the prevailing fear of atomic destruction is a baffling and disturbing question.

Looking back on this issue, the art historian Robert Rosenblum saw it charac-teristically in art historical terms:

> . . . a quartet of the largest canvases by Newman, Still, Rothko, and Pollock might well be interpreted as a post-World War II myth of genesis. During the Romantic era, the sublimities of nature gave proof of the divine; today, such supernatural experiences are conveyed through the abstract medium of paint alone.[12]

Their affinity with, one would hesitate to call it a historical derivation from, the deserted, magniloquent, and awesome landscapes of Romantic painting obviously furthered nationalist overtones for these artists as well. By 1950, in none of the recently occupied and worn-out countries could there be painting of such naked, prepossessing self-confidence, such a metaphoric equation of the grandeur of one's homeland with religious veneration.

Still, it would misrepresent this art to call it internally assured. As the '50s wore on, it became evident that however original in pictorial style, American painters had emotional ties with the anxieties and dreads of French existen-tialism. It is true that they disengaged themselves from the typical Sartrean prob-lem of the translation of personal to political liberty, but they showed great concern for his notion that one is condemned to freedom, that the very necessity to create oneself, to give oneself a distinguishable existence, was a desperate, fateful plight.

> The tension of the private myth is the content of every painting of this vanguard. The act on the canvas springs from an attempt to resurrect the saving moment in his "story" when the painter first felt himself released from Value – myth of past self-recognition. Or it attempts to initiate a new moment in which the painter will realize his total personality – myth of future self-recognition.[13]

From a quite famous essay, "The American Action Painters," Harold Rosenberg's sonorous remarks were designed to reveal the heights to which the gestural side of our art aspired by indicating the precipices off which the psychology of gesture might easily fall. One false step, one divergence from the "real act," and you produced merely "apocalyptic wallpaper."

> In terms of American tradition, the new painters stand somewhere between Christian Science and Whitman's "gangs of cosmos." That is, between a discipline of vagueness by which one protects oneself from disturbance while keeping one's eyes open for benefits; and the discipline of the Open Road of risk that leads to the farther side of the object and the outer spaces of the consciousness.[14]

It is certain that however much they may have disagreed with these dialectics, painting, for the American vanguardists, was often an uncertain and obstacle-prone activity, rife with internal challenges to authentic feeling, in which, "As you paint, changing and destroying, nothing can be assumed."[15] Behind their bravado and machismo, a more authentically insecure note is sounded, a tingle of fear in the muscle, acknowledging the very real possibility of sudden failure, and with that, something far more serious indeed, loss of identity. False consciousness was a not so secret enemy within the artist's organism. Rosenberg's article itself ended with an attack on the taste bureaucracy, the enemy without, which was witlessly drawn to modern art for reasons of status, and could not grasp the morality of the quivering strokes for which his whole piece was a singular promotion.

During the '50s the world-policing United States experienced a series of checks and frustrations that made it both a more sobering and uneasy place in which to live. Washington launched policies on the basic assumption that a loss of face and U.S. backdown in any area of the globe, no matter how remote, would bring about an adverse shift in the balance of power. Even a local defeat would amplify our weakness, shake faith in our resolve, and leave countless nations exposed to our communist enemies. One tends to forget that the domino theory, with its paranoid vision, budded over 20 years ago. It was an era of confrontation. To meet trial and crisis, American bases hemmed in the Iron Curtain on every front, radar nets were extended at ever further remove from our boundaries, the nuclear arsenal was expanded, SAC B-52's flew stepped-up patrol missions, and the defense budget and the armaments industry grew at an accelerated pace. But American influence could not match American power, despite its offensive and defensive potential.

Events proved that we could no more cross the Yalu River with impunity than we could aid the Hungarians when they revolted against Soviet manipulation. Eisenhower's "New Look" depended on the deterrence of "massive retaliation," consistent with the idea that the presence of hyperdestructive weaponry could resolve issues beyond the reach of inadequate manpower in the field. But this concept did not lend itself to flexibility. The discrepancy between commanding rhetoric and the control of actual affairs proved so evident that a noxious climate of suspicion, jingoism, apathy, and megalomania envenomed the American atmosphere. "There are many depressing examples," writes Charles Yost,

of international conflicts in which leaders have first aroused their own people against a neighbor and then discovered to their chagrin that even when they judged the time had come to move toward peace, they were prisoners of the popular passions they had stimulated.[16]

Such was the situation that set the scattered American left in retreat and brought forth the full ire of right-wing criticism of government policy in the American '50s. This manifested itself in a fusillade of civil-rights suppressions, and quickly became exemplified by the choke of McCarthyism.

Liberal personalities in sensitive or influential positions were purged in an ever more promiscuous campaign to root out the cancer of supposed disloyalty. Superpatriots, in their intimidating cry, "Twenty years of treason," conceived that there was as much an internal danger to their ideal America as the foreign threat. A superiority complex began to impose upon American civilization a form of demagogic thought control, ever more sterile, rigid, and unreal, with particular animus against intellectuals of the Eastern variety, stigmatized as "eggheads." Ironically, Stevenson, the chief egghead, felt obliged when campaigning against Eisenhower, to accuse him of not doing enough to stop the communists.

It was in the interest of federal government to ward off the accusations that would undermine its credibility as a bona fide cold warrior.

> You have to take chances for peace, just as you must take chances in war. Of course we were brought to the verge of war. The ability to get to the verge without getting into war is the necessary art . . . If you try to run away from it, if you are scared to go to the brink, you are lost. We've had to look it square in the face. We took strong action.[17]

Thus, John Foster Dulles explaining his policy of brinksmanship. In this unwitting mockery of existential realism, such cliff-hanging willingness to gamble the fate of millions (as at Quemoy and Matsu), was naturally accompanied by a persistent negative pattern of action: the refusal to negotiate or instrument test-ban treaties and disarmament proceedings. Moreover, Dulles' ideology of risk, really a form of international "chicken," was steeped in the pieties of Christian faith, whose application, just the same, required "the necessary art." However, the atmosphere eventually became so nightmarish that the conservative Republican, Eisenhower, went to the summit with Krushchev, in tacit admission that a stalemate had been reached.

The "haunted fifties," as I. F. Stone called the decade, acted as a psychological depressant on the national consciousness. At Little Rock, the desperation of blacks became once more visible and stayed just as unrectified. Under the gospel of anticolonialism and defense of freedom, the United States was supporting a multitude of corrupt and petty dictators. For all our energy, growth, affluence, and progressiveness, the Pax Americana emerged as the chief banner of counter-revolution. Under the stupefying, stale impact of these contradictions, a whole college generation earned the title "silent," while others, no less conformist in their way, dropped out among the beats. Separated by only a very few years, there appeared William Whyte's *The Organization Man* and Paul Goodman's *Growing Up Absurd*. Mort Sahl could quip that the federal government lived in mortal fear

of being cut off without a penny by General Motors, a mild enough acknowledgement, during the plethora of sick jokes, of who was really in charge.

> In 1958, Dwight Macdonald submitted an article to *Encounter* – 'America! America!' – in which he wondered whether the intellectuals' rush to rediscover their native land (one of the obsessive concerns of the fifties, at almost every level of cultural life) had not produced a somewhat uncritical acquiescence in the American imperium.[18]

Encounter magazine, which rejected Macdonald's piece, was sponsored by the Congress for Cultural Freedom, all of whose branches were discovered, by the '60s, to be supported secretly by dummy foundations set up by the CIA. Here was a group of prominent Cold War intellectuals who

> had achieved both autonomy and affluence, as the social value of their services became apparent to the government, to corporations, and to foundations. . . . The modern state, among other things, is an engine of propaganda, alternately manufacturing crises and claiming to be the only instrument which can effectively deal with them. This propaganda, in order to be successful, demands the cooperation of writers, teachers, and artists not as paid propagandists or as state censored timeservers but as free intellectuals.[19]

It signifies a new sophistication in bureaucratic circles that even dense and technical work of the intelligentsia, as long as it was self-censoring in its professional detachment from values, could be used ambassadorially as a commodity in the struggle for American dominance.

If this country was unrivaled in industrial capacity and military might, it must follow that we had a culture of our own, too. One ought not, therefore, be surprised to see the fading away during the late '50s of the official conviction that modern art, however incomprehensible, was subversive. While conquering all worthwhile critics and curators on its home territory, in the process being imitated a hundredfold in every art department in the country, Abstract Expressionism had also acquired fame in the media and riches in the support of culturally mobile middle-class collectors. A second and even third generation of followers, many of them trained on the G.I. Bill or on Fulbright scholarships, had testified to the virility of its original principles. But this onslaught of acceptance, that so vitiated its proud alienation and so undermined its concept of inhospitable life in America, went far to traumatize the movement. It was at the point of a stylistic hesitation that the work of the Abstract Expressionists was sent abroad by official agencies as evidence of America's coming of creative age. Where the USIA had earlier capitulated to furious reaction from right-wing groups when attempting exhibitions of nonrepresentational art or work by " communist tinged" painters, it was now able to mount, without interference, a number of successful programs abetted and amplified by the International Council of The Museum of Modern Art. While the Museum played a pivotal role in making our painting accessible across the seas, private dealers had already initiated the export process as early as 1950. But, now it was to be the austere and eruptive canvases of the early masters, those lordly things, that came to European attention through well organized and publicized traveling shows. This occurred during one of the

repeated dips in America's image on the continent. Making much headway England and Germany, less in France and Italy, the *New American Painting*, as it was called in an important show of 1959, furnished out-of-date and over-simplified metaphors of the actual complexity of American experience.

At the risk of considerable schematization, I would say that the torments of the '50s had enervated and ground down the ideological faculty of the American artist. Never comfortable with manifestoes, he embarked now into an ironic, twisted, and absurdist "Neo-Dada," as it was at first known, or a distinctly impersonal, highly engineered chromatic abstraction. Significantly, neither of these modes pretended any philosophical or moral claims at all – the better, as it turned out, to *specify* sensations and appearances in the immediate environment. Technology had shown, with dazzling conviction, that means were more important than ends, and that in the vacuum of a society that was losing a sense of its goals, professionalism and specialization had utmost value. Now that their mentors had shown that American art could be "mainstream," members of the younger generation could release their pent-up fascination for their surroundings without fear of being taken – or sometimes even delighting in being taken – for regionalists. In this flattened ethical landscape, public information, often of the most trivial, alarming, or contradictory character, held almost cabalistic sway for a huge percentage of artists. [. . .] Art thinking, that had been yoked to one field theory for several years, now gave evidence of breaking into many differing spheres of ephemeral, specialized interest. [. . .]

Whether they expanded or restricted the flow of available information, the younger artists tended to adopt a morally neutral stand except to the absorbing studio tasks at hand. Discredited for them were the he-man clichés that once magnified the would-be potentials of art and that bespoke of thorough refusal to accommodate the artistic enterprise to the tastes of the bourgeois audience. In place of Olympian but self-pitying humanism, they insisted on functional attitudes and a cool tone. No longer, for instance, was there any agonizing over personal identity or spiritual resources, the bugbears of crisis-oriented Action painters. Without undue pangs of conscience, work got done almost on a production-line basis.

To speed this mythless art, the '60s provided the tempi of enthusiasm. McNamara's "cost effectiveness" and Kennedy's Youth Corps and Alliance for Progress seemed at the time a heady combination of objectives that would leave behind the embarrassment of Sputnik and the U-2 incident. A "can-do" mentality promised momentum away from the stagnation of the Republican years. Pledging to end a fictional missile gap, the new president also engendered plans for flexible counterinsurgency, created the Green Berets, and masterminded the Bay of Pigs fiasco. Politics became a theater of charismatic hardsell. Science in the universities became a colony of the defense industry. Contingency plans, doomsday scenarios, think tanks, the Velvet Underground, Cape Canaveral, the drug culture: all this hard- and software, to use terms coined during the period, bobbled together in that indigestible stew of sinister, campy, solid-state effluvia with which the American '60s inundated the world. In retrospect, there is a

moment when we can see that Herman Kahn, "thinking the unthinkable," and Andy Warhol, wishing that everyone were like a machine, participate in the same sensibility.

In the beginning, there was Jasper Johns and Robert Rauschenberg. The interest both these men had in the work of Marcel Duchamp and the composer John Cage, from the late '50s on, indicates a deflationary impulse, as far at least as serious, grand manner abstraction was concerned. But it is still a moot point whether the American flags of the one, or the images of Kennedy in the art of the other, were derisory in any social sense. These two artists took from Dada neither its scornful theater nor its lightsome subversions, but rather its malleability, even its ambivalence. The absence in their work of any hierarchical scheme, either of subject or formal relation, was, in any event, far less malign than in Dada. Part of the difference may be explained by the fact that the American polity, unlike the sprawling chaos of the early European interregnum, maintained a high ratio of stability to prosperity. The possibilities of the sardonic were limited in a country whose youth, more and more during these years, was oriented to scientific careerism.

"What does he love, what does he hate?" asked Fairfield Porter of Johns. "He manipulates paint strokes like cards in a patience game."[20] Time and again, the note struck in his work, and that of Rauschenberg, is of a fascinated passivity. It fell to these brilliant Southerners to materialize the slippage of facts from one context to another, the possibilities inherent in the blurring of all definitions, the mutually enhancing collision of programmed chance and standard measurement. And all this was understood in the larger mental simulacrum of a game structure in which, not the potentials, but the deceits of form became the main issue. Theirs was an intellectual response that acknowledged pointlessness by making a subject out of it. They found in the numbness that afflicted any sensitive citizen agog before the disjunctive media stimuli of his world, a source of iconic energy. Instead of an arena of subjective human reflexes and editorialized sentiment, dominated with allusions to man and his space, they conjured a plane laden with neutralized objects or images of objects.

The commercial success of the Pop artists, legatees of Johns and Rauschenberg, is bound up for us, at its inception in 1962 as it is now, with their commercial subjects and styles. There was repeated all over again the controversy that Realist incursions into high art, like Courbet's, had originally provoked. The greatest heat was generated by the question: "Is any of this material esthetically transformed?" However, this time there was no socialist creed to add fuel to the debate – only an objectivity that seemed a mask for the celebration of what everyone, even the artists themselves, admitted to be the most abrasive images in the American urbanscape. Pop symptomized, more than it contributed to, an age noted for visual diarrhea. In that charged atmosphere around the time of the Cuban missile crisis of 1962, the "New Realist" show at the Sidney Janis Gallery deceived some into thinking that a political statement, in accord with their views or not, had been decreed in American art. If anything, however, its omission of any political *parti pris*, in contrast to its highly flagrant themes of crimes, sex, food, and violence gave Pop art the most insurrectionary value. Few

people could speak coolly about it at all.

One of the exceptions over a long period, Lawrence Alloway, later wrote:

> As an alternative to an aesthetic that isolated visual art from life and from the other arts, there emerged a new willingness to treat our whole culture as if it were art . . . It was recognized in London for what it was ten years ago, a move towards an anthropological view of our society . . . the mass media were entering the work of art and the whole environment was being regarded, reciprocally, by the artists as art, too.[21]

In contrast, Ivan Karp, who dealt in their works, pleaded the case of Warhol, Rosenquist, and Lichtenstein under the banner "Sensitivity is a bore." "Common Image Art," as he called it,

> is downright hostile. Its characters and objects are unabashedly egotistical and self-reliant. They do not invite contemplation. The style is happily retrograde and thrillingly insensitive . . . It is too much to endure, like a steel fist pressing in the face.[22]

The worship of brutality and the sociology of popular media as legitimate art folklore, both these attitudes, early and recent, add to rather than distort the record of the movement. For Pop art was simultaneously a tension-building and relieving phenomenon. It processed many of the most encroaching, extreme, and harsh experiences of American civilization into a mesh of grainy rotogravure or a phantasm taken from the dotted pulsations on the face of a cathode tube. Lichtenstein's *Torpedo Los*, cribbed from a comic about a Nazi sub commander, was placed with jokey topicality in the era of Polaris submarines. Here was an art that could shrewdly feed on the Second World War while keeping present, and yet assuaging, the fears of the Cold War.

On the national level, during those early years of the '60s, events were most confused. Under Kennedy the social scene had become relatively enlightened, style conscious, and permissive, with chic and fey undergrounds rivaling the White House court. [. . .] Meanwhile, Harvard professors were industriously planning strategy that would inaugurate ten years of mayhem in Vietnam. Culturally there ensued a kind of literate bad faith, the camp attitude, which was never so bitter as cynicism nor so unsophisticated as to allow for moral judgments. It became a necessary emotional veneer for audiences to feel removed from, yet assimilate with full indulgence of their hyped, insolent glamor, impulses, events and objects they knew to be hideous and depraved. For having discovered this formula in art, Pop was instantly acculturated and coopted by the mass media upon which it preyed.

The immense publicity and patronage these artists enjoyed was surely no put-on. The masses at large had at last found an avant-garde sensation which they could appreciate quite justifiably on extraesthetic grounds, while its esoteric origins lent piquancy to its appeal. If it had not already had rock music, a whole younger generation could have learned the disciplines of mod cool from Pop art alone. As could never be with Abstract Expressionism, Pop artists and their clients mutually manipulated each other. There were high dividends of com-

munications feedback and product promotion that were difficult to overlook, especially during the epoch when consumership was based almost entirely on style, and packaging had tacitly nothing to do with the value of goods received. Yet the upper bourgeois collectors who boosted Pop art with such adventurism were genuine enthusiasts.

The stereotype that they were parvenu vulgarians on a taste level with the images they so vocally adored, has to be modified under analysis. It is true that some of them were self-made men of nouveau-riche status, but this does not distinguish them at all from the field of the postwar monied in America. Professional or in business, most of them had seriously collected the Abstract Expressionists a few short years before. Pop art, oddly enough, given its exaltation of the standardized, but also explainably, considering its glorification of success, flattered their sense of individualism. Moreover, "Now middle-aged or older, they identify the pop movement with their children's generation. To own these works, they feel, is to stay young."[23] Perhaps an even more telling consideration was the excitement this art suffused in them as an absolutely up-to-the minute visual phenomenon, a condition they often interpreted by crowding out even their furniture with a plethora of Pop works that could no longer be looked at singly, but had to be taken in montage fashion, with that nonlinear, noncontemplative élan of the trendy Marshal McLuhan.

The Pop artist behaved with aplomb as a celebrity in the New York art world. Such an elevation to stardom, the while he was compelled to behave as a rising businessman, gave to the artist a recognizably new psychology. It was in a spirit of realism that Allan Kaprow, speaking generally of many different studio types, described what he thought were their relevant traits in a much-read article of 1964, "Should the Artist Become a Man of the World?" Kaprow had discerned not only the collapse of Bohemia, and that "the artist could no longer succeed by failing," but that he was a college trained, white collar bourgeois himself, who resembled the "personnel in other specialized disciplines and industries in America."[24] Best then, to make a moral adjustment and engage in the politics of *culture*, for avoiding it is never to know whether one has proven oneself in "the presence of temptation or simply run away."[25] Kaprow managed to make accommodation to the prevailing cultural powers sound still a heroic task (a very clever insinuation), though it was probably an involuntary *fait accompli*. An echo of Abstract Expressionist high-mindedness lurked in this argument. He admonished the new artists that "Political awareness may be all men's duty, but political expertise belongs to the politician. As with art, only the full-time career can yield results" – a separatist line strikingly reminiscent of one taken by Rosenberg and Motherwell in 1948! And yet, as against this, Claes Oldenburg could draw very opposite conclusions three years later: "You must realize cops are just you and I in uniform . . . Art as life is murder . . . Vulgar USA civilization now beginning to interfere my art."[26]

The Kaprow article was published close in time to the Gulf of Tonkin resolution. In that same year, the dealer Leo Castelli printed an ad in *Art International* showing a map of Europe with little flags indicating shows by his artists in various cities, an unsubtle anticipation of victory at that summer's Venice Biennale.

Earlier, Kennedy had come to see that domestic and third world liberties might not exactly flourish under a United States garrison mentality. He gave signs of lessening Cold War pressures, of curbing the CIA, and of ending racial discrimination in jobs. The August 1963 March on Washington, at which Martin Luther King spoke – "I have a dream" – symbolized the unappeased punishing inequity of the blacks. It was to herald, along with the Free Speech movement and student rebellion at Berkeley, the eruptions of the gathering New Left, all the protests, war sit-ins, strikes, guerrilla politics and peace vigils to come. After Kennedy had been killed, the nostalgic flavor of Pop art and the entertainment media in general became particularly evident, as if depiction of the present had all the heart go out of it.

The Pop artists became sporadically active on the fringe of dissent. Sometimes supported by their elders, they contributed to CORE, to many peace causes and moratoria against the Vietnam war. Rosenquist's extraordinary *F-111* could be read [. . .] as an indictment of United States militarism. [. . .] Rauschenberg secretly financed much of the Artists' Peace Tower against the war in Los Angeles in 1965. But he also celebrated the triumph of American space flight technology, the trip to the moon, for NASA in 1969.

The truth was that Pop art, whatever the angered political sentiments of its creators, was a mode captured by its own ambiguities, and cranked up willy-nilly to express benign sentiments. It could not have been Pop art, that beguiling invention, if its latencies of critique had not been sapped by its endorsement of business. Abroad, this flirtatious product of the "Great Society" was framed with maximum panache. At our lavish installation at the 1967 São Paulo Biennial, Hilton Kramer reported that "such a display of power cannot avoid carrying political implications in an international show . . . Some observers here, including the commissioners of the other national sections, have been quite vocal in condemning what they regard as an excessive display of wealth and chauvinism."[27] Under the tutelage of the National Collection of Fine Arts, Pop art could symbolize a continuing American freedom, but one whose supermarkets and synthetics had roosted in a score of different economies, and had come to speak above all of glut and complacency.

An entirely different kind of freedom was prefigured by the ultracompetitive color-field and systemic abstractionists of the '60s. One sees in the art of Stella, late Louis, Noland, Kelly, Irwin, Poons, and Olitski, an institutionalized counterpart of Pop, polarized with regard to it more in idiom than the mechanized style they both shared. But where Pop was timely and expansive, these artists upheld the timeless and the reductive. The symbolic values latent in such abstraction aspired to a vision of limitless control and ultimate, inhuman perfectibility (which was also a particular aspect of '60s America). The computer and transistorized age of corporate technology achieved in its striped and serialized emblems, its blocks or spreads of radiant hues, an acrylic metaphor of unsettling power.

Never, in modern art, had such a "purist" enterprise been deployed without recourse to utopian or "futurist" justifications, and it was perhaps because of its very muteness on this point that color-field abstraction now seems to us, in terms of American self-imagery on the world scene, the stick behind the carrot.

The antiseptic surfacing, the compressed, two-dimensional designing, the optical brilliance, and the gigantism of this art's scale, invoke a far more mundane awe than the sublime. And yet, no one can categorize the sources that stimulated this openness of space, or say of such painting that it refers to a concrete experience. Nothing interferes with the efficient plotting of its structure – in fact, efficiency itself becomes its pervasive ideal. The strength, sometimes even the passion of this ideal, rescues the best of this work from the stigma of the decorative, but only to cause it all the more to seem the heraldry of managerial self-respect.

It would not be irrelevant that during this time, the conglomerate executives with their lobbyists and bankers, through the efforts of their technical elites, had achieved an unprecedented hold on the economy. "While in the realm of pure logic, a Federal Power Commission in Washington might tell Standard Oil of California what it might or might not do, in actual fact such an agency is less powerful than the corporation . . . This is the politics of capitalism."[28] It is fruitful to suppose that this diffused, invisible, but immensely consequential reality, with its subtle manipulations, would find some correspondence in the sensitized zone of capitalist art. As Pop art spoke best to the entrepreneurial collector, so expensive-looking color-field abstraction blazoned the walls of banks, board-rooms, and those corporate fiefs, the museums. Never as literally readable or cosmetic as Pop, this art had more appropriately chaste and hierarchical overtones whose stripped functioning materialized a code that was more intuitively grasped than rationally comprehended. No deciphering of the conventions of art was necessary for the corporate homage of this art to come across to its patrons. In that sense, though without subject in a strict iconographical sense, it was self-sufficient expressively, and by 1964, no later, immediately meaningful as a consumed signifier.

There is another, larger dimension in which it made itself felt, as well. America had become ugly, fouled with industrial wastes, and split with divisive forces. As Norman Mailer put it:

> America was torn by the specter of civil war, and many a patriot and many a big industrialist – they were so often the same – saw the cities and the universities as a collective pit of Black heathen, Jewish revolutionaries, a minority polyglot hirsute scum of nihilists, hippies, sex maniacs, drug addicts, liberal apologists and freaks. Crime pushed the American public to give birth to dreams of order. Fantasies of order had to give way to lusts for new order. Order was restraint, but new order would call for a mighty vault, an exceptional effort, a unifying dream.[29]

Without so intending, American abstraction of the '60s strikes us as the visual anagram of these "lusts for new order." There is something understandable, very contemporary, and also chilling in the spectacle this new art offered. As a psychedelic poster for a whiz-bang at Fillmore East had its definite constituency, so chromatic abstraction would solace those in upper echelons who could not abide the inertial tugs and the irate spasms in the overheated ghettos of our national life.

None of this, however, can be assumed to have occupied the artists' conscious minds while at work. The gap between their own technical motives, the demiurge

of form pursued for its own sake, and the rarefied prestige their art conferred upon its backers, does not seem to have occasioned any comment among them – nor did it have to. On the contrary, they had been socially insulated by a critical framework – an explanation of purpose and a means of analysis – called formalism. The ineffable criterion of this doctrine, the word "quality," was sparingly applied to those works which were considered to have advanced the possibilities of radical innovation in painting while maintaining vital contact with its tradition. The artists had to contend with professional standards – none outside formalism were allowable – that were at once more ambitious and yet more conservative than those in the business world. These standards were also nakedly authoritarian, but if nervous-making on that score, they at least assured a seemingly objective superiority to those that had met them.

It is curious that the word "quality," though more abstract in connotation than, say, "risk," is more onerous and arrogant in implication. One went through a rite of passage, a rigorously imposed set of limitations that took the place of any moral stance, and yet arrogated to itself a historical mission. The enemy here was not the defunct School of Paris, but upstart "far-out" American competitors. Clement Greenberg, critic emeritus of formalism, was an intellectual Cold Warrior who traveled during the '60s under government sponsorship to foreign countries with the good news of color-field's ascendance. This message, however, proved to be less noteworthy abroad than in our university art departments, where the styles of Noland and Olitski were perpetuated with a less than becoming innocence.

Meanwhile, if political agitation on the left failed to stir these masters (Stella excepted), the more attenuated, parodistic elements of late Pop sidled into their work. There had been finally less antagonism between them than hitherto supposed. But then, the determination of American art in general to draw nourishment from its environment has been one of its most natural yet underestimated features. Long after the war, our artists were still participating in the vitality of American experience, but they also had a taste of something darker and more demonic within it, the pathology of oppression. This was an awareness that has come increasingly to motivate their social unrest. Toward the end of this development, the time and space of the art of the '60s having run their course, as had the work of the two preceding decades, the Metropolitan Museum accorded it a giant retrospective, with all the honor that venerable establishment is capable of giving. But compared to the projections of fear and desire which underlies our art, that honor, a kind of imperial bearing in state, now looks insignificant indeed.

Notes

1 Dean Acheson, in a conversation with the author at the Aspen Institute for Humanistic Studies, Aspen, Colorado, Summer, 1966.
2 Quoted in Stephen Ambrose, *Rise to Globalism*, Baltimore, 1971, p. 118.
3 Quoted by Barton Bernstein, "The Limitations of Pluck," *The Nation*, January 8, 1973, p. 40.

4 Quoted by Edward Alden Jewell, *The New York Times*, June 6, 1943, in Irving Sandler, *The Triumph of American Painting*, New York, 1970, p. 33.

5 Quoted in *New York School, The First Generation*, Los Angeles County Museum of Art, 1965, p. 11.

6 Robert Motherwell, "The Modern Painter's World," *Dyn VI*, 1944, quoted in Barbara Rose, *Readings in American Art Since 1900*, New York, 1968, pp. 130–131.

7 Motherwell, ibid.

8 Harold Rosenberg, "The American Action Painters," *Art News*, September, 1952, p. 37.

9 Max Kozloff, "An Interview with Robert Motherwell," *Artforum*, September, 1965, p. 37.

10 Barnett Newman, "The Ideas of Art," *Tiger's Eye*, December 15, 1948, p. 53.

11 Clyfford Still, "An Open Letter to an Art Critic," *Artforum*, December, 1963, p. 32.

12 Robert Rosenblum, "The Abstract Sublime," *Art News*, February, 1961, p. 56

13 Rosenberg, p. 48.

14 Rosenberg, ibid.

15 Philip Guston in "Philadelphia Panel," *It Is*, Spring, 1960, p. 34.

16 Charles Yost, *The Conduct and Misconduct of Foreign Affairs*, New York, 1972, quoted by James Reston in *The New York Times*, January 14, 1973.

17 John Foster Dulles, *Look* magazine, January, 1956, quoted in Ambrose, p. 225.

18 Christopher Lasch, "The Cultural Cold War," *Towards A New Past: Dissenting Essays in American History*, ed. Barton Bernstein, New York, 1969, p. 331.

19 Lasch, pp. 344–345.

20 Fairfield Porter, "The Education of Jasper Johns," *Art News*, February, 1964, p. 44.

21 Lawrence Alloway, "Popular Culture and Pop Art," *Studies in Popular Communication*, Panthe Record 7, 1969, p. 52.

22 Ivan Karp, "Anti-Sensibility Painting," *Artforum*, September, 1963, p. 26.

23 William Zinsser, *Pop Goes America*, New York, 1969, p. 24.

24 Allan Kaprow, "Should the Artist Become a Man of the World?," *Art News*, October, 1964.

25 Kaprow, ibid.

26 Claes Oldenburg, "America: War & Sex, Etc.," *Arts Magazine*, Summer, 1967.

27 Hilton Kramer, "Art: United States' Exhibition Dominates São Paulo's 9th Biennial," *The New York Times*, September 20, 1967.

28 Andrew Hacker, *The End of the American Era*, New York, 1970, p. 68.

29 Norman Mailer, *Of A Fire On The Moon*, New York, 1971, p. 65.

7 Abstract Expressionism, Weapon of the Cold War

Eva Cockcroft

To understand why a particular art movement becomes successful under a given set of historical circumstances requires an examination of the specifics of patronage and the ideological needs of the powerful. During the Renaissance and earlier, patronage of the arts went hand in hand with official power. Art and artists occupied a clearly defined place in the social structure and served specific functions in society. After the Industrial Revolution, with the decline of the academies, development of the gallery system, and rise of the museums, the role of artists became less clearly defined, and the objects artists fashioned increasingly became part of a general flow of commodities in a market economy. Artists, no longer having direct contact with the patrons of the arts, retained little or no control over the disposition of their works.

In rejecting the materialistic values of bourgeois society and indulging in the myth that they could exist entirely outside the dominant culture in bohemian enclaves, avant-garde artists generally refused to recognize or accept their role as producers of a cultural commodity. As a result, especially in the United States, many artists abdicated responsibility both to their own economic interests and to the uses to which their artwork was put after it entered the marketplace.

Museums, for their part, enlarged their role to become more than mere repositories of past art, and began to exhibit and collect contemporary art. Particularly in the United States, museums became a dominant force on the art scene. In many ways, American museums came to fulfill the role of official patronage – but without accountability to anyone but themselves. The U.S. museum, unlike its European counterpart, developed primarily as a private institution. Founded and supported by the giants of industry and finance, American museums were set up on the model of their corporate parents. To this day they are governed largely by self-perpetuating boards of trustees composed

Source: 'Abstract Expressionism, Weapon of the Cold War', *Artforum*, vol. xii, no. 10, June 1974, pp. 39–41. Reprinted by permission of the author and *Artforum*.

primarily of rich donors. It is these boards of trustees – often the same "prominent citizens" who control banks and corporations and help shape the formulation of foreign policy – which ultimately determine museum policy, hire and fire directors, and to which the professional staff is held accountable. Examination of the rising success of Abstract Expressionism in America after World War II, therefore, entails consideration of the role of the leading museum of contemporary art – The Museum of Modern Art (MOMA) – and the ideological needs of its officers during a period of virulent anticommunism and an intensifying "cold war."

In an article entitled "American Painting During the Cold War," published in the May, 1973, issue of *Artforum*, Max Kozloff pointed out the similarity between "American cold war rhetoric" and the way many Abstract Expressionist artists phrased their existentialist-individualist credos. However, Kozloff failed to examine the full import of this seminal insight, claiming instead that "this was a coincidence that must surely have gone unnoticed by rulers and ruled alike." Not so.

Links between cultural cold war politics and the success of Abstract Expressionism are by no means coincidental, or unnoticeable. They were consciously forged at the time by some of the most influential figures controlling museum policies and advocating enlightened cold war tactics designed to woo European intellectuals.

The political relationship between Abstract Expressionism and the cold war can be clearly perceived through the international programs of MOMA. As a tastemaker in the sphere of contemporary American art, the impact of MOMA – a major supporter of the Abstract Expressionist movement – can hardly be overestimated. In this context, the fact that MOMA has always been a Rockefeller-dominated institution becomes particularly relevant (other families financing the museum, although to a lesser extent than the Rockefellers, include the Whitneys, Paleys, Blisses, Warburgs, and Lewisohns).

MOMA was founded in 1929, mainly through the efforts of Mrs. John D. Rockefeller, Jr. In 1939, Nelson Rockefeller became president of MOMA. Although Nelson vacated the MOMA presidency in 1940 to become President Roosevelt's coordinator of the Office of Inter-American Affairs and later assistant secretary of state for Latin American affairs, he dominated the museum throughout the 1940s and 1950s, returning to MOMA's presidency in 1946. In the 1960s and 1970s, David Rockefeller and Mrs. John D. Rockefeller, 3rd, assumed the responsibility of the museum for the family. At the same time, almost every secretary of state after the end of World War II, right up to the present, has been an individual trained and groomed by the various foundations and agencies controlled or managed by the Rockefellers. The development of American cold war politics was directly shaped by the Rockefellers in particular and by expanding corporations and banks in general (David Rockefeller is also chairman of the board of Chase Manhattan Bank, the financial center of the Rockefeller dynasty).

The involvement of The Museum of Modern Art in American foreign policy became unmistakably clear during World War II. In June, 1941, a Central Press wire story claimed MOMA as the "latest and strangest recruit in Uncle Sam's

defense line-up." The story quoted the Chairman of the Museum's Board of Trustees, John Hay Whitney, on how the Museum could serve as a weapon for national defense to "educate, inspire, and strengthen the hearts and wills of free men in defense of their own freedom."[1] Whitney spent the war years working for the Office of Strategic Services (OSS, predecessor of CIA), as did many another notable cold warrior (e.g., Walt Whitman Rostow). In 1967, Whitney's charity trust was exposed as a CIA conduit (*New York Times*, February 25, 1967). Throughout the early 1940s MOMA engaged in a number of war-related programs which set the pattern for its later activities as a key institution in the cold war.

Primarily, MOMA became a minor war contractor, fulfilling 38 contracts for cultural materials totalling $1,590,234 for the Library of Congress, the Office of War Information, and especially Nelson Rockefeller's Office of the Coordinator of Inter-American Affairs. For Nelson's Inter-American Affairs Office, "mother's museum" put together 19 exhibitions of contemporary American painting which were shipped around Latin America, an area in which Nelson Rockefeller had developed his most lucrative investments – e.g., Creole Petroleum, a subsidiary of Standard Oil of New Jersey, and the single most important economic interest in oil-rich Venezuela.

After the war, staff from the Inter-American Affairs Office were transferred to MOMA's foreign activities. René d'Harnoncourt, who had proven himself an expert in the organization and installation of art exhibits when he helped American Ambassador Dwight Morrow cultivate the Mexican muralists at the time Mexico's oil nationalism threatened Rockefeller oil interests, was appointed head of the art section of Nelson's Office of Inter-American Affairs in 1943. A year later, he was brought to MOMA as vice-president in charge of foreign activities. In 1949, d'Harnoncourt became MOMA's director. The man who was to direct MOMA's international programs in the 1950s, Porter A. McCray, also worked in the Office of Inter-American Affairs during the war.

McCray is a particularly powerful and effective man in the history of cultural imperialism. He was trained as an architect at Yale University and introduced to the Rockefeller orbit through Rockefeller's architect Wallace Harrison. After the war, Nelson Rockefeller brought McCray into MOMA as director of circulating exhibits. From 1946 to 1949, while the Museum was without a director, McCray served as a member of MOMA's coordinating committee. In 1951, McCray took a year's leave of absence from the Museum to work for the exhibitions section of the Marshall Plan in Paris. In 1952, when MOMA's international program was launched with a five-year grant of $625,000 from the Rockefeller Brothers Fund, McCray became its director. He continued in that job, going on to head the program's expanded version, the International Council of MOMA (1956), during some of the most crucial years of the cold war. According to Russell Lynes, in his comprehensive new book *Good Old Modern: An Intimate Portrait of the Museum of Modern Art*, the purpose of MOMA's international program was overtly political: "to let it be known especially in Europe that America was not the cultural backwater that the Russians, during that tense period called 'the cold war,' were trying to demonstrate that it was."

MOMA's international program, under McCray's directorship, provided exhibitions of contemporary American art – primarily the Abstract Expressionists – for international exhibitions in London, Paris, São Paulo, and Tokyo (it also brought foreign shows to the United States). It assumed a quasi-official character, providing the "U.S. representation" in shows where most nations were represented by government-sponsored exhibits. The U.S. Government's difficulties in hand-ling the delicate issues of free speech and free artistic expression, generated by the McCarthyist hysteria of the early 1950s, made it necessary and convenient for MOMA to assume this role of international representation for the United States. For example, the State Department refused to take the responsibility for U.S. representation at the Venice Biennale, perhaps the most important of international-cultural-political art events, where all the European countries including the Soviet Union competed for cultural honors. MOMA bought the U.S. pavilion in Venice and took sole responsibility for the exhibitions from 1954 to 1962. This was the only case of a privately owned (instead of government-owned) pavilion at the Venice Biennale.

The CIA, primarily through the activities of Thomas W. Braden, also was active in the cold war cultural offensive. Braden, in fact, represents once again the important role of The Museum of Modern Art in the cold war. Before joining the CIA in 1950 to supervise its cultural activities from 1951 to 1954, Braden had been MOMA's executive secretary from April 1948 to November 1949. In defense of his political cultural activities, Braden published an article "I'm Glad the CIA is 'Immoral'," in the May 20, 1967 issue of *Saturday Evening Post*. According to Braden, enlightened members of the governmental bureaucracy recognized in the 1950s that "dissenting opinions within the framework of agree-ment on cold-war fundamentals" could be an effective propaganda weapon abroad. However, rabid anticommunists in Congress and the nation as a whole made official sponsorship of many cultural projects impracticable. In Braden's words, ". . . the idea that Congress would have approved of many of our projects was about as likely as the John Birch society's approving medicare." As the 1967 exposés revealed, the CIA funded a host of cultural programs and intellectual endeavors, from the National Student Association (NSA) to *Encounter* magazine and innumerable lesser-known "liberal and socialist" fronts.

In the cultural field, for example, CIA went so far as to fund a Paris tour of the Boston Symphony Orchestra in 1952. This was done, according to Braden, to avoid the severe security restrictions imposed by the U.S. Congress, which would have required security clearance for every last musician in order to procure official funds for the tour. "Does anyone think that congressmen would foster a foreign tour by an artist who has or had had left-wing connections?" Braden asked in his article to explain the need for CIA funding. The money was well spent, Braden asserted, because "the Boston Symphony Orchestra won more acclaim for the U.S. in Paris than John Foster Dulles or Dwight D. Eisenhower could have bought with a hundred speeches." As this example suggests, CIA's purposes of supporting international intellectual and cultural activities were not limited to espionage or establishing contact with leading foreign intellectuals. More crucially, CIA sought to influence the foreign intellectual community and to present a

strong propaganda image of the United States as a "free" society as opposed to the "regimented" communist bloc.

The functions of both CIA's undercover aid operations and the Modern Museum's international programs were similar. Freed from the kinds of pressure of unsubtle red-baiting and super-jingoism applied to official governmental agencies like the United States Information Agency (USIA), CIA and MOMA cultural projects could provide the well-funded and more persuasive arguments and exhibits needed to sell the rest of the world on the benefits of life and art under capitalism.

In the world of art, Abstract Expressionism constituted the ideal style for these propaganda activities. It was the perfect contrast to "the regimented, traditional, and narrow" nature of "socialist realism." It was new, fresh and creative. Artistically avant-garde and original, Abstract Expressionism could show the United States as culturally up-to-date in competition with Paris. This was possible because Pollock, as well as most of the other avant-garde American artists, had left behind his earlier interest in political activism.[2] This change was manifested in the organization of the Federation of Modern Painters and Sculptors in 1943, a group which included several of the Abstract Expressionists. Founded in opposition to the politically motivated Artists Congress, the new Federation was led by artists who, in Kozloff's words, were "interested more in aesthetic values than in political action." On the one hand, the earlier political activism of some of the Abstract Expressionists was a liability in terms of gaining congressional approval for government-sponsored cultural projects. On the other hand, from a cold warrior's point of view, such linkages to controversial political activities might actually heighten the value of these artists as a propaganda weapon in demonstrating the virtues of "freedom of expression" in an "open and free society."

Heralded as the artistic "coming of age" of America, Abstract Expressionist painting was exported abroad almost from the beginning. Willem de Kooning's work was included in the U.S. representation at the Venice Biennale as early as 1948. By 1950, he was joined by Arshile Gorky and Pollock. The U.S. representation at the Biennales in São Paulo beginning in 1951 averaged three Abstract Expressionists per show. They were also represented at international shows in Venezuela, India, Japan, etc. By 1956, a MOMA show called "Modern Art in the U.S.," including works by 12 Abstract Expressionists (Baziotes, Gorky, Guston, Hartigan, de Kooning, Kline, Motherwell, Pollock, Rothko, Stamos, Still, and Tomlin), toured eight European cities, including Vienna and Belgrade.

In terms of cultural propaganda, the functions of both the CIA cultural apparatus and MOMA's international programs were similar and, in fact, mutually supportive. As director of MOMA's international activities throughout the 1950s, Porter A. McCray in effect carried out governmental functions, even as Braden and the CIA served the interests of the Rockefellers and other corporate luminaries in the American ruling class. McCray served as one of the Rockefellers' main agents in furthering programs for the export of American culture to areas considered vital to Rockefeller interests: Latin America during the

war, Europe immediately afterwards, most of the world during the 1950s, and – in the 1960s – Asia. In 1962–63, McCray undertook a year's travel in Asia and Africa under the joint auspices of the State Department and MOMA. In October, 1963, when Asia had become a particularly crucial area for the United States, McCray left MOMA to become director of the John D. Rockefeller 3rd Fund, a newly created cultural exchange program directed specifically toward Asia.

The U.S. Government simply could not handle the needs of cultural imperialism alone during the cold war, at least overtly. Illustrative of the government's problems were the 1956 art-show scandals of the USIA – and the solution provided by MOMA. In May, 1956, a show of paintings by American artists called *Sport in Art*, organized by *Sports Illustrated* for USIA, was scheduled to be shown in conjunction with the Olympic Games in Australia. This show had to be cancelled after strong protests in Dallas, Texas, where the show toured before being sent abroad. A right-wing group in Dallas, the Patriotic Council, had objected to the exhibition on the grounds that four of the artists included had once belonged to communist-front groups.

In June, 1956, an even more serious case of thought censorship hit the press. The USIA abruptly cancelled a major show of American art, "100 American Artists." According to the June 21 issue of the *New York Times*, this show had been planned as "one of the most important exhibits of American painting ever sent abroad." The show was organized for USIA by the American Federation of Arts, a nonprofit organization based in New York, which refused to cooperate with USIA's attempt to force it to exclude about ten artists considered by the information agency to be "social hazards" and "unacceptable" for political reasons. The Federation's trustees voted unanimously not to participate in the show if any paintings were barred by the Government, citing a 1954 resolution that art "should be judged on its merits as a work of art and not by the political or social views of the artist."

Objections against censorship were also raised by the American Committee for Cultural Freedom (which was revealed as receiving CIA funds in the 1967 exposés). Theodore Streibert, Director of USIA, testifying before Senator Fulbright's Foreign Relations Committee, acknowledged that USIA had a policy against the use of politically suspect works in foreign exhibitions. The USIA, as a government agency, was handcuffed by the noisy and virulent speeches of right-wing congressmen like Representative George A. Dondero (Michigan) who regularly denounced from the House floor abstract art and "brainwashed artists in the uniform of the Red art brigade." As reported on June 18, 1956, by the *New York Times*, Fulbright replied: "unless the agency changes its policy it should not try to send any more exhibitions overseas."[3]

The Rockefellers promptly arranged a solution to this dilemma. In 1956, the international program of The Museum of Modern Art was greatly expanded in both its financial base and in its aims. It was reconstituted as the International Council of MOMA and officially launched six months after the censorship scandal of USIA's "100 American Artists" show. MOMA's newly expanded role in representing the United States abroad was explained by a *New York Times* article of December 30, 1956. According to the *Times*,

The government is leery of anything so controversial as art and hampered by the discreditable interference on the part of some politicians who are completely apathetic to art except when they encounter something really significant ... Some of the immediate projects which the Council is taking over financially are United States participation in three major international art exhibitions and a show of modern painting to travel in Europe.

This major show of American painting was produced two years later by MOMA's International Council as "The New American Painting," an elaborate traveling exhibition of the Abstract Expressionists. The exhibition, which included a comprehensive catalogue by the prestigious Alfred H. Barr, Jr., toured eight European countries in 1958–59. Barr's introduction to the catalogue exemplified the cold war propaganda role of Abstract Expressionist art.

Indeed one often hears Existentialist echoes in their words, but their "anxiety," their commitment, their "dreadful freedom" concern their work primarily. They defiantly reject the conventional values of the society which surrounds them, but they are not politically engagés even though their paintings have been praised and condemned as symbolic demonstrations of freedom in a world in which freedom connotes a political attitude.

As the director of MOMA from its inception until 1944, Barr was the single most important man in shaping the Museum's artistic character and determining the success or failure of individual American artists and art movements. Even after leaving MOMA's directorship, Barr continued to serve as the Museum's reigning tastemaker. His support of Abstract Expressionist artists played an influential role in their success. In addition to his role at MOMA, Barr was an artistic advisor to Peggy Guggenheim, whose Surrealist-oriented Art of This Century Gallery gave some of these artists their first important shows in the mid-1940s. For example, Peggy Guggenheim's gallery offered one-man shows to Jackson Pollock in 1943, 1945, 1947, Hans Hofmann in 1944, Robert Motherwell in 1944, and Mark Rothko in 1945. Barr was so enthusiastic about the work of the Abstract Expressionists that he often attended their informal meetings and even chaired some of their panel discussions at their meeting place, The Club, in New York City.

Barr's "credentials" as a cultural cold warrior, and the political rationale behind the promotion and export of Abstract Expressionist art during the cold war years, are set forth in a *New York Times* Magazine article Barr wrote in 1952, "Is Modern Art Communistic?," a condemnation of "social realism" in Nazi Germany and the Soviet Union. Barr argued in his article that totalitarianism and Realism go together. Abstract art, on the other hand, is feared and prohibited by the Hitlers and Stalins (as well as the Donderos of the world, who would equate abstraction with communism). In his battle against the ignorant right-wing McCarthyists at home, Barr reflected the attitudes of enlightened cold warriors like CIA's Braden and MOMA's McCray. However, in the case of MOMA's international policies, unlike those of CIA, it was not necessary to use subterfuge. Similar aims as those of CIA's cultural operations could be pursued openly with the support of Nelson Rockefeller's millions.

Especially important was the attempt to influence intellectuals and artists

behind the "iron curtain." During the post-Stalin era in 1956, when the Polish government under Gomulka became more liberal, Tadeusz Kantor, an artist from Cracow, impressed by the work of Pollock and other abstractionists which he had seen during an earlier trip to Paris, began to lead the movement away from socialist realism in Poland. Irrespective of the role of this art movement within the internal artistic evolution of Polish art, this kind of development was seen as a triumph for "our side." In 1961, Kantor and 14 other nonobjective Polish painters were given an exhibition at MOMA. Examples like this one reflect the success of the political aims of the international programs of MOMA.

Having succeeded so handsomely through MOMA in supporting the cold war, Nelson Rockefeller moved on, in the 1960's, to launch the Council of the Americas and its cultural component, the Center for Inter-American Relations. Funded almost entirely by Rockefeller money and that of other American investors in Latin America, the Council advises the U.S. Government on foreign policy, even as does the older and more influential Council on Foreign Relations (headed by David Rockefeller, the CFR is where Henry Kissinger began his rise to power). The Center for Inter-American Relations represents a thinly veiled cultural attempt to woo back respect from Latin America in the aftermath of the Cuban Revolution and the disgraceful Bay of Pigs and Missile Crisis incidents. In its Park Avenue offices of a former mansion donated by the Rockefeller family, the Center offers exhibits of Latin American art and guest lectures by leading Latin American painters and intellectuals. Like the John D. Rockefeller 3rd Fund for Asia, the Center is yet another link in a continuing and expanding chain of Rockefeller-dominated imperialism.

The alleged separation of art from politics proclaimed throughout the "free world" with the resurgence of abstraction after World War II was part of a general tendency in intellectual circles towards "objectivity." So foreign to the newly developing apolitical milieu of the 1950s was the idea of political commitment – not only to artists but also to many other intellectuals – that one social historian, Daniel Bell, eventually was to proclaim the postwar period as "the end of ideology." Abstract Expressionism neatly fits the needs of this supposedly new historical epoch. By giving their painting an individualist emphasis and eliminating recognizable subject matter, the Abstract Expressionists succeeded in creating an important new art movement. They also contributed, whether they knew it or not, to a purely political phenomenon – the supposed divorce between art and politics which so perfectly served America's needs in the cold war.

Attempts to claim that styles of art are politically neutral when there is no overt political subject matter are as simplistic as Dondero-ish attacks on all abstract art as "subversive." Intelligent and sophisticated cold warriors like Braden and his fellows in the CIA recognized that dissenting intellectuals who believe themselves to be acting freely could be useful tools in the international propaganda war. Rich and powerful patrons of the arts, men like Rockefeller and Whitney, who control the museums and help oversee foreign policy, also recognize the value of culture in the political arena. The artist creates freely. But his work is promoted and used by others for their own purposes. Rockefeller, through Barr and others at the Museum his mother founded and the family con-

trolled, consciously used Abstract Expressionism, "the symbol of political freedom," for political ends.

Notes

1 Cited in Russell Lynes, *Good Old Modern*, New York, 1973, p. 233.
2 For Pollock's connections with the Communist Party see Francis V. O'Connor, *Jackson Pollock*, New York, 1967, pp. 14, 21, 25, and Harold Rosenberg, "The Search for Jackson Pollock," *Art News*, February, 1961, p. 58. The question here is not whether or not Jackson Pollock was, in fact, affiliated with the Communist Party in the 1930s, but, simply, if there were enough "left-wing" connections to make him "politically suspect" in the eyes of right-wing congressmen.
3 For a more complete history of the right-wing offensive against art in the 1950s and the role of Dondero, see William Hauptman, "The Suppression of Art in the McCarthy Decade," *Artforum*, October, 1973, pp. 48–52.

8 Abstract Expressionism: The Politics of Apolitical Painting

David and Cecile Shapiro

> Abstract art was the main issue among the painters I knew in the late thirties. Radical politics was on many people's minds, but for these particular artists Social Realism was as dead as the American Scene. (Though that is not all, by far, that there was to politics in those years: some day it will have to be told how "anti-Stalinism," which started out more or less as "Trotskyism," turned into art for art's sake, and thereby cleared the way, heroically, for what was to come.) – CLEMENT GREENBERG, "The Late Thirties in New York," 1957, 1960, *Art and Culture* (Boston: Beacon Press, 1961).

I

[. . .] in the 1930s a group of left-wing artists in the United States attempted to effect a radical change in artists' self-concepts and in the work they produced. As Marxists they argued that art could and should serve ideological ends, as it had in the past, and in order to discuss and promote ways of achieving political art – art with a "message" – they organized themselves into groups such as the John Reed Clubs and the American Artists Congress.

The John Reed Clubs especially, led by members of the Communist party, sought to change the entire structure of the art world, not solely the work produced; they wanted to revamp its goals, ideology, and patrons, with the medieval or Renaissance systems as the models. In the new case, of course, it was the worker organizations, rather than the Church, that were to be patrons. Their art was intended to inform, educate, and radicalize the worker – and it was to be paid for by the trade unions. The artist, indeed, was to be educated at art schools oriented

Source: Prospects 3 (ed.) Jack Salzman, 1977, pp. 175–214. This text has been edited and footnotes have been renumbered. The original article included twelve illustrations, all of which have been omitted. Reprinted by permission of the authors. © David and Cecile Shapiro.

toward these same unions. Art, then, was to be by and for the working class. Not only was its content to be proletarian; it was to be readily understood by its patron, the ordinary working man, a stance that immediately suggests an aesthetic. Museums and art schools, as they then existed, were to be shunned – at least in theory – since art was to be redirected along revised class lines. Instead of serving as a luxury product for the pleasure of the upper classes and the affluent bourgeoisie, as it had been and continues to be in industrial capitalism, art was to be at the service of the working class.

This movement, known as Social Realism, became one of the leading art movements of the 1930s, if not the most prominent. Among the artists subscribing to some or all of its tenets were Philip Evergood, William Gropper, and Ben Shahn.[1] Also important and influential during the 1930s were such regionalist painters as Thomas Hart Benton, John Steuart Curry, and Grant Wood, whose art expressed their belief that true American values resided in the Midwest and who hoped to attract their audience there.[2] Although the Regionalists, too, were critical of the art world – the museums, the gallery system, the critics, and European influences – they never called for the overthrow of the system under which the art world functioned. A third group, organized as the American Abstract Artists, which included such painters as George L. K. Morris, Burgoyne Diller, and Carl Holty, worked in the European mode developing from Matisse, Braque, and Picasso, and they attempted to secure greater acceptance for their aims and their art within the framework of the existing art-world system, even to the extent of picketing the infant Museum of Modern Art for neglect. Perhaps the largest single group among American artists during the 1930s were those subsumed under the name American Scene, artists like Reginald Marsh, Peter Hurd, Paul Sample, and Dale Nichols who painted landscapes and genre scenes representing all areas of the country in works that often aimed at bolstering their concept of American values, particularly those perceived as threatened by the struggle to survive the Great Depression. There were yet other painters, quite independent on the whole, of any of these groups – such as Arthur Dove, Georgia O'Keefe, and even Charles Burchfield and Edward Hopper – who continued during these years of economic and world crisis to paint on their own in individual and highly personal manners, less at odds with the art world than hopeful of change, struggling in the meantime to survive and work.

An astonishingly large percentage of the artists painting during the 1930s were at one time or another associated with the federal government's arts projects. As such, many of them joined the Artists Union, which, like any other union, was involved with such matters as working conditions, pay, and job security. For the first time in centuries large numbers of artists were active within an economic organization – the union – that immediately connected them with one another and with the larger society.[3] To this degree these outsiders became insiders like everyone else – the federal government was their patron-employer, their fellow employees the peers with whom they shared self-interest. This unique situation, born of the Depression, was also the stimulant for the art organizations sponsored by the Communist party. Each of the other groups – the Regionalists, the American Scene painters, and the Abstract Artists – polemicized as well, with

the result that there was unprecedented political, social, and aesthetic ferment among artists.[4]

Government patronage helped to develop a new audience. Murals, for instance, were painted in post offices and other public buildings, frequently on themes that deferred to the needs and history of the community. The WPA arts projects distributed large numbers of paintings, prints, and sculpture to such public organizations as schools and museums. (Many of these were so undervalued that they were destroyed or allowed to disappear, but renewed interest in the period has now uncovered important caches.) Adult education art classes, commonplace today, had their beginnings on the projects. Museums showing WPA work reached hitherto untapped audiences.[5] It might readily be argued that the growth of the art audience so widely noticed in the 1960s and 1970s had its origin in the activities of the 1930s.

This, in sum, was the state of the art world in 1939, when Clement Greenberg published his brilliant and prescient essays, "Avant-Garde and Kitsch" in the *Partisan Review*, a magazine that had broken with its Stalinist, Communist party origins early on to become by the fall of 1939 the leading Marxist, Trotskyist intellectual journal in the United States. Scarcely noticed at the time of publication, but soon to be widely read and discussed, this essay can be considered the manifesto and program for the art movement known today as Abstract Expressionism. Moreover, although nowhere is American art of the 1930s specifically derogated, the essay in our view is a direct response to and attack on the then current schools of American art, particularly Social Realism, and it is an attack which arises as much from political considerations as aesthetic ones, albeit, in this case the two are indeed one. Greenberg, furthermore, as will be detailed below, may have arrived at the ideas expressed in this essay, from his understanding of Leon Trotsky's theories of culture,[6] in much the same way that the Social Realists arrived at their ideas from interpretations of cultural developments and ideology in the Soviet Union, from Lenin and Stalin, and from discussions among Communist writers and theoreticians elsewhere.

Greenberg's contention, in "Avant-Garde and Kitsch," is that artists in our Western culture, instead of academically repeating themselves in the decaying present, have produced something previously unheard of: "avant-garde culture."[7] [. . .]

The avant-garde represents the opposite of the kitsch; kitsch is the rear guard; it is debased. Kitsch is the "product of the industrial revolution which urbanized the masses of Western Europe and America and established what is called universal literacy." In the past, culture belonged to those who had leisure and literacy. "But with the introduction of universal literacy the ability to read and write became a minor skill like driving a car," making it more difficult to "distinguish an individual's cultural inclinations, since it was no longer the concomitant of refined tastes."

Kitsch is the devalued, watered-down version of high culture, repetitive and self-evidently academic, Greenberg writes. It takes different forms in different

countries, so that it can be found in Soviet Russia, where the masses have been "conditioned to shun 'formalism' and to admire 'socialist realism.' " [. . .] Kitsch is synthetic; it imitates life. Avant-garde art, on the other hand, is a new creation. It adds new forms of life. It is by definition difficult. Its difficulty guarantees that the masses will shun it and the elite will support it. The reaction of the audience becomes a litmus test of the art. "Avant-Garde and Kitsch," then, denies as high art all the dominant forms and styles of American art in the 1930s and serves as a guide toward the forms for which it issues a call.

Whatever else is true of Greenberg's essay [. . .] by making the enjoyment of recondite, hermetic art a cultural test, the avant-garde became attractive, a barrier to be overcome, for those with upwardly mobile aspirations. Who wants to be left standing outside the gardens of the elite? Who can admit to not understanding, if to do so were to cause one to be tagged "uncultured"? Unlikely as this was to have been Greenberg's intentional effect, the 1939 essay, as well as subsequent ones expanding and reinforcing the argument, plus the presence and influence of the critic among the artists with whom he was acquainted and to whose work he responded personally and in print, led to Greenberg's position as the grand guru of Abstract Expressionism – one who frequently could make as well as break reputations by means of public discussions or private introductions.

Just a year before Greenberg's piece appeared, Leon Trotsky and André Breton had published an essay, also in the *Partisan Review*, that the younger writer is unlikely to have missed, although at the time he may not have known its true authorship, since this was not publicly revealed until much later. The portions Greenberg seems to have adopted and expanded include the argument against

> those who would regiment intellectual activity in the direction of ends foreign to itself, and prescribe, in the guise of so-called "reasons of state," the themes of art. The free choice of these themes and the absence of all restrictions on the range of his explorations – these are the possessions which the artist has a right to claim as inalienable. In the realm of artistic creation, the imagination must escape from all constraint and must, under no pretext, allow itself to be placed under bonds. To those who would urge us, whether for today or tomorrow, to consent that art should submit to a discipline which we hold to be radically incompatible with its nature, we give a flat refusal, and we repeat our deliberate intention of standing by the formula: *complete freedom for art*.[8]

If, Trotsky and Breton write, "the revolution must build a *socialist* regime with centralized control, to develop intellectual creation an *anarchist* regime of individual liberty should from the first be established. No authority, no dictation, not the least trace of orders from above!"

Trotsky and Breton's lines against "themes" in art can be seen as preliminary to Greenberg's suggestion that the avant-garde artist turn away from subject matter of common experience. His idea that art cannot be reduced to anything not itself, a commonplace in literary criticism, is another way of saying that art cannot be *reduced* to its theme. [. . .] His expression of the need of the avant-garde to create something "new" in a sense quite different from Platonic mimesis – and radically

different from anything that had existed before in American art – can also be interpreted as a way of escaping from constraint, as Trotsky advised. The meshing of these ideas can be read as the initial formulation of the theory of Abstract Expressionism.

If Greenberg expanded the germ of Trotsky's idea of "complete freedom for art" into the basis for Abstract Expressionism, the second influential theoretician and spokesman was Harold Rosenberg. His seminal essay, "American Action Painters," appeared in *Art News* in 1952, when the movement was sweeping all before it.[9] It was in this article that Rosenberg made his now famous remark that "what was to go on canvas was not a picture but an event." Although the line invites parody, such as Mary McCarthy's quip that you can't hang an event on the wall, its meaning is clear enough when one grants that Rosenberg is saying that it is the act – or the event – of making a picture that takes precedence over what lines or colors or images appear on the resulting object. [. . .]

If the picture is an act, however, "it cannot be justified as an act of genius in a field whose whole measuring apparatus has been sent to the devil." The work of art depends not on the "psychologically given" but on the "intentional," which translates it into a " 'World' – and thus transcends it." The role the artist plays now is all important, as is the way he "organizes his emotional and intellectual energy as if he were in a living situation." The big moment came, Rosenberg says, when the artist "decided to paint. . . . Just to paint, the gesture on the canvas was a gesture of liberation, from Value – political, aesthetic, moral."

It may be worth suggesting at this point that the act of repudiating political, moral, and aesthetic values becomes, willy-nilly, an aesthetic both political and moral. In the context of its time it is easy to read Rosenberg as aiming his fire at three specific targets: at the Social Realists, who were "political"; at the Regionalists and American Scene painters, who were "moral"; and at the American Abstract Artists, who were "aesthetic."

The artist was not, Rosenberg continued in "American Action Painters," to defy or condemn society. Such quotidian matters left him "diffident." Rather than change the world, the artist made the canvas into a world. By liberating himself from the reality outside the canvas, the artist liberated himself from "nature, society, and art already there." [. . .] Since the art cannot be communicated, and the painting "is not an object nor the representation of an object nor the analysis or impression of it nor whatever else a painting has ever been," what has it become? A trademark, Rosenberg answers. The artist "has made himself into a commodity with a trademark," and this commodity "informs the populace that a supreme Value has emerged in our time, the Value of the NEW."

From somewhat different approaches and in different terms, both Greenberg and Rosenberg seem to agree that the artist must be freed from discipline, from the past, and from the public world for subject or even connection. Most especially, both believe in the "new."

It is not difficult to posit a link between the cultivation of the perpetually new in art and Trotsky's theory of permanent revolution. This new art, too, is to overthrow that which has gone before. For Greenberg the new art must be dif-

ficult enough to shut out all but an elite; for Rosenberg the intention of self-exploration is what counts. To both the image is anathema – for Greenberg not in and of itself, but simply because it is "easy"; for Rosenberg because it is a leash that yanks the artist out of his private world into the public one. Greenberg says that the cream of the rich, educated class will support the new art; Rosenberg implies something similar for an art with which, he says, even an elite cannot communicate, since the image itself has little significance, reduced as it is to a trademark evoking the artist's name and recording an adventure with paint. How the audience was to distinguish quality within these criteria is not explained – habitually in his essays Greenberg simply *feels* that one piece is superior to another, that the differences in quality are so immediately apparent that there is not much point in discussing them with anyone who does not instantaneously perceive them as he does. Rosenberg grants at the outset that questions of quality do not enter into the matter because they are irrelevant to the intentions and execution of this new kind of painting, since all standards have been programmatically thrown out of the studio. "Beauty" and "truth," and other such discarded mistresses, have never even been invited to sit on the studio couch.

Yet despite their restricted philosophic and aesthetic baggage – and despite certain leaps out of logic – the two essays became programs for the artists whom they championed, so much so that those artists explaining themselves and their works frequently sounded like quotations from one or another of the two critics. Curiously, however, within this symbiotic relationship between the artists and the critics, there was a constant whine that nobody loves us but us. Or to be more precise, both the artists who were working in the Abstract Expressionist mode and the critics who supported them complained early and late about their neglect, their lack of recognition and support in the art world. But the real case was quite the contrary: not only were the Abstract Expressionists recognized early and widely; they were so strongly promoted and dispersed by the art establishment that to an unprecedented degree, and for more than a decade, they effectively routed other stylistic and philosophic expressions in American painting.

II

As early as 1948, when few of the first generation of Abstract Expressionists had yet had the opportunity for more than one or two solo shows in the new mode, when reviews of this kind of art were thought to merit little more than the standard couple of inches in serious journals or the art magazines, *Life* magazine, then in its heyday with probably the largest circulation in America, devoted pages of text and pictures to a symposium held in the penthouse of the Museum of Modern Art.[10] The participants were fifteen internationally known critics, connoisseurs, museum curators, and directors, among them Clement Greenberg, Meyer Schapiro (associate professor of art at Columbia University), Francis Henry Taylor (then head of the Metropolitan Museum of Art), Raymond Mortimer (a British art critic), George Duthuit (editor of *Transition* and a French critic), H. W. Janson (professor of art at Washington University in St. Louis), Alfred

Frankfurter(editor and publisher of *Art News*), A. Hyatt Mayor(curator of prints at the Metropolitan Museum), James Thrall Soby (curator of paintings at the Museum of Modern Art), and James Johnson Sweeney (who directed many exhibitions at the Museum of Modern Art and elsewhere, and in the same year became an advisory editor of the *Partisan Review*). (All of the identifying titles above refer to 1948.)

The participants discussed modern art in general and works by Picasso, Braque, Matisse, and Rouault in particular, but they especially focused on the new paintings by Jackson Pollock, Willem de Kooning, Adolph Gottlieb, and William Baziotes. A long report of their by no means unanimous views, simplified for the unsophisticated reader, was interspersed among generous color reproductions of the works under discussion, most of them owned by the Museum of Modern Art. No movement given this kind of mass-media coverage within less than a decade of its birth can make too great a case for neglect, for even if the magazine was read largely by those whom Greenberg, as well as more latitudinarian observers, might dub "uncultured," the willingness of these top-level art people to devote time to a public consideration of Abstract Expressionism suggests that the movement was taken seriously in high places.

Earlier, a number of "little" magazines friendly to Abstract Expressionism – among them *Possibilities* (edited by Robert Motherwell with John Cage and Harold Rosenberg and lasting for only one highly influential issue), *Tiger's Eye*, and *Modern Artists in America* – had begun to publish articles and reproductions of work in the new style. The first large-circulation art magazine to become sympathetic to Abstract Expressionism was the *Magazine of Art* (now defunct but then under the powerful auspices of the American Federation of Art), which, between 1948 and 1951, "ran features on de Kooning, Still, Motherwell, Rothko, Pollock, and Gorky. . . . During the 1950s, *Art News* was more sympathetic toward Abstract Expressionism than any other publication. In 1948 a monograph on Hans Hofmann was published, the first on an Abstract Expressionist. It accompanied a retrospective of his painting held at the Addison Gallery of American Art in Andover, Massachusetts(the first major one-man show given by a museum to an Abstract Expressionist). . . . Other books that dealt seriously with the Abstract Expressionists were James Thrall Soby's *Contemporary Painters* (1948); John I. H. Baur's *Revolution and Tradition in Modern American Art*, and Andrew C. Ritchie's *Abstract Painting and Sculpture in America*, both published in 1951. In that year also there appeared the first general book to feature the Abstract Expressionists, [Thomas B.] Hess's *Abstract Painting*."[11]

In 1949 Denys Sutton wrote a major piece, "The Challenge of American Art," for *Horizon* (the English magazine published in London). Sutton, then visiting professor at Yale University, introduced the European community to some of the concepts of the new mode, supported many of its claims, and suggested that it was "a symbol of youth, adventure, and liberation."[12]

As to exhibitions, neither in galleries offering work for sale nor in museums did the Abstract Expressionists languish. Between 1946 and 1951 the Betty Parsons, the Samuel Kootz, the Charles Egan, and the Peggy Guggenheim Art of

this Century Gallery "exhibited the Abstract Expressionists in show after show. During the six seasons, for example, Pollock had seven one-man exhibitions; Rothko and Hofmann six; Gottlieb, Baziotes, Reinhardt, and Motherwell, five; Still, four; de Kooning, three; Newman and Franz Kline, two. Taken together, these shows made a strong impression on fellow artists and the art conscious public."[13]

The catalogue for Pollock's first solo show at Art of this Century in 1943 was written by a man of no less importance than James Johnson Sweeney, who was also one of the members of the jury that year – along with Alfred H. Barr, Jr. (then director of the Museum of Modern Art), James Thrall Soby, Max Ernst, Piet Mondrian, and Marcel Duchamp – for an exhibition called "Spring Salon for Young Artists" at Art of this Century, in which Pollock was included. Pollock also participated in a 1944 show at the Sidney Janis Gallery featuring abstract and surrealist art, and in 1945 the David Porter Gallery in Washington, D.C., included him, along with most of the first generation Abstract Expressionists, in a group show. In the same year the Arts Club of Chicago gave Pollock a one-man show, again with a catalogue by Sweeney. (For an artist to have this kind of establishment support for his first exhibitions is exceedingly rare.) In fact, Sweeney, always a prolific author on many phases of modern art, had also published "Five American Painters" in the April 1944 issue of the fashion magazine *Harper's Bazaar*, commenting on Pollock, Gorky, Matta, and others.

Museums were quick to notice Abstract Expressionism. The Museum of Modern Art bought Pollock's "She-Wolf" in 1944. In that year the artist was included in the exhibition, selected by Janis, that circulated from the Cincinnati Art Museum to the San Francisco Museum of Art, and from there to museums in Denver, Seattle, and Santa Barbara. In 1944 the Museum of Modern Art's circulating exhibit, "Twelve Contemporary American Painters," included Pollock, and Gorky and Motherwell were represented in the 1946 "Fourteen Americans." By 1947, when Baziotes won a major prize at the Annual of the Art Institute of Chicago, Pollock's works were being shown in a loan exhibition in Winchester, England. In 1948 Pollock was exhibiting at the Venice Biennale, as he was again in 1950 along with de Kooning and Gorky, the Abstract Expressionist portion of the United States Pavilion's show having been selected by Alfred Barr of the Modern under the auspices of the American Federation of Art. All this, and only a partial list at that, occurred in the years *before* Abstract Expressionism is acknowledged to have become important!

The Venice Biennale, in which Pollock and other Abstract Expressionists were exhibited so soon after inventing the new mode, held a special niche in the art world in the years after the war. The Biennale was the international exhibit that attempted to show representative works by the best artists from the largest number of participating nations. It was the exhibit with the greatest panache and prestige, and was well covered by art publications throughout the world. Visits to these exhibitions, furthermore, were among the first opportunities Europeans had after World War II to see the work of contemporary Americans. Artists from countries that had been living under fascism, like Italy and Germany, had not

even been permitted to see modern art, American or otherwise, in decades. Their response to whatever was shown by the Western democracies, especially what was shown from a vivid and lusty America, was immense. Indeed, their needs tended to make them sympathetic with whatever new art they saw and to do their utmost to identify with it. It is worth noting, however, that these Venice Biennales were not representative of American art in the sense of constituting a cross-section of what was being done here, or even representative of the "best" art as most established curatorial or critical opinion might then have selected it. That is, the choices made in 1950 by Barr (and by Alfred M. Frankfurter of the non-Abstract Expressionist painters Lee Gatch, Hyman Bloom, and Rico Lebrun) would have been totally different if made, say, by Francis Henry Taylor or Daniel Catton Rich. This is not the same as saying that tastes differ, which of course is true. It is to say, though, that if a literary Venice Biennale had been held in 1950, American critics of every taste probably would have felt impelled to include Faulkner and Hemingway, even if it meant excluding newer writers. To omit them would have been as arbitrary as were the American art choices.

By the early 1950s the bibliography on Abstract Expressionism and its individual practitioners was growing by geometric progression, and the galleries showing their work were increasing annually [. . .]

By 1954 a visiting English critic could write that

> at the start of last season I counted eighty-one New York galleries, showing contemporary art, of which only seven were exhibiting painting that could be called realist in the loosest sense. What happens? Trained by their abstract teachers, and confronted with a market-place hostile to anything outside abstract distortion, the young students excusably turn into model exempla of run-of-the-mill abstraction. What is more, the national salons and fellowship donors sedulously encourage abstract distortion and ugliness. Very few prizes are won by realist works at leading annuals, while beautiful paintings are severely handicapped. . . . And then a sincerely concerned museum director, like Mr. Herman More of the Whitney, comes along, surveys the field, and tells the *Times* art editor that he sees very little realism around, and so cannot in all conscience represent much of it in his annual.[14]
> [. . .]

Large numbers of artists swung over to Abstract Expressionism during the 1950s, thus contributing to the force of the movement they were joining because they could not beat it.

By 1959, John Canaday noted in the *New York Times*,

> Abstract Expressionism was at the zenith of its popularity, to such an extent that an unknown artist trying to exhibit in New York couldn't find a gallery unless he was painting in a mode derived from one or another member of the New York School. . . .
> But still, at that time, a critic not entrenched in the New York scene could find himself in a painful situation when he suggested that Abstract Expressionism was abusing its own success and that the monopolistic orgy had gone on long enough. It is painful for anyone to be declared a pariah by his colleagues whose opinions, even if they contradict his own, he respects; it is unpleasant when an anonymous voice tells you to watch out because "we're laying for you when you leave the office." Anonymous letters are always nasty. But in 1959, for a critic to question the validity of Abstract Expressionism as the ultimate art form was to inspire obscene mail,

threatening phone calls, and outraged letters to the editor signed by eminent artists, curators, collectors, and critics demanding his discharge as a Neanderthal throwback.[15]

III

The most surprising fact about American art in the 1950s is the dearth of well-written published material critical of or hostile to Abstract Expressionism. Since a conspiracy is entirely unlikely – even Senator Joe McCarthy never claimed to have uncovered any in the art world – more likely possibilities must be examined [. . .]

Abstract Expressionism, of course, can in no way be equated with McCarthyism, although the conformism that pervaded the decade goes a long way toward explaining the power of each. But while McCarthyism was the expression of a vicious political authoritarianism, Abstract Expressionism might better be described as anarchist or nihilist, both antipodes of authoritarianism, in its drive to jettison rules, tradition, order, and values. "Things fall apart; the center cannot hold; mere anarchy is loosed upon the world," Yeats prophetically wrote. Anarchist Abstract Expressionism and neofascist McCarthyism ruled in their separate spheres during the same period, and the fact that their control was almost complete for a time makes it fair to suggest certain parallels.

If the atmosphere of the times and the support of the leading critics, museums, and art publications helped Abstract Expressionism to reach an unprecedented vogue that stifled other forms during the 1950s, there were other stimulants to its success as well. The GI Bill for veterans and a new prosperity meant that schools, in this case mainly college art departments, were expanding and thus catching as young faculty the first wave of artists trained as Abstract Expressionists. They, in turn, taught the next generation of art students, a group substantially larger than ever before in our history. The varied modes of art noticeable during the 1930s and 1940s were virtually untaught and unrepresented during the 1950s for more reasons than that they seemed tired and perhaps old-fashioned in a postwar world. Unlike earlier periods, all art seemed to be funneled toward one type of expression [. . .] the lever that lifted Abstract Expressionism to the peak it achieved as the quasi-official art of the decade, suppressing other kinds of painting to a degree not heretofore conceivable in our society, was an arm of the United States government. [. . .]

The United States Information Agency, which as time went on was to sponsor a great deal of American art, worked within an official censorship policy which ruled that our government was not to support nonrepresentational examples of our creative energy nor circulate exhibitions that included the work of "avowed communists, persons convicted of crimes involving a threat to the security of the United States, or persons who publicly refuse to answer questions of Congressional committees regarding connection with the communist movement."[16]

Among the artists and organizations attacked at some point by one congressional committee or another were the Los Angeles City Council, the Dallas

Museum, the Metropolitan Museum, the American Federation of Art circulating exhibit called "100 American Artists of the Twentieth Century," the Orozco murals at the New School for Social Research, the Diego Rivera murals in Detroit, and the Anton Refregier mural created with federal funds for the Rincon Annex Post Office in San Francisco.[17]

Almost any style, then, was a potential target for congressional pot-shots, ranging from that which was explicitly political and/or executed by artists involved with sociopolitical affairs, to art that categorically denied any possibility of ideological communication. Yet despite the problems, Abstract Expressionism became the style most heavily dispensed by our government, for reasons that were in part explained by Thomas W. Braden in a 1967 article that appeared under the title "I'm Glad the C.I.A. Is Immoral" in the *Saturday Evening Post.*[18]

Braden, executive secretary of the Museum of Modern Art for a short period in the late 1940s, joined the Central Intelligence Agency as supervisor of cultural activities in 1951, and remained as director of this branch until 1954. Recognizing that congressional approval of many of their projects was "as likely as the John Birch Society's approving Medicare," he became involved with using such organizations as the Institute of Labor Research and the National Council of Churches as fronts in the American cold war against communism here and abroad. The rules that guided the CIA allowed them to "use legitimate existing organizations; disguise the extent of American interest; protect the integrity [*sic*] of the organization by not requiring it to support every aspect of official American policy."[19] Braden said that "we placed one agent in a Europe-based organization of intellectuals called the Congress for Cultural Freedom."[20] The agent remained for many years as executive director; another CIA agent became editor of *Encounter.* When money was needed to finance these projects it was supplied by the CIA via paper organizations devised for that purpose. Commenting on these activities years later, Conor Cruise O'Brien said that the "beauty of the operation . . . was that writers of the first rank, who had no interest in serving the power structure, were induced to do so unwittingly."[21] The same might be said of the Abstract Expressionists, and perhaps of the critics and museum personnel supporting them. In any case, Braden, possibly taking his aesthetic cue from his Museum of Modern Art years, supported the export of Abstract Expressionism in the propaganda war. It appears likely that he agreed with Greenberg's 1949 remark, the purport of which became for a time the American twentieth-century version of the discredited "white man's burden," which held – apropos art – that this country, "here, as elsewhere . . . has an international burden to carry."[22] Backed by money available to the CIA and supportive of Abstract Expressionism, Braden's branch became a means of circumventing Congress and sending abroad art-as-propaganda without federal intervention.

In his study of one of the organizations infiltrated by the CIA, the Congress for Cultural Freedom, Christopher Lasch wrote that

> especially in the fifties American intellectuals, on a scale that is only beginning to be understood, lent themselves to purposes having nothing to do with the values they professed – purposes, indeed, that were diametrically opposed to them.

> The defection of intellectuals from their true calling – critical thought – goes a long way toward explaining not only the poverty of political discussion but the intellectual bankruptcy of much historical scholarship. The infatuation with consensus; the vogue of disembodied "history of ideas" divorced from considerations of class or other determinants of social organization; the obsession with "American Studies" which perpetuates a nationalistic myth of American uniqueness – these things reflect the degree to which historians have become apologists, in effect, for American national power in the holy war against communism. . . .
>
> The prototype of the anti-communist intellectual in the fifties was the disillusioned ex-Communist, obsessed by the corruption of Western politics and culture by the pervasive influence of Stalinism and by a need to exorcise the evil and expiate his own past.[23]

Lasch's description fits both Greenberg and Rosenberg, who wrote articles supporting Abstract Expressionism for CIA-subsidized journals as well as others. (*Partisan Review*, according to Lasch, was one of those journals that for a time was sponsored by the CIA.) Their published material had a great deal to do with the acceptance of the style by other intellectuals in the 1950s. It is also worth remarking in this connection that the word "American" drums repeatedly in the titles of essays sympathetic to Abstract Expressionism: "The Present Prospects of American Painting and Sculpture," "American Action Painting," "American Type Painting," "The New American Painting," "Is Abstraction Un-American?" – the last a peculiarly 1950s-type question. It is not surprising, Lasch says, that these cold war intellectuals became affluent as well as powerful as their usefulness to the government, corporations, and foundations became apparent, "partly because the Cold War seemed to demand that the United States compete with communism in the cultural sphere as well as in every other."[24]

The Abstract Expressionists were used in the 1950s in a series of international exhibitions, sponsored by the International Council of MOMA, whose purpose appears to have coincided with the aims of government bodies.[25] (This may be a good place to note that from 1954 to 1962 the U.S. Pavilion in Venice was the property of the Museum of Modern Art, the only such national pavilion privately owned.) "The functions of both the CIA's undercover operations and the Modern Museum's international programs were similar,"[26] [. . .]

Although the artists who made this art were generally no longer political (including those who had been at some time in the past), they were on the whole in accord with official policy, not only in its fixation on the Communist menace but also in their disdain for figurative art, especially the left-wing political art of the Social Realists in America. If these factors did not entirely allay qualms about their employment as part of the establishment propaganda apparatus, they could take comfort, as artists inevitably do, in the exhibition record. Few are ever likely to argue about the purposes for which their paintings are exhibited just so long as they are in fact widely and regularly shown.

A vocal portion of the art world, moreover, was cockily triumphant about the splash American art was making abroad for the first time. As the Luce publications proclaimed, this was to be the American century. We had emerged from the war unscathed; we had the biggest and best of everything. We wanted the rest

of the world to know it, and to know that it was all due to our true-blue goodness, our planning, and our form of government. The new world had invented a new art which lay claim to epitomizing a new freedom.

Yet another reason suggests itself for the speed with which government and museums cooperated in arranging exhibitions of Abstract Expressionism abroad. Social Realism, widely exhibited until World War II, is programmatically critical of capitalism. Its stated aim, in fact, is to serve as an instrument in the social change that will disestablish capitalism. The Museum of Modern Art had on occasion exhibited and purchased works of certain Social Realists and continued to do so for a time after the emergence of Abstract Expressionism. Indeed, in 1946 MOMA had shown Social Realist Ben Shahn's work in a retrospective that established his reputation. But they may now have been relieved to be helped off a hot spot, for it should not be forgotten that MOMA, like most American museums, was founded and funded by extremely rich private collectors, and MOMA was still actively supported by the Rockefellers, a clan as refulgent with money and power as American capitalism has produced.

These people, to paraphrase Churchill, had no wish to preside over the dismantling of the economic system that had served them so well. It is likely that related reasons influenced other museums, which, after varying periods of hesitation, joined in support of Abstract Expressionist art. (Many other elements, of course, were operative as well.) Museums backed up exhibitions of the new mode with massive purchases of work by living artists on a scale that had never before been approached. "It was a kind of instant history, and quickly a sampling of their works was to be found in most museums," wrote Joshua Taylor, director of the National Collection, Smithsonian Institution.[27] Earlier the rule had been for museums to be extremely chary of acquiring work by living artists. Now museums not only splurged on canvases sold to them at ever-augmenting prices; the trustees who had authorized the acquisitions became collectors of the new art. "Trustees often urged the museum to acquire works by the very artists they were collecting, thus helping to bolster their own taste," Daniel Catton Rich has observed.[28] Even curators – giving rise to ethical problems – functioned as public taste makers and private clients.

Thus it came about that the critics and their theories, the art publications as well as the general press, the museums led by the Museum of Modern Art, the avant-garde art galleries, the clandestine functions of the CIA supported by the taxpayer, the need of artists to show and sell their work, the leveling of dissent encouraged by McCarthyism and a conformist era, the convergence of all varieties of anti-Communists and anti-Stalinists on a neutral cultural point, the cold war and the cultural weapons employed in its behalf, American postwar economic vigor and its sense of moral leadership, plus the explosion of a totally new kind of American-born painting that seemed the objective correlative of Greenberg's early announcement that "the main premises of Western art have at last migrated to the United States"[29] – all these combined to make Abstract Expressionism the only art acceptable on a wide scale during the conforming 1950s.

The rise of Abstract Expressionism to its leadership of the avant-garde, and

from there to its position of official art, is replete with irony. First, because the very term "avant-garde," as proudly vaunted as Baudelaire's "modernism," was first used in art by *socialist* artists in the nineteenth century, and its meaning then was very close to what we have come to call Social Realism. "Avant-garde" as cultural vanguard was used in an 1845 essay in the following way:

> Art, the expression of Society, reveals in its highest forms the most advanced *social* tendencies; it is a precursor and herald. Now, to know whether an art worthily fulfills its proper mission as initiator, if an artist is really at the *avant-garde*, one must know where humanity is heading, what is the destiny of the species . . . *strip nude with a brutal brush all the ugliness, all the garbage that is at the base of our society.*[30]

Or, as the French socialist philosopher Henri de Saint-Simon wrote twenty years earlier,

> It is we, artists, who will serve you as *avant-garde* [in the struggle toward socialism]: the power of the arts is in fact most immediate and most rapid: when we wish to spread new ideas among men, we inscribe them on marble or canvas.[31]

It is ironic, too, that an apolitical art that arose at least in part as a reaction to didactic art, as an "art-for-art's-sake" antidote to "art-as-a-weapon," should have become a prime political weapon. As Max Kozloff wrote in 1973, in the 1950s the art establishment saw this kind of art as the "sole trustee of the avant-garde spirit, a belief so reminiscent of the U.S. Government's notion of itself as the lone guarantor of capitalist liberty."[32] It is also an irony that an art indifferent to morality became the prime example of the morality of free expression, and that an art foreswearing aesthetics came to be used as the originator of a new aesthetic.

And perhaps the final irony is that instead of reigning for a thousand years, as Adolph Gottlieb had predicted,[33] it lasted as king for a decade, with pop art – the epitome of the banal and the glorification of kitsch – its immediate successor. Jack had killed the giant, but the giant arose again, deformed, stronger, with greater pretensions, and flexing muscles never dared before. Pop, as everyone knows, has been succeeded by op, minimal, conceptual, photorealism, and more yet – but each of these in one way or another either derives from Abstract Expressionism or is a violent reaction against it, so that the disruption caused by the dominance of Abstract Expressionism for its decade will be felt not only in American art but all over the world throughout this century.

Notes

1 David Shapiro, "Social Realism Reconsidered," in *Social Realism: Art as a Weapon*, ed., David Shapiro (New York: Ungar, 1973), pp. 3–35.
2 Thomas Hart Benton, "Answers to Ten Questions," in Shapiro, *Social Realism*, pp. 100–101. Originally this essay appeared in *Art Digest*, March 15, 1935, in response to an attack made by Stuart Davis in *The Art Front* on nationalism in art and the Regionalists in particular. *The Art Front* was the journal of the Artists' Union.

3 Stuart Davis, "The Artist Today: The Standpoint of the Artists' Union," in Shapiro, *Social Realism*, pp. 111–17. Reprinted from the *American Magazine of Art*, August 1935. Davis said that "this article deals with the artistic, social, and the economic situation of the American artist in the field of fine arts, regarding the situation in the broadest possible way, and does not intend to stigmatize individuals except as they are the name-symbols of certain group tendencies." He ends the essay by saying that "an artist does not join the Union merely to get a job: he joins it to fight for his right to economic stability on a decent level and to develop as an artist through development as a social human being."

4 Irving Sandler, *The Triumph of American Painting* (New York: Harper & Row, 1970), p. 7.

5 Holger Cahill, *New Horizons in American Art* (New York: Museum of Modern Art, 1936), pp. 9–41. A catalogue of an exhibition surveying one year's activity of the Federal Art Project of the Works Progress Administration, this book is a valuable source for the ideas and intent of the Federal Art Project as seen by Cahill, its national director.

6 André Breton and Diego Rivera, "Manifesto Towards a Free Revolutionary Art," *Partisan Review*, 6 (Fall 1938), 49–53. Translated by Dwight MacDonald. Republished in *Theories of Modern Art*, ed., Herschel B. Chipp (Berkeley: Univ. of California, 1968), pp. 483–97. Although when originally published the essay was signed by Breton and Diego Rivera, its authorship was clarified by Breton in a letter to Peter Selz dated February 12, 1962 [. . .] "This text, in its entirety, was drawn up by Leon Trotsky and me, and it was for tactical reasons that Trotsky wanted Rivera's signature substituted for his own. On page 40 of my work, *La Clé des champs* [Paris: Sagittarie, 1953], I have shown a facsimile page of the original manuscript in additional support of this rectification." Chipp, *Theories*, pp. 457–58.

7 Clement Greenberg, "Avant-Garde and Kitsch," *Art and Culture* (Boston: Beacon Press, 1965), pp. 3–21 [see Text 1]. All quotations in this essay are from the 1965 collection. The original essay appeared in the *Partisan Review* in 1939. There were many changes in the text published in the *Partisan Reader* (New York: Dial Press, 1946), pp. 378–89, among them the omission of the final paragraph [. . .]

8 Breton and Rivera (i.e., Trotsky), "Manifesto," in Chipp, *Theories*, p. 485. Trotsky's view of culture in this essay differs from that presented in his earlier "Literature and Revolution," first published in Russian in 1923, and in English in 1925. Portions of this English translation are excerpted in Chipp's *Theories*.

9 Harold Rosenberg, "American Action Painters," *Art News*, December 1952, pp. 22–23, 48–49 [. . .]
 The content of this essay accounts in part for the intense rivalry between Rosenberg and Greenberg. In response to "American Action Painting" Greenberg published "American Type Painting" (*Partisan Review*, 22 [Spring, 1955], 179–96). Rosenberg brought their differences into the open in "Action Painting: A Decade of Distortion" (*Art News*, December 1961, rpt. in *Encounter*, May 1963). Greenberg answered with "How Art Writing Earns Its Bad Name" (*Encounter*, December 1962) and "After Abstract Expressionism" (*Art International*, October 1962). Rosenberg's reply was "After Next, What?" (*Art in America*, April 1964).

10 *Life*, (October 11, 1948), pp. 56 ff.

11 Sandler, *Triumph of American Painting*, pp. 211–12.

12 Denys Sutton, "The Challenge of American Art," *Horizon* (London) October 1949, pp. 268–84 [. . .]

13 Sandler, *Triumph of American Painting*, p. 211. "I have really had amazing success for the first year of showing a color reproduction in the April *Harpers Bazaar* – and reproductions in the *Arts and Architecture*," Pollock wrote in a letter to his brother Charles. Quoted by Francis V. O'Connor, *Jackson Pollock* (The Museum of Modern Art, New York: 1967), p. 33.

14 Geoffrey Wagner, "The New American Painting," *Antioch Review* (March–June 1954). Both Greenberg and Rosenberg responded to this article with anger and contempt in letters published in the following issue of the *Antioch Review*.

15 John Canaday, "A Critic's Valedictory: The Americanization of Modern Art and Other Upheavals," *New York Times*, August 8, 1976. Some of the letters referred to were published in the *New York Times*, September 6, 1959, and more were reprinted along with them in Canaday's *Embattled Critic* (New York: Farrar, Straus, 1962).

16 William Hauptman, "The Suppression of Art in the McCarthy Decade," *Artforum*, October 1973, p. 49.

17 Ibid., pp. 50–51.

18 Thomas W. Braden, "I'm Glad the C.I.A. Is Immoral," *Saturday Evening Post*, May 20, 1967, pp. 10 ff.

19 Ibid., p. 11.

20 Ibid.

21 Christopher Lasch, "The Cultural Cold War," in *Towards a New Past, Dissenting Essays in American History*, ed., Barton J. Bernstein (New York: Pantheon, 1968), p. 353.

22 Clement Greenberg, "Art Chronicle: A Season of Art," *Partisan Review* (July–August 1949), 414.

23 Lasch, "Cultural Cold War," pp. 323, 336.

24 Ibid., p. 344. His statement about the CIA and the *Partisan Review* is on p. 335.

25 Russell Lynes, *Good Old Modern: An Intimate Portrait of the Museum of Modern Art* (New York: Atheneum, 1973), p. 384. MOMA's international exhibition program, Lynes said, was "to let it be known especially in Europe that America was not a cultural backwater that the Russians, during the tense period called 'the cold war,' were trying to demonstrate that it was."

26 Eva Cockcroft, "Abstract Expressionism, Weapon of the Cold War," *Artforum*, June 1974, p. 40 [see Text 7, p. 129].

27 Joshua C. Taylor, "The Art Museum in the United States," in *On Understanding Art Museums*, ed., Sherman E. Lee (Englewood Cliffs, N.J.: Prentice-Hall, 1975), p. 60.

28 Daniel Catton Rich, "Management, Power, and Integrity," in Lee, *On Understanding Art Museums*, p. 137.

29 Clement Greenberg, "Art Chronicle: The Decline of Cubism," *Partisan Review* (March 1948), p. 369.

30 James S. Ackerman, "The Demise of the Avant-Garde: Notes on the Sociology of Recent American Art," *Comparative Studies in Society and History* 2 (October 1969), 375n. (Italics added.) Ackerman quotes from Renato

Poggioli, *Theory of the Avant-Garde* (Cambridge, Mass.: 1968). The original lines were written by Gabriel-Desiré Laverdant, a follower of the socialist Fourier.

31 Ackerman, "Demise of the Avant-Garde," p. 375n. Ackerman is quoting from Donald Egbert, "The Idea of the Avant-Garde in Art and Politics," *American Historical Review*, 70 (1967). (Italics added.)

32 Max Kozloff, "American Painting During the Cold War," *Artforum*, May 1973, p. 44 [see Text 6, pp. 108–109].

33 Selden Rodman, *Conversations with Artists* (New York: Capricorn Books, 1961), p. 87.

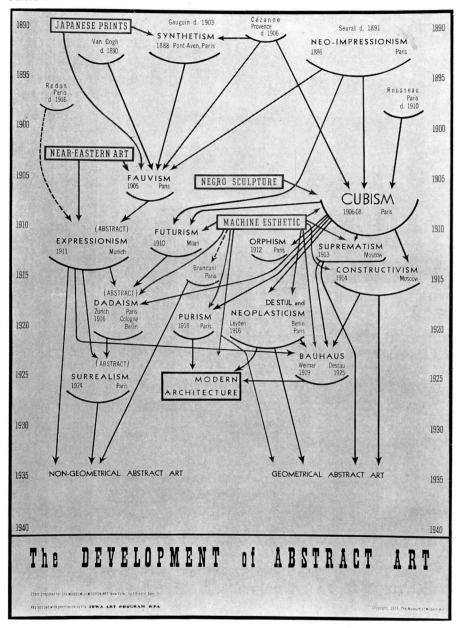

The Development of Abstract Art. Chart prepared for the Museum of Modern Art, New York, by Alfred H. Barr, Jr. This chart appeared on the jacket of Barr's catalogue and guide to the exhibition *Cubism and Abstract Art*, M.O.M.A., New York, 1936. Photograph courtesy The Museum of Modern Art, New York.

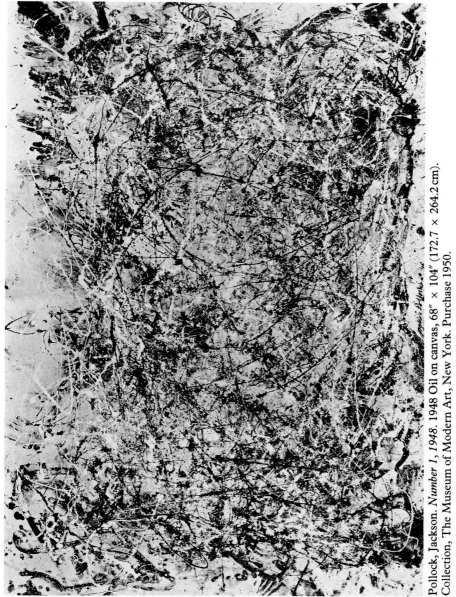

Pollock, Jackson. *Number 1, 1948.* 1948 Oil on canvas, 68″ × 104″ (172.7 × 264.2 cm). Collection, The Museum of Modern Art, New York. Purchase 1950.

PLATE C

Manet, Édouard. *Le Déjeuner sur l'herbe* 1863 Oil on canvas, 82″ × 104″ (208.2 × 264.2 cm). Musée du Louvre, Jeu de Paume, Paris. Photograph courtesy Reunion des Musées Nationaux, Paris.

Caro, Anthony. *Table Piece XXII* (1967). Steel painted green. 10″ × 31¼″ × 27″ (25.4 × 80 × 68.5 cm). Private collection, London. © Floyd Picture Library.

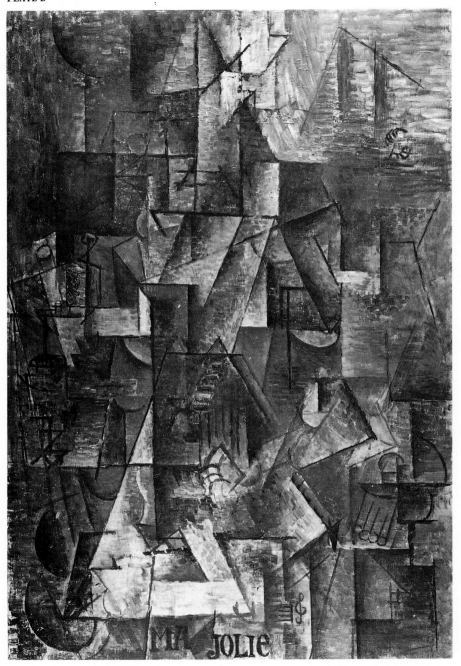

Picasso, Pablo. '*Ma Jolie*' (1911–12, winter). Oil on canvas, $39\frac{3}{8}''$ × $25\frac{3}{4}''$ (100 × 65.4 cm). Collection, The Museum of Modern Art, New York. Acquired through the Lillie P. Bliss Bequest. © DACS 1984.

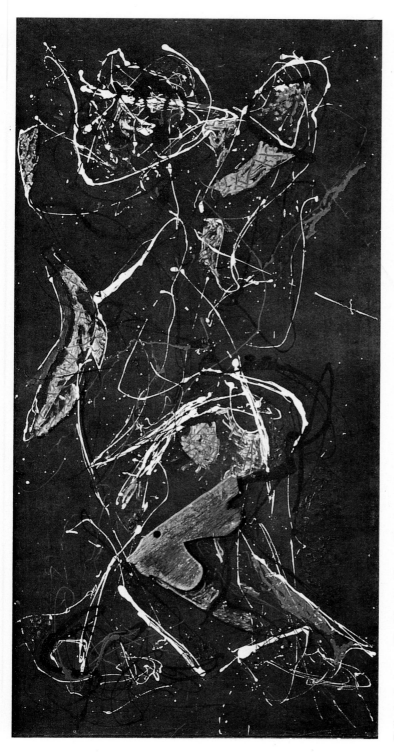

Pollock, Jackson. *The Wooden Horse: Number 10A* (1948): Oil, enamel and wooden hobbyhorse head on brown cotton canvas, mounted on board. 36″ × 7⅛″ (90 × 17.8 cm). Moderna Museet, Stockholm. Photograph courtesy Statens Konstmuseer, Stockholm.

9 The New Adventures of the Avant-Garde in America

Greenberg, Pollock, or from Trotskyism to the New Liberalism of the "Vital Center"

Serge Guilbaut

translated by Thomas Repensek

We now know that the traditional make-up of the avant-garde was revitalized in the United States after the Second World War. In the unprecedented economic boom of the war years, the same strategies that had become familiar to a jaded Parisian bourgeoisie were skillfully deployed, confronted as they were with a new bourgeois public recently instructed in the principles of modern art.

Between 1939 and 1948 Clement Greenberg developed a formalist theory of modern art which he would juxtapose with the notion of the avant-garde, in order to create a structure which, like that of Baudelaire or Apollinaire, would play an aggressive, dominant role on the international scene.

The evolution of Greenbergian formalism during its formative period from 1939 to 1948 cannot be understood without analyzing the circumstances in which Greenberg attempted to extract from the various ideological and aesthetic positions existing at the end of the war an analytical system that would create a specifically American art, distinct from other contemporary tendencies, and international in import.

When we speak about Greenbergian formalism, we are speaking about a theory that was somewhat flexible as it began clearly to define its position within the new social and aesthetic order that was taking shape during and after the war; only later would it solidify into dogma. We are also speaking about its relationship to the powerful Marxist movement of the 1930s, to the crisis of Marxism, and finally to the complete disintegration of Marxism in the 1940s – a close relationship clearly visible from the writings and ideological positions of Greenberg and the abstract expressionists during the movement's development. Greenbergian formalism was born from those Stalinist-Trotskyite ideological

Source: 'The New Adventures of the Avant-Garde in America', *October* 15, Winter 1980, pp. 61–78. Reprinted by permission of the author and M.I.T. Press, Cambridge, Mass. This article is a revised and expanded version of a paper delivered at the *Conference on Art History and Theory; Aspects of American Formalism*, Montreal, October 1979. This text has been edited, and footnotes have been renumbered.

battles, the disillusionment of the American Left, and the de-Marxification of the New York intelligentsia. [. . .]

De-Marxification really began in 1937 when a large number of intellectuals, confronted with the mediocrity of the political and aesthetic options offered by the Popular Front, became Trotskyites. Greenberg, allied for a time with Dwight MacDonald and *Partisan Review* in its Trotskyite period (1937–1939), located the origin of the American avant-garde venture in a Trotskyite context: "Some day it will have to be told how anti-Stalinism which started out more or less as Trotskyism turned into art for art's sake, and thereby cleared the way heroically for what was to come."[1] When the importance of the Popular Front, its voraciousness and success are taken into account, it is hardly surprising that Trotskyism attracted a certain number of intellectuals. The American Communist party's alliance with liberalism disillusioned those who sought a radical change of the political system that had been responsible for the Depression. This alliance prepared the stage for revolution. [. . .]

It was the art historian Meyer Schapiro who initiated the shift. In 1937, abandoning the rhetoric of the Popular Front as well as the revolutionary language used in his article "Social Bases of Art," in which he emphasized the importance of the alliance between the artist and the proletariat,[2] he crossed over to the Trotskyite opposition. He published in *Marxist Quarterly* his celebrated article "Nature of Abstract Art,"[3] important not only for its intelligent refutation of Alfred Barr's formalist essay "Cubism and Abstract Art,"[4] but also for the displacement of the ideology of his earlier writing, a displacement that would subsequently enable the Left to accept artistic experimentation, which the Communist Popular Front vigorously opposed.

If in 1936, in "Social Bases of Art," Schapiro guaranteed the artist's place in the revolutionary process through his alliance with the proletariat, in 1937, in "Nature of Abstract Art," he became pessimistic, cutting the artist off from any revolutionary hope whatsoever. For Schapiro, even abstract art, which Alfred Barr and others persistently segregated from social reality in a closed, independent system, had its roots in its own conditions of production. The abstract artist, he claimed, believing in the illusion of liberty, was unable to understand the complexity and precariousness of his own position, nor could he grasp the implications of what he was doing. By attacking abstract art in this way, by destroying the illusory notion of the artist's independence, and by insisting on the relationships that link abstract art with the society that produces it, Schapiro implied that abstraction had a larger signification than that attributed to it by the formalists.

Schapiro's was a two-edged sword: while it destroyed Alfred Barr's illusion of independence, it also shattered the Communist critique of abstract art as an ivory tower isolated from society. The notion of the nonindependence of abstract art totally disarmed both camps. Leftist painters who rejected "pure art" but who were also disheartened by the Communist aesthetic, saw the "negative" ideological formulation provided by abstract art as a positive force, a way out. It was easy for the Communists to reject art that was cut off from reality, isolated in its ivory tower. But if, as Schapiro claimed, abstract art was part of the social fabric, if it

reacted to conflicts and contradictions, then it was theoretically possible to use an abstract language to express a critical social consciousness. In this way, the use of abstraction as critical language answered a pressing need articulated by *Partisan Review* and *Marxist Quarterly*: the independence of the artist vis-à-vis political parties and totalitarian ideologies. An opening had been made that would develop (in 1938 with Breton–Trotsky, in 1939 with Greenberg, in 1944 with Motherwell)[5] into the concept of a critical, avant-garde abstract art. The "Nature of Abstract Art" relaxed the rigid opposition of idealist formalism and social realism, allowing for the reevaluation of abstraction. For American painters tired of their role as propagandizing illustrators, this article was a deliverance, and it conferred unassailable prestige on the author in anti-Stalinist artistic circles. Schapiro remained in the minority, however, in spite of his alignment with J. T. Farrell, who also attacked the vulgar Marxism and the aesthetic of the Popular Front in his "Note on Literary Criticism."[6]

In December 1937, *Partisan Review* published a letter from Trotsky in which he analyzed the catastrophic position of the American artist who, he claimed, could better himself, caught as he was in the bourgeois stranglehold of mediocrity, only through a thorough political analysis of society. He continued:

> Art, which is the most complex part of culture, the most sensitive and at the same time the least protected, suffers most from the decline and decay of Bourgeois society. To find a solution to this impasse through art itself is impossible. It is a crisis which concerns all culture, beginning at its economic base and ending in the highest spheres of ideology. Art can neither escape the crisis nor partition itself off. Art cannot save itself. It will rot away inevitably – as Grecian art rotted beneath the ruins of a culture founded on slavery – unless present day society is able to rebuild itself. This task is essentially revolutionary in character. For these reasons the function of art in our epoch is determined by its relation to the revolution.[7] [. . .]

Trotsky and Breton's analysis, like Greenberg's, blamed cultural crisis on the decadence of the aristocracy and the bourgeoisie, and placed its solution in the hands of the independent artist; yet they maintained a revolutionary optimism that Greenberg lacked. For Trotsky, the artist should be free of partisanship but not politics. Greenberg's solution, however, abandoned this critical position, as well as what Trotsky called eclectic action, in favor of a unique solution: the modernist avant-garde.[8] In fact, in making the transition from the political to the artistic avant-garde, Greenberg believed that only the latter could preserve the quality of culture against the overwhelming influence of kitsch by enabling culture to continue to progress. Greenberg did not conceive of this cultural crisis as a conclusion, as had been the case during the preceding decade, that is, as the death of a bourgeois culture being replaced by a proletarian one, but as the beginning of a new era contingent on the death of a proletarian culture destroyed in its infancy by the Communist alliance with the Popular Front, which *Partisan Review* had documented. As this crisis swiftly took on larger proportions, absorbing the ideals of the modern artist, the formation of an avant-garde seemed to be the only solution, the only thing able to prevent complete disintegration. Yet it ignored the revolutionary aspirations that had burned so brightly only a few years before. After the moral failure of the Communist party and the incompetence of the

Trotskyites, many artists recognized the need for a frankly realistic, non-revolutionary solution. Appealing to a concept of the avant-garde, with which Greenberg was certainly familiar, allowed for a defense of "quality," throwing back into gear the progressive process brought to a standstill in academic immobility – even if it meant abandoning the political struggle in order to create a conservative force to rescue a foundering bourgeois culture.

Greenberg believed that the most serious threat to culture came from academic immobility, the Alexandrianism characteristic of kitsch. During that period the power structure was able to use kitsch easily for propaganda purposes. According to Greenberg, modern avant-garde art was less susceptible to absorbtion, not, as Trotsky believed, because it was too critical, but on the contrary because it was "innocent," therefore less likely to allow a propagandistic message to be implanted in its folds. Continuing Trotsky's defense of a critical art "remaining faithful to itself," Greenberg insisted on the critical endeavor of the avant-garde, but a critique that was directed inward, to the work itself, its medium, as the determining condition of quality. Against the menacing background of the Second World War, it seemed unrealistic to Greenberg to attempt to act simultaneously on both a political and cultural front. Protecting Western culture meant saving the furniture.

"Avant-Garde and Kitsch" was thus an important step in the process of de-Marxification of the American intelligentsia that had begun around 1936. The article appeared in the nick of time to rescue the intellectual wandering in the dark. After passing through a Trotskyite period of its own, *Partisan Review* emphasized the importance of the intellectual at the expense of the working class. It became preoccupied with the formation of an international intellectual elite to the extent that it sometimes became oblivious to politics itself. [. . .]

Greenberg's article should be understood in this context. The delicate balance between art and politics which Trotsky, Breton, and Schapiro tried to preserve in their writings, is absent in Greenberg. Although preserving certain analytical procedures and a Marxist vocabulary, Greenberg established a theoretical basis for an elitist modernism, which certain artists had been thinking about since 1936, especially those associated with the American Abstract Artists group, who were also interested in Trotskyism and European culture.[9]

"Avant Garde and Kitsch" formalized, defined, and rationalized an intellectual position that was adopted by many artists who failed fully to understand it. Extremely disappointing as it was to anyone seeking a revolutionary solution to the crisis, the article gave renewed hope to artists. By using kitsch as a target, as a symbol of the totalitarian authority to which it was allied and by which it was exploited, Greenberg made it possible for the artist to act. By opposing mass culture on an artistic level, the artist was able to have the illusion of battling the degraded structures of power with elitist weapons. Greenberg's position was rooted in Trotskyism, but it resulted in a total withdrawal from the political strategies adopted during the Depression: he appealed to socialism to rescue a dying culture by continuing tradition. "Today we no longer look towards socialism for a new culture – as inevitably as one will appear, once we do have

socialism. Today we look to socialism *simply* for the preservation of whatever living culture we have right now."[10] The transformation functioned perfectly, and for many years Greenberg's article was used to mark the beginning of the American pictorial renaissance, restored to a preeminent position. The old formula for the avant-garde, as was expected, was a complete success.

The appearance of "Avant-Garde and Kitsch" coincided with two events that threw into question the integrity of the Soviet Union – the German-Soviet alliance and the invasion of Finland by the Soviet Union – and which produced a radical shift in alliances among Greenberg's literary friends and the contributors to *Partisan Review*. After the pact, many intellectuals attempted to return to politics. But the optimism which some maintained even after the alliance was announced evaporated with the Soviet invasion of Finland. Meyer Schapiro could not have chosen a better time to interrupt the self-satisfied purrings of the Communist-dominated American Artist's Congress and create a split in the movement. He and some thirty artist colleagues, in the minority because of their attempt to censure the Soviet Union, realized the importance of distancing themselves from an organization so closely linked not only to Stalinism, but also the social aesthetic of the Popular Front.

And so the Federation of American Painters and Sculptors was born, a non-political association that would play an important part in the creation of the avant-garde after the war, and from which would come many of the first-generation painters of abstract expressionism (Gottlieb, Rothko, Poussette-Dart). After the disillusion of 1939 and in spite of a slight rise in the fortunes of the Popular Front after Germany attacked Russia in June of 1941, the relationship of the artist to the masses was no longer the central concern of major painters and intellectuals, as it had been during the 1930s. With the disappearance of the structures of political action and the dismantling of the Works Progress Administration programs, there was a shift in interest away from society back to the individual. As the private sector reemerged from the long years of the Depression, the artist was faced with the unhappy task of finding a public and convincing them of the value of his work. After 1940 artists employed an individual idiom whose roots were nevertheless thoroughly embedded in social appearance. The relationship of the artist to the public was still central, but the object had changed. Whereas the artist had previously addressed himself to the masses through social programs like the WPA, with the reopening of the private sector he addressed an elite through the "universal." By rediscovering alienation, the artist began to see an end to his anonymity, as Ad Reinhardt explained, "Toward the late '30s a real fear of anonymity developed and most painters were reluctant to join a group for fear of being labeled or submerged."[11] [. . .]

Nineteen forty-three was a particularly crucial year, for quietly, without shock, the United States passed from complete isolationism to the most utopian internationalism of that year's best-seller, *One World* by Wendell Wilkie.[12] Prospects for the internationalization of American culture generated a sense of optimism that silenced the anticapitalist criticism of some of its foremost artists. In fact, artists who, in the best tradition of the avant-garde, organized an ex-

hibition of rejected work in January 1943, clearly expressed this new point of view. In his catalogue introduction Barnett Newman revealed a new notion of the modern American artist:

> We have come together as American modern artists because we feel the need to present to the public a body of art that will adequately reflect the new America that is taking place today and the kind of America that will, it is hoped, become the cultural center of the world. This exhibition is a first step to free the artist from the stifling control of an outmoded politics. For art in America is still the plaything of politicians. Isolationist art still dominates the American scene. Regionalism still holds the reins of America's artistic future. It is high time we cleared the cultural atmosphere of America. We artists, therefore, conscious of the dangers that beset our country and our art can no longer remain silent.[13]

This rejection of politics, which had been reassimilated by the propagandistic art of the 1930s, was, according to Newman, necessary to the realization of international modernism. His manifest interest in internationalism thus aligned him – in spite of the illusory antagonism he maintained in order to preserve the adversary image of the avant-garde – with the majority of the public and of political institutions.

The United States emerged from the war a victorious, powerful, and confident country. The American public's infatuation with art steadily increased under the influence of the media. Artists strengthened by contact with European colleagues, yet relieved by their departures, possessed new confidence, and art historians and museums were ready to devote themselves to a new national art. All that was needed was a network of galleries to promote and profit from this new awareness. By 1943 the movement had begun; in March of that year the Mortimer Brandt Gallery, which dealt in old masters, opened a wing for experimental art, headed by Betty Parsons, to satisfy the market's demand for modernity.[14] In April 1945, Sam Kootz opened his gallery. And in February 1946, Charles Egan, who had been at Ferargil, opened a gallery of modern art, followed in September by Parsons, who opened her own gallery with the artists Peggy Guggenheim left behind when she returned to Europe (Rothko, Hofmann, Pollock, Reinhardt, Stamos, Still, Newman). Everything was prepared to enter the postwar years confidently.

The optimism of the art world contrasted sharply with the difficulties of the Left in identifying itself in the nation that emerged from the war. In fact, as the newly powerful middle-class worked to safeguard the privileges it had won during the economic boom, expectations of revolution, even dissidence, began to fade among the Communist party Left. And the disillusions of the postwar period (the international conferences, the Truman administration, the Iron Curtain) did nothing to ease their anxiety. What began as a de-Marxification of the extreme Left during the war, turned into a total de-politicization when the alternatives became clear: Truman's America or the Soviet Union. Dwight MacDonald accurately summarized the desperate position of the radical Left: "In terms of 'practical' political politics we are living in an age which consistently presents us with impossible alternatives. . . . It is no longer possible for the individual to

relate himself to world politics. . . . Now the clearer one's insight, the more numbed one becomes."[15]

Rejected by traditional political structures, the radical intellectual after 1939 drifted from the usual channels of political discourse into isolation, and, utterly powerless, surrendered, refused to speak. Between 1946 and 1948, while political discussion grew heated in the debate over the Marshall Plan, the Soviet threat, and the presidential election in which Henry Wallace and the Communists again played an important part, a humanist abstract art began to appear that imitated the art of Paris and soon began to appear in all the galleries. Greenberg considered this new academicism[16] a serious threat, saying in 1945:

> We are in danger of having a new kind of official art foisted on us – official "modern" art. It is being done by well intentioned people like the Pepsi-cola company who fail to realize that to be for something uncritically does more harm in the end than being against it. For while official art, when it was thoroughly academic, furnished at least a sort of challenge, official "modern" art of this type will confuse, discourage and dissuade the true creator.[17]

During that period of anxious renewal, art and American society needed an infusion of new life, not the static pessimism of academicism. Toward that end Greenberg began to formulate in his weekly articles for the *Nation* a critical system based on characteristics which he defined as typically American, and which were supposed to differentiate American from French art. This system was to revive modern American art, infuse it with a new life by identifying an essential formalism that could not be applied to the pale imitations of the School of Paris turned out by the American Abstract Artists. Greenberg's first attempt at differentiation occurred in an article about Pollock and Dubuffet[18] [. . .]

Greenberg emphasized the greater vitality, virility, and brutality of the American artist. He was developing an ideology that would transform the provincialism of American art into internationalism by replacing the Parisian standards that had until then defined the notion of quality in art (grace, craft, finish) with American ones (violence, spontaneity, incompleteness).[19] Brutality and vulgarity were signs of the direct, uncorrupted communication that contemporary life demanded. American art became the trustee of this new age.

On March 8, 1947, Greenberg stated that new American painting ought to be modern, urbane, casual, and detached, in order to achieve control and composure. It should not allow itself to become enmeshed in the absurdity of daily political and social events. That was the fault of American art, he said, for it had never been able to restrain itself from articulating some sort of message, describing, speaking, telling a story:

> In the face of current events painting feels, apparently, that it must be epic poetry, it must be theatre, it must be an atomic bomb, it must be the rights of man. But the greatest painter of our time, Matisse, preeminently demonstrated the sincerity and penetration that go with the kind of greatness particular to twentieth century painting by saying that he wanted his art to be an armchair for the tired business man.[20]

For Greenberg, painting could be important only if it made up its mind to return to its ivory tower, which the previous decade had so avidly attempted to destroy. This position of detachment followed naturally from his earlier critical

works (1939), and from many artists' fears of participating in the virulent political propaganda of the early years of the Cold War. It was this integration that Greenberg attempted to circumvent through a reinterpretation of modernist detachment – a difficult undertaking for artists rooted in the tradition of the 1930s who had so ruthlessly been made a part of the social fabric. The central concern of avant-garde artists like Rothko and Still was to save their pictorial message from distortion: "The familiar identity of things had to be pulverized in order to destroy the finite associations with which our society increasingly enshrouds every aspect of our environment."[21]

Rothko tried to purge his art of any sign that could convey a precise image, for fear of being assimilated by society. Still went so far as to refuse at various times to exhibit his paintings publicly because he was afraid critics would deform or obliterate the content embedded in his abstract forms. In a particularly violent letter to Betty Parsons in 1948, he said:

> Please – and this is important, show them [my paintings] only to those who may have some insight into the values involved, and allow no one to write about them. NO ONE. My contempt for the intelligence of the scribblers I have read is so complete that I cannot tolerate their imbecilities, particularly when they attempt to deal with my canvases. Men like Soby, Greenberg, Barr, etc. . . . are to be categorically rejected. And I no longer want them shown to the public at large, either singly or in group.[22]

The work of many avant-garde artists, in particular Pollock, de Kooning, Rothko, and Still, seemed to become a kind of un-writing, an art of effacement, of erasure, a discourse which in its articulation tried to negate itself, to be re-absorbed. There was a morbid fear of the expressive image that threatened to regiment, to petrify painting once again. Confronted with the atomic terror in 1946, Dwight MacDonald analyzed in the same way the impossibility of expression that characterizes the modern age, thus imputing meaning to the avant-garde's silence. "Naturalism is no longer adequate," he wrote, "either esthetically or morally, to cope with the modern horror."[23]

Descriptions of nuclear destruction had become an obscenity, for to describe it was to accept it, to make a show of it, to represent it. The modern artist therefore had to avoid two dangers: assimilation of the message by political propaganda, and the terrible representation of a world that was beyond reach, unrepresentable. Abstraction, individualism, and originality seemed to be the best weapons against society's voracious assimilative appetite.

In March 1948, when none of the work being shown in New York reflected in any way Greenberg's position, he announced in his article "The Decline of Cubism," published in *Partisan Review*, that American art had definitively broken with Paris and that it had finally become essential to the vitality of Western culture. This declaration of faith assumed the decline of Parisian cubism, he said, because the forces that had given it birth had emigrated to the United States.

The fact that Greenberg launched his attack when he did was not unrelated to certain political events and to the prewar atmosphere that had existed in New York since January of that year.[24] The threat of a Third World War was openly

discussed in the press; and the importance accorded by the government to the passage of the European Recovery Plan reinforced the idea that Europe – France and Italy – was about to topple into the Soviet camp. What would become of Western civilization? Under these circumstances, Greenberg's article seemed to rescue the cultural future of the West:[25]

> If artists as great as Picasso, Braque and Léger have declined so grievously, it can only be because the general social premises that used to guarantee their functioning have disappeared in Europe. And when one sees, on the other hand, how much the level of American art has risen in the last five years, with the emergence of new talents so full of energy and content as Arshile Gorky, Jackson Pollock, David Smith – then the conclusion forces itself, much to our own surprise, that the main premises of Western art have at last migrated to the United States, along with the center of gravity of industrial production and political power.[26]

New York's independence from an enfeebled, faction-ridden Paris, threatened by communism from within and without, was in Greenberg's eyes necessary if modern culture was to survive. Softened by many struggles and too much success, the Parisian avant-garde survived only with difficulty. Only the virility of an art like Pollock's, its brutality, ruggedness, and individualism, could revitalize modern culture, traditionally represented by Paris, and effeminized by too much praise. By dealing only with abstract-expressionist art, Greenberg's formal analysis offered a theory of art that finally brought "international" over to the American side.

For the first time an important critic had been aggressive, confident, and devoted enough to American art to openly defy the supremacy of Parisian art and to replace it on an international scale with the art of Pollock and the New York School. Greenberg dispensed with the Parisian avant-garde and placed New York at the center of world culture. From then on the United States held all the winning cards in its struggle with communism: the atomic bomb, a powerful economy, a strong army, and now artistic supremacy – the cultural superiority that had been missing.

After 1949 and Truman's victory, the proclamation of the Fair Deal, and the publication of Schlesinger's *Vital Center*, traditional liberal democratic pluralism was a thing of the past. Henry Wallace disappeared from the political scene, the Communist party lost its momentum and even at times ventured outside the law. Victorious liberalism, ideologically refashioned by Schlesinger, barricaded itself behind an elementary anticommunism, centered on the notion of freedom. Aesthetic pluralism was also rejected in favor of a unique, powerful, abstract, purely American modern art, as demonstrated by Sam Kootz's refusal to show the French-influenced modern painters Brown and Holty.[27] Individualism would become the basis for all American art that wanted to represent the new era – confident and uneasy at the same time. Artistic freedom and experimentation became central to abstract-expressionist art.[28]

In May 1948, René d'Harnoncourt presented a paper before the annual meeting of the American Federation of Art in which he explored the notion of individuality, explaining why – his words were carefully chosen for May 1948 – no collective art could come to terms with the age. Freedom of individual expression, indepen-

dent of any other consideration, was the basis of our culture and deserved protection and even encouragement when confronted with cultures that were collectivist and authoritarian.

> The art of the twentieth century has no collective style, not because it has divorced itself from contemporary society but because it is part of it. And here we are with our hard-earned new freedom. Walls are crumbling all around us and we are terrified by the endless vistas and the responsibility of an infinite choice. It is this terror of the new freedom which removed the familiar signposts from the roads that makes many of us wish to turn the clock back and recover the security of yesterday's dogma. The totalitarian state established in the image of the past is one reflection of this terror of the new freedom.[29]

The solution to the problems created by such alienation was, according to d'Harnoncourt, an abstract accord between society and the individual:

> It can be solved only by an order which reconciles the freedom of the individual with the welfare of society and replaces yesterday's image of one unified civilization by a pattern in which many elements, while retaining their own individual qualities, join to form a new entity. . . . The perfecting of this new order would unquestionably tax our abilities to the very limit, but would give us a society enriched beyond belief by the full development of the individual for the sake of the whole. I believe a good name for such a society is democracy, and I also believe that modern art in its infinite variety and ceaseless exploration is its foremost symbol.[30]

In this text we have, perhaps for the first time, the ideology of the avant-garde aligned with postwar liberalism – the reconciliation of the ideology forged by Rothko and Newman, Greenberg and Rosenberg (individuality, risk, the new frontier) with the liberal ideology as Schlesinger defined it in *Vital Center*: a new radicalism. [. . .]

The new liberalism was identified with the avant-garde not only because that kind of painting was identifiable in modern internationalist terms (also perceived as uniquely American), but also because the values represented in the pictorial work were especially cherished during the Cold War (the notion of individualism and risk essential to the artist to achieve complete freedom of expression). The element of risk that was central to the ideology of the avant-garde, was also central to the ideology of *Vital Center*.[31] Risk, as defined by the avant-garde and formulated in their work as a necessary condition for freedom of expression, was what distinguished a free society from a totalitarian one, according to Schlesinger: "The eternal awareness of choice can drive the weak to the point where the simplest decision becomes a nightmare. Most men prefer to flee choice, to flee anxiety, to flee freedom."[32] In the modern world, which brutally stifles the individual, the artist becomes a rampart, an example of will against the uniformity of totalitarian society. In this way the individualism of abstract expressionism allowed the avant-garde to define and occupy a unique position on the artistic front. The avant-garde appropriated a coherent, definable, consumable image that reflected rather accurately the objectives and aspirations of a newly powerful, liberal, internationalist America. This juxtaposition of political and artistic images was possible because both groups consciously or unconsciously repressed aspects of their ideology in order to ally themselves with the ideology of the other. Contradictions were passed over in silence.

It was ironic but not contradictory that in a society as fixed in a right-of-center position as the United States, and where intellectual repression was strongly felt,[33] abstract expressionism was for many people an expression of freedom: freedom to create controversial works, freedom symbolized by action and gesture, by the expression of the artist apparently freed from all restraints. It was an essential existential liberty that was defended by the moderns (Barr, Soby, Greenberg, Rosenberg) against the attacks of the humanist liberals (Devree, Jewell) and the conservatives (Dondero, Taylor), serving to present the internal struggle to those outside as proof of the inherent liberty of the American system, as opposed to the restrictions imposed on the artist by the Soviet system. Freedom was the symbol most enthusiastically promoted by the new liberalism during the Cold War.[34]

Expressionism became the expression of the difference between a free society and totalitarianism; it represented an essential aspect of liberal society: its aggressiveness and ability to generate controversy that in the final analysis posed no threat. Once again Schlesinger leads us through the labyrinth of liberal ideology:

> It is threatening to turn us all into frightened conformists; and conformity can lead only to stagnation. We need courageous men to help us recapture a sense of the indispensability of dissent, and we need dissent if we are to make up our minds equably and intelligently.[35]

While Pollock's drip paintings offended both the Left and the Right as well as the middle class, they revitalized and strengthened the new liberalism.[36] Pollock became its hero and around him a sort of school developed, for which he became the catalyst, the one who, as de Kooning put it, broke the ice. He became its symbol. But his success and the success of the other abstract-expressionist artists was also the bitter defeat of being powerless to prevent their art from being assimilated into the political struggle.

The trap that the modern American artist wanted to avoid, as we've seen, was the image, the "statement." Distrusting the traditional idiom, he wanted to warp the trace of what he wanted to express, consciously attempt to erase, to void the readable, to censure himself. In a certain way he wanted to write about the impossibility of description. In doing this, he rejected two things, the aesthetic of the Popular Front and the traditional American aesthetic, which reflected the political isolationism of an earlier era. The access to modernism that Greenberg had theoretically achieved elevated the art of the avant-garde to a position of international importance, but in so doing integrated it into the imperialist machine of the Museum of Modern Art.[37]

So it was that the progressively disillusioned avant-garde, although theoretically in opposition to the Truman administration, aligned itself, often unconsciously, with the majority, which after 1948 moved dangerously toward the right. Greenberg followed this development with the painters, and was its catalyst. By analyzing the political aspect of American art, he defined the ideological, formal vantage point from which the avant-garde would have to assert itself if it intended to survive the ascendency of the new American middle class. To do so it was forced to suppress what many first generation artists had

defended against the sterility of American abstract art: emotional content, social commentary, the discourse that avant-garde artists intended in their work, and which Meyer Schapiro had articulated.

Ironically, it was that constant rebellion against political exploitation and the stubborn determination to save Western culture by Americanizing it that led the avant-garde, after killing the father (Paris), to topple into the once disgraced arms of the mother country.

Notes

1 Clement Greenberg, "The Late 30's in New York," *Art and Culture*, Boston, Beacon Press, 1961, p. 230.

2 Meyer Schapiro, "Social Bases of Art," *First American Artist's Congress*, New York, 1936, pp. 31–37.

3 Meyer Schapiro, "Nature of Abstract Art," *Marxist Quarterly*, January/February 1937, pp. 77–98; comment by Delmore Schwartz in *Marxist Quarterly*, April/June 1937, pp. 305–310, and Schapiro's reply, pp. 310–314.

4 Alfred Barr, *Cubism and Abstract Art*, New York, Museum of Modern Art, 1936.

5 Leon Trotsky, "Art and Politics," *Partisan Review*, August/September, 1938, p. 310; Diego Rivera and André Breton, "Manifesto: Towards a Free Revolutionary Art," *Partisan Review*, Fall 1938, pp. 49–53; Robert Motherwell, "The Modern Painter's World," *Dyn*, November 1944, pp. 9–14.

6 J. T. Farrell, *A Note on Literary Criticism*, New York, Vanguard, 1936.

7 Trotsky, "Art and Politics," p. 4. In spite of Trotsky's article, which was translated by Dwight MacDonald, the magazine's relationship with the movement remained unencumbered. In fact, Trotsky distrusted the avant-garde publication which he accused of timidity in its attack on Stalinism and turned down several invitations to write for the magazine (Gilbert, *Writers and Partisans: A History of Literary Radicalism in America*, New York, John Wiley and Sons, p. 200).

8 Trotsky agreed with Breton that any artistic school was valid (his "eclecticism") that recognized a revolutionary imperative; see Trotsky's letter to Breton, October 27, 1938, quoted in Arturo Schwartz, *Breton/Trotsky*, Paris, 10/18, 1977, p. 129.

9 Many members of American Abstract Artists were sympathetic to Trotskyism but looked to Paris for an aesthetic standard; Rosalind Bengelsdorf interviewed by the author, February 12, 1978, New York.

10 Greenberg, "Avant-Garde and Kitsch", *Partisan Review*, Fall 1939, p. 49 [see Text 1, p. 32].

11 Ad Reinhardt, interviewed by F. Celentano, September 2, 1955, for *The Origins and Development of Abstract Expressionism in the U.S.*, unpublished thesis, New York, 1957, p. xi.

12 Nineteen forty-three was the year of internationalism in the United States. Although occurring slowly, the change was a radical one. The entire political

spectrum supported United States involvement in world affairs. Henry Luce, speaking for the right, published his celebrated article "The American Century" in *Life* magazine in 1941, in which he called on the American people vigorously to seize world leadership. The century to come, he said, could be the American century as the nineteenth had been that of England and France. Conservatives approved this new direction in the MacKinac resolution. See Wendell Wilkie's best-seller, *One World*, New York, 1943.

13 Catalogue introduction to the First Exhibition of Modern American Artists at Riverside Museum, January 1943. This exhibition was intended as an alternative to the gigantic one organized by the Communist-dominated Artists for Victory. Newman's appeal for an apolitical art was in fact a political act since it attacked the involvement of the Communist artist in the war effort. Newman was joined by M. Avery, B. Brown, G. Constant, A. Gottlieb, B. Green, G. Green, J. Graham, L. Krasner, B. Margo, M. Rothko, and others.

14 Betty Parsons, interviewed by the author, New York, February 16, 1978.

15 Dwight MacDonald, "Truman's Doctrine, Abroad and at Home," May 1947, published in *Memoirs of a Revolutionist*, New York, World Publishing, 1963, p. 191.

16 The abstract art fashionable at the time (R. Gwathmey, P. Burlin, J. de Martini) borrowed classical themes and modernized or "Picassoized" them.

17 Greenberg, *Nation*, April 1947.

18 Greenberg, "Art," *Nation*, February 1, 1947, pp. 138–139.

19 For an analysis of the ideology of this position see S. Guilbaut, "Création et développement d'une Avant-Garde: New York 1946–1951," *Histoire et critique des arts*, "Les Avant-Gardes," July 1978, pp. 29–48.

20 Greenberg, "Art," *Nation*, March 8, 1947, p. 284.

21 M. Rothko, *Possibilities*, No. 1, Winter 1947/48, p. 84.

22 Clifford Still, letter to Betty Parsons, March 20, 1948, Archives of American Art, Betty Parsons papers, N 68–72.

23 Dwight MacDonald, October 1946, published in *Memoirs*, "Looking at the War," p. 180.

24 His article had an explosive effect since it was the first time an American art critic had given pride of place to American art. There were some who were shocked and angered by it. G. L. K. Morris, a modern painter of the cubist school, former Trotskyite and Communist party supporter, violently attacked Greenberg's position in the pages of his magazine. He went on to accuse American critics in general of being unable to interpret the secrets of modern art: "This approach – completely irresponsible as to accuracy or taste – has been with us so long that we might say that it amounts to a tradition." He ironically attacked Greenberg's thesis for being unfounded: "It would have been rewarding if Greenberg had indicated in *what ways* the works of our losers have declined since the 30's." Working in the tradition of Picasso, Morris was unable to accept the untimely, surprising demise of cubism ("Morris on Critics and Greenberg: A Communication," *Partisan Review*, pp. 681–684; Greenberg's reply, 686–687).

25 For a more detailed analysis of how events in Europe were understood by the American public, see Richard M. Freeland, *The Truman Doctrine and the*

Origins of McCarthyism, New York, Schocken Books, 1974, pp. 293–306.

26 Greenberg, "The Decline of Cubism," *Partisan Review*, March 1948, p. 369.

27 When Kootz reopened his gallery in 1949 with a show entitled "The Intrasubjectives," Brown and Holty were no longer with him. The artists shown included Baziotes, de Kooning, Gorky, Gottlieb, Graves, Hofmann, Motherwell, Pollock, Reinhardt, Rothko, Tobey, and Tomlin. It was clear what had happened: artists who worked in the tradition of the School of Paris were no longer welcome. In 1950 and 1951, Kootz disposed of Holty and Brown's work, making a killing by selling the paintings at discount prices in the Bargain Basement of the Gimbels department store chain. It was the end of a certain way of thinking about painting. The avant-garde jettisoned its past once and for all.

28 The ideology of individualism would be codified in 1952 by Harold Rosenberg in his well-known article "The American Action Painters," *Art News*, December 1952.

29 René d'Harnoncourt, "Challenge and Promise: Modern Art and Society," *Art News*, November 1949, p. 252.

30 Ibid.

31 See discussion in "Artist's Session at Studio 35" in *Modern Artists in America*, ed. Motherwell, Reinhardt, Wittenborn, Schultz, New York, 1951, pp. 9–23.

32 Arthur Schlesinger, *The Vital Center, Our Purposes and Perils on the Tightrope of American Liberalism*, Cambridge, Riverside Press, 1949, p. 52.

33 We should recall that at that time the power of the various anticommunist committees was on the rise (HUAC, the Attorney General's list) and that attempts were made to bar persons with Marxist leanings from university positions. Sidney Hook, himself a former Marxist, was one of the most vocal critics; see "Communism and the Intellectuals," *The American Mercury*, Vol. LXVIII, No. 302 (February 1949), 133–144.

34 See Max Kozloff, "American Painting during the Cold War," *Artforum*, May 1973, pp. 42–54 [Text 6].

35 Schlesinger, *Vital Center*, p. 208.

36 The new liberalism accepted and even welcomed the revitalizing influence of a certain level of nonconformity and rebellion. This was the system's strength, which Schlesinger clearly explains in his book. Political ideology and the ideology of the avant-garde were united: "And there is a 'clear and present danger' that anti-communist feeling will boil over into a vicious and unconstitutional attack on nonconformists in general and thereby endanger the sources of our democratic strength" (p. 210).

37 See Eva Cockcroft, "Abstract Expressionism: Weapon of the Cold War," *Artforum*, XII (June 1974), 39–41 [Text 7].

10 *Avant-Gardes* and Partisans Reviewed

Fred Orton and Griselda Pollock

An *avant-garde* does not simply emerge 'readymade' from virgin soil to be attributed *à la mode*. It is actively formed and fulfils a particular function. It is the product of self-consciousness on the part of those who identify themselves as, and with, a special social and artistic grouping within the intelligentsia at a specific historical conjuncture. It is not a process inherent in the evolution of art in modern times: it is not the motor of spiritual renovation and artistic innovation; and it is more than an ideological concept, one part of a complex pattern of imagery and belief. An *avant-garde* is a concrete cultural phenomenon that is realised in terms of identifiable (though never predetermined) practices and representations through which it constitutes for itself a relationship to, and a distance from, the overall cultural patterns of the time. Moreover, its construction and the definition of its function results from a broader discursive formation that provides the terms of reference by which artists can see themselves in this illusory but effective mode of difference, and by which others can validate what they are producing as somehow fulfilling an *avant-garde's* function. [. . .]

Modernist art history has evacuated the term's historical meanings, using it to signify an idea about the way art develops and artists function in relation to society. *Avant-garde* is now a catch-all label to celebrate most twentieth-century art and artists. '*Avant-gardism*' has become the pervasive, dominant ideology of artistic production and scholarship.[1] It instates and reproduces the appearance of a succession of styles and movements often in competition and each one seemingly unique and different in its turn. And like all ideologies, '*avant-gardism*' has its own structures of closure and disclosure, its own way of allowing certain perceptions and rendering others impossible. The illusion of constant change and innovation disguises a more profound level of consistency, a consistency of meaning for the *avant-garde* that results from the concrete history of real

Source: '*Avant-Gardes* and Partisans Reviewed', *Art History*, vol. 4, no. 3, September 1981, pp. 305–327. This text has been edited and footnotes have been renumbered. Reprinted by permission of Routledge & Kegan Paul PLC.

practices and postures which were first designated as a cultural *avant-garde* in Paris in the 1850s–1870s. [. . .]

Art, it was claimed, should have no aim but itself: art should use its own techniques to bring itself into question. This set of artistic practices and its aesthetic ideology can rightly be characterised as *avant-garde*. But the *avant-garde* means more than this. *Avant-garde* must also signify, as it did at its inception in the second half of the nineteenth century, a range of social postures and strategies for artists by which they could differentiate themselves from current social and cultural structures while also intervening in them. To be of the *avant-garde* was to participate in complex and contradictory tactics of involvement with, and evasion of, immediate forms of metropolitan social and economic life. That transitory period of engagement and disengagement can be called the *avant-garde* moment.

In this century there has been only one other, successful *avant-garde* moment when the *avant-garde* and the definition of appropriate *avant-garde* practices had to be, and was, revivified and re-articulated. This occurred in New York in the late 1930s and early 1940s when a new discursive framework was established that enabled some of the artists and intellectuals who gathered there to construct an identity for themselves which was simultaneously an opposition to, and an extension of, available American and European traditions. It provided them with the consciousness of a role and function through which they could engage with, and disengage from, the current social turmoil and ideological crisis. What concerns us here as historians of modern American art is the failure of art history to recognise this formation. Most historians of American art since the Second World War make no distinction between the influences – artistic or otherwise – on the development of Abstract Expressionism as a style of painting, and those decisive forces which shaped the consciousness of the artists and apologists involved in its production and ratification. Until these forces are mapped we shall not understand what it was that allowed those artists and intellectuals to regard themselves as an *avant-garde* and to be recognised as such in America and eventually in Europe.

In the celebratory histories of the American phase in the history of Modern Art the term *avant-garde* or vanguard is taken for granted. The opening sentences of Irving Sandler's introduction to his book on *The New York School: The Painters and Sculptors of the Fifties* (New York, 1978) are paradigmatic.

> From 1947 to 1951, more than a dozen Abstract Expressionists achieved 'breakthroughs' to independent styles. During the following years, these painters, the first generation of the New York School, received growing recognition nationally and globally, to the extent that American vanguard art came to be considered the primary source of creative ideas and energies in the world, and a few masters, notably Pollock, de Kooning, and Rothko, were elevated to art history's pantheon.[2] [. . .]

Sandler's conception of artistic production is a simple, threefold process. First, there is the creation of a new style in art. Thereafter, critical acclaim at home and abroad recognises the advancedness of those styles. Finally, those advances are situated in the history of art as a school with certain masters.

Sandler's art historical method is common enough. It is intentionalist and formalist, a history of style which is based on notions of individualism and multiple discovery. It manifests all the symptoms of '*avant-gardism*' in its inability to account for the *avant-garde*. In Sandler's history the *avant-garde* becomes commonplace, matter of fact, eternal rather than something specific or disputable. It is not surprising, therefore, that his major full-length study of New York painting c. 1942–52, *Abstract Expressionism: The Triumph of American Painting* (New York, 1970)[3] fails to identify the twentieth-century *avant-garde* moment, and does not consider how the *avant-garde* was formed and what it was formed for. Sandler's narrative of 'broader attributes of [this] process of stylistic change'[4] conceals the fact that a section of the New York intelligentsia was intensely preoccupied with the *avant-garde* in the late 1930s and early 1940s. No mention is made of the intervention which one member of that group, Clement Greenberg, made at that time in *avant-garde* theory and American intellectual – and, importantly with regard to Abstract Expressionism – artistic strategies. Greenberg has to be accounted for. Yet he is virtually absent from Sandler's discussion of the 1930s and he is misrepresented in the chapter wherein Sandler describes how 'A New Vanguard Emerges' in the early 1940s.[5] [. . .] Greenberg is never acknowledged as having been a part of the *avant-garde*, and his contribution to its formation in writings which were published prior to the appearance of Abstract Expressionism as a recognisable style is ignored. 'Avant-Garde and Kitsch', 1939, Greenberg's major article on the *avant-garde* is neither referred to in Sandler's text nor cited in his bibliography.[6] Sandler draws his notion of *avant-gardeness* from Greenberg's essay 'Towards a Newer Laocoon' which was published in 1940.[7] It is an important text but it is not about the *avant-garde*. [. . .]

Greenberg's first essay on the *avant-garde*, 'Avant-Garde and Kitsch', was published in *Partisan Review* in the Fall of 1939.[8] The article – an essay not on painting or sculpture but on culture – was Greenberg's considered contribution to a debate about the role and nature of revolutionary literature and art which was undertaken in this magazine between 1936 and 1940. *Partisan Review* was a literary magazine which had been founded in 1934 by William Phillips and Philip Rahv. The intention was for the magazine to publish the best writings of the New York John Reed Clubs,[9] to publish creative and critical literature from the viewpoint of the revolutionary working class. From the outset, however, the editors thought that it was wrong to make literature the vehicle for currently expedient political ideas. Literature should not just promote class struggle. Literary history had to be preserved even if it was largely the history of bourgeois authors writing for a bourgeois audience. As far as Phillips and Rahv were concerned, a literary theory derived from Marxism was an intellectual tool to be used to understand and preserve the best literature of the past while creating the basis for a new culture.

In July 1935 the Seventh World Congress of the Third Communist International defined the new Soviet policy of the Popular Front, an attempt to unite a broad spectrum of intellectuals in a common campaign against fascism which

would, moreover, favourably dispose non-aligned Marxists and liberals towards the Soviet Union. The John Reed Clubs were one of the first casualties of this redefinition of Soviet policy with its move away from revolutionary class struggle. They were disbanded and replaced by the League of American Writers, an organisation that was formed to provide the necessary framework to accommodate sympathetic intellectuals and a more flexible approach to literature.[10] Most of the radical little magazines who relied on the John Reed Clubs for literary and financial support were forced to cease publication. *Partisan Review* was critical of the Popular Front and remained committed to a revolutionary new literature. It managed to continue publication without becoming affiliated to the League but toward the end of 1936 it, too, folded. In December 1937 *Partisan Review* resumed publication, but with a different orientation.

To *Partisan Review* the 'death' of proletarian literature left the problem of the modern writer and intellectual with no adequate solution. How could revolutionary writers forge a new sensibility out of a reconciliation of Marxist ideology with formal or artistic experimentation? The events of 1935 (Popular Front) and 1936 (Stalin's purge of independent intellectuals and political enemies, the Moscow Trials) cast fundamental doubts on the integrity of Soviet communism. It seemed imperative to recognise and resist the degeneration of the Communist movement which had been responsible for the misdirection of revolutionary culture towards the policy of the Popular Front. This process is most evident in the magazine's reassertion of the theoretical purity of Marxism by a temporary identification with Trotskyism – a form of Marxism which appealed to the editors' highly intellectualised radicalism and clarified their objection to Communism. When *Partisan Review* resumed publication it did so independent and critical of the Communist movement. There were four new editors. Phillips and Rahv were joined by G. L. K. Morris (the painter and member of the American Abstract Artists) who provided much of the financing of the magazine until 1943 but had little to do with literary or political issues, and Fred Dupee (formerly an editor of the *New Masses*), Mary McCarthy (the novelist and poet), and Dwight MacDonald (who had been on the staff of *Fortune* magazine), who were all sympathetic towards Trotskyism. It was MacDonald who in late 1937 wrote to Trotsky – in exile in Mexico – on behalf of the editors outlining the policy of the magazine and requesting a contribution to a symposium on the theme 'What is Alive and What is Dead in Marxism?' [Trotsky replied doubting] the strength of *Partisan Review*'s conviction to rid itself of Stalinist influence. Towards the end of his letter, dated 20 January 1938, Trotsky wrote:

> A world war is approaching. The inner political struggle in all countries tends to become transformed into civil war. Currents of the highest tension are active in all fields of culture and ideology. You evidently wish to create a small cultural monastery, guarding itself from the outside world by skepticism, agnosticism and respectability. Such an endeavour does not open up any kind of perspective.[11] [. . .]

However, another, later request to Trotsky met with a positive response. His doubts about *Partisan Review* eased, he expanded his arguments in a letter dated 18 June 1938 which was published in August under the title 'Art and Politics'.[12] Much of 'Art and Politics' is devoted to an attack on the conception of art's func-

tion and the bureaucratic constraints on artistic practice in Stalinist Russia. Trotsky also addressed American artists for whom the immediate crisis of capitalism and the imminence of war, which might either produce or foreclose the potential for revolution, were pressing realities. Trotsky offered some ideas on the revolutionary role which artists and their art could play. [. . .] History had set a trap for the artist. Trotsky gave the October Revolution as an example. The October Revolution gave a magnificent impetus to all kinds of Soviet art. After the Revolution, however, a massive bureaucracy was formed which stifled artistic creation. According to Trotsky, art was basically a function of the nerves and demanded complete sincerity. This genuine art was impossible in Soviet Russia where art – official art – was based on lies, deceits and subservience.

For Trotsky, art, culture and politics needed a new perspective without which humanity would not develop. But, he maintained, this new perspective should not begin with or be addressed to, a mass base. A progressive idea only found its masses in its last stage. Trotsky maintained that all great movements had begun as 'splinters' of older movements. Protestantism, for example, had been a splinter of Catholicism and the group of Marx and Engels had come into being as a splinter of the Hegelian left. Movements in art occurred in the same way, and the more daring the pioneers showed in their ideas and actions, the more bitterly they opposed themselves to established authority which rested on a conservative mass base.

Trotsky regarded it as vital that art should remain independent of any authority other than its own rules and principles.

> Art, like science, not only does not seek orders, but by its very essence, cannot tolerate them. Artistic creation has its own laws – even when it consciously serves a social movement. Truly intellectual creation is incompatible with lies, hypocrisy and the spirit of conformity. Art can become a strong ally of the revolution only in so far as it remains faithful to itself.[13]

This view, which Trotsky had first put forward in *Literature and Revolution*[14] – wherein he had argued that a work of art should in the first place be judged by its own law, that is, the law of art[15] – was restated in the 'Manifesto: Towards a Free Revolutionary Art' in *Partisan Review*, Fall 1938.[16] The 'Manifesto' was published under the signatures of André Breton and Diego Rivera but it is generally agreed that the text is substantially Trotsky's. Here it was pointed out that certain conditions were required if art was to play a revolutionary role. Foremost among these was the need for a complete opposition to any restriction on artistic creation. The imagination had to escape from all constraint. However, the practice of art had to be undertaken in concert with political practice.

> It should be clear by now that in defending freedom of thought we have no intention of justifying political indifference, and that it is far from our wish to revive a so-called 'pure' art which generally serves the extremely impure ends of reaction. No, our conception of the role of art is too high to refuse it an influence on the fate of society. We believe that the supreme task of art in our epoch is to take part actively and consciously in the preparation of the revolution. But the artist cannot serve the struggle for freedom unless he subjectively assimilates its social content, unless he feels in his very nerves its meaning and drama and freely seeks to give his own inner world incarnation in his art.[17]

In February 1939 *Partisan Review* published an enthusiastic letter from Trotsky which was written in support of the 'Manifesto'.[18] Trotsky explicitly located the demand for artistic freedom in relation to Stalinist corruption: 'The struggle for revolutionary ideas in art must begin once again with the struggle for artistic *truth*.'[19] In relation to the current world crisis, reaction and cultural decline 'truly independent creation cannot but be revolutionary by its very nature, for it cannot but seek an outlet from intolerable social suffocation.'[20]

Thus Trotsky proposed a particular and historical relationship between art and bourgeois society in its state of aggravated contradictions and of art to social authority in general. Art requires a social base. Currently it depends on bourgeois society. At the same time it plays a liberating role in relation to it. Art cannot escape the present crisis or save itself. Art will wither if society withers. It is historically tied to those forces which will rebuild society – revolution. Art has to be considered in a dialectical relationship to historical forces and social forms, autonomous in pursuing its role but not independent of the society which sustains it. Art is a force through which humanity advances. It liberates by contributing progressive ideas and new perspectives on the world. But artistic progress cannot be prescribed in advance: it is not subject to bureaucratic contract or mass opinion. Art is therefore presented as a kind of 'advanced guard' on the level of culture and consciousness. In order to fulfil its function art must be free from external constraints. It may be dependent but it serves only by pursuing its own trajectory – specifically, not arbitrarily. Art's participation in revolution will not be accomplished by subservience to political bureaucracies, to fabricating and supporting party lines, but by its concern for its own human integrity.

During 1939 *Partisan Review* became increasingly concerned about conditions in Europe. In addition to the need to take a political stance opposing fascism and the imminent war, *Partisan Review* discussed the fate of western culture under this dual threat. The unsigned editorial, 'The Crisis in France', Winter 1939, described the special significance which Paris had as the 'eye' of modern European civilisation.[21] For a century the history of Paris had been the history of European politics, art and literature. It was there that 'the expression of the best integrated culture in modern times, the *avant-garde* . . . in art and literature' was born and survived.[22] Now that was threatened. The eye of western culture was dimming. If France went fascist, as seemed likely under the Daladier government,[23] the West could say goodbye to culture in all seriousness for a long time to come.

In the editorial of the Spring 1939 issue of *Partisan Review* titled 'War and the Intellectuals: Act Two', Dwight MacDonald appealed to intellectuals to resist the drive towards a second war.[24] Spuriously presented as a crusade for democracy the war was, in fact, a war in the interests of the capitalist ruling class and itself a product of capitalism. MacDonald insisted that support for the war under the banner of opposition to fascism abroad meant 'political and cultural submission to the ruling class at home'.[25] He restated opposition to the Stalinist policy of a united front against European fascism. American intellectuals seemed to have forgotten that there was a genuine alternative to capitalism and its wars – social revolution.

> The great objection to the war programme of the intellectuals is not so much that it
> will get us into the war – the bourgeoisie will decide that question for themselves . . .
> but that it is diverting us from our main task: to work with the masses for socialism,
> which alone can save our civilisation.[26]

Intellectuals who support the war claim to be concerned with the future of civilis-
ation; they think themselves to be on the side of the people. In effect, they are
aligning themselves with the bourgeoisie, with capitalism, in supporting the war,
in identifying the enemy as foreign fascism. According to MacDonald this
paradox results from the 'peculiar relationship of the intelligentsia to the class
struggle'.[27] By virtue of their not having a direct economic interest in one side or
another they can pose as 'disinterested', free from class loyalties, addressing
themselves to 'society in general'. However, like the small bourgeoisie from
which most intellectuals come, the intelligentsia does adopt class alignments. In
times of severe capitalist crisis they may side with the workers but more often they
follow the big bourgeoisie – which is now leading them into war. In this virulently
anti-war piece MacDonald calls on American intellectuals to ally themselves
with socialism to defend civilisation and to reoccupy their position which involves
the 'privilege – and duty – of criticising ruling class values'.[28]

The role and place of the intellectuals, the intelligentsia, was taken up by
Philip Rahv in his editorial 'Twilight of the Thirties' in the next issue of *Partisan
Review*, Summer 1939.[29] [. . .] Rahv argues that there are lessons to be learned
from the relationship of politics to literature, especially in the abuse of talent
which results when writers serve party machines and follow party lines. Politics
qua politics is neither good nor bad for literature which is none the less subject to
general processes of social determination. Literature cannot escape the influence
of its society, its history. At the present time politics is shaping its destiny. This
impact can be seen in the prevalence of a reactionary *Zeitgeist* which reflects the
two great catastrophes of the epoch, the victory of fascism and the defeat of
the Bolshevik Revolution. In America Rahv sees symptoms of this decline in the
emergence of a new gentility in literature, a cowardly and hypocritical pandering
to official public opinion, a patriotic regionalism celebrating America's bourgeois
history. In pointing to the ebb of creative energy and rapid decline in standards,
Rahv identifies an absence:

> This is the one period in many decades which is not being enlivened by the feats and
> excesses of that attractive artistic animal known as 'the younger generation'. With
> very few exceptions, the younger writers of today, instead of defying, instead of
> going beyond, are in fact imitating and falling behind their elders. There still are rem-
> nants, but no *avant-garde* movement to speak of exists any longer. . . . Everywhere
> the academicians, the time-servers, the experts in accommodation, the vulgarizers
> and the big money adepts are ruling the literary roost; . . . For more than a hundred
> years literature, . . . was in the throes of a constant inner revolution, was the arena of
> uninterrupted rebellions and counter rebellions, was incessantly renewing itself both
> in substance and in form. But at present it seems as if this magnificent process is
> drawing to a close.[30]

To speak of modern literature, Rahv argues, is to speak of a particular social
group created by the drastic division of labour which prevails under capitalism,
namely, the intelligentsia. [. . .] The intelligentsia is materially and politically

dependent on society and its classes, but the illusion of self-determination has enabled it to act and think independently of both masses and ruling strata and to produce moral and aesthetic values which oppose and criticise the bourgeois spirit. Thus Rahv proposes that the most typically modern literary tendencies have become articulate because of the supportive social framework provided by the relative detachment of intellectuals from a society basically hostile and indifferent to human or creative – i.e. non-commercial – values.

Modern artists have been criticised by socially minded critics of the right and left for their introversion and privacy, their aesthetic mysticism, their tendency to the obscure and morbid. Without these qualities – which are not derived from limitless self-confidence but from the group ethos, the self-imposed isolation of a cultivated minority – the modern artist could not have survived in bourgeois society. It is this isolation, ideologically translated into various doctrines – Rahv gives the theory of 'art for art's sake' as an example – which prevented the art object being drawn entirely into the web of commodity relations. The modern artist preferred alienation from society to alienation from herself or himself.

The effect of the crisis of the 1930s has been to undermine this. Weakened, the capitalist system withdrew the privilege of limited self-determination which it had previously allowed the intelligentsia. It could not afford an independent or even semi-independent class of intellectuals, and the intelligentsia could no longer make light of or disregard political beliefs or actions. It was drawn back into alliances with the ruling class. But which class was the ruling class – the decrepit bourgeoisie or the contending proletariat? The question momentarily posed by the events of 1917 had been elided by Stalinism with its political prescriptions for literature [. . .]

Rahv doubted whether a new *avant-garde* movement 'in the proper historical sense of the term' could be founded in the pre-war situation, but he was not prepared to write an obituary. This is hardly surprising. At its reappearance *Partisan Review* was conceived as a kind of 'international' of intellectuals who were devoted not to writing off the *avant-garde* but to redefining it, preserving it, and reproducing it. The editors, including Rahv, believed that cultural change could only be initiated by an international community of intellectuals and that the cultural epicentre – the *avant-garde* – of that community would be the Trotskyist intellectuals whose best work was being published in *Partisan Review*.

Partisan Review's discussion of the *avant-garde* was continued and developed in the next issue by Clement Greenberg in his essay 'Avant-Garde and Kitsch' [. . .] his first major piece of writing. It is strategically complex both in terms of why it was written and in what it argued. On one level it can be read as a contribution to the discourse within *Partisan Review* on art and revolution and cultural change, and on another level it can be seen as an attempt by a young writer to situate himself, or to have himself accepted within, the Marxist intelligentsia of New York. 'Avant-Garde and Kitsch' was both a discussion of the nature and function of the *avant-garde* and the author's means of access to it. It was his way of claiming space within an *avant-garde* at that formative moment. Greenberg was successful on both counts. In 1940 *Partisan Review* published another extended essay by him entitled 'Towards a Newer Laocoon' which, with

'Avant-Garde and Kitsch', provides the premises of his subsequent art writing, his apology for Abstract Expressionism and after. In 1941 he also became an editor of the magazine. He was brought on to the board by MacDonald – with whom he agreed on most important political and cultural issues – and stayed until 1943. In the same year that he became an editor of *Partisan Review* he also became the first art critic of *The Nation*, a position of considerable influence which he held throughout the decade. Within a very short period then Greenberg moved from the relative obscurity of his job in the customs service in the Port of New York, spare time writer and painter, and sometime attender at Hans Hofmann's School, to occupy a central position within the radical intellectual movement and cultural intelligentsia.

'Avant-Garde and Kitsch' was written for the specific historical context of the debates in *Partisan Review*. In 1939 it had tactical implications. However, it was able to transcend that immediate context. Although 'Avant-Garde and Kitsch' accords with *Partisan Review*'s Trotskyism it does not proselytise a self-evident Trotskyist position. At that time Greenberg thought that it was 'necessary to quote Marx word for word' not Trotsky.[31] Greenberg's address was to the diversity amongst the young New York and East Coast left intellectuals and to the much larger body of liberals and radicals of various shades of opinion who made up the readership of the magazine.[32] After the war its status and credibility changed. In the 1940s and 1950s America's anti-Communism made the work of those intellectuals and institutions who had been, like Greenberg and *Partisan Review*, anti-Stalinist and against Communism before the war acceptable and important. Greenberg and his work could be, and were mobilised for other projects. 'Avant-Garde and Kitsch', in particular, gained a currency and accessibility beyond that afforded it at the *avant-garde* moment. Moreover, Greenberg offered something novel in his discussion of the *avant-garde*. He considered not only what it was but what it was not. [. . .]

The article operates on two axes. It provides a particular historical perspective on western bourgeois culture since the mid-nineteenth century, and, critically, it addresses the contemporary condition of that culture. [. . .]

Greenberg provides a profile of the *avant-garde* not as an idea or as an artistic development. The *avant-garde* is a special socio-artistic intellectual *agency* through which culture can be advanced. Greenberg's characterisation implies a particular relationship between the artists who constitute the *avant-garde* and society which has need of such a special cultural instrument. Greenberg also writes of *avant-garde* culture. This was produced at a historical moment c. 1850 in and against a network of particular ideological, social and economic conditions. Thus, *avant-garde* refers to a novel *form* of culture produced in bourgeois society in the mid-nineteenth century and a novel *force* which advances and keeps culture at a high level. [. . .]

The *avant-garde* withdrew from both bourgeois and anti-bourgeois politics in order to keep culture alive and developing independent of extraneous directives from external masters. This does not imply a non-political position or political indifference but a necessary distance, a distinct function which the *avant-garde* accomplished by disengagement. The *avant-garde* was formed by that from

which it became separated. Politics gave it consciousness and courage but culture has its own spheres of activity and processes which are distinct from those of politics. Although revolutionary impetus provided notions of change and progress, and the impulse to move forwards and reject stasis, the form of cultural revolution was not to be dictated by it.

The aim of the *avant-garde* was to preserve, direct and advance culture, but this could not be achieved by arbitrary experimentation. The *avant-garde* functions by defining and pursuing the proper concerns of art. 'Art for art's sake' was one result of this impetus: subject matter or content were dissolved completely into form so that to all intents and purposes the processes and disciplines of art became the subject matter of art. Abstract or non-representational art followed on from this. [. . .]

The *avant-garde*'s methods are fully justified because they are the only means by which to keep culture progressing, to create the genuinely new, and to maintain high standards in literature and art. However, 'art for art's sake' – the *avant-garde*'s specialisation of itself – is a necessity which is not without its disadvantages. Many of those who traditionally supported and appreciated ambitious literature and art have been alienated because of the difficulty which the *avant-garde*'s preoccupation with art's own means and materials presents. Culture in the process of its development has never been a mass phenomenon. The *avant-garde* was never *economically* independent of bourgeois society but was tied to a fraction of its ruling class by an 'umbilical cord of gold'.[33] Now, *avant-garde* culture has begun to estrange some of that cultural élite on whose support it depended. The existence of the *avant-garde* is currently threatened by the erosion of its limited and inevitably select social and economic base; this undermines its confidence and courage and tempts it into Academicism.

There is also another threat to culture. Greenberg calls this *kitsch*, which is the popular, commercial art or literature that appeared at the same time as the *avant-garde*. *Kitsch* is a product of the industrial revolution which urbanised the masses of Western Europe and America and established what is called universal literacy. *Kitsch* is a commodity produced to satisfy urban populations that have become dislocated from traditional rural folk cultures and now enjoy leisure sufficient to be bored. The masses need entertainment and diversion. *Kitsch*, which is mechanical, formulaeistic and profitable, provides it. *Kitsch* offers vicarious experience and faked sensations. It does not demand of its audience the hard work which is required for the enjoyment of high culture. [. . .]

Kitsch is ersatz culture; it uses the debased and academicised simulacra of the mature cultural tradition as a reservoir for its tricks and strategems. It provides a short cut to what is inevitably difficult and demanding in living culture, in art and literature of a high order.

As a mass-produced commodity of Western industrialism *kitsch* has been exported to the whole world. It is a cultural form for the masses. *Kitsch* has been adopted as the official culture of totalitarian régimes in Nazi Germany and Soviet Russia where it is used to win the political support of the masses. [. . .] *Kitsch*, the cultural rearguard, has become a tool of political reaction.

'Avant-Garde and Kitsch' is a manifesto for the *avant-garde* in which Green-

berg plays off a description of the reasons for the historical formation of these two cultural products against the circumstances of culture and society in 1939. The *avant-garde* was originally a product of bourgeois society, but, in decline, capitalism is threatened by whatever of quality and progressiveness it is still capable of producing. Accordingly, in the current crisis of capitalism, the dialectic by which the *avant-garde* was formed in and against bourgeois society as a product of it and challenge to it, is resolved in a different manner. Now, Greenberg argues, the *avant-garde* must look to revolutionary politics, to socialism, not only for a new culture but for the preservation of living culture, of itself. The *avant-garde* can, in this way, be aligned with revolution.

In 'Avant-Garde and Kitsch' Greenberg drew a map of the forces and relations of cultural production in Western bourgeois society since the mid-nineteenth century in order to describe the constellation of those forces and relations in the present. Like Rahv, Greenberg could not point to the existence of an active *avant-garde* but he did indicate the necessity for it and describe how it might be formed.

'Towards a Newer Laocoon' which was published in July–August 1940 is in many ways the corollary to the arguments advanced in 'Avant-Garde and Kitsch'. In it Greenberg takes up issues which were summarily treated in the earlier piece such as imitation, the importance of the medium, and the historical significance of Cubism with reference to *avant-garde* painting. [. . .]

The article is presented primarily as a defence of abstract purism, abstract and non-objective painting, which rejects literature as a model for the plastic arts and therefore eschews overt subject matter. The purists had been dismissed as merely symptomatic of a cultist attitude towards art. Greenberg justifies their dogmatism and intransigence because it represents an extreme concern for the fate of art and a desire to conserve painting's identity. However, Greenberg argues that the claims made for abstract purism by its supporters and practitioners can be questioned on the grounds that they are unhistorical. He writes:

> It is quite easy to show that abstract art like every other cultural phenomenon reflects the social and other circumstances of the age in which its creators live, and that there is nothing inside art itself, disconnected from history, which compels it to go in one direction or another. But it is not so easy to reject the purist's assertion that the best of contemporary plastic art is abstract.[34]

Greenberg proposes an historical answer to the problem of the present supremacy of abstract purism. It can be seen as 'the terminus of a salutory reaction against the mistakes of painting and sculpture in the past several centuries' which resulted from a confusion, a tendency for the arts to imitate each other and their respective effects.[35] [. . .]

Visual artists had attained such technical facility and virtuosity that they could annihilate the mediums they worked in in favour of illusion. They could achieve not only illusionism but the effects attained in other arts, and they were especially tempted to become the stooges of literature, sacrificing the medium to literary subject matter and to the creation of poetic effects in the interpretation of that subject matter. [. . .]

The Romantic Revolution coincided with the triumph of the bourgeoisie and as a result a fresh current of creative energy was released into every field. In the visual arts frivolous literary subject matter was replaced by more sincere and powerful themes which necessitated new and bolder pictorial means. Temporarily the medium was brought back into the limelight but the exploration of it soon deteriorated into virtuosity and talent was perverted in the service of realistic imitation. [. . .] The legacy of Romanticism was a novel cultural phenomenon, Academicism, a stasis in which talented artists serviced bourgeois society with an art of realistic illusion required by sentimental or sensational literature.

Here Greenberg situates the formation of *avant-garde* culture, the successor to and negation of Romanticism, a product of bourgeois society but also a challenge to it. [. . .] In its Bohemian retreat the *avant-garde* strives to find 'adequate cultural forms for the expression' of bourgeois society.[36] This it does without succumbing to the ideological divisions within that society, its class conflicts and political struggles. The *avant-garde* also demands that the arts should be recognised as their own justification and not as vehicles or servants of society or politics. The major concern of the *avant-garde* is the preservation of art, and its exclusive responsibility is to the values of art. The *avant-garde* attempts to liberate painting and sculpture from ideas through which they are affected by current political struggles. It also tries to escape from the domination of literature, from the idea of art as communication, from subject matter in general, and from the concomitant disregard for the medium.

In an important aside Greenberg makes a distinction between subject matter and content. All art has content – it is neither empty nor meaningless – but subject matter is something extraneous which the artist has in mind whilst working. Content is a result, an effect of the work of art. Subject matter is a prior programme for it, something to be communicated to which the medium must be subservient. In place of subject matter the *avant-garde* strives to emphasise form and to insist on each art as an independent vocation, as craft and discipline, as something which deserves respect for itself not as a servant of social or literary communication.

In the subsequent paragraphs of this third section of 'Towards a Newer Laocoon' and in the whole of Section IV Greenberg's focus narrows to the internal history of *avant-garde* painting. He discusses the project of the *avant-garde* since the mid-nineteenth century and identifies two variants in it. The first variant is represented by Courbet – 'the first real *avant-garde* painter'[37] – Manet, and the Impressionists who stressed sensations as the basis for painting and who, with materialist objectivity, attempted to emphasise the medium of their craft. [. . .] Within this first variant of *avant-garde* practice the redemption of painting was accomplished by the erosion of subject matter through parody, indifference, detachment, or the inversion of the relative status of subject matter and medium. It also demonstrated the materialist emphasis on medium, visual experience and effect in painting.

The second variant of the *avant-garde* was also preoccupied with medium but investigated it for its expressive resources. It intended to express not ideas but sensations, the 'irreduceable elements of experience'.[38] This tendency held

several dangers, one of which was to tempt painting back into imitation. In this case it was not emulation of literature and its effects which was the danger but rather the emulation of music and to a lesser extent poetry. [. . .] The *avant-garde* in painting, learning from music, had to pursue the particular identity of the medium of painting. Painting had to attend to its own pure form; it had to identify the sensations by which its medium appealed and by which it was to be known and responded to as a distinct art. Its emphasis, therefore, was found to be on the physical, the 'sensory'. Music had appealed to the *avant-garde* because, in opposition to literature which was concerned with the communication of conceptual messages, it was pure, sensuous, abstract. In order to liberate painting once again from the imitation of effects it was necessary for the *avant-garde* to realise that music was not (or need not be) the only pure, sensuous, and abstract art form. [. . .]

According to Greenberg there has been an historical process taking place by which the confusion between several arts has been increasingly clarified. Each art has been defined in its particularity in terms of the discipline which its medium imposes on it and the effects that medium produces. It is the *avant-garde* which functions to preserve the specific identity of each art. In the visual arts the medium is physical: it produces visual sensations and such emotion as it conveys may be called, in the words of Valéry, an emotion of 'plastic sight'. But there is yet one more distinction to be made within the plastic arts. Painting must be differentiated from sculpture. Greenberg maintains that much of the history of the *avant-garde* in painting hangs upon the programme of excluding the sculptural and other related means of realistic imitation from painting. Chiaroscuro and modelling are abandoned. Line no longer delineates shape, contour or volume; it is treated as colour. Space and depth or fictive three-dimensional illusion are reduced as the planes become flattened, pressed together to meet on the real plane of the canvas surface. These moves constituted a decisive surrender to the problems and character of the medium particular to painting. The most crucial of these is the flatness of the picture plane which had, since the Renaissance, been consistently evaded by attempts to create the illusion of realistic space and the illusion of three-dimensional objects located in that space. The destruction of this pictorial space and with it the object 'was accomplished by means of the travesty that was cubism'.[39] Cubism represents the culmination of *avant-garde* moves to date and represents a decisive break with the past. But painting was not fully brought to abstraction by the Cubists. That was accomplished by subsequent artists, by the Germans, by the Dutch, and by the English and the Americans. Paris, hitherto the home of *avant-garde* culture, is not the centre of abstract art. Abstract art has now emigrated to London, and Paris is now the home of a regressive tendency in the arts towards literature and subject matter. This reaction, Surrealism, has to be omitted from Greenberg's notion of the *avant-garde*. It is here that his strategy becomes clear. Greenberg uses the phrase 'development of Modern painting',[40] which is a collective term for art produced within the various strands of the historical *avant-garde* in painting. But not all Modern painting is *avant-garde* – Modern painting and the *avant-garde* are not synonymous. In this penultimate section of the essay, Greenberg identifies what, within the category of Modern art

practices, is still, in 1940, of the *avant-garde* and capable of advancing culture.

In the concluding part of 'Towards a Newer Laocoon', Section VI, Greenberg clearly states that he has 'offered no other explanation for the present superiority of abstract art than its historical justification'.[41] He is adamant that abstract art is a justifiable product of the *avant-garde*'s necessary procedures for identifying and preserving the specific identity of painting as an art. There can be both *avant-garde* and reactionary tendencies in the arts; which is which is determined by the history of the *avant-garde* and the present condition of each art with regard to its traditions and conventions. Abstraction is only one of several contemporary tendencies in Modern art. It is historically the most significant and potentially the vanguard of *avant-garde* culture in painting. [. . .] In 'Avant-Garde and Kitsch' Greenberg appealed to history, especially to an historical moment in the mid-nineteenth century in order to identify a comparable moment and recognise a parallel need for a special agency, the *avant-garde*. In 'Towards a Newer Laocoon' he traces the internal history of the art produced by that *avant-garde*. Greenberg not only contributes to the reconstruction of an *avant-garde* consciousness, a need for the force, but he also specifies the form of *avant-garde* culture in painting. The two essays, in conjunction, point to a new moment, a rupture, and indicate a consistency that enables Greenberg to identify the course in painting which the *avant-garde* might take.

The polemic of 'Towards a Newer Laocoon' is directed at contemporary critics and artists who, favouring a return to the imitation of nature in art, oppose and repudiate abstraction. Greenberg was addressing a specific constituency in the cultural intelligentsia, the practitioners and apologists of visual art. His essay represents a strategic manoeuvre within the coterie of *Partisan Review*'s editors and readership. The debates in the magazine had hitherto been pursued either in general cultural terms or with exclusive reference to literature and cinema. In 'Towards a Newer Laocoon' Greenberg was attempting to define a special place for himself within the artistic community and to reconstruct an *avant-garde* position for painting.

Greenberg reminisced about the late 1930s in New York in an article published in 1957, 'New York Painting Only Yesterday'.[42] He wrote:

> Abstract art was the main issue among the artists I knew then; radical politics was on many people's minds but for them Social Realism was as dead as the American Scene.[43]

When this was republished in 1961 in the edition of his selected writings, *Art and Culture*, a parenthesis was added in which Greenberg made an oblique but crucial reference to the political climate and debates on art, revolution and the *avant-garde* in *Partisan Review* between 1937 and 1940.

> (Though that is not all, by far, that there was to politics in art in those years; some day it will have to be told how 'anti-Stalinism', which started out more or less as

'Trotskyism', turned into art for art's sake, and thereby cleared the way, heroically, for what has to come.)[44]

On to a Trotskyist claim for a special freedom for art, and for art as a form of cognition of the world and as a necessary precondition for the building of a new consciousness, Greenberg mapped one of the strategies of the historic *avant-garde*, 'art for art's sake', the steeping of painting in its own cause. In this transaction the momentary specificity of Trotsky's revolutionary perspective and Marxist vocabulary – some might say Trotsky's millenarianism – was erased. Opposition to prescribed subjects or functions for art – anti-Stalinism – was matched by a claim for the relative autonomy of artistic practices. This was then overlaid by the concept of a cultural *avant-garde* which, of necessity, fulfilled its social purposes at a distance from party politics and political organisation. Greenberg's participation in, and manoeuvres upon, that ideological terrain had the effect of clearing a space. He contributed to that moment by offering a special sense of group identity for some painters and by defining a function for a specific kind of painting.

Notes

1 N. Hadjinicolaou, 'Sur l'idéologie de l'avant-gardisme', *Histoire et Critique d'Art*, 1976, vol. 2, pp. 49–76.

2 I. Sandler, *The New York School: The Painters and Sculptors of the Fifties*, New York, 1978, p. ix.

3 Republished in paperback as *The Triumph of American Painting: A History of Abstract Expressionism*, New York, 1976.

4 I. Sandler, *Abstract Expressionism: The Triumph of American Painting*, New York, 1970, p. 1.

5 Sandler, op. cit. (1970), ch. 6, pp. 78–89. In Chapter I, 'The Great Depression', pp. 5–28, Sandler discusses New York art and artists in the 1930s. He quotes from Greenberg's later writings, using them only as a document or source of information, pp. 20, 23, 24. Greenberg is not discussed as a participant or formative figure in the intellectual and cultural milieu.

6 C. Greenberg, 'Avant-Garde and Kitsch', *Partisan Review*, Fall 1939, vol. VI, no. 6, pp. 34–49 [see Text 1]. Hereafter noted as *A-G & K*.

7 C. Greenberg, 'Towards a Newer Laocoon', *Partisan Review*, July–August 1940, vol. VII, no. 4, pp. 296–310 [see Text 2]. Hereafter noted as *TANL*.

8 See note 6.

9 The John Reed Clubs were founded in 1929 in memory of the American literary Bolshevik John Reed. For information on the Clubs see J. B. Gilbert, *Writers and Partisans: A History of Literary Radicalism in America*, New York, 1968, pp. 91–2, 108–9; and D. Aaron, *Writers on the Left*, Oxford and New York, 1977, pp. 221–30, 271–3, 280–3.

10 On the League of American Writers see Gilbert, op. cit., pp. 134, 138–40; and Aaron, op. cit., pp. 283–4.

11 Leon Trotsky, 'Letter to Dwight MacDonald', 20 January 1938, republished

in *Leon Trotsky on Literature and Art*, ed. by P. N. Siegel, New York, 1970, p. 103.

12 Leon Trotsky, 'Art and Politics', *Partisan Review*, August–September, 1938, vol. V, no. 3, pp. 3–10.

13 Ibid., p. 10.

14 Leon Trotsky, *Literature and Revolution*, 1923, first translated into English by Rose Strunsky and published in 1925.

15 Leon Trotsky, 'The Social Roots and Social Function of Literature' in *Literature and Revolution* (1923) reprinted in *Leon Trotsky on Literature and Art*, ed. P. N. Siegel, p. 37.

16 André Breton and Diego Rivera, 'Manifesto: Towards a Free Revolutionary Art' (translated by Dwight MacDonald), *Partisan Review*, Fall 1938, vol. VI, no. 1, pp. 49–53.

17 Ibid., pp. 51–2.

18 'Leon Trotsky to André Breton', 22 December 1938, *Partisan Review*, Winter 1939, vol. VI, no. 2, pp. 126–7.

19 Ibid., p. 127.

20 Ibid.

21 'This Quarter – The Crisis in France', *Partisan Review*, Winter 1939, vol. VI, no. 2, pp. 3–4.

22 Ibid., p. 3.

23 S. Niall, 'Paris Letter Christmas Day 1938', *Partisan Review*, Winter 1939, vol. VI, no. 2, pp. 103–7. For instance, Niall wrote (pp. 103–4): 'A spectre is haunting France – not, alas, the spectre of Communism, but that of internal fascism and external war . . . for politically conscious artists are already sufficiently distressed by the conviction that Daladier bears a more sinister resemblance to one Heinrich Brüning than to the Napoleon Bonaparte he apparently fancies himself to be, without having a quiet art weekly suddenly burst into reactionary howls against artistic progress which are unnervingly reminiscent of that 'Anti-Kultur-Bolshewismus' movement which, similarly born in 1932 Berlin, grew like a rank weed till, with Hitler's accession to power, it finally succeeded in entirely strangling German culture.'

24 D[wight] M[acDonald], 'This Quarter – War and the Intellectuals: Act Two', *Partisan Review*, Spring 1939, vol. VI, no. 3, pp. 3–20.

25 Ibid., p. 10.

26 Ibid.

27 Ibid., p. 19.

28 Ibid., p. 10.

29 P. Rahv, 'This Quarter – Twilight of the Thirties', *Partisan Review*, Summer 1939, vol. VI, no. 4, pp. 3–15.

30 Ibid., p. 5.

31 Greenberg, *A–G & K*, p. 49 *[32]*.

32 See Gilbert, op. cit., pp. 195–7 for discussion of the results of a questionnaire sent out to subscribers and readers in 1941: 35 per cent were found to live in New York and 50 per cent were spread out over the East Coast. 'But in general the magazine was directed to the radical intellectual community of New York' (p. 197). See also L. Fiedler, 'Partisan Review' – Phoenix or Dodo? – The Life History of America's Most Influential Cultural Magazine', *Perspectives*, Spring 1956, vol. 15, p. 84.

33 Greenberg, *A–G & K*, p. 38 *[24]*. The notion stems from a text by Joseph

Freeman, *Proletarian Literature in the United States*, New York, 1935, p. 20.
34 Greenberg, *TANL*, p. 296 *[35]*.
35 Ibid.
36 Ibid., p. 301 *[39]*.
37 Ibid., p. 302 *[39]*.
38 Ibid., p. 303 *[40]*.
39 Ibid., p. 308 *[44]*.
40 Ibid., p. 309 *[45]*.
41 Ibid., p. 310 *[45]*.
42 C. Greenberg, 'New York Painting Only Yesterday', *Art News*, Summer 1957, vol. 56, no. 4, pp. 58–9, 84–6.
43 Ibid., p. 58.
44 Reprinted as 'The Late Thirties in New York' in *Art and Culture: Critical Essays*, 1961, p. 230.

III

MODERNISM: HISTORY, CRITICISM AND EXPLANATION

Introduction

In 1967 Clement Greenberg wrote:

> I, who am considered an arch-'formalist,' used to indulge in . . . talk about 'content' myself. If I do not do so any longer it is because it came to me, dismayingly, some years ago that I could always assert the opposite of whatever it was I did say about 'content' and not get found out; that I could say almost anything I pleased about 'content' and sound plausible.[1]

This is an important lesson for anyone interested in the explanation of art. It is a warning against the 'reading in' of 'content', emotion, or the moral wishes and ideals of the spectator of a work of art. The issue for Greenberg is *relevance*. To be relevant when characterizing a work of art requires a submission to the disinterested and immediate experience of the 'work itself'. This submission does not necessitate seeing the work as produced or caused,

> But given the point that what works of art are *of* is causally determined, his implications have to be denied. . . . Briefly, it can be stated that 'aesthetic experience' – *whatever* it can be taken to mean – *has* to be seen as a cultural category and not as a natural category.[2]

For Baldwin, Harrison and Ramsden, a critique of the *cognitive adequacy* or *theoretical power* of Modernism requires the use of tools provided by logical and linguistic analysis in the Anglo-Saxon philosophical tradition. These need to be used, as they acknowledge, alongside those forms of historical materialist analysis which avail us of a critique of Modernism's *non-cognitive agency*.[3] The first of the texts in this section examines certain concepts and procedures in pursuit of this project. The second text aims to characterize the history and development of Modernist theory by means of an approach interested in the same project, and to address the circumstances of English and American art in the fifties and early sixties 'as they may be perceived against this theoretical ground'. It may be noted that Greenberg, particularly in the latter text, emerges with considerable intellectual credit, for it is fair to say that for Harrison, however one 'moralises the

development of Greenberg's criticism through the late thirties into the sixties, . . . no art critic at the time did more to preserve the integrity of the modern tradition' even though 'a high price was paid'.[4] This may be translated as 'no critic did more to elaborate the Modernist paradigm into a coherent theory.' We must, though, be open to the possibility that the position acknowledged by Greenberg in his 'Complaints of an Art Critic' in 1967 was not simply the product of some intellectual debate which was separate from any moral, social and political contingencies. The preservation of the 'integrity of the modern tradition' cannot be divorced from the preservation of other interests consistent with the ideological position of the social class of the intelligentsia in America from the 1930s onwards; to divorce them is to deny the explanatory force of either an historical materialist analysis, or that provided by Kuhn's notion of paradigms.

If Modernism is 'the system of shared ideology and propaganda' produced 'through the modes of distortion developed by substantial segments of the intelligentsia', then an analysis of it needs to be philosophically adequate and clear of the defence of special interests, *whatever* they may be. In the final analysis, though, an account of 'actual events' is a *produced* representation which may only be theoretically and methodologically defensible if there is a conscious admission and awareness of the interests of the historian.

As T. J. Clark states, we need an art (and an art history and art criticism) which

> poses to itself the problems of modernism's place, limits, historical situation and responsibilities, and which tries to integrate those limits within its formal practice . . . the practice of Art & Language, for all its erratic, strange and at times mannerist proceedings in the 70s, I see as a serious practice, directed at the problems of modernism . . . Modernism is our resource. We may have problems with it. We may in some ways be, or feel ourselves to be moving towards the outside of it, but it's our resource. We cannot do without it. We are not somewhere else.[5]

Clark here refers to 'modernism' with a small 'm' as a description of forms of art *practice* in the modern period (see Text 5) which needs to be distinguished from 'Modernism' with a capital 'M' which refers to that body of critical theory and historical explanation consistent with the views put forward in Greenberg's 'Modernist Painting'. Yet, in a sense, for our position the two are now closely linked within the dominant forms of the post-war system of 'shared ideology'. To understand our place, limits, historical situation and responsibilities we need work of intellectual and historical rigour. We need to investigate the origins and development of those practices which are perceived as paradigmatic. This requires that work not only such as that in 'Art History, Art Criticism and Explanation' is done but also that which is represented by Thomas Crow's 'Modernism and Mass Culture in the Visual Arts'.

An analysis of the origins of a critical paradigm, including consideration of the nature of the discursive framework which articulated the breakdown of the preceding paradigm, assists us in a critique of its cognitive adequacy and non-cognitive agency. This is necessary work which requires the development of a competent analysis, which is both theoretically and historically rigorous. Anything else would be to replace one system of shared ideology with the modes and

distortions developed by the agents – the intelligentsia as a 'social class', and the representatives of the *rentier* class in developed capitalism – of another.

Notes

1 'Problems of Criticism II: Complaints of an Art Critic', *Artforum*, **VI**, no. 2, October 1967, pp. 38–39.
2 'Art History, Art Criticism, and Explanation', p. 434, See Text 11, pp. 193–194 for full reference.
3 See the introduction to Harrison and Orton (eds) *Modernism, Criticism, Realism* (London and New York, Harper & Row, 1984), especially p. xxiii.
4 Ibid., p. xii.
5 Contribution to 'General Panel Discussion' in *Modernism and Modernity: The Vancouver Conference Papers*, edited by Benjamin H. D. Buchloh, Serge Guilbaut and David Solkin (Halifax, Nova Scotia, The Press of the Nova Scotia College of Art and Design, 1983, p. 277).

11 Art History, Art Criticism and Explanation

Michael Baldwin, Charles Harrison and Mel Ramsden

The aim of this paper is to show that the practice, history and criticism of art must be open to conversation, that it must have some discursive, rather than merely liturgical, aspect in relation to others, and that it must be adequate in respect of the mind-independent world, if it is to have a history rather than to exist as mere anecdote or as a function of historicism. It also needs to be shown why it should be important to make this point; that is to say a characterisation of normal art discourse as dogmatic, self-certifying and comparatively empty of real explanatory content needs to be given and defended.

There may be those whose sense that they are neither critics nor Modernists will seem to offer some reassurance in the face of such a characterisation. And it is indeed the case that the historian of Renaissance art, for instance, can nowadays at least find a few decent books to read. But how art is *in general* interpreted is an aspect of how it is generally seen as produced, and the prevailing modern models of interpretation and explanation, by which the conditions of production of art are obscured and mystified, are by now sufficiently well entrenched to afflict most discussion of most art.

The proper concerns of the majority of discourse about art might be characterised in terms of fuzzy families of questions. Apart from those which might reasonably be satisfied by factual-type answers, like date, dimensions, location and so on, the substantial questions will be related to one or more of the following: What is it? To whom is or was it addressed? What does it look like? What is it *of*? or What does it represent or signify? What does it express? or What is its meaning? and Is it any good?

Source: 'Art History, Art Criticism and Explanation', *Art History*, vol. 4, no. 4, December 1981, pp. 432–456. © Charles Harrison. This article is an edited version of a paper delivered by Charles Harrison to the Association of Art Historians Conference on 3rd April 1981. The paper summarised some recent discussions within, and publications by, Art & Language. This text has been edited, and footnotes have been renumbered.

It is a convention of our empiricist world that history or historians eschew the transient matter of value, which is seen as the critic's concern. It might be thought that a historian with explanatory-type pretensions or aims must eschew the matter of value *a fortiori*. This is not the case. A concentration on the last of the above list of questions serves only speciously as a line of demarcation distinguishing critics from historians. This paper is not concerned with the fugitive professional distinctions between critics and historians of art, but rather with those concerns and activities they have in common. The principal unifying practices have normally been those of interpretation and explanation, and it is on these that we should therefore concentrate. It should become clear why the issue of judgments of 'quality' – which may be taken as an artistic term for value – seems to be subsidiary in the face of a concern with explanation. Suffice it to say, for the moment, that explanatory-type discourse has itself to be considered as value-impregnating.

In normal art-historical discourse the interpretation of a work of art – the recovery of its meaning – has been thought to hinge upon the questions, 'What is it *of*?' or 'What does it represent or signify?', and 'What does it express or mean?' These questions are plainly connected or homologous or identical. They have generally been seen as distinct from the question, 'To whom is it or was it addressed?' This may turn out to have been a mistake.

Of

If anyone is still labouring under the delusion that what a picture looks *like* is necessarily what it is *of*, they are referred to Nelson Goodman's *Languages of Art*,[1] where the confusion between the two is decisively sorted out. Briefly, a portrait which happens to look like Arthur Scargill* may not be *of* Arthur Scargill, and given the information that it is actually *of* Keith Joseph,** we are plainly better occupied in searching it for the *nature* of its resemblance to Keith Joseph, or even for reasons for its apparent *unlikeness* to him, than in complaining that it looks like Arthur Scargill. Of course, given the right circumstances it could be *of* Arthur Scargill as well. For instance, a satirical purpose might render an apparent likeness to Arthur Scargill highly significant in a portrait of Keith Joseph.

The acknowledgment of such a possibility is not unduly complicated. Indeed, it could be said that the very point about the activity of representation is that it makes possible just such manipulation of referents. We have grown accustomed to blue nudes, soft watches and moustachioed Mona Lisas, but it has *always* been important to the construction of pictures that the mapping-on of characteristics and aspects is a normal, indeed virtually indispensable function of the inculcation of meaning.

Given this acknowledgment, likeness can be seen as a distracting vagary. The

*Arthur Scargill, President of the National Union of Mineworkers.
**Keith Joseph, Conservative Member of Parliament who has held several Cabinet offices.

question of what a picture is *of* is far more substantial; that is to say it demands that we inquire into the *causes* of its specific appearance, those features of the world, things, people, events, ideas, practices or other works of art, to which the picture is causally connected. A portrait is of Keith Joseph by virtue of his having featured somehow in the chain of causes leading to its production, and *not, prima facie*, because it happens to look like him.

It should be made clear that we are not here talking of a cause simply as an action by contact, in the sense that one billiard ball by its impetus may be said to cause movement in another, nor of causal explanations of the type, 'The First World War was caused by the assassination of the Archduke Ferdinand at Sarajevo', all too lamentably common as these are in the work both of students of art history and of many of those who claim to be their teachers. The relevant sense of cause is given in the following example. To say that someone's being a trade unionist may be a cause of his voting Labour is not to claim that all trade unionists vote Labour. We are talking about real and law-like *tendencies*, but these are not such as to be coercive or to imply constant conjuncture of 'being a trade unionist' and 'voting Labour', or to rule out explanations in terms of the operation of other causes, mechanisms or tendencies.[2] All occurrences – and *a fortiori* all works of art – are multiply caused, which means that they exist as and in open systems.

What, then, is to *count* as a cause? What do we need to take into consideration in explaining the specific appearance and tendency of a work of art, and in recovering its meaning? According to Clive Bell – writing in 1914, but still echoing through the dingy corridors of myriad art schools and art departments – 'To appreciate a work of art we need bring with us nothing from life, no knowledge of its ideas and affairs, no familiarity with its emotions . . . nothing but a sense of form and colour and a knowledge of three-dimensional space.'[3] This is virtually to say that we do not need to see the work of art as caused or produced at all. Or are appreciation and understanding not connected?

Clement Greenberg has offered a more sophisticated version of this.

> Esthetic judgements are given and contained in the immediate experience of art. They coincide with it; they are not arrived at afterwards through reflection and thought

And later in the same article:

> I . . . used to indulge in . . . talk about 'content' myself. If I do not do so any longer it is because it came to me, dismayingly, some years ago that I could always assert the opposite of whatever it was I did say about 'content' and not get found out; that I could say almost anything I pleased about 'content' and sound plausible.[4]

Greenberg is always harder to pin down, and easier to underestimate than many of his less intelligent critics seem to suppose. The word 'content' in this passage is carefully scare-quoted. But given the point that what works of art are *of* is causally determined, his implications have to be denied. What he is saying is not that questions about the causes of meanings in pictures are impossible or necessarily irrelevant, but rather that they are undecidable, and that such inquiry is therefore fruitless in accounting for aesthetic experience, which itself is somehow naturally

'given'. (Given to whom? we might ask.) The argument against this position is an argument against the means of identification of aesthetic experience as a separate and ineffable category somehow distinct from other types of cognitive and non-cognitive activity. If any are in doubt as to the validity of this counter-argument, they are again referred to Nelson Goodman, specifically to his article on 'Art as Inquiry'.[5] Briefly, it can be stated that 'aesthetic experience' – *whatever* it can be taken to mean – *has* to be seen as a cultural category and not as a natural category. This entails that it *cannot* be independent of knowledge, reflection, thought or interest.

What is at issue is just where the range of possible causes is closed off in the inquiring practices of art criticism and art history. That *The Story of Art* can be considered as a feasible project, for instance, presupposes that *some* closures operate to circumscribe inquiry and explanation. It presupposes Art as a distinct category with a story properly its own. The achievements of the author of *Art and Illusion* are indeed indispensable, but it has to be said that, along with the great majority of even sophisticated western aestheticians, Gombrich has mostly kept his hands clean of the nasty social sciences by making the assumption that what comes up for the count *as* art is what has stood the test of time. That is to say that he has tended – at least until recently – to accept the operations of the connoisseur and the critic as prior to those of the historian in deciding what is to count as a subject.

There is indeed some satisfaction to be drawn from the prospect of the former Director of the Warburg Institute enthroned on the beach of art history in a noble attempt to repel the flowing tides of social science and epistemological relativism.[6] But in evading any consideration of the possibility of false consciousness Gombrich was bound to ignore the extent to which specific interests might at some point have determined the nature of his subject matter; unless, that is, the operations of the connoisseur and the critic are to be seen as interest-free, or as only determined by properly cognitive interests and by the pursuit of empirically adequate knowledge. For the underlying assumption of *The Story of Art* – of almost *any* presently conceivable Story of Art – is that what the critic and connoisseur have been in a position to single out is what a work of art ontologically *is*, and what it is *of*; that its meaning has somehow been fixed by their operations into a coherent tableau; or at least that inquiry into what the work of art is *of*, and thus into the conditions of its production, takes place in terms of the interpretations which have initially been fixed by the critic and connoisseur in their roles as transcendental consumers. They have been allowed to decide not just *what* will stand the test of time, but what that residue is to be seen *as*. This is to say that they transmit a culture – a set of interpretations and meanings and meaning-horizons – not just a set of 'neutral' objects on which open inquiry is then somehow possible.

The danger is that the art historian will then search for just those causes which will ratify their subject matter *as* their subject matter and as an aspect of *their* culture. Or, to put it another way, that inquiry into conditions of production – even where it appears to be conducted in a spirit of historical materialism – will in fact be limited by presuppositions about what have counted and will count as the con-

ditions of interpretation or as 'meaning'. To do this is to put the cart of 'meaning' and understanding before the horse of reference and explanation.

Within a framework thus determined by the connoisseur – the paradigm sensitive contemplating observer – statements such as 'He did it for the money' are accorded the perlocutionary status of fouls and the cognitive status of noises-off, and are ruled out as types of explanation of how proper works of art are caused, and thus, in part, of what they are *of*. Whatever such rude statements are taken to refer to is *not* what the sensitive observer takes the work of art to be and to mean. He needs to be able to see it *as* so-and-so, and as caused by so-and-so, in order that others of his beliefs and assumptions should remain tenable. Only in the case of works already put beyond the Pale, already put outside the limits of the sensitive observer's world, are such vulgar explanations as 'He did it for the money' allowed as confirmations of derogatory assessments.

For the self-employed speculator or the tenured academic – motivated, no doubt, by the great concerns of civilisation and a desire for the advancement of culture – 'He did it for the money' may indeed seem a simple-minded and vulgar statement. But isn't it possible that the same statement is a far more complex expression for the wage-earner who would willingly acknowledge that his or her *own* life is structurally determined by just such a necessity? To be able to see the production of the work of art as determined in ways commensurate with one's own social existence and self-consciousness and needs is, after all, a prerequisite for the recovery of some meaning. According to one of the most important, and surely most secure, theses of Marx, the production of the means to satisfy basic needs is the primary historical act of human existence.[7] From a historical-materialist point of view, whatever art means it *cannot* be constituted in such a way as to rule out 'He did it for the money' as a form of explanation, since, in the historical-materialist picture of the modern world, *no* form of production is so constituted.

Of course, to make this point hold, we have to be able to see the artist as a type of producer. We assert, dogmatically, that artists *are* producers;[8] and it should follow as a consequence that the operations of the critic and connoisseur, of whatever persuasion, cannot defensibly be taken as prior to those of the historian in the production of explanations.

So much, for the moment, for the question of what pictures are *of*.

Expression

We return to the second question which must feature in interpretation and explanation of the work of art, namely 'What does it express?'[9] In the context of twentieth-century art, and *a fortiori* of twentieth-century art criticism, this question has assumed a structural importance. The prevailing theories of art are expression-theories of one kind or another. We may recall that 'expressionism' was considered by Roger Fry as a possible designation for what came to be incorporated as 'Post-Impressionism', and that more recently Clement Greenberg asserted of those works gathered together under the label of 'Post-Painterly

Abstraction' that these paintings stand or fall as vehicles for 'the expression of feeling'.[10] And even today you can't spend long in any art school Fine Art department without hearing an admonition to some poor student to 'express himself/ herself'.

Of claims as to what pictures express, a similar argument may be used as that which addresses the question of what is entailed by claims about what they are *of*. The point at issue is just how, or by whom, the expressive referents of works of art are fixed. According to the prevailing Modernist view – from the ubiquitous Roger Fry on down to the egregious Peter Fuller – the work of art carries its immanent expressive meaning to the sensitive observer across cultures and down the ages; in the one case by virtue of its 'formal strength' and 'purity' (whatever these may mean), in the other by virtue of its rootedness in those 'relative constants', the great themes of the psycho-biological human condition as specified by Sebastiano Timpanaro.[11]

The Modernist thesis is that 'although the past did appreciate [the old masters] . . . justly, it often gave wrong or irrelevant reasons for doing so.'[12] Michael Baxandall has made the point that the gown which is cast off in Sassetta's panel of St Francis renouncing his heritage is 'an ultramarine gown'; this is to say that to a contemporary spectator – and more specifically to the friars of Sansepolcro who had had to fork out for the lapis lazuli – the specific pigment used for this part of the picture would have served to make it symbolically and literally clear that something materially costly was being cast aside.[13] To Roger Fry and his epigones, for whom form and colour are above all to be perceived as autonomous expressive resources, such types of meaning, in so far as they are aware of them at all, are ruled out as 'unaesthetic' and 'unartistic'. The conditions of production which served to secure meaning for the fifteenth-century spectator are thus idealised away in the conditions of interpretation of the Modernist explainer, confident as he is that what speaks to him is what matters historically.

This is the climate in which we live. The expressive referents of pictures are most commonly fixed for us by those whose authority derives not so much from real research, as from a self-certifying confidence in their own sensitivity, or, as the tedious tribe of art-school teachers would have it, in their possession of that fictional category, 'visual awareness'. Such sensitivity and such awareness are developed with practice apparently, where they are not God-given, as necessary professional qualifications of those concerned with art. So far as the aspiring critic or art historian is concerned, the requirement is to 'practise looking'. You have to 'really look at the picture'.

Yes indeed. But given differences in culture, in psychology, in interests, etc., there is no guarantee that any two observers, however conscientious and prolonged their scrutiny, will be in agreement as to what they see, let alone about what they see it *as* and as representing. In a sample group of forty students who examined a projected slide of Piero della Francesca's *Flagellation* for ten minutes, no two were in agreement as to the depth of the fictional picture space, and the range of answers ran from 8 to 300 feet.[14] Piero's picture was partly determined by a burgeoning ambition that criteria of competence in artistic represen-

tation should be associated with criteria of accuracy and with the possibility of measurement; that is to say, you can actually work this picture out within reasonable tolerances, as Carter and Wittkower have shown.[15] What hope then for agreement as to the reading of an Analytical Cubist still life, or a Rothko, or a Francis Bacon? Is an untutored but sensitive contemplation of any of these supposed to yield some single authentic expressive meaning? The idea is manifestly ludicrous, though widespread. It needs to be recognised that those who *look* at works of art, like those who make them, are engaged in a representational activity, which itself has multiple causes and determinations and ends, some shared, some inevitably marked off by differences in psychology, experience and interests. The Modernist might perhaps reply that the authentic reading is provided by the person who is indeed disposed towards, and experienced and interested in aesthetic experience. But he can't have it both ways. He can't then claim with any plausibility that aesthetic experience, and the objects of aesthetic experience, are in any way to be included in natural or transcendental categories. He will have to try though. His best hope is that no one will notice the implausibility of identifying universal experience with the contingently produced experience of a minority.

What actually happens is that some reading by an observer taken as authoritative, or a meaning somehow negotiated within a community of enthusiasts, becomes what the picture is seen to express; or rather, that the achievement of seeing the picture as expressing so-and-so comes to be taken as a test of the 'sensitivity' of any lay observer. Such procedures are clearly and inevitably transmitted in the teaching of art history.

That supposedly basic teaching routine, the compare-and-contrast exercise, founders in this quagmire. The very combination of any two elements, any two pictures, presupposes a set of assumptions about how they are to be connected. The successful student is the one whose 'correct' observations demonstrate a potential professionalism, a willingness to be institutionalised by the assumptions of his mentors. Yet what is given in the setting of such exercises, and what is inquired about and stated in their performance, goes all too rarely to those aspects of the pictures conjoined which have actually determined their production, and which might therefore be considered as sine qua non in any discussion of representation, expression and significance. Once again, those assumptions about meaning which determine the grounds for comparison misdirect or circumscribe inquiry into the conditions of production.[16]

As regards normal claims about what pictures express, the essence of the problem is this: first, it is assumed that what a picture expresses is somehow to be decided by the ideal sensitive observer in terms of its 'visual appearance', and in isolation from any information about how it was produced; second – and this is practically entailed by the first point – that the sensitive observer's statement about what he observes and 'feels' is identical with what the picture expresses. To put it simply, the statement, 'This is what I *feel*', is seen as equivalent to the statement, 'This is what the picture *expresses*.'

There are a number of possible meanings of statements like 'This picture p expresses sadness.' What is meant by this statement is often 'This picture p makes me feel sadness', sometimes 'This picture is thought by me (and etc.) to

express sadness', sometimes in the sense that 'What is depicted (e.g. a person) is sad', sometimes that 'This picture has the expressive effect of sadness', etc., etc. These various possibilities imply various conceptions as to the sort of symbol p is, as to the dependence or independence of expression with respect to the onlooker, and so on.

Let us consider first the critical circumstances in which 'p expresses s' is taken to mean 'p expresses s irrespective of (or possibly in respect of) any (or some) cognitive or emotive state s caused by the symbol p in the critic'. In practice, what often happens is that critics establish expressive meanings by virtue of their own stipulative power. They constitute the possibilities of the 'fixing of reference', so to speak. What occurs in this mechanism is the conventionalisation of, or near conventionalisation of, expressive symbols. The force of the idea of expression gets lost. (This is not to say, however, that expressive symbols are never deposited in a culture as conventions. And obviously expressive things are symbolic. They form part of, or are, a system of signification.)

What is lost or obscured is the indexicality of expressive symbols. Or rather, the fact that at some point the *claim* that p expresses s entails the indexicality of p – its causal character. There is a tendency in criticism to make an abstraction of the expressive relation. The constitutiveness of the critic's account renders it incorrigible.

Another way that expression claims are grounded is in terms of 'p makes me feel sad'. This faces worse difficulties in respect of the above analysis, *mutatis mutandis*.

In view of the foregoing it should be clear that the two statements 'This is what I feel' and 'This is what the picture expresses' are *not* equivalent; or at the very least that we have no grounds, *a priori*, for assuming that they are or that any natural mechanism connects them. Nor is this problem solved by modern cinéaste semiologists like Christian Metz with the idea that the work of art is ontologically a kind of 'text' somehow 'co-produced' by author and spectator, since this tells us nothing about how the resulting 'reading' is to be evaluated as a naturalistic explanatory claim.[17] As regards the observer, how does he *know* that what he feels has been caused by the picture, rather than by a headache, by the rise in the bankrate, by something he read about the picture, or by something he read about the artist, or by assumptions about art or aesthetic experience in general? Is aesthetic experience so unlike all other forms of experience that it is incapable of admixture with them or of being multiply caused and determined, and therefore of being itself explained? And as regards the picture, unless what we mean by 'a picture' is some bundle of indices to our own psychological properties, the meaning it has – what it expresses – is what there was *cause* for, independently of our minds and interests. We may represent it to ourselves, but this does not mean that we make or reproduce it. For representation is an activity directed by our own aims and interests.[18]

If a meaning has been deposited in a work of art, then art history must ask *how* that meaning was possible and how it was possibly produced. It is not enough just to 'uncover' it. What a work of art means is determined by what it is *possible* that it means, and to inquire into the determinations on meaning and expression is

therefore to inquire into real and possible causes – to do some historical work. A claim about what a work of art expresses can only be defended to the extent that statements about its history can be defended. Claims about what a picture expresses are no more than autobiographical statements unless they are claims about how that picture was produced. The world of art is infested with people all too eager to volunteer autobiographical statements as if these counted as real explanations. [. . .]

The Trobriand Island problem

Our aim up to this point has been to show that both inquiries into what works of art are *of*, or what they represent or signify, and inquiries into what they express or mean are properly inquiries into causes, and that explanations of representation and expression are properly claims about how works of art have been or are caused and produced. What follows is a characterisation of a type of study in which interests in cause are inhibited by an interest in 'understanding'.

Our metaphor is borrowed from the field of Social Anthropology. It was suggested by Alasdair MacIntyre's essay on 'The Idea of a Social Science', which in turn was largely written as a review of Peter Winch's book by the same name.[19]

Imagine an anthropologist – a structuralist if you like – studying a community of Trobriand Islanders. According to Winch's view of the aims and practices of social science, the anthropologist studies this community by joining it. It is only by doing so, he asserts, by learning its language, internalising its customs and rules, living its life, that he can explain it. His aim is to represent the world of the Trobriand Islander by being one himself. The Islander's behaviour is shown to be motivated by what the Islander himself believes. To quote MacIntyre, 'Their rules, not his, define the objects of [the anthropologist's] study.' Inquiry into the independent causes and mechanisms of the Islanders' behaviour is not this anthropologist's aim; indeed, the very process of going native prohibits such inquiry, since the consequent forms of self-consciousness are ruled out for the members of the community itself, by definition. To understand the causes of belief in the supernatural, for instance, is to suspend such belief and thus to rule oneself out of the congregation.

The social anthropologist of a Winchian persuasion is accustomed to defend his interpretation in terms of the amount of time he has spent among the natives, observing their rules and handling their artefacts, and in terms of the coherence of the picture which he can reconstitute by virtue of having learned their language. If you wish to criticise his work, he will tell you, you must first go where he has been and spend longer and become a more complete Trobriand Islander than he. To fail to do this is to be disqualified from any status as a considerable critic of his work.

What if such a characterisation were applied to the community of art, art history and art criticism? Suppose that this community were to be seen as a kind of Trobriand Island, composed of natives and anthropologists, with the latter doing

their best to turn themselves into the former? What might we then expect, and how might we tell anthropologists and natives apart? We offer five potential symptoms in search of a diagnosis.

First: There will be an attempt to identify the anthropologist's interpretations with the *explicit* meanings expressed by the natives. Indeed the anthropologist's professional self-image depends on just such an identification. The danger is that the observable effects in the Islanders' behaviour will be confused with the causes of that behaviour. 'Why does he carry a stone in a forked stick?' 'Because it's his soul.' To the Winchian anthropologist the statement that souls are not such as to be carried in forked sticks is neither here nor there. The islander's statement of his reasons has to be taken as constitutive, and other explanations for his actions are likely to be ruled out as fouls. Agents' conceptions and reasons are seen as adequate in explanation precisely because they are constitutive of the anthropologist's view.

'Why did Kandinsky paint pictures that looked like nothing on earth?' 'Because he wished to make art more spiritual', or 'Because he was prompted by inner necessity', or 'Because by achieving autonomy for the expressive resources of painting he would produce a greater concentration on visual experience.' These are all equivalents to the anthropologist's reproduction of the Trobriand Islander's reasons for carrying a stone in a forked stick. They are *not* causal explanations.[20] If we ask, 'How could Kandinsky have entertained such reasons; how could he have held such plainly irrational beliefs?' the answer is all too often, like the Winchian anthropologist's, that it is beyond the art historian's brief to account for beliefs. He merely represents them as aspects of the structure of the art-historical tableau; and it is the structure he's interested in, not what it holds up or is held up by. The activities whereby members of the art world produce and manage 'settings' for themselves within that world are identical with their procedures for making those activities accountable. Such practices may be widespread, but their effect is to facilitate mystification.

Second: We can expect that the anthropologist's or art historian's constitution of meaning within the community will be derived from what he can read out of its language. The limits of the language are taken to be the limits of the world. Terms and categories derived from the conversational circumstances of the artist's practice – 'form', 'tone', 'pushing the paint about', 'exploring the unconscious', 'unmasking the codes of bourgeois society' or whatever – will be taken as signifiers of meaning in explanation of that practice. Behaviour will again be seen as governed by what has been articulated about it. Such a procedure faces the dangers which C. B. MacPherson has pointed out for the study of seventeenth-century political theory.[21] If you want to make sense of what the Levellers said and wrote, you must identify those assumptions which were *unspoken* precisely because they were universally shared amongst the community addressed. If you take 'franchise of the freeborn' according to your own usage, you may idealise those Levellers who upheld the political aim of 'franchise of the freeborn' as proponents of a revolution in favour of the working class. But given the information that 'the freeborn' was actually used in the seventeenth century as a category excluding servants and other employees, and that its real causal referents were

thus different from yours, you will be drawn rather to the conclusion that an essentially bourgeois revolution was what was to be effected – and you will be talking about a very different type of historical change and about different ideological determinations and consequences. In the seventeenth century there was no geographically stable working class identifiable as such in Marxist terms, and a proletarian revolution was not historically conceivable at the time.

Similarly, if you accept the usage of the English art world in the later 1950s at its own valuation, you may come to the conclusion that Pop Art represents a democratising tendency in favour of popular culture. Whereas in fact the confusion of 'popular culture' with 'mass culture' by the bright young things of the ICA and the Royal College of Art is far more accurately interpreted as signifying an inclination to sidle up to the world of advertising and 'the media'. It signified a concern, that is to say, with conditions of distribution and consumption, not a concern with conditions of production. And art, as defined by such a concern, is not a *possibly* popular activity.[22] (We are, of course, making a point about the similar logical form of two errors in historical explanation and not suggesting a comparison between the achievements of Richard Hamilton and Peter Blake with those of Richard Overton and John Lilburne.)

Third: We will expect historical inquiry to be determined by the search for constitutive meanings – for those types of conclusion which support the anthropologist-cum-historian's coherent and self-certifying tableau – rather than by the search for mechanisms of production of both meanings *and* interpretations. Just as the anthropologist's capacity to 'understand' becomes the determinant of meaning, so the critic's capacity to 'feel' becomes the determinant of meaning. This serves to mask the requirement that recognition of mechanisms of production – causes – should determine what it is the critic or historian must strive to come to terms with and to explain. We have already suggested how the art historian's compare-and-contrast exercise is determined by just such an inclination to read an acceptable meaning *into* the pictures presented, rather than read *from* them whatever can be learned from the consideration of how they were produced.

Fourth: Because the Winchian-anthropologist-cum-historian's aim is to internalise an attitude towards nature rather than to explain the mechanisms of production of a culture, we will expect cultural categories to be represented as if they were natural categories. The identification of certain 'eternal verities' – birth and death and hunger and reverence for the elements, etc. – will be seen as unquestionable criteria of the constitutiveness and coherence of his account.[23] Enter the quivering romantic humanist art critic, or his more fashionable twin, the Freudian-cum-Marxist self-promoter, the self-appointed guardian and explainer of the transcendental tear-jerking communicativeness of Great Art: Francis Bacon, Leon Kossof, Dennis Creffield, 'A New Spirit in Painting', David Owen, Shirley Williams* and all.

*David Owen is Leader of the Social Democratic Party. Shirley Williams is a former Labour Member of Parliament and a founder member of the Social Democratic Party.

Fifth, and perhaps most important of all: The anthropologising art historian's own findings will be seen by him as validated by the coherence, the structural elegance or adequacy of his own account; and the coherence of his account, in turn, will be seen as demonstrating the coherence and rationality of the community under study. That he can successfully fix its 'meanings' within a structure of meanings – a language – is to be taken as demonstrating that that is what the community's meanings *are*, and that these are unquestionable and adequately explained. What Roy Bhaskhar, discussing scientific projects, has called 'non-cognitive conditions'[24] – the operations of those interests, aims and influences which are not epistemologically significant to the ratification of the enterprise (like worrying about the bank-rate while you write your tragic poem, or having an eye on the market while you paint your hyper-realist picture) – are ruled out of consideration, *both* in the anthropologist-historian's inquiry into the meaning of behaviour within the community *and* in his justification of his own account. To consider such factors as significant in explanation would, after all, be to step outside the conceptual framework of the study itself and to commit a foul. In the world of the Winchian anthropologist, what are given as reasons *must* be taken as adequate causal explanations in themselves.

So, if a group of artists can be gathered under the curatorial category of 'A New Spirit in Painting', it follows that there must *be* such a spirit, as a natural and ineffable feature of the world. Never mind the sheer irrationality and the provincial bathos of concatenating Alan Charlton or Georg Basilitz with Pablo Picasso; forget the manifest machinations of dealers, the massive financial support provided by the West German government, and the gougeing careerism of the curators; just look at the pictures and feel a reawakened humanism. No vulgar considerations can have any bearing – any causal significance in relation to what these pictures mean and express.[25] To claim that such considerations *must* have causal and explanatory significance would be to commit a social solecism, to risk being accused of lacking 'love for art' and lacking 'objectivity' (which are taken as synonymous), and thus to invite ostracism from the Islands of the Sensitive.

Modernism

If you can specify a set of characteristic symptoms, and if these are then shown by observation to be present, it seems reasonable to proceed to a diagnosis of infection. We have offered a hypothesis: What if the modern community of art and art discourse *were* a kind of Trobriand Island, full of natives and Winchian would-be joiners? Certain consequences would be observable; and we are suggesting that just such consequences *are* to be observed as normal and normative aspects of art discourse. The hypothesis therefore seems to be valid. We are, it seems, marooned on a Trobriand Island.

This metaphor may be used as a means of identifying the ideological character and practices of Modernism – not Modernism seen simply as an art-historical period, or a mere art-critical stance, but as an historical ideology, or a part of one, a type of culture, by which the activities of *all* of us are affected to varying

degrees, and in which we are all therefore variously implicated. The very fact that an analogy can be sustained with an account of concepts of meaning in the Social Sciences suggests that we are dealing with a characterisation of intellectual practice which goes well beyond the art-world in its scope.

It is hard to imagine how those who teach or have taught in colleges or departments of art could have failed to observe examples of those practices we have described. If any have failed to observe such examples, they should at least consider the possibility that their own activities may be open to a radical redescription by those who have managed to avoid going native. They are open, that is to say, to the charge of false consciousness.

There is much talk of the liberating effects of art. The possibility of true liberation, we would assert, entails the ability to distinguish the real from the ideological. To see a system of beliefs as ideological is to see it as grounded in the existence of a particular contingent form of class society, and as serving the interests of a system of false consciousness intrinsic to it. It is to see these beliefs as part of culture, part of history, and therefore themselves open to causal explanation.

So where do the causes of Modernism lie? The question is plainly ambitious and deeply complex, and it lies well outside the possible range of this paper. It is assuredly not to be answered by some crude Marxist formula concerning the Determination of the Superstructure by the Base, or the Logic of Bourgeois Domination under Modern Capitalism, though it is certainly true that ideologies do have material and other causes and that the function of a dominant ideology *is* to dominate.

In so far, however, as *some* guide to the mechanisms of production of an ideology are to be found in the interests it seems to satisfy, we offer a tentative suggestion for a research project in social history. Those ideas and attitudes characteristic of Modernism appear to surface during the nineteenth century and to become clearly identifiable in its latter half, at a time when the hereditary upper bourgeoisie appeared militantly concerned to distinguish themselves from the rising petty bourgeoisie and the nouveau riche – to make it clear, in a world in which the distinctions between aristocracy and working class were well rehearsed, that more than one class was sandwiched between them. This literate, educated and comparatively leisured class seems to have been concerned to establish its place in history as the proper guardian of knowledge, civilisation, sensitivity and the eternal verities. The concepts of change and renewal and novelty were admitted by this class, and served to distinguish its view of history from that of the aristocracy; on the other hand it did not envisage itself as subject to *transformation* by such changes, and this served to distinguish its self-image from that of the working class.

As the focus and symbol of its own historic capacity for the articulation of meaning, art was idealised as the proper subject of this class. The artist, in so far as he could be securely identified at all, was projected as the ideal 'creator', the ideal worker, but never as a *producer* in any sense compatible with historical materialism, determined as other producers are determined. His artefacts were not sorted out as types of production, but as bundles of those properties which were negotiable within the conversation of the bourgeoisie. As such, though their

incidental characteristics were seen as changing in response to a 'changing world' (i.e. to fashion), the fundamental expressive values of works of art were seen as transcendental, ahistorical and immaculate in the sense of being uncaused. It follows that such remarks as we have caricatured in the form 'He did it for the money' had always to be ruled out as conditions for the recovery of any meaning in proper art.

This may well seem an over-simple and over-tidy hypothesis, and it is certainly true that it is easiest to exemplify from those writers on art who are most easily criticised. But it is also the case that these have been among the most influential.[26] Clive Bell is a prime example, and the one whose class-character was most clearly stamped on his writing. Here he is in characteristic vein:

> The artist and the saint do what they have to do, not to make a living, but in obedience to some mysterious necessity. They do not produce to live – they live to produce. There is no place for them in a social system based on the theory that what men desire is prolonged and pleasant existence. You cannot fit them into the machine, you must make them extraneous to it. You must make pariahs of them, since they are not a part of society but the salt of the earth.[27]

Whatever else it may or may not imply, such a characterisation of the artist is plainly not compatible with the historical-materialist conception of man as in the last instance characterised by basic needs which must be satisfied by production of the means of subsistence. In this ideal projection of art, the intellectual abilities, the needs,[28] desires, pleasures, aspirations and self-images of the literate hereditary bourgeoisie achieved their perfect realisation.

The ideology of which Modernism is a part may to a certain extent have moved beyond this class, which itself has been subject to some historical change, and its entrenchment in America is perhaps subject to a slightly different class analysis. Certainly the ideology of Modernism cannot now be wholly incorporated in or dismissed as 'bourgeois ideology'. It is hard indeed to characterise it as a class-based ideology at all. It has perhaps achieved the status of something like a religion: a set of widespread and institutionalising protocols and beliefs regarding what is neither real nor true. But this does not invalidate the initial identification we have proposed, and it might be said that the stamp of the concept of a 'knowledge class' was successfully carried in Modernism's migration across the Atlantic, where it now serves the interests of SoHo and Park Avenue alike. After all, if 'knowledge' is not knowledge of what's real, then anyone can lay claim to it, and conversion comes easy.

It probably was true at the time of the entrenchment of the ideology of Modernism that the hereditary bourgeoisie held the central position in the advancement of knowledge. What is at issue now is whether it still does; or rather, since *de facto* membership of the congregation is now open to *all* those able and willing to demonstrate a measure of education, intelligence and sensitivity, just *what* is joined in joining it and what price is paid. The suggestion offered here is that the conditions of entry are those which the Winchian anthropologist imposes upon himself on joining the Trobriand Islanders: that one leave behind those concepts and modes of inquiry and explanation which are not available to the mem-

bers of the congregation themselves, and thus not constitutive of their meanings, their beliefs, their picture of the world.

There are of course those in the field of aesthetics and art history who have managed to keep at least a foot outside the Island. They are not generally to be found among the volunteers of left-wing commitments. Nor are they often people who are *just* aestheticians or art historians. They are typically scholars who at one time or another have been exposed to the methodological and epistemological constraints which govern theory-formation and practice in the natural sciences, where the problems of distinction between the ideological and the real are seen as more central and are very much better rehearsed. Gombrich at his best and Goodman most of the time are cases in point, and lately Michael Baxandall has shown how art-historical inquiry *can* profit from the interests of social science.[29] His concept of a period 'cognitive style' serves to suggest how claims about the expressive meaning of pictures can be prised apart from the tedious self-centredness of modern art appreciation. And Barry Barnes, though he would not claim to be either an art historian or an aesthetician, has provided a most useful and broad framework for the consideration of representation in general as an activity both epistemologically and socially determined and directed.[30] Normal art criticism, however, now seems virtually irredeemable in its entirety.

There has been much talk of late of 'Post-Modernism' and 'Anti-Modernism' and so on. Some of this talk has appeared to express a well-intentioned and leftish awareness of, and dissociation from, the Hegemony of Bourgeois Idealism, etc. etc. But in practice these vaunted alternatives have been all too easily incorporated as favourable mutations within just that ideology they purport to supplant, but which they have failed adequately to characterise and to redescribe. 'Alternative art history' – Pissarro instead of Monet, Tatlin instead of Malevich, Grosz instead of Klee, Hockney instead of Hoyland, or whoever – merely increases the range of consumer durables for normative exercises in art appreciation.

> The line of Daumier, Courbet, the early Van Gogh, Meunier and Dalou is that of the real art of the growing proletariat, while that of the bourgeoisie continues towards the abstraction of the twentieth century.[31]

Anthony Blunt wrote that in 1937, and look what happened. A true alternative will at least initially survey the same subject matter, the same artists. There is no real future or interest in trying to reverse the relative ranking of good and indifferent art if you can't redirect the categories according to which art is singled out in the first place, and to try to do so is to miss the substantive point. [. . .]

Nor does the ahistorical semiologist's vaunted 'unmasking of codes' do much to effect real changes in understanding or provide grounds for explanation which are better than self-certifying. For all its apparent elegance, the so-called 'science of signs' will never wake up among the real sciences. Committed as the semiologist is to the position that the limits of a dubiously metaphorised language are the limits of a world, he can do little but proliferate translation problems, alternative readings of 'pictures-as-texts'. The new, fashionable global form of

semiology, the nouveau mélange[32] of psychoanalysis, Marxism and linguistics, seems stuck with this mistake – seems indeed ambitious to extend its currency. With some assistance from semiology we achieve, perhaps, a measure of methodological sophistication and a capacity to add some detail to our compacted structure of meaning, but we're still back on the Trobriand Island, joining away like the rest. And controversy in normal art history remains a matter of competing interpretations, which reduce to the status of translation problems.

No, if there is to be a real alternative to the Modernist Trobriand Island, it will have to be through the characterisation of art-historical practice in terms of different forms of inquiry. The only means to break out of the charmed circle of self-authenticating explanation is through inquiry into causes and conditions of production – an inquiry which is at least initially free of those presuppositions about what meaning in art *is* and who it is *for* which have for so long been allowed to restrict the range of causes which come up for consideration. Such freedom might seem difficult to achieve, but it may be worth considering the resource provided by those who already have it; those, that is to say, for whom art is indeed meaningless, unless 'He did it for the money' (etc.) be allowed as a condition for the recovery of meaning. And if we can't ask the right questions we should not be surprised if people get tired of the answers.

Explanation: a hypothesis and three prescriptions

We offer the following hypothesis: Art history has to be explanatory, because artists are producers; that is to say, if art history is *not* truly explanatory – if the circle of 'understanding' is not broken by identification of those types of causal explanation from which our anthropologist abstains – then the status of the artist as a producer will remain masked and his works will continue to generate mere problems of translation and discrimination for those equipped to argue about what place works of art are to have in the decoration and justification of their own lives.

So, for art history to lay claim to a real explanatory function, what criteria must be fulfilled? Our first two answers to this question are by way of recapitulation.

First: Those objects – works of art – which are taken to initiate art-historical inquiry must be described in a logically scrupulous ontology, and *not* according to the entrenched themes and topics of an ideology for which the habits of art appreciation may stand as pathetic symptoms. But logic will not solve all the problems. It may eliminate many embarrassing errors, but it cannot redirect inquiry in favour of different interests. Causal theories of meaning and reference remain relatively exotic in logic. So

Second: It must be recognised in theory and in practice that interpretations of what pictures are *of*, of what they represent, and claims about what they express and mean are to be derived from knowledge – or at least practically grounded speculation – about how they are caused and produced, and not from the autobiographical pronouncements of mandarins or would-be mandarins. We

must therefore be willing to scrutinise any statement about what works of art mean for the residue of hidden or inexplicit claims and assumptions about the mechanisms of their production.

Our third prescription addresses the issue of what is required if the first two are to be given some practical effect.

Third: What is needed is that the inquiring practices of art history and art criticism should themselves be open to accountability as to their causes and determinations. Just as claims about the meaning of works of art must be scrutinised for hidden assumptions about the mechanisms of production of those works, so the art historian's own means of interpretation and explanation must be open to scrutiny as to how those interpretations and explanations have themselves been caused and determined. In 'Art and Inquiry', Goodman dismisses the idea of aesthetic contemplation out of hand. As an analytical philosopher supposing his hands to be clean of the social sciences he can afford to be coolly dismissive of what appears to him as a clearly absurd approach to art and aesthetic experience. But for those of us who have lived and worked in the atmosphere of Modernism, the determining agency of Modernist ideas has to be acknowledged. For us, the possibility of liberation resides only distantly in the view of a different conceptual framework. First, we have to come to an understanding of the causal determinations upon our own present modes of inquiry, interpretation and explanation. As art historians we have to scrutinise our own practices for those constitutive assumptions which are not subject to criteria of empirical adequacy or to rational defence before rational minds. We too, it may have to be acknowledged, do it for the money, to further our self-images, because we are idle, because it's better than working for a living. And these factors may have to be acknowledged as causal determinations on the *meaning* of what we say and write. The best defence against the accusation that the meaning of our activity is *exhausted* by such accounts is that our interpretations should be open to correction according to causal as well as hermeneutical criteria, and that they should therefore be explanatory. If an interpretation is *not* genuinely explanatory, then nothing counts against it.

To accept the possibility of correction is, of course, to accept a degree of professional risk. Such requirements are criteria of good practice in science (at least as idealised by Popper), but are not customarily made of art-historical explanation. The point about science is that non-cognitive causes do not necessarily impugn its normative power or vitiate the informative content of explanation. That is to say, scientific experiments or theories can be so framed and scrutinised as to enable considerations of the scientist's gougeing careerism, or his anxiety about the bankrate or whatever, to be set aside in evaluation of their informative content and their truth. But it remains to be demonstrated how the same statement could be defended in respect of art-historical inquiry, let alone of art criticism. [. . .]

Normal art history is characterised by its essential conformism, by habits of playing safe, by fear of speculation, by lack of intellectual and methodological rigour, and by those dogmatic effects which suggest that there must have been dogmatic aims. There is some apparent justification for this in the timorousness of

the majority of contemporary art, with its pathetically contained or bathetically aggrandised ambitions, and its trivial confusions and mysteries. But are art students, for example, therefore to be abandoned, to be deprived of proper teaching even in that small percentage of the timetable given over to art history and so-called complementary studies? The concept of complementarity entails a defensible base. So how do teachers of complementary studies earn their salaries? The question is at least worth asking. For to ask what kind of art we have or could have is to ask, 'What must the world be like, or have been like, for such a thing to be produced?' And answers to such questions have a clearly prescriptive aspect in relation to the practices, interests and aims of art history and criticism.

Certainly what art historians do is irretrievably a part of culture and not a part of that part of culture which is science.[33] But that is no excuse for exploiting the ease with which they can get away with empty and uninformative pronouncements, nor, unless they are indeed Winchian anthropologists, are they excused the requirement of asking 'What *kind* of culture? What are its aims and interests? What ends, for instance, are served by the mystification of meaning and the idealisation of practice?'

In his introduction to the Arts Council's valediction of Roger Fry some fifteen years ago,[34] Quentin Bell ended with the following quotation:

> And finally the lecturer, after looking long through his spectacles, came to a pause. He was pointing to a late work by Cézanne, and he was baffled. He shook his head; his stick rested on the floor. It went, he said, far beyond any analysis of which he was capable. And so instead of saying 'Next slide', he bowed, and the audience emptied itself into Langham Place.
>
> For two hours they had been looking at pictures. But they had seen one of which the lecturer himself was unconscious – the outline of the man against the screen, an ascetic figure in evening dress who paused and pondered, and then raised his stick and pointed. That was a picture that would remain in memory together with the rest, a rough sketch that would serve many of his audience in years to come as the portrait of a great critic, a man of profound sensibility but of exacting honesty, who, when reason could penetrate no further, broke off; but was convinced, and convinced others, that what he saw was there.

It is an ironic, if symptomatic, achievement of Modernist criticism that 'going beyond analysis' has become fixed as one of the principle expressive referents in terms of which value is actually established for works of art. The fundamental criterion of value, that is to say, is proposed as ineffable and irrational. The point is not that there *are* no mysteries. No doubt there are some, though we should bear in mind that the mysteries of one generation are often explained in the knowledge of another. The point is rather that a tendency to value the acceptance of mystery as a humanising characteristic in the professions of art and art history tends to encourage idleness at best and evasiveness at worst in the face of that which may indeed be open to rational inquiry and to explanation – albeit, perhaps, by others less sensitive than those who normally write about art. [...]

The need for a second-order discourse

We return to the issue of what is to come up for the count in and as explanation, the question of which bits of information belong together in the attempt to recover meaning from art. According to what assumptions about the possibility of meaning in art is 'He did it for the money' ruled out as a determinant? We offer one further hypothesis: The meanings we can make are causally determined by the world in which those meanings have their effects. Within cultural discourse, as opposed to natural-scientific discourse, to explain the non-cognitive conditions of production of an interpretation is to impugn its normative power. Cultural discourse is a moment in its own making. Scientific theory is not. In experimental science, the experimenter devises experiments to find out what he did not produce. The islanders of art's institutions proceed in terms of what they must themselves have produced as if they had had no hand in its production. Knowledge is handed down to the onlookers.

Imagine a conversation between three art historians concerned to explain the work of Degas to students. The first says, 'In order to understand Degas you have to really look at the pictures.' The second says, 'In order to understand Degas you have to read nineteenth-century French novels.' The third says, 'In order to understand Degas you have to know how much he paid his models.' Under present conditions the ensuing argument is all too likely to reduce to the equivalent of a squabble over translation problems, alternative readings of the 'text' as it were, decidable for each participant only in terms of his or her own interpretations and interests and preferences. Yet each of these statements serves as a paradigm of how the work is to be approached; not just of how it is to be characterised as a piece of production, but also of how that characterisation itself relates to some view of the world within which the historian produces his or her *own* work.[35]

For such squabbles to be transformed into substantial and decidable arguments, we need a form of second-order discourse, a conversation within which to include, to discuss and to explain the content of the first.[36] And to be able to explain this first-order discourse we shall, once again, have to inquire into the mechanisms of production, the causes, of what is said within it. Art is produced from all kinds of causes, but so are art history and art criticism. The relationship between the two sets of causes is not generally very well thought about. It should be made clear, incidentally, that we are not proposing a crude determinism – suggesting, for instance, that all ideas and beliefs are open to exhaustive causal explanation by reference to 'the material conditions of life'. Ideas may not move mountains, as the proponents of a 'universal' abstract art seemed to have believed they could in the 1920s and 1930s, but ideas can certainly be determinants of modes of production, activities, the consequences of which are that mountains do get moved.[37] What we have to offer is not a form of economic reductionism. It does not go to a rigid materialist inversion of Hegel. It does not go to the overthrowing of all claims for the autonomy of art. It goes rather to the matter of the fraudulence of the discursive or analytical closures performed in art, and to its hermeneutical circularity, which are the principal symbols of its ideological purpose.

Particular modes of interpretation are plainly to be acknowledged among the determinants on production of works of art. Criticism plainly influences art. Our second-order discourse might help us to discover how and why this is so. Within such a discourse, that is to say, it might be possible to decide the extent to which historical, cultural and ideological accretions – ideas and beliefs *about* art – have been the causes of particular identifications of meanings in art; to distinguish, that is to say, between the mechanisms of production of particular interpretations and explanations, and the mechanisms of production of meaning in the works of art themselves. It is perhaps partly because we don't have such a second-order discourse – or because in so far as we do have one it merely reflects and ratifies the first without explaining it – that normal argument in art criticism and art history is so readily reduced to *ad hominem* slanging; to a confusion, that is to say, of re-descriptions of someone's ideology with redescriptions of some work of art's ontology.

To return for the last time to our analogy of the Trobriand Island; the function of a second-order discourse in respect of the anthropologist's deliberations will be two-fold: it must be capable of describing what he describes and explaining what he explains; and it must *include that function* within an explanation of the determinants on the anthropologist's own deliberations. A second-order discourse – a real alternative practice – will therefore ideally both have to show how the artist's behaviour is open to causal explanation rather than to mere structuring and ratification in terms of some art-historical tableau, *and* it will have to provide an account of the art historian's own interpretations and explanations which goes outside the Island itself, outside Art, and outside the art historian's own professional vocabulary, for its terms and concepts and notions of cause. If the limits of the art-world's own vocabulary are to be taken as the limits of art-historical explanation, then art history itself will be open to critical redescription and encapsulation by those who are not of its congregation.

There is no other way to avoid such encapsulation than to do some work. After all, to realise that there are things you can't talk about, possible truths beyond the limits of your language, is surely to recognise the need to learn. The demand that is made of the critic's or historian's thought is a demand 'to reflect on his position in the process of production'.[38]

It should be made clear that the second-order discourse can be no more free from aims and interests than the first. How it is framed will depend on where one stands in relation to social theory and other comparable commitments. Recognition of the essentially bourgeois roots of the modern ideology of art does invite redescription from an historical-materialist standpoint. The latter is not, as the French might have it, the 'logical opposite' of bourgeois ideology; it is its *historical opponent*. Tim Clark gets halfway there in his recent article on Manet's *Olympia*, in talking of the critical and explanatory potential of the 'meanings of the dominated' – of what is recovered or recoverable as meaning by those who are not generally in control of the manipulation of symbols in culture.[39] But the point is that within a world constituted by bourgeois understanding, the dominated *have* no 'meanings' that are not either noises-off or pale imitations of the meanings of the dominating. Only by the operation of a second-order discourse in which their

own interests and intuitions are expressed, can the dominated change the rules, so that, for instance, 'He did it for the money' ceases to be a perlocutionary noise-off and becomes instead an acceptable explanation, a critical condition of the possibility of recovery of meaning. Only within such a second-order discourse can the roles be reversed, and the redescribed meanings of those formerly dominating become a subset of the meanings of those formerly dominated.

Our conviction that such a reversal *is what is required* is not an attempt to bend theory into conformity with some Marxist faith – some vulgar economic reductionism. Nor is it the result of any illusion that the middle-class artist or art critic or art historian is in a position to volunteer self-identification with the interests of the working class without a methodological hiatus. It is rather a somewhat reluctant recognition of the fact that in face of the manifest problems and deficiencies of normal art history *no other characterisation of practice seems at present likely to offer a defensible project of work.* Only a redescription of culture and art within which historical-materialist and causal forms of explanation can be seen as critically efficient will serve to bring the right skills and competences into operation. And it should be clear that what is at stake here is not just the deployment of skills relevant to the practice of art criticism or art history, but also of those required in the production of art itself.

The purport of this paper is methodologically prescriptive, but does not attempt to be prescriptive in respect of the metaphysical relations between persons and objects. We are not searching for and would not expect to find cognitive foundations for knowledge of art. There are no such foundations for any knowledge. Our aim is rather to seek some points of reference for thinking about a discourse which is not always quite thinkable, but which is at least not characterised by the fraudulence of its emancipatory claims. Whether such a discourse can be envisaged as art discourse or not is at present an *administrative* issue.

Notes

1. Hackett, Indianapolis, 1976. See also 'A Portrait of V. I. Lenin' in *Art-Language*, vol. 4, no. 4, June 1980, where a more detailed and extensive discussion of the relation 'picture of . . .' may be found; article reprinted in C. Harrison and F. Orton (eds) *Modernism, Criticism, Realism* (London and New York, Harper & Row, 1984), pp. 145–169.

2. The point is that different designations or descriptions or topicalisations invoke recognition of causes with varying degrees of explanatory power. To paraphrase Isaiah Berlin, the two statements 'Germany was depopulated in the 1930s' and 'Millions of Jews were massacred by the Nazis in Germany in the 1930s' may both be true and they may both designate the same process; but to say that the second statement has a higher explanatory value, or is a perlocutionary act of greater power, is not to commit a naturalistic fallacy. It's not hard to transfer the logical form of the example to discussion of the value of explanations of works of art. Consider, for instance, the two descriptions, 'X, the gougeing self-provider of life's necessities' and 'X, the

creator of devastating critiques of the bourgeois life-style', which may well designate the same person, though they invoke different types of explanations. It is a matter of some interest that the production of one description may impose a necessity upon the production of the other – as a *misrepresentation*.

3 Clive Bell, *Art*, 1914, Chatto & Windus edn, London, 1935, pp. 25 and 27. This was the eleventh impression, pp. 3–8.

4 Clement Greenberg, 'Problems of Criticism II: Complaints of an Art Critic', *Artforum*, vol. VI, no. 2, October 1967; reprinted in Harrison and Orton, op. cit., 1984, pp. 3–8.

5 Printed in Nelson Goodman, *Problems and Projects*, Bobbs-Merrill, Indianapolis and New York, 1972, pp. 103–19.

6 See particularly, 'Art History and the Social Sciences', the Romanes Lecture for 1973, delivered at the Sheldonian Theatre, Oxford, on 22 November 1973; republished in *Ideals and Idols: Essays on values in history and in art*, Phaidon, Oxford, 1979. In justice to Gombrich it should be acknowledged that he has done much to point out the determining effect of interpretations of history and of art, and that in his retiring address to the Warburg Institute he drew attention to his current and intended projects on design and on the psychological aspects of art. To say that more than any other comparable art historian Gombrich has worked according to the best practical hypotheses available to him is neither to reduce his authority nor to acknowledge the security of those hypotheses.

7 Karl Marx and Frederick Engels, *The German Ideology*, International Publishers, New York, 1968 edn, p. 16.

8 For an argument in favour of this assertion see Walter Benjamin, 'The Author as Producer', 1934, reprinted in Andrew Arato and Ike Gebhardt, eds, *The Essential Frankfurt School Reader*, Urizen Books, New York and Basil Blackwell, Oxford, 1978, pp. 254–69. Edited version in F. Frascina and C. Harrison (eds), *Modern Art and Modernism: A Critical Anthology* (London and New York, Harper & Row, 1982), pp. 213–216.

9 See 'Abstract Expression' in *Art-Language*, vol. 5, no. 1, 1981, where a more detailed and extensive discussion of the question of expression may be found; article reprinted in Harrison and Orton, op. cit., 1984, pp. 191–204.

10 See Clement Greenberg, 'Louis and Noland', *Art International*, vol. 4, no. 5, 25 May 1960, pp. 26–9; and the same author's introduction to *Three New American Painters: Louis, Noland, Olitski*, Norman McKenzie Art Gallery, 1963, reprinted in *Canadian Art*, vol. 20, May 1963, pp. 69–70.

11 Sebastiano Timpanaro, *On Materialism*, New Left Books, London, 1975.

12 Clement Greenberg, 'Modernist Painting', *Arts Yearbook* 4, 1961, reprinted in Frascina and Harrison, op. cit., 1982, pp. 5–10.

13 Michael Baxandall, *Painting and Experience in Fifteenth Century Italy: a Primer in the Social History of Pictorial Style*, Clarendon Press, Oxford, 1972, pp. 10–11.

14 The 'experiment' was conducted with a group of students at Hatfield Polytechnic in 1975 and has been tried on different groups of students since with comparable results. The purpose was to substantiate an anxiety –

developed late after several years of lecturing – that when talking about pictures there were no good grounds for confidence that the audience was seeing the lecturer's subject as what he saw it as.

15 R. Wittkower and B.A.R. Carter, 'The Perspective of Piero della Francesca's "Flagellation",' *Journal of the Warburg and Courtauld Institutes*, vol. 16, 1953, pp. 292–302.

16 Examiners of compare-and-contrast exercises frequently express their disappointment at the percentage of students who seem to 'miss the point' of such exercises; i.e., presumably, fail to reproduce the examiners' *reasons* for selecting the pictures to be compared. It sometimes happens that the information expected from students about what the works *look like* is not actually discernible from the reproductions provided. Can the examiners be unaware of how much more you *see* in a reproduction if you are acquainted with what it is *of* (in the sense discussed above)? That the percentage rate of disappointment is generally lower in the case of courses on Renaissance art could perhaps be taken as a reflection (a) of a greater explanatory content in the teaching of the subject, or (b) of a more regularly mediated determination of expressive by iconic aspects in the production of the works themselves. It is, of course, not inconceivable that (a) and (b) are causally connected.

17 The ideas for which Metz is here seen as representative were developed by semiologists in discussions of meaning in films. Their currency has since spread in pursuit of a 'cure' for the 'distressing economic-determinism' of Marxism. For a vivid critique of such enterprises, see Jonathan Rée, 'Marxist Modes', in *Radical Philosophy*, no. 23, winter 1979, pp. 2–11.

18 On this issue, see Barry Barnes, *Interests and the Growth of Knowledge*, Routledge & Kegan Paul, London, 1977.

19 Alasdair MacIntyre, 'The Idea of a Social Science', *Aristotelian Society Supplementary Volume*, 1967, pp. 95–114; reprinted in MacIntyre, *Against the Self-Images of the Age: Essays on Ideology and Philosophy*, Duckworth, London, 1971, and in Harrison and Orton, op. cit., 1984, pp. 213–227. Peter Winch, *The Idea of a Social Science*, Routledge & Kegan Paul, London, 1958. We should make it clear that in exploiting the possibilities of analogy presented by MacIntyre's critique, we have not attempted to do justice to Winch's ideas.

20 For a more extended discussion of the congregational 'Ratification of Abstract Art', see our article of that title in *Towards a New Art: Essays on the Background to Abstract Art 1910–20*, Tate Gallery, London, 1980, pp. 146–55.

21 C.B. MacPherson, *The Political Theory of Possessive Individualism: Hobbes to Locke*, Oxford University Press, 1962.

22 'The political importance of the movement was indeed exhausted in many cases by the conversion of revolutionary reflexes, in so far as they occurred in the bourgeoisie, into objects of amusement which found their way without difficulty into the big-city cabaret business. The transformation of the political struggle from a compulsion to decide into an object of contemplative enjoyment, from a means of production into a consumer article, is the defining characteristic of this literature.' Benjamin, loc. cit., on 'New Matter-of-Factness as a literary movement'.

23 See, e.g., Peter Fuller, 'Towards a Theory of Expression', *Art Monthly* no. 36, 1980.

24 See Roy Bhaskar, 'Scientific Explanation and Human Emancipation' in *Radical Philosophy*, no. 26, autumn 1980, pp. 16–28.

25 'A New Spirit in Painting' was the title of an exhibition at the Royal Academy, London, held from 15 January to 18 March 1981. In his Foreword to the catalogue, the President of the Royal Academy made clear that the exhibition was designed to 'serve the cause of modern painting by making a clear and cogent statement about the state of painting today – just as Roger Fry had done at the Grafton Galleries at the beginning of the century.' The exhibitors were Auerbach, Bacon, Balthus, Basilitz, Calzolari, Chia, Fetting, Freud, Graubner, Guston, Hacker, Hélion, Hockney, Hodgkin, Hödicke, Kirkeby, Kitaj, Koberling, de Kooning, Kounellis, Lüpertz, Marden, Matta, McLean, Merz, Morley, Paladino, Penck, Picasso, Polke, Richter, Ryman, Schnabel, Stella, Twombly and Warhol. The selectors were Norman Rosenthal, Christos M. Joachimides ('the Berlin art critic') and Nicholas Serota. The exhibition was 'assisted by generous grants from the Arts Council of Great Britain, the Government of the Federal Republic of Germany, the Senate of Berlin (West), W. Wingate and Johnson (Fine Arts Ltd.) and two anonymous private donations'. 'In the end', the selectors state in their preface, 'the only care is about the act of painting itself.'

Our assertion is that the concatenation of these items of information is explanatory *in itself* (though not, of course, exhaustively), not just of the exhibition as an exhibition, but also of the 'meaning', as culture, of the works themselves. For this assertion to be refuted it would have to be shown that such exhibitions were *not* somehow categorically relevant determinations on the production of the works concerned. It should not need saying that such determinations have *less* explanatory power in the case of the work, qua work, of, say, Picasso – who did at least have the decency to die before the exhibition was conceived – than of some other exhibitors. But this is not to deny that the information given can be seen as explanatory in respect of the mechanisms of production of *interpretations* of Picasso's work.

26 The prising apart of agency and real explanatory power is an observable feature in the professional character of Modernist criticism.

27 Bell, op. cit., p. 261.

28 Of course, to paraphrase Marx, need for caviare is a different kind of need from need for bread, though we may use the term 'hunger' to refer to both.

29 See note 13. See also Baxandall's more recent publication, *The Limewood Sculptors of Renaissance Germany*, Yale University Press, 1980.

30 See note 18.

31 Anthony Blunt, 'The Realism Quarrel', *Left Review*, April, 1937.

32 The phrase occurs in Rée, op. cit. His article was written as a review of R. Coward and J. Ellis, *Language and Materialism: Developments in the Theory of the Subject*, Routledge & Kegan Paul, London, 1977. Our sympathies are all for the authors of this book. If they read the review they must for a while have had to avoid high places and keep razor blades and aspirins out of reach.

33 But see Goodman, 'Art and Inquiry':

The difference between art and science is not that between feeling and fact, intuition and inference, delight and deliberation, synthesis and analysis, sensation and cere-

bration, concreteness and abstraction, passion and action, mediacy and immediacy, or truth and beauty, but rather a difference in domination of certain specific characteristics of symbols.

. . . Earnest and elaborate efforts to devise and test means of finding and fostering aesthetic abilities are always being initiated. But none of this talk or these trials can come to much without an adequate conceptual framework for designing crucial experiments and interpreting their results. . . . Firm and usable results are as far off as badly needed; and the time has come in this field for the false truism and the plangent platitude to give way to the elementary experiment and the hesitant hypothesis. . . .

34 *Vision and Design: the Life, Work and Influence of Roger Fry*, an exhibition arranged by the Arts Council and the University of Nottingham, London, 1966.

35 'The excellent Lichtenberg has said: "A man's opinions are not what matters, but the kind of man these opinions make of him". Now it is true that opinions matter greatly, but the best are of no use if they make nothing useful out of those who have them.' Benjamin, op. cit.

36 'Our sense of the relative "orders" of discourse is as follows. Within any practice a first-order discourse characterises the normal terms in which discussion, business, exegesis, etc. is conducted. A second-order discourse is conventionally understood as conducted in a type of meta-language by means of which the terms and concepts etc. of the first may be related, analysed etc. and their referents explained. The requirement upon a second-order discourse is that it should be capable of "including" the first (i.e. describing what it describes and explaining what it explains) but that it should also furnish an explanation of *how* (and perhaps *why*) that describing and explaining is done. A second-order discourse thus presupposes a position somehow "outside" but engaged with the contexts of the first. It is suggested that a cognitively defensible discourse for the recovery of meaning from art will have a second-order character with respect to the normal and current means of interpretation. To the extent that this is true the second-order discourse might be expected to supersede the first, except insofar as it is prevented from doing so by the agency which invests and maintains the normal order. Attendant upon such a re-ordering of discourses would be a transformation of concepts and categories and of their fields of reference. The relations between orders of discourse (and there can plainly be more than two) may be characterised in different ways according to different practices. It is suggested here that the relations between Modernist art discourse (or Modernist art) and historical-materialist discourse (or some art practice compatible with the projects of historical materialism and an analysis and critique of capitalism) may be considered in terms of the above outline.' From Michael Baldwin, Charles Harrison, Mel Ramsden, 'Manet's *Olympia* and Contradictions: apropos T.J. Clark's and Peter Wollen's recent articles', in *Block* 5, autumn 1981. Some of the implications of the present paper are further developed in this article.

37 For a resolution of the apparent contradiction between economic determinism and the belief that 'ideas can revolutionise things', see Alison Assiter, 'Philosophical Materialism or the Materialist Conception of History', in *Radical Philosophy*, no. 23, winter 1979; edited version in Harrison and Orton, op. cit., 1984, pp. 113–121. In defence of a view of Marx as a

Historical rather than a Philosophical Materialist, Assiter argues 'that there is a class of identity statements which are contingent, because the two terms designate different "time slices" of the one individual. . . . If the relation is a contingent identity, it is not ruled out that it is also causal.' This, she asserts, 'is compatible with Marx's determinism, because the view is that people as thinkers are determined (or conditioned) by people as producers. But since it allows that some thoughts may not be conditioned by the environment, it is also compatible with Marx's view that a person or a class may influence the environment.' For an example of two designations which may refer to the same individual, where there may be some causal connection between the two, see the concluding sentences to our note 2.

38 Benjamin, loc. cit., p. 267.
39 T.J. Clark, 'Preliminaries to a possible treatment of Manet's "Olympia" in 1865', in *Screen*, spring 1980, pp. 18–41; edited version in Frascina and Harrison, op. cit., 1982, pp. 259–273. For a further discussion of this article and of the concept of the 'meanings of the dominated', see our article cited in note 36.

12 Modernism and the 'Transatlantic Dialogue'

Charles Harrison

I

[. . .] An adequate discourse with critical intent must depart from identification of some dominant and prevailing theory or body of theory. As regards both the production and the interpretation of modern art, the *normal* protocols and procedures are still those of Modernism or its apostates, however strident the recent proclamations may have been of a Post-Modernist art or an anti-Modernist criticism and history [. . .]

By Modernism I mean some concept of modern art and its discourses capable of being reconciled to the position represented by Clement Greenberg's essay, 'Modernist Painting', first published in 1961.[1] An adequate understanding of Modernism is a prerequisite for discussion of the art of the last twenty years and more. Modernist theory has simply done a better job than any other of representing the concepts which have determined modern artistic practice. In the first part of this paper I therefore aim to characterise the history and development of that theory.

The second part is addressed to the circumstances of English and American art in the fifties and early sixties as they may be perceived against this theoretical ground.

As a determining concept in the discourses of art, Modernism now signifies not simply up-to-dateness, but a developing set of interests and priorities by

Source: edited version of the first of six lectures on 'Art and its Languages: the last twenty years' given at University College, London, in November and December 1982 as the Durning-Lawrence Lectures for 1982–3. (*Author's note:* The aim of these lectures was to tell a kind of story – a historical narrative of sorts, but one which was necessarily selective and partial. The goal was to discuss a group of paintings on the theme of *The Artist's Studio*, by Art & Language. The lectures were intended as a means to talk my way towards the conditions of this work, which was then current, not in order to ratify it but in search of some adequate account of what it was made of – practically, intellectually, culturally and conceptually.) © Charles Harrison.

217

means of which the modern in art has supposedly been formed, and according to which it is seen as properly distinguished from the art of previous eras. The beginning of the period of Modernist art is generally located around 1860, with Manet. Many of the principles which distinguish Modernist criticism and history were established in response to the French art of the following 40 to 50 years, and to the international modern art of the 35 years from around 1905 to the outbreak of the Second World War. In English-language criticism, Roger Fry and Clive Bell were the dominating interpreters of the first phase and Herbert Read of the second. It was not until the 1950s, however, that the relationship between modern art and Modernist criticism was established on a basis which could be seen as systematic. This was the achievement of the American critic Clement Greenberg.

Whatever Fry's theoretical pretensions may have been – and however homogeneous the work of those artists subjected to his direct influence – the great strength of his writing lay in the eclecticism of his response and of his capacity for speculation. Clive Bell was not a subtle enough thinker to do much more than dogmatise a set of typical attitudes. (This nevertheless qualified him to exercise a more immediate and extensive influence than Fry.) Read's work, for all his importance as a propagandist for the international modern movement, was largely incoherent in detail and in sum. It was Greenberg who seemed to achieve the Copernican revolution which Modernist theory so desperately needed: a form of criticism in which principles of relevance were connected to an apparently coherent theory of change and development in modern art; a theory according to which the 'internal' dynamic aspect of each form of art lay in its tendency towards 'self-definition' and 'purity of means'.

Modernism is not the mere retrospective rationalisation it is sometimes taken to be. Many of the most secure of its premises were established in the later nineteenth century, as aspects of a well-founded critique addressed to that Academic tendency which confused representation with resemblance. The Symbolists' assertion of the autonomy of artistic meaning and expression was justified by the militancy with which conservative artists and critics identified the representing picture with the represented subject, and by the stultifying effects of those notions of competence which followed from that identification. In establishing the principle that works of art should be judged according to their coherence as *art*, rather than by their correspondence to some naturalistic canon, the founding fathers of artistic Modernism enabled a series of progressive changes in practice and criticism. In the 1940s and '50s, Greenberg was largely responsible for recovering and ordering what was fruitful in these changes, following the appropriation of the concept of autonomy between the wars by those on the Purist right or the neo-Constructivist left, whose ambition was to establish art as the ideal model of planning for the world at large – not so much determined by its own past as seeking to determine the future of all.

While other writers of the later thirties and forties were celebrating modern art for achieving just what it had in fact failed – and necessarily failed – to do, what distinguished the early Greenberg was that he confronted the implications of this failure. In this spirit he set about developing a form of criticism which would systematically exclude any claim in respect of art's purport or value or effectiveness

which did not take account of the limits on modern art's agency and representativeness. He has been criticised from the left for abandoning a Trotskyite position in favour of a reassertion of art's autonomy.[2] This could be interpreted as an accusation that he abandoned wishful thinking for a kind of pragmatism.

However one moralises the development of Greenberg's criticism through the late thirties into the fifties, it has to be said that no art critic at the time did more to preserve the integrity of the modern tradition. It has also to be said that a high price was paid. The purging of talk about content was no great immediate loss, particularly where what was most often at issue was the valuation to be placed on types of abstract art. Such talk has generally in the twentieth century been easy to generate and often exciting, but almost entirely uninformative; which is to say that it has rarely been of critical interest. The more troubling restrictions which were imposed upon criticism by Greenberg's relatively systematic Modernism were these: firstly that aesthetic judgements had to be represented as involuntary and disinterested[3]; and secondly that consideration of the causal conditions of art had to be largely restricted to a consideration of artistic causes as the only cognitive ones – at least for the purposes of criticism itself. These two restrictions are traceable back to the writings of Fry and Bell (if not, as Greenberg himself would have it, to Immanuel Kant[4]), but it was Greenberg, however disingenuously he may have disclaimed any role as a historian, who first implemented them in the interests of an apparently consistent form of historical explanation.

The argument goes like this. The modern tendency within the arts – as supposedly within philosophy and science – is towards the entrenchment of each distinct pursuit within its own specific area of competence. Greenberg describes this as the pursuit of purity and self-definition. What painting shares with no other art form is its flatness; the dynamic of development in Modernist painting is thus explained as the intensification of flatness, or, as Richard Wollheim would have it, in terms of the conceptual priority accorded to painting's 'possession of a surface'.[5] This will inevitably entail the squeezing out of mimetic, descriptive and narrative content, which are anyway properly within literature's area of competence. Substantive change is seen as technical change in relation to other art. If true, this is a rationale for restricting criticism and explanation to discussion of formal and technical change and development. It is a measure of the adequacy of Greenberg's account of change that it can be reconciled to Karl Popper's. That same observation should encourage us to look to the work of Thomas Kuhn and Barry Barnes for means to criticise Greenberg's position.[6]

Within the Modernist view, aesthetic judgement, which is not seen as open to question or revision, confirms that the individual examples which constitute the best art of the last 120 years can be related in terms of the Modernist scenario. The historical interpretation and the set of value judgements are mutually implicated and mutually reinforcing – as necessary, inevitable and thus disinterested. It should be clear that what we have here is a hermeneutic circle, closed by the inevitability of the artistic development and the involuntariness and disinterestedness of the aesthetic response. While the details of interpretation may be argued over, the total structure is protected by a positive disengagement from rational critique.[7]

Outside this circle and consigned to the cold lie two possible forms of critical inquiry which are characterised from within – as they are in other fields – as oppositional, anti-aesthetic, anti-liberal, tendentious, and potentially vitiated by epistemological relativism. The first of these departs from the presupposition that development in art is *not* necessary or consistent, but is rather largely determined by contingency and accident; or alternatively that such necessity and consistency as there is must be imposed as it were from outside art itself and by more basic changes and tendencies. The second departs from the presupposition that aesthetic judgements are *not* disinterested. According to this view, the claim for disinterestedness serves to hide or to misrepresent those interests and agencies which are served by attributing certain values to certain objects and endeavours. These interests and agencies are normally identified with capitalism and with the bourgeoisie as a dominant class. In the words of the Italian Marxist Sebastiano Timpanaro, 'Every exploiting class needs a discourse on spiritual values'.[8]

The Modernist position in general and Greenberg's later work in particular have been subjected to criticism from various materialist, would-be materialist and would-be post-Modernist points of view. The cultural edifice of Modernism has remained comparatively immune, absorbing and incorporating what it can and dismissing the rest as infected by the non-aesthetic interests of those who have no eye for quality and no love of art.[9] This is made all the easier because many of those subsequent writers who claim somehow to have disposed of Greenberg have signally failed to answer that requirement of relevance for which his writing stands as example. They go on presenting their wishful readings-in as the reading-out of critical meaning and significance.

The Social History of Art, now gaining ground in the journals and in universities and polytechnic and art school complementary studies departments is undermined when it fails to internalise some principle of relevance, some methodical guard against category mistakes and category trespass. It has too often entailed little more than the proliferation of suggestive historical detail, justified as explanatory of the work it surrounds, and as critical of that which it aims to supplant, by nothing so much as saturation and pious optimism. If the social historians' critique of Modernism is to proceed upon some *ethical* basis, grounded in perception of the inequity of relations between classes, they must either come to terms with early Modernist arguments for the autonomy of art and of aesthetic experience, *or* they must furnish a cognitively adequate explanation of why they have taken art as their subject at all. This is not to say that Greenberg's work is itself immune to substantive criticism from a historical materialist point of view, nor that some of his followers are not appropriately identified as apologists of business. The point is rather that no critique will be adequate which fails to take account of the most fruitful aspect of Greenberg's writing. Interpretation of the major figures of Modernist art history, or attempts to revise the pantheon, must either come to terms with his strictures on discussion of content, or must attend upon some critical explanation of that system of ideas within which those strictures have their place.

Such an explanation has been late in coming, perhaps because it has been easier to see Greenberg as damned by association and innuendo than to address

the substantive purport of his work. The restrictions he imposed upon criticism are methodological closures applied in the interests of relevance to the aesthetic effects of art.[10] As such they are defensible, at least in the absence of some re-description of 'aesthetic effects', or of some *relevant* alternative explanatory system in which 'effects' are displaced from the primary position accorded them in the Modernist ontology of art.[11]

II

The history of modern art in England – at least until the 1960s – is to a large extent a history of delayed and mediated responses. In the second decade of this century the work of Cézanne was perceived and absorbed by English artists in terms of those 'pure plastic structures' and 'significant forms' which were the passwords to Fry's and to Bell's aesthetic worlds. Similarly in the later 1950s and early '60s, the American painting of the later forties was perceived and discussed in terms of an antecedently available critical vocabulary; a vocabulary already tuned to pick out those aspects which could be represented as progressive within the teleology of Modernism. English art from the start of the First World War to the start of the Second is densely populated with paintings which extract from Cézanne's complex endeavour the kind of emphatic formal structure which was topicalised by Fry and Bell. The typical 'advanced' English painting of the 1960s wears its 'emphatic surface', its 'flatness', its 'creative emptiness' like a provincial's badge of allegiance to a specific *discourse* about the American paintings of Newman, Rothko, Still and Pollock.

These are two examples of the domestication of a style formed elsewhere and earlier. What unites them is an empiricistic faith in the priority of what works of art look like over an interest in the conditions and mechanisms of their production. To paraphrase Wollheim again,[12] there has been in the modern period a progressive shift in conceptual priorities from the represented subject to the decorated surface. This is by now conventional wisdom, which lives easily enough with the reductionist theories of Modernism. Another way to put this would be to say that the signifying power of painting has been reduced to the demand that paintings should look like what paintings are supposed to look like. If this has to be seen as a *necessary* development, rather than a contingent one, Greenberg's Modernist theories will be hard to assail.

But the irony in this is that the further removed from the circumstances of their production, the more the empirical experience of works of art – the 'attentive looking' so dear to the modern art teacher – seems to result in perception of just those effects and aspects already picked out in the vocabulary of Modernist criticism: flatness, literalness, reductiveness, expressiveness and so on. Whether or not these are significant properties exemplified by the paintings concerned, they certainly are identifiable as linguistic terms in the litany of Modernist progress. We are entitled to ask whether the dynamic is carried through the art, or through the linguistic concepts of an attendant vocabulary. The point is that a tendency to identify and exalt works of art in terms of their 'formal properties', their

221

'optical characteristics', their 'ineffable appearance' leaves representation of the experience they produce highly vulnerable to encapsulation within the typical terms of a dominant culture. Talk about works of art has nowhere else to go if it does not lead to inquiry into conditions and mechanisms of production. And no discourse is so palpably bathetic as the discourse of a comprador sensibility; no economy so powerless as that of the island controlled by a larger economy for which it has no independent terms of reference, no potential redescription of the mechanisms at work. The world of provincial Modernism, I would suggest, is just such an island.[13]

That there was a transatlantic dialogue between English and American art in the fifties has been most vociferously asserted by the painter and writer Patrick Heron.[14] It is my contention that this dialogue was somewhat one-sided. The supposed dialogue of the 1960s was also unequally distributed, but it did at least come to have some discursive potential.

Though it was not clear to many in England until the late 1950s, the centre of significant change and development in modern art had moved from Paris to New York in the forties. There are two principal ways in which this move has been perceived and explained. On the one hand, according to Modernist accounts, the American artists were empowered by their distance from certain exhausted traditions and preoccupations, and by their commitment to achieve and maintain the standards of quality of authentic art. The critical potential of this first position is that it recognises the relative autonomy of art. On the other hand, according to the interests of what has been called 'contextual art history', or of the Social History of Art, or of a kind of shock-horror Marxism, the success of American art merely follows from the military fall of Paris in 1940, and from the cultural agency which inevitably attended upon the economic power and imperialist ambitions of post-war America.[15] The critical potential of this second position is that it reminds us that *no* practice or theory dominates in virtue of its aesthetic or cognitive power alone. It is not entirely coincidental that the area of debate between these two positions can be mapped at a certain level onto the debate between Popperian and Kuhnian positions regarding criticism and the growth of knowledge.[16]

Two large exhibitions staged in Cologne[17] and Paris in 1981 sought to re-establish the European art of the forties and fifties. The Beaubourg's 'Paris 37–57' in particular brought back together that range of informal abstract or semi-abstract art which was initially perceived in England as a primarily European phenomenon, to which certain Americans were making a distinct contribution. What was in fact made clear by these exhibitions was the practical and theoretical incoherence of post-war European art. Picasso, Matisse, Léger and Braque, and particularly Braque, were still able to use the languages of painting to individual and significant ends. But among those who still had their careers to establish there ruled a neurotic eclecticism and individualism on the one hand, and on the other a compulsive coming-together for the purposes of 'going-beyond' painting and sculpture. The tendency to defend the latter enterprises as 'research' was rendered bathetic both by the lack of any cognitive means to distinguish success from failure, and by their palpable determination by the non-cognitive interests of dealers anxious to organise and promote the next avant-garde. And in

certain circles art was only avant-garde if it moved or made you blink. The Parisian Galerie Denise Réné in particular appeared governed by the McLuhanite delusion that a change in the perceptual basis of experience was the key to the future of the modern. It was not, of course, but during the 1950s a fashionable belief in the need for change in perception certainly was a means to organise art's nervous relation to the post-war growth of film and television in particular, and of mass consumer culture in general.

We can distinguish two different tendencies in the European art of the fifties. One continues the technical concerns associated with the École de Paris in the direction of a more-or-less abstract, more-or-less expressionistic, more-or-less painterly painting and textural sculpture (Poliakoff, de Stael, Giacometti). The terms of its defence are those which have echoed through the European modern mainstream of the last 60 years: individual creativity, primitive urgency, expressiveness, spontaneity, fundamental human values, the eternal human condition, and so on. The other tendency, less superficially homogeneous, advances under the banners of new technology, new subject-matter, new audiences, new perceptions for a new world. Among its constituents is a revival of Dada technical strategies (Group Zero, Groupe Espace, Groupe de Recherche d'Art Visuel, the Nouvelle Realistes etc.).

The counterparts to these two tendencies in England may be found in the fifties on the one hand in the painting and sculpture of the so-called Middle Generation (Gear, Hilton, Frost, Chadwick etc.), and on the other in those activities associated with the Independent Group, which first gathered at the ICA in 1952. (Its members included Reyner Banham, Lawrence Alloway, Richard Hamilton, Eduardo Paolozzi and William Turnbull.) The two attendant discourses were not seen as socially or culturally incompatible during the fifties; Paolozzi and Turnbull, for instance, could at the time be associated with either tendency. As the principal avant-garde meeting place, the ICA provided a forum for exhibitions of Tachiste painting, for evenings of Dada revivals, for lectures on science fiction comics, and for discussions about architecture and design. These were attended by persons committed to nothing so much as a fascination with artistic culture and its extension, and a disinclination for political debate.

The exhibition 'This is Tomorrow' was staged at the Whitechapel Art Gallery in 1956 by an alliance of the Independent Group with a faction engaged on Constructivism's third or fourth revival (the latter led by Victor Pasmore). The exhibition has retrospectively been seen as marking the launching of Pop Art in England, principally as a consequence of Richard Hamilton's contributions. 'This is Tomorrow' could as appropriately be seen as a recapitulation of that pseudo-Wagnerian tendency within European modernism which connects the legacies of once-critical practices – Constructivism, Dadaism and Surrealism, stripped of their specific political energies and aims – to a dream of cultural and technical modernisation; a dream which had among its indices at the Whitechapel the memory of the Festival of Britain, an amateur fascination with *Scientific American*, and a neurotic desire to manipulate the up-to-date imagery of consumer culture. 'This is Tomorrow' was a big moment for a little idea: the idea that what an artist identifies as usable in his practice is as important in the world as he

takes it to be. The resulting symbols carry a load they are not built to sustain. Such productions tend to date with extreme rapidity.

The more culturally autonomous interests of the 'real painters' of the fifties were expressed in an exhibition at the Redfern Gallery a few months later. This attempted to connect London and Paris under the title 'Metavisual, Abstract, Tachiste'. The title itself testifies to the anxiety with which artists and critics at the time sought a vocabulary with which to organise genealogically disparate endeavours having empirically compatible *effects*. (Matthieu's work of the mid-40s looked 'like' Pollock's, Soulages' of the mid-50s looked like Kline's. Sam Francis was working in Paris in the early '50s and his paintings looked European, though presumably on causally different grounds etc., etc.) Harold Rosenberg's essay on 'The American Action Painters', first published in *Art News* in 1952, had been put into circulation in England in time to compound the confusion. In offering a pseudo-existentialist vocabulary for discussion of the American painters he obscured the real nature of their distinctness from the Europeans. 'Action Painting' and 'Tachisme' were to be virtually interchangeable designations well into the sixties.

A very rough distinction between the artistic investments of the Middle Generation and those of the Independent Group can be made in terms not so much of age as of culture. By the fifties, the artists of the Middle Generation were already committed to a concept of high art largely formed in relation to pre-war European painting and the language of its critical defences. The bright young things of the Independent Group may have had an eye on Europe, but they were fascinated by the notion of a post-war culture. For them this entailed both a need for critical distance from the idealisations of the European modern movement – a distance expressed, for instance, in the writings of Reyner Banham[18] – and a resistance to the supposed artistic hegemony of post-war Paris. They looked to America initially not as a source of authentic art, but as the point of distribution of an exciting culture and mythology.

Two major surveys of American painting were shown at the Tate Gallery in 1956 and '59.[19] Whatever preparation individual English artists may have had for the success of these exhibitions, their effect was nevertheless such as to change the climate of debate; this despite the fact that the first show contained only a single roomful of works by members of the Abstract Expressionist generation: two Pollocks, three De Koonings, one Kline, two Motherwells, two Rothkos, one Still, nothing by Newman. The issue was not simply one of style or size. It is certainly true that the majority of Middle Generation paintings looked small and fussy in comparison. It is also true that the interests of burgeoning English Pop Art were made to seem curiously arch and small-town. But at the risk of sounding like a rampant Modernist I would suggest that the real issue was that the best American painting of the late forties and early fifties was unanswerably more convincing than either. It was just better art.

In the light of my own strictures on the supposed circularity of Modernist value judgements, I must now try to explain my own. Firstly some necessary qualifications. While Jackson Pollock surely effected the kind of change in the terms of reference for painting which can be claimed for *no* twentieth-century

English painter, it does not follow that all those grouped as Abstract Expressionists have to be seen as riding on Pollock's coat-tails over the bodies of all the English painters of a similar generation. At his best, for instance, Roger Hilton was a better painter than the Americans Kline or Motherwell were most of the time. More important, though, than squabbling over the values to be attributed to a range of middle-sized dry goods, is the issue of *why* American-type painting was so successful – in what sense it was better.

Of the two possible forms of answer to this question I will lay aside for the moment the one which would draw attention to the determining power of a domi-nant culture. I do so not because it is devoid of explanatory potential, but because I wish for the moment to address the valuations of Modernism in terms which Modernism itself would not systematically rule out of order.

What distinguished the painting of the Americans was its dialectical stability; on the one hand the security and coherence of its relationship to the European painting of the previous 70 or 80 years, and on the other its resolute if relative unavailability to discussion in terms of those bankrupt discourses about content, effectiveness and the spiritual, technical or social future which had come to dominate European criticism. It was perhaps this latter aspect which Patrick Heron was noticing when he wrote in 1956 of the 'creative emptiness' of the American paintings.[20] A consistent feature both of Greenberg's theory and criticism, and of the 'American-type' painting which he defended, was that they drew attention to the exhaustion of certain conditions for the production of cul-ture: neither a Wagnerian neurosis (Bacon) nor a private enchantment with the picturesque (Sutherland) were now sustainable as features of the artistic tempera-ment. The relational drama of plastic structures connected mimetically to the phenomenal or domestic world (Nicholson, Scott), the importation of whiffs of modern-life detail, the arch allusion (Hamilton); these were all exposed by counter-example as means to compromise the integrity of painting. It has to be said that this purgative left British art with few of its accustomed resources intact.

Pollock had succeeded in making the monumental out of the ad hoc. *No* English painter could do this. [. . .] We also need to remember that the price of a provincial pride is to impose real limits on ambition in the practice of art and on breadth in the practice of criticism. One thing is clear about the response of Middle Generation painters to the difficult circumstances of post-war art and to the dis-tinctness of American painting. They went on worrying about how to pack in con-tent, reference, allusion and metaphor (Davie); about how to complicate or simplify their surfaces, their colour, their space (Scott, Frost). They worried about space and light, seeing these not as quantities, but as abstract values (Heron). Their means of thinking about their own practice were replete with the category mistakes of *uninspired* art talk. The state of scientific knowledge was invoked and domesticated in the interests of a civilized and civilising discourse. These were just the kinds of mistakes which American Modernism at its most sophisticated managed not to make.

American painting may not have been easy to interpret, but at least it was as it were public on its own terms. It was a real if not a predictable product of its own

discourses. The majority of European art of the fifties and early sixties was made public only as a series of vagaries, novelties, entertainments and little complications.

For the young English artist seeking to carve out a modern career in the later fifties and early sixties, there were two principal concerns in terms of which to locate his or her practice. The first was the issue of modernisation and its iconography – an iconography which was largely American, as were the models of modernisation which increasingly determined the British economy (Richard Smith). The second was Modernism *itself*, which had now to be perceived and understood in terms of the dynamic of American painting and the rationalisation of theory for which Greenberg was largely responsible.

The Young Contemporaries exhibition of 1961 was dominated by the metropolitan interests which characterised the work of those who had selected the first of these alternatives (Hockney, Jones). In building their pictorial imagery out of that which had already been given a representational aspect in consumer culture, they continued that strain of ironic detachment from the European history of high art which derived from the Independent Group in the early '50s.

More significant though was the 'Situation' exhibition held at the RBA Galleries in 1960, with some 20 painters involved.[21] 'Situation' marked a clear distinction between the interests of different generations. With hindsight what was significant about the work shown was not the conditions of selection – abstract and at least 30 feet square – as that it provided evidence that a substantial group of artists had decided that *professionalism* in art now entailed subjection to the prescriptions of American Modernism.

As a 19-year old student I was among those for whom 'Situation' signified an exciting commitment and furnished a guide to what to look at. Some eight years later, if I was noticeable at all, I was probably to be numbered among those younger art critics whom Patrick Heron castigated for their unthinking allegiance to American art.[22] It may not have been clear to me then, but it is now, that the primary issue was not one of discrimination between English and American art. The issue was Modernism itself; the need to recognise its relative coherence and its critical implications. The point was not that art had to be American to be any good, or that it had to be Modernist to be taken seriously, but rather that little could be expected of any artist who had failed to come to terms with the dominant discourse, and that that discourse could not now be adequately grounded without reference to American art since the 1940s. If the conceptual framework identified in Modernism had come historically to determine the modern practice of art, then those who worked on in unreflective ignorance of that framework were the most likely to be slavishly restricted by it – all the more provincial for their assertions of independence.

The emergence of this realisation in England can be detected in the mid-fifties in the criticism of Lawrence Alloway, and in his transformation from supporter of the Middle Generation – as demonstrated by his introduction to the slim volume *Nine Abstract Artists* in 1954[23] – to opponent of that same range of abstract art which he later came to see as compromised by its dependence on landscape, still life and figure. The St Ives painters were deliberately excluded from 'Situation',[24]

which Alloway helped to organise. The influence of Greenberg's criticism (which he read earlier than most people in England), and the realisation of its distinctness from Harold Rosenberg's, seems to have played at least as strong a part in Alloway's shift of loyalties as did the very limited exposure which American painting had received in London before the late fifties.

The organisation of 'Situation' *was* an important moment. But it cannot be seen as representing the inauguration of some historically significant practice in painting. The development of English painting in the sixties was disappointing – and disappointing I think in some of the same ways and for some of the same reasons that the vast majority of first-generation American painting of the *fifties* was disappointing in relation to what was produced between 1946 and 1950. That Barnett Newman became the discovery of the late fifties was a symptom of the failure of Modernist criticism to face up to the full implications of its own analysis. Newman's painting can be seen as sabotaged – as Pollock's never was – by the exciting but fatuous claims hung out for its implicit content and symbolism.[25] It is of interest in this connection that Pollock's own post-1950 work – in which he reinvoked a world of European difficulties, expressed in explicit images – is generally and surely unjustly denigrated in Modernist criticism.[26] In the plundered and ratified art of the twentieth century, these may be some of the last paintings left with something difficult, intractable and fertile to yield.

What happened to English art after 1960 – or rather what *didn't* happen – can be explained in terms of what happened to American art and art criticism after 1950, the year, in Ad Reinhardt's words, 'When the revolution became an institution, when avant garde became official art'[27]; the year, also, in which Pollock, de Kooning and Gorky were shown at the Venice Biennale.

The Cold War years between 1950 and '56 offer rich material for the art historian and the historian alike, and even richer material for a dialogue between the two. 1956 was the year of the first large American show at the Tate, and of 'This is Tomorrow'. It was also the year of the Hungarian uprising and of Suez. What price the bright tomorrow canvassed at the Whitechapel? In time this six-year period may come to be seen in the same terms as the nine years between the exhibition of Manet's *Olympia* at the French Salon and the first Impressionist Group exhibition in 1874. They will be seen as strategically critical ground, that is to say, on which to test the autonomy of art history and art criticism as means to characterise a culture, and to open or to close a period. This work will have to be done, but it lies well outside the scope of this paper. I will advance so far into the territory of the social history of art as to observe that the success of Abstract Expressionism in the 1950s established a rapacious and volatile market. To say that the subsequent production of art was determined by the manipulations of this market would be a crude economic reduction. But ours *is* a deeply corrupt and decadent culture, and we should at least be prepared to step up our scepticism where it is clear that the power of non-cognitive determinations on the practices of art and of art criticism have been so massively increased. We should also recognise that under these circumstances the terms of defence and promotion of art will become militant and entrenched in direct proportion to the shakiness of the categories involved. A developing market requires nothing so much as stability,

consistency and coherence in those products for which it has found potential con-
sumers. Under these circumstances, that which is *unstable* must be misrepresented
if it falls within the purview of a distributing agency – a museum, a journal, a
gallery, a critic. The more deeply art's autonomy is compromised, the more
stridently that autonomy will be asserted. Given these conditions, it seems
entirely likely that the loss of moral strenuousness and of critical potential in
Modernist discourse can be traced at some level to the determining power of an
economic agency.[28]

Having said that I must acknowledge that the collapse of vitality in Modernist
art does seem to have preceded by a few years the decline of Modernist criticism.
This can perhaps be explained. What I suggest is this: there was no 'going
beyond' the moment of 1946–50 in American art, or not, at least, in the same
terms or with the same technical interests as those by which that moment was
determined and defined. Pollock's achievement was central. In an important
sense it was also accidental. His statement in 1947[29] of what he aspired to do – to
learn how to paint a new kind of picture – and his reintroduction of a dialogue with
the history of European art after 1950 tempt one to consider that what has been
represented as a self-sufficient and essentially American body of work between
these dates was initially envisaged as the development and practice of a technique
for ends of a quite different sort.

Modern art has often changed in this way. Ad hoc solutions to contingent
problems sometimes effectively redefine a much larger problem field. What
Monet in 1869 described as his 'bad sketches' of La Grenouillère[30] redefined de
facto what could be done thereafter, and helped to close off that very range of
ambitions to which these paintings had initially been addressed: the production of
large-scale modern subject pictures.

The expressive range of Pollock's art rests on very limited resources. In that
sense it is both classical and pessimistic. As painting goes it is also very easy to
reconstruct technically. The substantial lesson of Pollock's art lies not in its 'optical
qualities', its 'reduction of pictorial depth', its 'freeing of line from the functions of
description and definition', its invocation of the 'cosmos of hope', or in any of the
other available forms of valediction. It lies rather in the requirement of assiduous-
ness: in the demand that one recognise how little is left to work with, and that one
nevertheless persist. It is in this sense that Pollock's work truly represents.

III

Good art inaugurates no style. It exhausts certain resources of expression. It is a
distinguishing characteristic of recent art – and perhaps of our terrible culture –
that it exhausts its own resources of expression at an alarming rate. Good art does
not tell you what to do next. It now produces nothing so much as spiritual
penitence; an intuition of the means to identify failure. Art is marginal. André
Breton referred to painting as a 'lamentable expedient'. *We need to remember
this.* Yet I think that most of the major areas of controversy in modern art can be
related at some level to a modern philosophical debate of fundamental import-

ance: how do we arbitrate between, or how do we reconcile, the commitments of empiricism and of realism?

The supposed Kantian detachment of the aesthetic observer is backed up by the gentlemanly and idealist strain in empiricism. The impoverished nature of certain squabbles over the art of the fifties and sixties seems to me to be symptomatic of this area of weakness in the empiricist position, which I see as represented in the field of art criticism by the circumstanced sensibilities of the supposedly disinterested observer – who may also be an artist.

In 1974, Patrick Heron was accorded the remarkable facility of four pages in three issues of a national daily newspaper in which to make his claim that the relations between English and American art in the '50s had been wilfully misrepresented.[31] Insofar as he correctly identified the determining power of a corrupt market structure, he deserved a better response than he got. The force of his own argument was sabotaged, however, by a series of ludicrous comparisons, rendered more feasible by the reproduction of pairs of paintings on grainy newsprint in miniscule reproduction. An English Peter Lanyon of the early fifties shares certain qualities of surface and style with an American de Kooning of the *later* fifties. So Lanyon did it first. Did what? What was at stake? What did it matter? Were we to suppose that the '*what*' – the empirical identification of some phenomenal conglomeration, some decorated surface, some series of effects – exhausted all interest in the 'how'? The critical ontology of art resides not in what it *looks like*, but in what it is *made of*. An adequate perception of what it is made of – what technical and cultural materials under what conditions – will tell you why it *must* look as it does.

Around 1960, aggrieved and ignored middle-aged English artists sought means to put it all back together – to restore content, reference, variety, contrast, relevance or whatever – while certain American artists subjected themselves to the prescriptive aspects of Modernist theory, in pursuit of the next reduction predictable in Modernism's historicistic engine. Some younger English painters tried to follow them in this. In an important sense it was all entirely beside the point. *There was nowhere to go*. The point was not how to make the next kind of expressive painting. The point was that the American painters in 1946–50 – and Pollock in particular – had simply used up the possibility of unselfconscious, unreflective painting. (This is not to say that Pollock himself worked unselfconsciously or unreflectively.) After 1950 they couldn't even make much of it themselves.

This is the real condition we have faced since then – or rather perhaps in general tried not to face. The modern tradition in painting – as Wollheim has rightly observed[32] – is a tradition of priority for the expressive surface and for its manifest effects. But a kind of culmination was reached in 1950. It is after this point that Modernist criticism replaces response with prescription, enablement with coercion. After 1950 art in the Modernist tradition staggers under claims for its expressive content which it simply cannot sustain. Loss of the possibility of expression is a terrible deprivation. It has also been an endemic feature of our post-war culture. The strident discourse of anti-Modernists has tended to invoke the Marxist tradition. Marx does indeed avail us of an explanation for our present

circumstance. He does not, however, furnish the terms in which to describe it. For these we should look rather to Friedrich Nietzsche, who in 1882 confronted the moral and intellectual implications of a similar and not unrelated loss: the 'death of God'.

The Modernist Church is still a robust edifice. For those who would not accept its shelter it has been cold out. You cannot make representations without something to make them of. So you have to work to find materials, and the art of the recent past will tell you only where they are no longer to be found. If you do find something to work with, you will still not know what can be made from it. Your only available measures are measures of failure.

Notes

1 In *Arts Yearbook*, no. 4; reprinted in *Art and Literature*, Spring 1965, and in F. Frascina and C. Harrison (eds) *Modern Art and Modernism: A Critical Anthology*, Harper & Row, 1982, pp. 5–10.

2 See, for example, articles by Serge Guilbaut, Fred Orton and Griselda Pollock, and T. J. Clark [Texts 9, 10, 3, 5]. For its republication in his collected essays, *Art and Culture* (1961), Greenberg added a significant parenthesis to his 1957 article 'The Late Thirties in New York': '. . . some day it will have to be told how "anti-Stalinism", which started out more or less as "Trotskyism", turned into art for art's sake, and thereby cleared the way, heroically, for what was to come.'

3 See, for instance, Greenberg's 'Complaints of an Art Critic', *Artforum*, September 1967, reprinted in C. Harrison and F. Orton, *Modernism, Criticism, Realism*, Harper & Row, 1984, pp. 3–8.

4 See 'Modernist Painting', loc. cit.

5 Richard Wollheim, 'The Work of Art as Object', first published in *Studio International*, Vol. 180, No. 128, December 1970; revised edition in Wollheim, *On Art and the Mind*, Harvard University Press, 1973, edited version in Harrison and Orton, op. cit., pp. 9–17.

6 See, for example, Karl Popper, *The Logic of Scientific Discovery*, Hutchinson, London and Basic Books, New York, 1959; T. S. Kuhn, *The Structure of Scientific Revolutions* (second, revised edition), University of Chicago Press, 1970; Barry Barnes, *Interests and the Growth of Knowledge*, RKP, London, 1977.

7 For an elaboration of this account of Modernism, see the 'Introduction: Modernism, Explanation and Knowledge', to Harrison and Orton, op. cit.

8 Sebastiano Timpanaro, 'Considerations on Materialism', in *New Left Review*, 85, May–June 1974.

9 For a discussion of the relations between non-cognitive agency and theoretical adequacy in Modernism, see Harrison and Orton, op. cit., n.7.

10 See 'Complaints of an Art Critic', loc. cit., n. 3.

11 For a critique along these lines see Art & Language, 'A Portrait of V. I. Lenin' and 'Abstract Expression', reprinted in Harrison and Orton, op. cit., pp. 145–169, 191–204.

12 Loc. cit., n. 5.

13 For an elaboration of this analogy, see M. Baldwin, C. Harrison and M.

Ramsden, 'Art History, Art Criticism and Explanation' [Text 11].

14 In the first part of a three-part article in *The Guardian*, October 10, 11, 12, 1974, for example, Heron wrote of the 'vitally important dialogue between London and New York', supposedly misrepresented in historical accounts by lack of attention to the New York exhibitions of Middle Generation English artists.

15 In so far as Greenberg tends to be associated with an account of the development of modern art as autonomous with respect to social and economic forces, the following passage is of interest: '. . . the conclusion forces itself, much to our own surprise, that the main premises of Western art have at last migrated to the United States, along with the center of gravity of industrial production and political power' ('The Decline of Cubism', *Partisan Review*, March 1948).

16 See, for example, the symposium I. Lakatos and A. Musgrave (eds), *Criticism and the Growth of Knowledge*, Cambridge University Press, 1970.

17 'Westkunst – Zeitgenössische Kunst seit 1939', an exhibition staged by the museums of the City of Cologne, 30 May – 16 August 1981.

18 See, for instance, his introduction to the catalogue for 'This is Tomorrow'.

19 'Modern Art in the United States', 5 January – 12 February 1956; 'New American Painting', 24 February – 22 March 1959.

20 In a review of the 1956 Tate Gallery exhibition, published in *Arts* in March 1956. In view of my observations in the following paragraph, it may be worth quoting at more length: 'I was instantly elated by the size, energy, originality, economy and inventive daring of many of the paintings. Their creative emptiness represented a radical discovery, I felt, as did their flatness, or rather their spatial shallowness. I was fascinated by their consistent denial of illusionistic depth . . . Also, there was an absence of relish in the matière as an end in itself . . .'

21 The members of the organising committee were Alloway, Bernard Cohen, Roger Coleman, Robyn Denny, Gordon House, Henry Mundy, Hugh Shaw and William Turnbull. The exhibitors were Denny, House, Turnbull, Stroud, Plumb, Hoyland, Rumney, Coviello, Vaux, Ayres, Mundy, Green, B. and H. Cohen, Smith, Hobbs, Epstein, Law and Young. A sculpture by Caro was included in 'New London Situation' at the New London Gallery the following year.

22 Heron first referred to '. . . the sheer gutless obsequiousness to the Americans which prevails amongst so many British critics and art pundits generally' in an article on 'The Ascendancy of London in the Sixties', in *Studio International*, December 1966. He repeated the charge in a second article, 'A Kind of Cultural Imperialism?', in the same journal, February 1968.

23 Lawrence Alloway, *Nine Abstract Artists; their work and theory*, Tiranti, London, 1954. The nine were Robert Adams, Terry Frost, Adrian Heath, Anthony Hill, Roger Hilton, Kenneth Martin, Mary Martin, Victor Pasmore and William Scott.

24 'The conditions set by this committee were that the works should be abstract (that is, without explicit reference to events outside the painting – landscape, boats, figures – hence the absence of the St Ives painters, for instance), and not less than thirty square feet' – from Roger Coleman's Introduction to the

first 'Situation' exhibition. The notion of 'events' which are either 'outside' or 'inside' the painting betrays the influence of Rosenberg's article on 'The American Action Painters'.

25 For example, see Thomas Hess' catalogue for the Barnett Newman retrospective, originated by the Museum of Modern Art, New York and shown at the Tate Gallery 28th June–6th August 1972.

26 'From 1951 on his work shows the strong tendency to revert to traditional drawing at the expense of opticality . . . These . . . works probably mark Pollock's decline as a major artist' – Michael Fried, *Three American Painters*, Fogg Art Museum, Harvard, 1965. This is certainly not consistent, incidentally, with the judgement Greenberg expressed in his review of the exhibition in which these works were first substantially shown (Betty Parsons Gallery, New York, 26 November – 15 December 1951): '. . . his new pictures hint, as it were, at the innumerable unplayed cards in the artist's hand. And also, perhaps, at the large future still left to easel painting . . . the weight of the evidence still convinces me – after this last show more than ever – that Pollock is in a class by himself' (*Partisan Review*, January–February 1952).

27 From a talk on 'Art as Art Dogma', given at the ICA, London, May 1964; excerpts from a transcript published as 'Ad Reinhardt on his art' in *Studio International*, December 1967.

28 For a more extended discussion of changes in the conditions of American art in the 1950s and early '60s see C. Harrison and F. Orton, 'Jasper Johns: "Meaning what you see" ', in *Art History*, March 1984.

29 'I believe the easel picture to be a dying form, and the tendency of modern feeling is towards the wall picture or mural. I believe the time is not yet ripe for a *full* transition from easel to mural. The pictures I contemplate painting would constitute a halfway state, and an attempt to point out the direction of the future, without arriving there completely' (from Pollock's application for a Guggenheim Fellowship, printed in F. V. O'Connor, *Jackson Pollock*, MOMA, New York, 1967). There are good reasons to doubt that Pollock's concept of the mural necessarily excluded reference to figurative imagery, even in 1947.

30 'I have indeed a dream, a picture of bathing at La Grenouillère, for which I've made some bad sketches, but it's a dream . . .' (letter from Monet to Bazille, 25 September 1869). In 1865–67 Monet had embarked on two large modern subject pictures, clearly intended for the Salon. One had been rejected, the other remained unfinished.

31 See note 14.

32 Op. cit., n. 5.

13 Modernism and Mass Culture in the Visual Arts

Thomas Crow

I

What are we to make of the continuing involvement between modernist art and the materials of low or mass culture? From its beginnings, the artistic avant-garde has discovered, renewed, or re-invented itself by identifying with marginal, 'non-artistic' forms of expressivity and display – forms improvised by other social groups out of otherwise devalued or ephemeral commodities. Manet's "Olympia" offered a bewildered middle-class public the flattened pictorial economy of the cheap sign or carnival backdrop, the pose and allegories of contemporary pornography superimposed over those of Titian's "Venus of Urbino". For both Manet and Baudelaire, can we separate their invention of powerful models of modernist practice from the seductive and nauseating image the modern city seemed to be constructing for itself? Similarly, can we imagine the Impressionist invention of painting as a field of both particularized and diffuse sensual play separately from the new spaces of commercial pleasure the painters seem rarely to have left – spaces whose packaged diversions were themselves contrived in an analogous pattern? The identification with the social practices of mass diversion – whether uncritically reproduced, caricatured, or transformed into abstract Arcadias – remains a durable constant in early modernism. The actual debris of that world makes its appearance in Cubist and Dada collage as part of a more aggressive renewal of the deconstructive course of the avant-garde. Even the most austere and hermetic twentieth-century abstractionist, Piet Mondrian, in his

Source: 'Modernism and Mass Culture' in *Modernism and Modernity: The Vancouver Conference Papers*, (Ed.) Benjamin H. D. Buchloh, Serge Guilbaut and David Solkin, The Press of the Nova Scotia College of Art and Design, Halifax, Nova Scotia, 1983, pp. 215–264. © Thomas Crow, reprinted by permission of the author. This essay is an expanded version of the paper delivered at the Conference on 'Modernism and Modernity' held at the University of British Columbia, Vancouver, March 12th–14th, 1981. This text, which has been slightly revised by the author, has been edited and footnotes renumbered. The original article included seven illustrations, all of which have been omitted.

final "Boogie-Woogie" series, anchored the results of decades of formal research in a delighted discovery of American traffic, neon, and commercialized black music. In recent history, this dialectic has repeated itself most vividly in the paintings, assemblages, and happenings of the artists who arrived on the heels of the New York School: Johns, Rauschenberg, Oldenburg, and Warhol.

How fundamental is this repeated pattern to the history of modernism? At the outset, the terms in which the question is posed ought to be clarified. So far, I have been using the words avant-garde and modernism in a roughly equivalent way: modernism designating the characteristic practice that goes on within the social and ideological formation we call the avant-garde. But there remains a tension or lack of fit between the two terms which might have a bearing on the meaning of this observed connection between modernism and appropriated low culture. Modernism as a word carries connotations of an autonomous, inward, self-referential and self-critical artistic practice; our usual use of the term avant-garde is on the other hand much more inclusive, encompassing extra-artistic styles and tactics of provocation, group closure, and social survival. We might choose to see the record of avant-garde appropriation of devalued or marginal materials as part of the latter, extrinsic and expedient in relation to the former. Yes, time and again low-cultural forms are called on to displace and estrange the deadening givens of accepted practice, and some residuum of these forms is visible in many works of modernist art. But might not such gestures be seen as only means to an end, weapons in a necessary, aggressive clearing of space, which are discarded when their work is done? This has been the prevailing argument on those occasions when modernism's practitioners and apologists have addressed the problem. This is the case even in those instances where the inclusion of refractory material drawn from low culture was most conspicuous and provocative. In the early history of modernist painting, these would be Manet's images of the 1860's and Seurat's depiction in the 1880's of the cut-rate commercial diversions of Paris. And in each instance we have an important piece of writing by an avant-garde artist which addresses the confrontation between high and low culture, but assigns the popular component to a securely secondary position.

In the case of Manet, the argument comes from Mallarmé in 1876.[1] It is true, he states, that the painter began with Parisian low-life: ". . . something long hidden, but suddenly revealed. Captivating and repulsive at the same time, eccentric, and new, such types as were needed in our ambient lives." But Mallarmé, in the most powerful reading of Manet's art produced in the nineteenth century, regarded these subjects as merely tactical and temporary. He was looking back at the work of the sixties with relief that the absinthe drinkers, dissolute picnics, and upstart whores had faded from view. What was left was a cool, self-regarding formal precision, dispassionate technique as the principal site of meaning, behind which the social referent retreats; the art of painting overtakes its tactical arm and restores to itself the high-cultural autonomy it had momentarily abandoned. The avant-garde schism had, after all, been prompted in the first place by the surrender of the academy to the philistine demands of the modern marketplace – the call for finish, platitude, and trivial anecdote. The purpose of modernism was to save painting, not sacrifice it to the debased requirements of yet another market, this time one of

common amusement and cheap spectacle. For Mallarmé, Manet's aim "was not to make a momentary escapade or sensation, but . . . to impress upon his work a natural and general law." In the process, the rebarbative qualities of the early pictures – generated in an aggressive confrontation with perverse and alien imagery – are harmonized and resolved. The essay concludes with the voice of an imaginary Impressionist painter who flatly states the modernist credo:

> I content myself with reflecting on the clear and durable mirror of painting . . . when rudely thrown, at the close of an epoch of dreams, in the front of reality, I have taken from it only that which properly belongs to my art, an original and exact perception which distinguishes for itself the things it perceives with the steadfast gaze of a vision restored to its simplest perfection.

Despite the distance that separates their politics, a parallel argument to Mallarmé's was made by "*un camarade impressioniste*" in 1891 in the pages of the anarchist journal *La Révolte*.[2] Entitled "Impressionists and Revolutionaries", his text is a political justification of the art of Seurat and his colleagues to Jean Grave's readership – and the anonymous "impressionist comrade" has been identified as painter Paul Signac. Like Mallarmé's 1876 essay, it is another account by an avant-garde insider that addresses the relationship between iconography drawn from degraded urban experience and a subsequent art of resolute formal autonomy. And similarly, it marks the former as expedient and temporary, the latter as essential and permanent. The Neo-Impressionists, he states, had at first tried to draw attention to the conflict between the classes through the visual discovery of industrial work as spectacle and, above all, through portraying the kinds of proletarian pleasure that are only industrial work in another guise: in Seurat's "La Parade" for example, the joyless and sinister come-on for Ferdinand Corvi's down-at-heels circus; or the Pavlovian smile of the stolid music-hall patron who anchors the mechanical upward thrust of "Le Chahut".[3] Signac puts it this way:

> . . . with their synthetic representation of the pleasures of decadence: dancing places, music halls, circuses, like those provided by the painter Seurat, who had such a vivid feeling for the degradation of our epoch of transition, they bear witness to the great social trial taking place between workers and Capital.

But this tactic was to be no more permanent than the impulse which in 1890 sent Charles Henry, armed with Signac's posters and charts, off to instruct the furniture workers of the Faubourg Saint-Antoine (the venerable revolutionary district) in Neo-Impressionist color theory.[4] The continuing oppositional character of *Néo* painting does not derive, Signac is quick to say, from those earlier keen dissections of the world of organized diversion, but from an aesthetic developed in their making, one which now can be applied to any subject whatever. The liberated sensibility of the avant-gardist will stand as an implicit exemplar of revolutionary possibility, and the artist will most effectively perform this function by concentration on the self-contained demands of his medium. (This stands as one of the earliest statements of this now well-worn formula of leftist aesthetics.) Signac refuses any demand that his group continue

a precise socialist direction in works of art, because this direction is encountered much more strongly among the pure aesthetes, revolutionaries by temperament, who, striking away from the beaten paths, paint what they see, as they feel it, and very often, unconsciously supply a solid axe-blow to the creaking social edifice.

Four years later, he would sum up the progress of Neo-Impressionism in a single sentence:[5] "We are emerging from the hard and useful period of analysis, where all our studies resembled one another, and entering that of varied and personal creation." By this time, Signac and company had left behind the subjects and people of the industrial *banlieue* for the Côte d'Azur.

For both of these writers, the relationship between painting and the ordinary diversions of urban life moves from wary identity to determined difference. At the beginning, "rudely thrown, at the close of an epoch of dreams, in the front of reality," as Mallarmé puts it, low culture provides by default the artist's only apparent grasp on modernity. Even this hermetic and withdrawn poet, like the anarchist-socialist Signac, holds that the advanced artist is necessarily allied with the lower classes in their struggle for political recognition: "The multitude demands to see with its own eyes . . . the transition from the old imaginative artist and dreamer to the energetic modern worker is found in Impressionism." But it goes without saying, for both, that emancipated vision will not come from imitating the degraded habits induced in the multitude by its currently favored amusements. Mass political emancipation will occasion a "parallel" search in the arts – now, thanks to politics, shed of an oppressive, authoritarian tradition – for ideal origins and purified practice.

This idea has been so recurrent an organizing belief in the history of the avant-garde that we could raise it to the status of a group ideology. As such, it will determine the way popular sources are understood by the artists who use them. When we turn to the self-conscious theories of modernism developed subsequently, we find that ideology ratified and made explicit. In an essay that stands as one of Clement Greenberg's more complete statements of formal method, "Collage" of 1959, he puts the 'intruder objects' of cubist collage firmly in their place. He belittles the view of some early commentators, like Apollinaire and Kahnweiler, that the technique represented a renewed vision outward, its disruptions sparking attention to a "new world of beauty" dormant in the littered commercial landscape of wall posters, shop windows, and business signs.[6] Greenberg, in contrast, stresses the lack of any such claims coming from Picasso or Braque, continuing, "The writers who have tried to explain their intentions for them speak, with a unanimity that is suspect in itself, of the need for renewed contact with 'reality' (but) even if these materials were more 'real', the question would still be begged, for 'reality' would still explain next to nothing about the actual *appearance* of cubist collage."[7] The word reality here stands for any independent significance the bits of newspaper or woodgrain might retain once inserted into the cubist pictorial matrix. One reads through the entire essay without once finding this even admitted as an interpretive possibility. Collage is entirely subsumed in a self-sufficient dialogue between the flat plane and sculptural effect; the artist's worry over the problem of representation in general precludes representation in the particular. Thus, as the theory of modernism takes on independent life, these

dislodged bits of commercial culture become, even more drastically, means to an end.

II

The testimony of modernism itself then would appear thoroughly to obviate the low culture problem – or indicate that its solution must be pursued in another critical discourse entirely. Certainly to the many partisans of a post-modernist present, who dismiss Greenberg's model as an arbitrary and arid teleology, it would seem foolish to look to the theory of modernism for any help on this issue. Avant-garde borrowing from below necessarily involves questions of heterogeneous cultural practice, of transgressing limits and boundaries. The post-modernists, who profess to value heterogeneity and transgression, find modernist self-understanding utterly closed to anything but purity and truth to media.[8]

The critique of Greenbergian modernism is now well advanced, and its defenders are scarce. But I am pursuing this point in the belief that Greenberg – and the moment of theoretical practice to which he contributed – does have something to tell us, despite this apparent closure against the sphere of low culture. Greenberg's criticism, in fact, offers an explanation for that very act of closure as carried out by Mallarmé, Signac, and all the rest; he brackets the idealism of Mallarmé's mirror of painting and Signac's liberated consciousness in a social and historical frame. Greenberg's critics have almost exclusively focused on the prescriptive outcome of his analysis, and there is some justice in this, in that since 1950 or so Greenberg himself has been rather myopically enamored with those prescriptions. But the later Greenberg has obscured the earlier, his eventual modernist triumphalism pushing aside the initial logic of his criticism and the particular urgency that prompted it.

In 1939, what worried him was not the picture plane; his seminal essay "Avant-Garde and Kitsch"[9] begins with a flat rejection of the limited frame of formal aesthetics: "It appears to me it is necessary to examine more closely and with more originality than hitherto the relationship between aesthetic experience as met by the specific – not the generalized – individual, and the social and historical contexts in which that experience takes place." This is a mildly stated but deeply meant preamble; what occupies his attention is nothing less than a material and social crisis which threatens the traditional forms of nineteenth-century culture with extinction. This crisis has resulted from the economic pressure of an industry devoted to the simulation of art in the form of reproducible cultural commodities, that is to say, the industry of mass culture. In search of raw material, mass culture strips traditional art of its marketable qualities, and leaves as the only remaining path to authenticity a ceaseless alertness against the stereotyped and pre-processed. The name of this path is modernism, which with every success is itself vulnerable to the same kind of appropriation. Ultimately, the surviving autonomous art object becomes a fragile and fugitive thing, withdrawn in the face of the culture industry to the refuge of its material support. By refusing any other demand but the most self-contained technical ones, it closes

237

itself to the reproduction and rationalization that would process its useable bits and destroy its inner logic. From this resistance is derived modernism's inwardness, self-reflexivity, 'truth to media'.

Greenberg makes this plain in "Towards a Newer Laocoon" of 1940,[10] the essay in which he drew out the largely unstated aesthetic implications of "Avant-Garde and Kitsch". "The arts, then," he states, "have been hunted back to their mediums, and there they have been isolated, concentrated and defined To restore the identity of an art, the opacity of the medium must be emphasized." As stated, this conclusion is provisional and even reluctant, its tone far removed from the complacency of his later criticism. As we have seen, he would come to ratify in an untroubled way the absolute priority of a high modernism over its occasional popular materials. But in his original work, which provided the premises for his subsequent critical practice, that priority is reversed. 'Quality', it is true, remains exclusively with modernist remnants of traditional high culture, but mass culture has determined the form high culture must assume. Mass culture is prior and determining; modernism is its effect.

The point I am making is that the formative theoretical moment in the history of modernism in the visual arts was inseparably an effort to come to terms with cultural production as a whole under developed capitalism. Because of this – and only because of this – it was able temporarily to surpass the idealism of the ideologies generated within the avant-garde, an idealism to which it soon tacitly succumbed. Recovering this nearly lost moment of theoretical consciousness can begin to give us a purchase on the low-culture problem, one which the avant-garde itself cannot provide. Interdependence between high and low is at the heart of the theory. In Greenberg's analysis, mass culture is never left behind in modernist practice, but persists as a constant pressure on the artist, severely restricting creative 'freedom'. But the pressure is, of course, all in one direction – all repulsion, no attraction; the continued return to vernacular materials on the part of the avant-garde thus remains unexplained.

Greenberg could not admit any positive interdependence between the two spheres because of the rigid distinction he makes between popular culture and the modern phenomenon of kitsch. The former is for him inseparable from some integrated community comparable to the kind that sustained traditional high art; the latter is peculiarly modern, a product of rural migration to the cities and the immigrants' eager abandonment of the folk culture they brought with them. Expanded literacy, the demarcation of assigned leisure outside the hours of work, the promise of heightened diversion and pleasure within that leisure time, all set up pressure for a simulated culture adapted to the needs of this new clientele. Kitsch exists to fill a vacuum; the urban worker, whether in factory or office, compensates for the surrender of his personal autonomy to the discipline of the workplace in the intense development of the time left over; lost control over one's life is rediscovered in the symbolic and affective experiences now defined as specific to leisure. But because the ultimate logic of this re-creation (the hyphen restores the root meaning of the term) is the rationalized efficiency of the system as a whole, these needs are met by the same means as material ones: by culture in the form of reproducible commodities.

For those whose cultural horizons are limited to kitsch, subjectivity is thus mirrored and trapped in the lifeless logic of mass production; imagining, thinking, feeling are all done by the machine long before the individual consumer encounters its products: the tabloids, pop tunes, pulp novels, melodramas of stage and film. For this reason, the artist – in any genuine sense of the term – can expect no audience outside those cultivated fractions of the dominant class who maintain in their patronage a pre-modern independence of taste. Greenberg can state categorically,[11]

> The masses have always remained more or less indifferent to culture in the process of development. . . . No culture can develop without a social basis, without a source of stable income. And in the case of the avant-garde, this was provided by an elite among the ruling class of that society from which it assumed itself to be cut off, but to which it has always remained attached by an umbilical cord of gold.

In light of this analysis, it is not surprising that he should posit the relationship between modernism and mass culture as one of relentless refusal. The problem remains, however, that the elite audience for modernism endorses, in every respect but its art, the social order responsible for the crisis of culture. The implicit contention of modernist theory – and the name of T. W. Adorno for modern music can be joined to that of Greenberg for the visual arts – was that the contradiction between an oppositional art and a public with appetite for no other kind of opposition could be bracketed off, if not transcended, in the rigor of austere, autonomous practice.

III

There was and is great explanatory and moral power in this position. But there are, it hardly need be said, problems with it. The critics of modernism have tirelessly pointed out that none of its formal innovations have escaped being sleekly incorporated into, first, a new academicism, and subsequently, chic items of upscale consumption and glamorous facades for state and corporate power. By the mid-1960's, painting and sculpture had reached a point of terminal reticence barely distinguishable from expensive vacuity. This sort of critique is by now easy to make, and has settled into glib orthodoxy. It has at times taken the bizarre form of holding the theory somehow responsible for the fate that befell modernist art. I have tried to show that the fashion for anti-modernism has obscured a complex and useful historical account imbedded in Greenberg's early writings. And if we are to surpass Greenberg's conclusion that authentic art must forego interchange with the rest of the culture, we need to question his analysis on a point his critics have largely conceded: the issue of audiences for advanced art.

If we make Manet the effective beginning of modernism, it would be hard not to admit the general accuracy of Greenberg's dismissal of any but an elite audience. The impulse which moved Signac momentarily to make an audience of those Parisian furniture workers stands out by its extreme rarity in the history of the avant-garde. The fleetingness of those efforts in Berlin, Cologne, and Vitebsk after World War I to re-define avant-garde liberation in working-class terms tells

the same story. But oppositional art did not begin with Manet and did not before him always opt for detachment.

The two artists together most responsible for defining advanced art in terms of opposition to established convention, making painting a scene of dispute over the meaning of high culture, were David and Courbet; and the art of each, at least in the critical moments of 1785 and 1850, was about a re-definition of publics. The formal qualities which are rightly seen as anticipating fully-fledged modernism – the dramatic defiance of academic compositional rules, technical parsimony, and compressed dissonance of the "Oath of the Horatii" or "Burial at Ornans" – were carried forward in the name of *another* public, excluded outsiders, whose own signifying practices these pictures managed to address. In the process, 'Rome' or 'the countryside' as privileged symbols in a conflict of ideologies were turned over to the outsiders. The antagonistic character of these pictures can thus be read as duplicating real antagonisms within the audience assembled in the Salon. Already perceived oppositions of style and visual language drawn from the world outside painting were drawn into the space of art and put to work in a real dialectic of publics: the appeal of each artist to the excluded group was validated by the demonstrated hostility of the established, high-minded art public; that hostility was redoubled by the positive response of the illegitimate public; and so on in a self-reinforcing way.[12]

But with the installation of oppositional art within a permanent avant-garde, that group itself comes to replace the oppositional public precariously mobilized by David or Courbet; antagonism is abstracted and generalized; and only then does dependence on an elite audience and luxury-trade consumption become a given. One writer of Greenberg's generation, rather than bracketting off this dependence, made it central to his analysis: this was Meyer Schapiro. In his little-known but fundamental essay of 1936, "The Social Bases of Art", and in "The Nature of Abstract Art" published the following year,[13] he argued in an original and powerful way that the avant-garde has habitually based its model of artistic freedom on the aimlessness of the strolling, middle-class consumer of packaged diversion. The complicity between modernism and the consumer society is, he maintains, clearly to be read in Impressionist painting:[14]

It is remarkable how many pictures we have in early Impressionism of informal and spontaneous sociability, of breakfasts, picnics, promenades, boating trips, holidays, and vacation travel. These urban idylls not only present the objective forms of bourgeois recreation in the 1860's and 1870's; they also reflect in the very choice of subjects and in the new aesthetic devices the conception of art solely as a field of individual enjoyment, without reference to ideas and motives, and they presuppose the cultivation of these pleasures as the highest field of freedom for an enlightened bourgeois detached from the official beliefs of his class. In enjoying realistic pictures of his surroundings as a spectacle of traffic and changing atmospheres, the cultivated rentier was experiencing in its phenomenal aspect that mobility of the environment, the market and of industry to which he owed his income and his freedom. And in the new Impressionist techniques which broke things up into finely discriminated points of color, as well as in the 'accidental' momentary vision, he found, in a degree hitherto unknown in art, conditions of sensibility closely related to those of the urban promenader and the refined consumer of luxury goods.

Schapiro's contention is that the advanced artist, after 1860 or so, succumbs to the general division of labor as a full-time leisure specialist, an aesthetic technician picturing and prodding the sensual expectations of other, part-time consumers. The preceding passage is from the 1937 essay; in its predecessor Schapiro offered an extraordinary iconographic summation of modernism in a single paragraph, one in which its progress is logically linked to Impressionism's initial alliance with the emerging forms of mass culture. If only because of the undeserved obscurity of the text, it is worth quoting at length:[15]

> Although painters will say again and again that content doesn't matter, they are curiously selective in their subjects. They paint only certain themes and only in a certain aspect First, there are natural spectacles, landscapes or city scenes, regarded from the point of view of a relaxed spectator, a vacationist or sportsman, who values the landscape chiefly as a source of agreeable sensations or mood; artificial spectacles and entertainments – the theatre, the circus, the horse-race, the athletic field, the music hall – or even works of painting, sculpture, architecture, or technology, experienced as spectacles or objects of art; . . . symbols of the artist's activity, individuals practicing other arts, rehearsing, or in their privacy; instruments of art, especially of music, which suggest an abstract art and improvisation; isolated intimate fields, like a table covered with private instruments of idle sensations, drinking glasses, a pipe, playing cards, books, all objects of manipulation, referring to an exclusive, private world in which the individual is immobile, but free to enjoy his own moods and self stimulation. And finally, there are pictures in which the elements of professional artistic discrimination, present to some degree in all painting – the lines, spots of color, areas, textures, modelling – are disengaged from things and juxtaposed as 'pure' aesthetic objects.
>
> Thus elements drawn from the professional surroundings and activity of the artist; situations in which we are consumers and spectators; objects which we confront intimately, but passively or accidentally – these are the typical subjects of modern painting The preponderance of objects drawn from a personal and artistic world does not mean that pictures are more pure than in the past, more completely works of art. It means simply that the personal and aesthetic contexts of secular life now condition the formal character of art

With Schapiro, then, we have an account of modernist painting that makes the engagement with urban leisure central to its interpretation. In the hands of the avant-garde, the aesthetic itself is identified with habits of enjoyment and release produced quite concretely within the existing apparatus of commercial entertainment and tourism – even, and perhaps most of all, when art appears entirely withdrawn into its own sphere, its own sensibility, its own medium.

IV

Schapiro would one day become a renowned and powerful defender of the American avant-garde, but we find his original contribution to the debate over modernism and mass culture squarely opposed to Greenberg's conclusions of a few years later: the 1936 essay was in fact a forthright anti-modernist polemic, an effort to demonstrate that the avant-garde's claims to independence, to disengagement from the values of its patron class were a sham; "in a society where all men can be free individuals," he concluded, "individuality must lose its

exclusiveness and its ruthless and perverse character."[16] The social analysis underlying Schapiro's polemic, however, is almost identical to Greenberg's. Both see the commodification of culture as the negation of the real thing, that is, the rich and coherent symbolic dimension of collective life in earlier times; both see beneath the apparent variety and allure of the modern urban spectacle only the "ruthless and perverse" laws of capital; both posit modernist art as a direct response to that condition, one which will remain in force until a new, socialist society is achieved.[17] Given these basic points of agreement and the fact that both men were operating in the same intellectual/political milieu, how do we explain the extent of their differences?

One determining difference between Greenberg and Schapiro lay, I think, in the specificity of their respective understandings of mass culture: though each is schematic in his account, Greenberg is more schematic. His use of the term kitsch encompasses practically the entire range of consumable culture, from the crassest proletarian entertainments to the genteel academicism of 'serious' art: "What is academic is kitsch, what is kitsch is academic,"[18] is his view in a pithy sentence. Schapiro, on the other hand, is less interested in the congealed, inauthentic character of cultural commodities taken by themselves than he is in behavior: what are the characteristic forms of experience induced by these commodities? In his discussion of Impressionism, this leads to the historically accurate perception that the people with the time and money fully to occupy the new spaces of urban leisure were primarily middle class. The week-end resorts and *grands boulevards* were, at first, places given over to conspicuous display of a brand of individual autonomy specific to that class stratum; the right clothes and accessories, as well as the right poses and attitudes were required. The new department stores, like Boucicaut's *Bon Marché*, grew spectacularly by supplying the necessary material equipment and, by their practices of sales and promotion, effective instruction in the more intangible requirements of this sphere of life. The economic barriers were enough, in the 1860's and 1870's, to ward off the incursion of other classes. Even such typically working-class diversions of our time as soccer and bicycle racing (Manet planned a large canvas on the latter subject in 1870) began in this period as enthusiasms of the affluent.[19]

In Schapiro's eyes, the avant-garde merely followed a decentering of individual life which overtakes the middle-class as a whole. It is for him entirely appropriate that the formation of Impressionism should coincide with the Second Empire, that is, the period when acquiescence to political authoritarianism was followed by the first spectacular flowering of the consumer society. The two phenomena cannot in fact be separated from one another; the self-liquidation after 1848 of the classical form of middle-class political culture prompted a reconstruction of traditional ideals of individual autonomy and effectiveness in spaces outside the official institutions of society, spaces where conspicuous styles of 'freedom' were made available. That shift was bound up with the increasingly sophisticated engineering of mass consumption, the internal conquest of markets, required for continuous economic expansion. The department store, which assumed a position somewhere between encyclopedia and ritual temple of consumption, is the appropriate symbol for the era. And we are just beginning to

understand what a powerful mechanism for socialization it was. It served as one of the primary means by which a bourgeois public, often deeply unsettled by the dislocations in its older patterns of life, was won over to the new order being wrought in its name.[20]

As noted above, this is the historical observation which underlies Greenberg's "Avant-Garde and Kitsch", but his account is incomplete in that it sees kitsch, the *nouveautés* in the cultural display windows, as simply meeting the needs of the productive apparatus: there is a void in urban life, the 'empty' time outside work, which can be filled with any ersatz product whatever; the market for kitsch is credited with no resistance to manipulation. What this picture leaves out is the historical origin of that market in the *suppression* of pre-industrial forms of communal life. Greenberg assumes that the "new urban masses" abandoned their traditional cultural equipment readily and without a fight; actually they found what elements of rural ritual and recreation they brought with them actively opposed by urban authorities and moral reformers. It was the case throughout the industrializing West that the rhythms of work and rest imbedded in rural communal life were held incompatible with urban tranquility and the efficient operation of expanding workshops and factories. The distinctive festive and athletic amusements of the countryside were re-defined in the city as vice and violence, and treated accordingly.[21]

Older forms of community were thus under constant pressure and slowly but surely dismantled. They were not, however, erased. Communal impulses were channeled into new forms of labor association, ranging in their aims from pious improvement to radical conspiracy. In France, the growing sense of grievance and political assertiveness of these groups following the February Revolution in 1848 provoked the crisis of the following June – and the abandonment by the republican bourgeoisie of parliamentary accommodation of working-class demands in favor of a naked show of force. And that strategy led in 1851 to an unprotesting surrender of the central institutions of bourgeois political culture – representative government, parties, legal opposition, a free press – all liquidated in the interests of 'order'. Morny and the upstart Bonaparte brought off their coup without serious resistance from the politicians or intelligentsia.

These early essays of Greenberg and Schapiro, which take as their common subject the sacrifice of the best elements in bourgeois culture to economic expediency, are both visibly marked, as I read them, by the best known interpretation of the 1848–51 crisis in France: that of Marx in the *Eighteenth Brumaire of Louis Bonaparte*. There Marx described the way in which the forcible exclusion of oppositional groups from the political process necessitated a kind of cultural suicide on the part of the republican bourgeoisie, the willed destruction of its own optimal institutions, values, and expressive forms:[22]

> While the *parliamentary party of Order*, by its clamor for tranquility, as I have shown, committed itself to quiescence, while it declared the political rule of the bourgeoisie to be incompatible with the safety and existence of the bourgeoisie, by destroying with its own hands in the struggle against other classes in society all the conditions for its own regime, the parliamentary regime, the *extra-parliamentary mass of the bourgeoisie*, on the other hand, by its servility toward the President, by

its vilification of parliament, by its brutal treatment of its own press, invited Bonaparte to suppress and annihilate its speaking and writing section, its politicians and its *literati*, its platform and its press, in order that it might be able to pursue its private affairs with full confidence in the protection of a strong and unrestricted government. It declared unequivocally that it longed to get rid of its own political rule in order to get rid of the troubles and dangers of ruling.

When Schapiro speaks of the "enlightened bourgeois detached from the official beliefs of his class," he directs us back to the actual processes by which that detachment occurred. Out of the desolation of early nineteenth-century forms of collective life, which affected all classes of the city, fractions of the dominant class led the way in colonizing the one remaining domain of relative freedom: the spaces of public leisure. There suppressed community is displaced and dispersed into isolated acts of individual consumption; but those acts can in turn coalesce into characteristic group styles. Within leisure, a sense of solidarity can be re-captured, at least temporarily, in which individuality is made to appear imbedded in group life: the community of fans, aficionados, supporters, sportsmen, experts. Lost possibilities of individual effectiveness within the larger social order are represented as a catalogue of leisure-time roles.[23]

Another contributer to this extraordinary theoretical moment of the later 1930's, Walter Benjamin, makes this point plainly in his study of Baudelaire and Second-Empire Paris. Speaking of the class to which the poet belonged, he states,[24]

> The very fact that their share could at best be enjoyment, but never power, made the period which history gave them a space for passing time. Anyone who sets out to while away time seeks enjoyment. It was self-evident, however, that the more this class wanted to have its enjoyment in this society, the more limited this enjoyment would be. The enjoyment promised to be less limited if this class found enjoyment of this society possible. If it wanted to achieve virtuosity in this kind of enjoyment, it could not spurn empathizing with commodities. It had to enjoy this identification with all the pleasure and uneasiness which derived from a presentiment of its destiny as a class. Finally, it had to approach this destiny with a sensitivity that perceives charm even in damaged and decaying goods. Baudelaire, who in a poem to a courtesan called her heart 'bruised like a peach, ripe like her body, for the lore of love,' possessed this sensitivity. To it he owed his enjoyment of this society as one who had already half withdrawn from it.

V

In his drafted introduction to the never-completed Baudelaire project, Benjamin writes,[25] "In point of fact, the theory of *l'art pour l'art* assumes decisive importance around 1852, at a time when the bourgeoisie sought to take its 'cause' from the hands of the writers and poets. In the *Eighteenth Brumaire* Marx recollects this moment" Modernism, in the conventional sense of the term, begins in the forced marginalization of the artistic vocation. And what Benjamin says of literature applies as well if not better to the visual arts. The avant-garde leaves behind the older concerns of official public art not out of any special rebelliousness on the part of its members, but because their political representatives had jet-

tisoned as dangerous and obstructive the institutions and ideals for which official art was metaphorically to stand. David's public, to cite the obvious contrasting case, had found in his pictures of the 1780's a way imaginatively to align itself with novel and pressing demands of public life; the *Horatii* and the *Brutus* resonated as vivid tracts on individual resolve, collective action, and their price. Oppositional art meant opposition on a broad social front. Until 1848, there was at least a latent potential for a middle-class political vanguard to act on its discontents, and an oppositional public painting maintained itself in reserve. This was literally the case with the most powerful attempt to duplicate David's early tactics, Géricault's "Raft of the Medusa", which failed to find an oppositional public in the politically bleak atmosphere of 1819. But when the Revolution of 1830 roused Delacroix from his obsession with individual victimization and sexual violence, he reached back to the "Raft". "Liberty's" barricade, heaving up in the foreground, is the raft itself turned ninety degrees; the bodies tumble off its leading rather than trailing edge (Delacroix shifts the sprawling, bare-legged corpse more or less intact from the right corner to the left, precisely marking the way he has transposed his model); the straining pyramid of figures now pushes toward the viewer rather than away. In the first days of the year 1848, the republican Michelet employed the "Raft" in his oratory as a rallying metaphor for national resistance. After February, "Liberty" emerged briefly from its captivity in the storerooms.[26]

1851 ended all this. (It certainly obviated Courbet's effort to shift the address of history painting to a new outsider public, a radical opposition based in the working class.) For a bourgeois public, the idea of a combative and singular individuality, impatient with social confinement, remained fundamental to a widely internalized sense of self – as it still does. But that notion of individuality could henceforth be realized only in private acts of self-estrangement, in distancing and blocking out the gray realities of administration and production in favor of a brighter world of sport, tourism, and spectacle. This process was redoubled in the fierce repression that followed the Commune twenty years later; between 1871 and 1876, the hey-day of Impressionist formal innovation, Paris was under martial law. And in the following decade, the Third Republic would orchestrate the return to 'normalcy' (translate as policies of re-armament, nationalism, commercial and colonial expansion) around the most massive provision of spectacular diversion yet conceived: the Eiffel Tower exhibition of 1889. The event was designed and organized from the start for the purpose of painless management of political consent; it did so by transforming the official picture of French society and empire into an object of giddy, touristic consumption. After the close of the exhibition, the government, riding a fat electoral victory, unabashedly pronounced the operation a success in just these terms.[27]

If the subjective experience of freedom becomes a function of a supplied identity, one detached from the social mechanism and contemplating it from a distance, then the early modernist painters – as Schapiro trenchantly observed in 1936 – lived that role to the hilt. If we accept his initial position, we might well end our discussion right here, dismissing, as one kind of Leftist art history still does, all avant-garde claims to a critical and independent stance as so much false con-

sciousness. In Schapiro's essay of the following year, however, there occurs a significant shift in his position. The basic argument remains in place, but we find him using without irony terms like "implicit criticism" and "freedom" to describe modernist painting. Of early modernism, he states,[28]

> The very existence of Impressionism which transformed nature into a private, unformalized field of sensitive vision, shifting with the spectator, made painting an ideal domain of freedom; it attracted many who were tied unhappily to middle-class jobs and moral standards, now increasingly problematic and stultifying with the advance of monopoly capitalism In its discovery of a constantly changing phenomenal outdoor world of which the shapes depended on the momentary position of the casual or mobile spectator, there was an implicit criticism of symbolic and domestic formalities, or at least a norm opposed to these.

What has been added here is recognition of some degree of active, resistant consciousness within the avant-garde. And this extends to his valuation of middle-class leisure as well. He speaks of an Impressionist "discovery" of an implicitly critical, even moral, point of view. This critical art is not secured through withdrawal into self-sufficiency, but is found in existing social practices outside the sphere of art.

Schapiro creates a deliberate ambiguity in the second essay in that it offers a qualified apology for modernism without renouncing his prior dismissal of all modernist apologetics. How do we interpret that ambiguity? To start, we could note the immediate political and biographical reasons of his shift.[29] It is, among other things, a step toward his anodyne celebrations of abstract painting in the 1950's.[30] But for the moment, I want to hold these texts apart from their immediate determinations and functions within the political and artistic battles of New York in the 1930's, in the belief that, together, they still provide the most productive access to the modernism/mass culture problem in the visual arts. "The Nature of Abstract Art" is an inconclusive, 'open' text, and it is just this quality, its unresolved oscillation between negative and affirmative positions, that makes it so valuable.

The fundamental change in Schapiro's thinking is that he no longer identifies the avant-garde with the outlook of a homogeneous 'dominant' class. Yes, Impressionism belongs to and figures a world of privilege, but there is disaffection and erosion of consensus within that world. The society of consumption as a means of engineering political consent and socially integrative codes was no simple or uncontested solution to the 'problem of culture' under high capitalism. As it displaced resistant impulses, it also gave them a refuge in a relatively unregulated social space where contrary social definitions could survive, and occasionally flourish. Much of this was and is, obviously, permitted disorder. Managed consensus depends on a compensating balance between submission and negotiated resistance within leisure – Marcuse's "repressive de-sublimation". But once that zone of permitted 'freedom' exists, it can be seized by groups which articulate for themselves a counter-consensual identity, an implicit message of rupture and discontinuity. From the official point of view, these groups are defined as deviant or delinquent; we can call them, following contemporary sociological usage, resistant subcultures.[31]

If we wanted briefly to characterize the early avant-garde as a social formation, we could do no better than simply to apply this sociologists' description of these subcultures in general.[32] Their purpose is to

> win space They cluster around particular locations. They develop specific rhythms of interchange, structured relations between members: younger to older, experienced to novice, stylish to square. They explore 'focal concerns' central to the inner life of the group: things always 'done' or 'never done', a set of social rituals which underpin their collective identity and define them as a 'group' instead of a mere collection of individuals. They adopt and adapt material objects – goods and possessions – and reorganize them into distinctive 'styles' which express the collectivity of their being-as-a-group. These concerns, activities, relationships, materials become embodied in rituals of relationship and occasion and movement. Sometimes, the world is marked out, linguistically, by names or an *argot* which classifies the social world exterior to them in terms meaningful only within their group perspective, and maintains its boundaries. This also helps them to develop, ahead of immediate activities, a perspective on the immediate future – plans, projects, things to do to fill out time, exploits They too are concrete, identifiable social formations constructed as a collective response to the material and situated experience of their class.

To make the meaning of that last sentence more precise, the resistant subcultural response is a means by which certain members of a class 'handle' and attempt to resolve difficult and contradictory experience common to their class but felt more acutely by the subcultural recruits. In our own time, youth, black, brown, or gay identity are the common determining factors; the uneasy and incomplete integration of such groups into the institutions of work, training, politics, and social welfare necessitates distinctive defensive maneuvers in style, language, and behavior. In the later nineteenth century, an artistic vocation, in the sense established by the examples of David, Goya, Géricault, Delacroix, Courbet, had become so problematic as to require similar defense. The invention of the avant-garde constitutes a small, face-to-face group of artists and supporters as a significant oppositional public, one which is socially grounded within structured leisure. The distinctive point of view and iconographic markers of the subculture are drawn from a repertoire of objects, locations, and behaviors supplied by other colonists of the same social spaces; avant-garde opposition is drawn out of inarticulate and unresolved dissatisfactions which those spaces, though designed to contain them, also put on display.

VI

At this point, we need to draw distinctions more clearly between kinds of subcultural response. There are those which are no more than the temporary outlet of the ordinary citizen; there are those which are *merely* defensive, in that the group style they embody, though it may be central to the social life of its members, registers only as a harmless, perhaps colourful, enthusiasm. But the stylistic and behavioral maneuvers of certain subcultures will transgress settled social boundaries. From the outside, these will be read as extreme, opaque, inexplicably

evasive and for that reason hostile. The dependable negative reaction from figures in authority and the semi-official guardians of propriety and morality will then further sharpen the negative identity of the subculture, help cement group solidarity, and often stimulate new adherents and imitators. Defense passes over into symbolic resistance.

The required boundary transgression can occur in several ways. Where different classes and class fractions meet in leisure-time settings, there is the possibility that objects, styles, and practices with an established significance for one class identity can be appropriated and re-positioned by another group to generate new, dissonant meanings. This shifting of signifiers can occur in both directions on the social scale (or scales). Another means to counter-consensual group statement is to isolate one element out of the normal pattern of leisure consumption, and then exaggerate and intensify its use until it comes to signify the opposite of its intended meaning.

It is easy to think of examples of such semiotic tactics in present-day subcultures; our model of subversive consumption is derived from the analysis of these deviant groups.[33] But we can see, just as easily I think, the same tactics at work in the early avant-garde. The mixing of class signifiers was central to the formation of the avant-garde sensibility. Courbet's prescient excursion into suburban pleasure for sale, the "Young Ladies on the Banks of the Seine" of 1856, showed two drowsing prostitutes in the intimate finery of their betters, piled on past all 'correct' usage of fashionable underclothing.[34] In the next decade, Manet would exploit similar kinds of dissonance. It showed up in his own body; his friend and biographer Proust speaks of his habitual imitation of the speech patterns and peculiar gait of a Parisian street urchin.[35] The subject of both the "Déjeuner" and the "Olympia" is the pursuit of commercial pleasure at a comparably early stage when it necessarily involved negotiation with older, illicit subcultures at the frontier between legality and criminality.[36]

Establishing itself where Courbet and Manet had led, 'classic' Impressionism, the sensually flooded depictions of weekend leisure produced by Monet, Renoir, and Sisley in the 1870's, opted for the second tactic. The life they portray was being lived entirely within the confines of real-estate development and entrepreneurial capitalism; these are images of provided pleasures. But they are images which, by the very exclusivity of their concentration on ease and uncoerced activity, alter the balance between the regulated and unregulated compartments of experience. They take leisure out of its place; instead of appearing as a controlled, compensatory feature of the modern social mechanism, securely framed by other institutions, it stands out in unrelieved difference from the unfreedom which surrounds it.

It is in this sense that Schapiro can plausibly speak of Impressionism's "implicit criticism of symbolic and domestic formalities, or at least a norm opposed to these." But what Schapiro does not address is how this criticism was specifically articulated as criticism: a difference is not an opposition unless it is consistently read as such. This brings us necessarily back to the question of modernism in its conventional aesthetic sense of autonomous, self-critical form – back to Greenberg, we might say. The 'focal concern' of the avant-garde subculture is,

obviously, painting conceived in the most ambitious terms available. It was in its particular opposition to the settled discourse of high art that the central avant-garde group style, i.e. modernism, gained its cogency and its point. They were able to take their nearly total identification with the uses of leisure and make that move count in another arena, a major one where official beliefs in cultural stability were particularly vulnerable. The *grands boulevards* and Argenteuil may have provided the solution, but the problem had been established elsewhere: in the evacuation of artistic tradition by academic eclecticism, pastiche, the manipulative reaching for canned effects, all the played-out maneuvers of Salon kitsch. Almost every conventional order, technique, and motif which had made painting possible in the past, had, by this point, been fatally appropriated and compromised by academicism. And this presented immediate practical difficulties for the simple making of pictures: how do you compose, that is, construct a pictorial order with evident coherence and closure, without resorting to any pre-fabricated solutions? The unavailability of those solutions inevitably placed the greatest emphasis – and burden – on those elements of picture-making which seemed unmediated and irreducible: the single vivid gesture of the hand by which a single visual sensation is registered. As tonal relationships belonged to the rhetoric of the schools – rote procedures of drawing, modelling, and chiaroscuro – these gestural notations would ideally be of pure, saturated color.

The daunting formal problematic that resulted was this: how to build from the independent gesture or touch some stable, over-arching structure which fulfills two essential requirements: 1) it must be constructed only from an accumulation of single touches and cannot appear to subordinate immediate sensation to another system of cognition; 2) it must at the same time effectively close off the internal system of the picture and invest each touch with consistent descriptive sense in relation to every other touch. Without the latter, painting would remain literally pre-artistic, an arbitrary slice out of an undifferentiated field of minute, equivalent, and competing stimuli. Impressionism, quite obviously, found ways around this impasse, discovered a number of improvised, ingenious devices for making its colored touches jell into readability and closure: disguised compositional grids, sophisticated play within the picture between kinds of notation and levels of descriptive specificity, selecting motifs in which the solidity of larger forms is inherently obscured, and finally, building the picture surface into a tangibly constructed wall or woven mesh of pigment. The persuasiveness of these solutions, however, depended to a great degree on the built-in orders of the places they painted. The aquatic resort or dazzling shopping street offered 'reality' as a collection of uncomposed and disconnected surface sensations. The disjunction of sensation from judgement was not the invention of artists, but had been contrived by the emerging leisure industry to appear the more natural and liberated moment of individual life. The structural demarcation of leisure within the capitalist economy provided the invisible frame which made that distracted experience cohere as the image of pleasure.

The most provocative and distinctive pictorial qualities of early modernism were not only justified by formal homologies with its subject matter as an already created image, they also served to defend that image by preserving it from in-

appropriate kinds of attention. So that the promises of leisure would not be tested against too much contrary visual evidence – not only dissonant features of the landscape like the famous factories of Argenteuil, but also the actual varieties of individual pleasure and unpleasure in evidence – the painters consistently fix on optical phenomena which are virtually unrepresentable: rushing shoppers glimpsed from above and far away, the disorienting confusion of the crowded *café-concert*, smoke and steam in the mottled light of the glass-roofed railway shed, wind in foliage, flickering shadows, and above all, reflections in moving water. These phenomena have become, largely thanks to Impressionism, conventional signs of the spaces of leisure and tourism, of their promised vividness and perpetual surprise, but as optical 'facts' they are so changeable or indistinct that one cannot really hold them in mind and preserve them as a mental picture; therefore one cannot securely test the painter's version against remembered visual experience. The inevitably approximate and unverifiable registration of these visual ephemera in painting makes larger areas of the canvas less descriptive than celebratory of gesture, color and shape – pictorial incidents attended to for their own sake.[37] [. . .]

Impressionism's transformation of leisure into an obsessive and exclusive value, its inversion of the intended social significance of its material, necessitated special painterly means, which in turn invert the intended social significance of its medium. Nineteenth-century high culture was nothing if it did not embody the permanent, indisputable, and ideal; the avant-garde appropriates the form of high art in the name of the contingent, unstable, and material. To accept modernism's oppositional claims, we need not assume that it somehow transcends the culture of the commodity; we can see it rather as exploiting to critical purpose contradictions within and between distinct sectors of that culture. Validated fine art, the art of the museums, is that special preserve where the commodity character of modern cultural production is sealed off from apprehension. There the aggressively reiterated pretense is that traditional forms have survived unaltered and remain available as an experience outside history. Marginal leisure-time subcultures perform a parallel denial of the commodity using the objects at their disposal. Lacking legitimating institutions, their transformation of the commodity must be activist and improvisatory: thus their continual inventiveness in displacing provided cultural goods into new constellations of meaning. The privileged moments of modernist negation occur, if the present argument is correct, when the two aesthetic orders, the high and the low, are forced into scandalous identity. Each of the two positions occupied by the avant-garde artist, the high-cultural and subcultural, is thereby continuously dislocated by the other. And this ceaseless switching of codes is readable as articulate protest against the double marginalization of art – and through that, against the forced marginalization of individual life in the wake of 1848 and 1871.

The instances of repeated return to mass-cultural material on the part of the avant-garde can be understood as efforts to revive and repeat this strategy – each time in a more marginal and refractory leisure location. Seurat in the 1880's, when he conceived "Sunday Afternoon on the Island of the Grande Jatte" as the outsized pendant to his "Bathers at Asnières",[38] pointedly placed an awkward

and routinized bourgeois leisure in another context, that of exhausted but uncontrived working-class time off. The nearly exclusive subject of his subsequent figure painting was, as Signac has informed us, the tawdriest fringes of Parisian commercial entertainment, the proletarianization of pleasure for both consumer and performer alike. This scene was dissected according to the putatively objective and analytic system of Charles Henry. But according to the first-hand testimony of Emile Verhaeren,[39] Seurat was moved to the artifice and rigidity imposed by Henry's emotional mechanics through identifying an analogous process already at work in his subject. Art historians have long noted the appearance in Seurat's later paintings of the exaggerated angular contours that were the trademark of the poster artist Jules Chéret.[40] As much as the circus or the *café-concert*, Seurat's material was the advertisement of pleasure, the seductive face it puts on; he spoke of that face in a deferential tone, and pushed his formal means in an attempt to master it. States Verhaeren: "The poster artist Chéret, whose genius he greatly admired, had charmed him with the joy and gaiety of his designs. He had studied them, wanting to analyze their means of expression and uncover their aesthetic secrets." These last words are significant for the present argument, indicating as they do that the artist begins with an already existing aesthetic developed in the overlooked fringes of culture. In its marginality is its secret allure, one which derives less from the promise of pleasure – from the evidence Seurat was cool and critical in his attitude – than from the simple existence of a corner of the city which has improvised an appropriate and vivid way to represent itself. The sophisticated and self-conscious artist, intent on controlling an artifice and abstraction which have irrevocably overtaken his art, keeping it in contact with an appropriate descriptive task, finds subject matter in which this connection has already been made.

Cubist collage stands as another step in the same direction, its critical character derived from a re-positioning of even more exotically low-brow goods and protocols within the preserve of high art. The iconography of café table and cheap cabaret mark out its milieu, and the intruder objects of Cubist collage map this territory with significant precision.[41] The correct brand name on the bottle label was as significant for Picasso and Braque as it had been to Manet in the "Bar at the Folies-Bergère".[42] The handbills, posters, packs of cigarette papers, department-store advertisements, are disposed in the pictures with conscious regard for the specific associations of each item and the interplay between them. The Cubists proceeded in the manner of mock conspirators or Poe's sedentary detective Dupin, piecing together evidence of secret pleasures and crimes hidden beneath the apparently trivial surface of the popular media. That their consumption was subversive in intent Gris indicates clearly enough in newspaper clippings that describe the 'illegality' of their manoeuvers: a discussion of artistic forgeries; a photo story on the effects of a government ban on political affiches.[43] That the Cubist scene is one of pleasure and excess is emblazoned in the continual play on the word Journal, which becomes not just the spread newspaper page, but "jouer", "jeu", "jouir" – the letters thus made to advertise familiar and prized male subcultural roles: the player, the gambler, the sexual athlete.

Collage does its work within the problematic of pictorial modernism,

dramatizing the literal support while preserving representation, but it is a solution discovered in a secretly coded world describable by means of these literal surfaces. And Cubism is readable as a message from the margins not only in the graphic content of the intruder objects, but in their substance and organization as well. The printed oilcloth and wallpaper substitutes for solid bourgeois surfaces, supplied originally by Braque from his provincial decorator's repertoire, are determinedly second-rate – the equivalent in present-day terms of vinyl walnut veneers or petrochemical mimics of silk and suede. As such surfaces soon degrade, peel, flake, and fade, as newsprint and handbills turn brown and brittle, so collage disrupts the false harmonies of oil painting by reproducing the disposability of the late-capitalist commodity. The principle of collage construction itself collapses the distinction between high and low by transforming the totalizing creative practice of traditional painting into a fragmented consumption of already existing manufactured images.

VII

Today, every phenomenon of culture, even if a model of integrity, is liable to be suffocated in the cultivation of kitsch. Yet paradoxically in the same epoch it is to works of art that has fallen the burden of wordlessly asserting what is barred to politics This is not a time for political art, but politics has migrated into autonomous art, and nowhere more so than where it seems to be politically dead.

T. W. Adorno, 1962[44]

Of the surviving contributors to the theory of modernism and mass culture that coalesced in the 1930's, Adorno alone was able to preserve its original range of reference and intent. One purpose of the present discussion of the avant-garde as a resistant subculture has been to lend historical and sociological substance to Adorno's stance as it pertains to the visual arts.[45] I have tried to describe the formal autonomy achieved in early modernist painting not as withdrawal into self-sufficiency, but as a mediated synthesis of possibilities derived from both the failures of existing artistic technique and a repertoire of potentially oppositional practices discovered in the world outside. From the beginning the successes of modernism have been neither to affirm nor refuse its concrete position in the social order, but to represent that position in its contradiction, and so act out the possibility of critical consciousness in general. Even Mallarmé, in the midst of his 1876 defense of Impressionism as a pure art of light and air,[46] could speak of it also as an art "which the public, with rare prescience, dubbed, from its first appearance, intransigeant, which in political language means radical and democratic."

We can identify, in the examples cited above, a regular rhythm which emerges within the progress of the Paris avant-garde. For early Impressionism, early Neo-Impressionism, and for Cubism before 1914, the provocative inclusion of materials from outside validated high culture was joined with a new rigor of formal organization, an articulate consistency of attention within the material fact of

the picture surface; joining the two permitted the fine adjustment of this assertive abstraction to the demands of description – not description in the abstract, but of specific enclaves of the industrial city. The avant-garde group itself enacts this engagement in an intensification of collective cooperation and interchange, individual works of art figuring in a concentrated group dialogue over means and criteria. But in each instance, this moment is followed by retreat – from specific description, from formal rigor, from group life, and from the fringes of commodity culture to its center. And this pattern marks for us the inherent limitations of the resistant subculture as a solution to the problematic experience of a marginalized and disaffected group.

We can take Monet's painting after the early 1880's as emblematic of the fate of the Impressionist avant-garde. The problem of verifiable description is relaxed when the artist withdraws to remote or isolated locations to paint: the difficulty of improvising pictorial orders appropriate to a complex and sensually animated form of sociability is obviated by concentration on stable, simplified, and depopulated motifs (we *know* this is a cathedral, a stack of grain, a row of poplars – the painting does not have to work to convince). In the process, the broad and definite touch of the 1870's, held between structure and description, is replaced by a precious, culinary surface, which largely gives up the job of dramatizing constructive logic. Not coincidentally, the 1880's was the period when Monet, thanks to Durand-Ruel's conquest of the American market, achieved secure financial success. Pissarro in 1887 dismissed it all as showy eccentricity of a familiar and marketable kind:[47] "I say this: Monet plays his salesman's game, and it serves him; but it is not in my character to do likewise, nor is it in my interest, and it would be in contradiction above all to my conception of art. I am not a romantic!"

Pissarro had by this time thrown in his lot with the Neo-Impressionists, for whom Monet's "grimacing" spontaneity was precisely a point at issue. Monet had transformed Impressionism from a painting *about* play to a variety of play in itself (this is the sense in which modernist painting becomes its own subject matter in a regressive sense). Seurat and company moved back to the actual social locations of play – and again put the formal problem of individual touch/sensation versus larger governing order squarely in the foreground. The result of Seurat's laborious method was drawing and stately compositions made assertively out of color alone. But we have already read evidence of the subsequent retreat in Signac's testimony of 1894:[48] "We are emerging from the hard and useful period of analysis when all our studies resembled one another, and entering that of varied and personal creation." What that meant, as the group carried on after Seurat's death, was a repertoire of stock tourist views: sunsets, Côte d'Azur fishing villages, Mont St. Michel, Venice. And the pointillist touch had, in the process, come loose from its moorings in Seurat's system. In the later Signac and Cross, the intimate connection between pictorial vocabulary, syntax, and a precise representational task is no longer in force: the touch expands, becomes freer and expressive in itself, works with its neighbors less within finely adjusted color relationships than as part of a relaxed, rhythmic animation of flat areas. As in the Impressionism of the 1880's, making the single gesture or touch now advertises

itself as a kind of play within an unproblematic playground, one provided by motif and picture surface alike.

This "varied and personal" tendency was pushed further by the younger painters soon to be called Fauves. Derain and Matisse especially, who came to artistic maturity within the late Neo-Impressionist milieu in southern France, used the liberated pointillist gesture as their point of departure. The result was a painting built from loose sprays and spreading patches of prismatic color, the descriptive function of which is casually approximate and unsystematic. Conventionalized landscape motifs do much of that work and allow the free abstraction of surface effects. Derain's dealer Vollard dispatched the young artist to London to paint a collection of postcard views: Big Ben, Westminster Abbey, Tower Bridge (Vollard was thinking of the success of Monet's London pictures of the nineties).[49] And the Fauve 'movement' was practically appropriated even before it gained its public identity in the *Indépendants* and Autumn Salons of 1905: the major pictures were spoken for by collectors; Vollard was buying out their studios; the influential critic Vauxcelles, who supplied them with their supposedly derisive sobriquet, was in fact lyrically supportive.[50]

But with that success went the sort of indeterminacy that Pissarro had decried in Monet. Derain testifies to this himself; writing from L'Estaque in 1905, he expressed these anxious doubts to Vlaminck:[51]

> Truly, we have arrived at a very difficult stage of the problem. I am so lost I wonder what words I can use to explain it to you. If one rejects decorative applications, the only direction one can take is to purify this transposition of nature. But we have only done this so far in terms of color. There is drawing as well. There are so many things lacking in our conception of art.
> In short, I see the future only in terms of composition, because in working before nature I am the slave of so many trivial things that my excitement is quashed. I cannot believe that the future will follow our path: on the one hand, we seek to disengage ourselves from objective things, and on the other, we preserve them as the origin and end of our art. No, truly, taking a detached point of view, I cannot see what I must do to be logical.

With assimilation into a more or less official modernism came then the felt loss of a descriptive project and a corollary erosion of pictorial logic. The rapid collapse of Fauvism as a shared enterprise, which followed directly on its public success, testifies to the cost of this indeterminacy. The reaction of Braque, who had taken liberated Fauve gesture and color the furthest toward surface abstraction, was silently eloquent: withdrawing with Picasso from the exhibition and gallery apparatus during the crucial years and renewing the old avant-garde commitment to collective practice. Even if the collectivity was reduced to the minimum number of two, the effacement of creative 'personality' was all the greater. And that combined withdrawal and commitment to reasoned, shared experiment was tied down to specific representation – and celebration – of a compact, marginalized form of life.

Like the others, of course, this moment didn't last. After Braque's departure for the war, Picasso retained the identification with mass culture, but now only in the terms which the culture industry itself dictates. The sign of manufactured culture is empty diversity, an eclecticism resulting from market expediency, targeting

consumers, and hedging bets. Modernist practice sustains its claim to autonomy by standing in implicit opposition to the diversity of material glut, the evident shape of the work standing in critical contrast to the shapelessness of human life as subjected to production-rationality. My argument has been that modernism has done this successfully when it has figured in detail the manufactured culture it opposes, put it on display by shifting boundaries and altering received meanings. The Berlin Dadaists were most attentive to this side of cubist collage, and sought in their own work to make this significance brutally explicit. Raoul Haussmann wrote in 1919,[52] "In Dada, you will find your true state: wonderful constellations in real materials, wire, glass, cardboard, cloth, organically matching your own consummate, inherent unsoundness, your own shoddiness." The example of Berlin Dada demonstrates, however, that to make this meaning explicit was to collapse art into a kind of politics, to end all its claims to resolve and harmonize an unendurable social order. The cubist precedent was, in contrast, an effort to fend off that outcome, to articulate and defend a protected aesthetic space. And it was overtaken and assimilated like each of the avant-garde subcultures that preceded it. Collage – the final outcome of Cubism's interleaving of high and low – was smoothly incorporated as a source of excitement and crisp simplification within an undeflected official modernism. The translation of the collage pieces into painted replications folds the noisy, heterogeneous scene of fringe leisure into the sonority of museum painting. And the critical distance which Cubism had established from both museum culture and mass culture was seriously undermined the moment that Picasso, in 1915, returned to conventional illusionism and art-historical pastiche, while at the same time continuing to produce Cubist pictures. That move drained Cubism of its claim to logical and descriptive necessity, transforming it into no more than one portable style among many on offer.

VIII

The basic argument of this essay has been that modernist negation proceeds from a productive confusion within the 'normal' hierarchy of cultural legitimacy. Modernism repeatedly makes subversive equations between high and low which dislocate the apparently fixed terms of that hierarchy into new and persuasive configurations, thus calling it into question from within. But this pattern of alternating provocation and retreat indicates that these equations are, in the end, as productive for affirmative culture as they are for the articulation of critical consciousness. While traditionalists can be depended on to bewail the break-down of past artistic authority, there will be significant elite fractions which will welcome new values, new varieties and techniques of feeling. On the surface, this is easy to comprehend as an attraction to the glamour of marginality, to undangerous poses of risk and singularity. But there is a deeper, more systematic rationale for this acceptance, which ends in the domestication of every modernist movement.

The context of subcultural life is the shift within a capitalist economy toward consumption as its own justification. The success of this shift – which is

inseparably bound up with the developing management of political consent – depends on expanded desires and sensibilities, that is, the skills required for an ever more intense marketing of sensual gratification. In our image-saturated present, the culture industry has demonstrated the ability to package and sell nearly every variety of desire imaginable, but because its ultimate logic is the strictly rational and utilitarian one of profit maximization, it is not able to invent the desires and sensibilities it exploits. In fact, the emphasis on continual novelty basic to that industry runs counter to the need of every large enterprise for product standardization and economies of scale. This difficulty is solved by the very defensive and resistant subcultures that come into being as negotiated breathing space on the margins of controlled social life. These are the groups most committed to leisure, its pioneers, who for that reason come up with the richest, most surprising, inventive, and effective ways of using it. Their improvised forms are usually first made saleable by the artisan-level entrepreneurs who spring up in and around any active subculture. Through their efforts, a wider circle of consumers gains access to an alluring subcultural pose, but in a more detached and shallow form as the elements of the original style are removed from the context of subtle ritual that had first informed them. At this point, it appears to the large fashion and entertainment concerns as a promising trend. Components of an already diluted stylistic complex are selected out, adapted to the demands of mass manufacture, and pushed to the last job-lot and bargain counter.

The translation of style from margin to center evacuates the form of its original vividness and subtlety, but a sufficient residue of those qualities remains such that audience sensibilities expand roughly at the rate the various sectors of the culture industry require and can accommodate. What is more, the success of this translation guarantees its cyclical repetition. While it is true that the apparatus of spectacular consumption makes genuine human striving – even the resistance it meets – into reified commodities, this is no simple procedure: exploitation by the culture industry serves at the same time to stimulate and complicate those strivings in such a way that they continually outrun and surpass its programming. The expansion of the cultural economy continually creates new fringe areas, and young and more extreme members of incorporated subcultures will regroup with new recruits at still more marginal positions. So the process begins again.

Elements of this mechanism are in place by the mid-nineteenth century,[53] and the rest of the century will see its coming to maturity in sport, fashion, and entertainment. The artistic avant-garde provides an early, developed example of the process at work. In fact, because of its unique position between the upper and lower zones of commodity culture, this group performs a special and powerful function within that process.

To begin with its primary audience, the fact that the avant-garde depends on elite patronage – the "umbilical cord of gold" – cannot be written off as an inconsequential or regrettable circumstance; we need to assume that so durable a form of social interchange is not based merely on the indulgence or charity of the affluent, but that the avant-garde serves the interests of its actual consumers in a way that goes beyond purely individual attraction to 'quality' or the glamour of

the forbidden. That service could be described as a necessary brokerage between high and low. In its selective appropriation from fringe mass culture, the avant-garde searches out areas of social practice which retain some vivid life in an increasingly administered and rationalized society. These it refines and pack-ages, directing them to an elite, self-conscious audience. Certain played-out pro-cedures within established high art are forcibly refused, but the form itself, in this case easel painting, is preserved and renewed – renewed with the aesthetic dis-coveries of non-elite groups. The survival of high art as an irreplaceable status indicator would otherwise be very much in doubt. Nor, clearly, does the process of selective incorporation end there. Legitimated modernism is re-packaged in turn for consumption as chic and kitsch commodities. The work of the avant-garde is returned to the sphere of culture where much of its substantial material originated. In the process, outmoded or under-utilized products of the capitalist economy – or even just the disorder and brutality thrown up in its wake – are refur-bished and glamourized to be sold as new.

Functionally then, the avant-garde serves as a kind of research and develop-ment arm of the culture industry: it searches out areas of social practice not yet completely available to efficient utilization and makes them discrete and visible. For example, it was only a matter of a few years before the Impressionist vision of the spaces of commercial diversion became the advertisement of the thing itself, a functioning part of the imaginary enticement directed toward tourists and resi-dents alike. The work of Toulouse-Lautrec as a designer and illustrator can be taken as emblematic of this shift. His cultivated irony, perversity and com-positional extremism continued previously established kinds of avant-garde attention to low-life spectacle. In his commercial work, however, certain patented modernist devices became the preferred vocabulary of an emerging sector of the entertainment industry; and thereby erased was that crucial distance which allowed a Seurat to work *on* the art of a Chéret. The collapse of art into its subject was displayed as concretely as possible in 1895, when the Folies-Bergère enter-tainer La Goulue went out on her own at the Foire du Trône, setting up her act in a structure which appeared from the outside to be literally constructed out of two large painted panels by Lautrec.[54]

In the twentieth century, this process of mass-cultural recuperation has operated on an ever-increasing scale. The Cubist vision of sensory flux and isola-tion in the city became in Art Deco a portable vocabulary for a whole modern 'look' in fashion and design. Cubism's geometricization of organic form and its rendering of three-dimensional illusion into animated patterns of overlapping planes were a principal means by which modernist architecture and interior design were transformed into a refined and precious high style. Advertised as such, now through the powerful medium of film costume and set decoration – the 'white telephone' school of cinema – the Art-Deco stamp was put on the whole range of twenties and Depression-era commodities: office buildings, fabric, home appliances, furniture, crockery. (The Art-Deco style was also easily drawn into the imagery of the mechanized body characteristic of protofascist and fascist utopianism.) The case of Surrealism is perhaps the most notorious instance of this process. Breton and his companions had discovered in the sedimentary layers of

earlier capitalist forms of life in Paris something like the material unconscious of the city, the residue of earlier repressions. But in retrieving marginal forms of consumption, in making that latent text manifest, they provided modern advertising with one of its most powerful visual tools – that now familiar terrain in which commodities behave autonomously and create an alluring dreamscape of their own.[55]

This brokerage between high and low, between legitimate and illegitimate, thus makes the avant-garde an important mechanism in an administered cultural economy. It mediates between three publics really: 1) its immediate initiated clientele; 2) the much larger middle-class public for validated high culture with which it is in fairly constant negotiation; and 3) those publics excluded from or indifferent to high culture which, after Courbet and outside of a few occasions of overt political revolution, the avant-garde never attempts to address directly. Though the experience of people whose horizons are closed by 'low' culture is repeatedly used to lend shape and substance to powerfully self-conscious and revelatory art, we assume no audience *there* for the qualities of negation, allusiveness, willed moral transgression, refusal of closure, formal rigor, and self-criticism that variously characterize modernist practice – however much such people might 'innocently' act out these qualities for the benefit of the artist. The cycle of exchange which modernism sets in motion moves only in one direction: appropriation of oppositional practices upward, the return of evacuated cultural goods downward. When some piece of avant-garde invention does re-enter the lower zone of mass culture, it is in a form drained of its original force and integrity. It is this one-directional exchange cycle, predicated on the purely legitimating character of museum culture and the entrenchment of the culture industry, that has made the class bias of modernism immoveable. [. . .]

X

In 1868 I painted a good deal at La Grenouillère. I remember an amusing restaurant called Fournaise's, where life was a perpetual holiday The world knew how to laugh in those days! Machinery had not yet absorbed all of life; you had leisure for enjoyment and no one was the worse for it.

Renoir, late in life[56]

This essay is not meant as a verdict on modernism in the visual arts. Recent discussion of the issue has suffered from a surplus of verdicts. Typically, one moment of the series of transformations described above is chosen as the definitive one. The social iconographers of modernism (the most recent trend in art history) largely limit themselves to its raw material. The aesthetic dialecticians, Adorno holding out until the end, concentrate on the moment of negativity crystallized in form. Modernist triumphalism, the later Greenberg and his followers for example, celebrate the initial recuperation of that form into a continuous canon of value. Finally, that recuperation is the object of attack from two directions: from the Left, who see in this moment a revelation that modernist negation was always a sham, never more than a way to refurbish elite commodities; and

from the Right, the advocates of a relaxed and eclectic pluralism, who see this recuperation as insufficient and resent the retention of any negativity even if it is sublimated entirely into formal criteria – this is the 'post-modernist' stance.

Each of these positions has its own 'modernism', and takes that as the essence of the thing. The purpose of the present essay has been to widen discussion to include, or rather re-include, all the elements present in the original formulation of modernist theory. One of my motivations for writing came from reflection on the fact that the founding moments for subsequent discourse on both modernist art and mass culture were one and the same. Current debates over both topics invariably begin with the same names – Adorno, Benjamin, Greenberg (less often Schapiro, but I hope I have done something to change that). Very seldom, however, are these debates about both topics together, though at the beginning they always were: the theory of the one *was* the theory of the other. And in that identity was the realization, occasionally manifest and always latent, that the two were in no fundamental way separable. Mass culture, which is just another way of saying culture under developed capitalism, displays both moments of negation and an ultimately overwhelming recuperative inertia. Modernism exists in the tension between these two opposed movements. The avant-garde, the bearer of modernism, has been successful when it has found for itself a social location where this tension is visible and can be acted on.

Notes

1 The source is an article entitled "The Impressionists and Edouard Manet," *Art Monthly Review*, (September 30, 1876), which survives only in an English translation. For an edited reprint see Frascina and Harrison (eds) *Modern Art and Modernism: A Critical Anthology.* Harper and Row, 1982, pp. 39–44. [. . .] The special power and importance of this text has been pointed out by T. J. Clark, "The Bar at the Folies-Bergère," in J. Beauroy, M. Bertrand, and E. Gargan, eds., *The Wolf and the Lamb: Popular Culture in France*, Saratoga, CA, 1977, p. 234 n. 5.

2 [Paul Signac], "Impressionistes et Révolutionnaires," *La Révolte*, 4:40, (June 13–19, 1891), p. 4 (quoted in R. and E. Herbert, "Artists and Anarchism: Unpublished letters of Pissarro, Signac, and Others," *Burlington Magazine*, 102, (November, 1960), p. 692.

3 On Corvi and the connection to Seurat, see R. Herbert, " 'Parade du Cirque' de Seurat et l'esthétique scientifique de Charles Henry," *Revue de l'Art*, no. 50, (1980), pp. 9–23. A monumental and maudlin depiction of the same dis-pirited location by Fernand Pelez was exhibited in the Salon of 1888; see R. Rosenblum, "Fernand Pelez, or the Other Side of the Post-Impressionist Coin", in *Art the Ape of Nature*, M. Barasch and L. Sandler eds., New York, 1981, pp. 710–12. For a contemporary description of the spectator in "Le Chahut", see Gustave Kahn, "Seurat," *L'Art Moderne*, (April 5, 1891), pp. 109–10 (selection translated in N. Broude, *Seurat in Perspective*, Englewood Cliffs, NJ, 1978). [. . .]

4 The lecture was given on March 27, 1890 and published in 1891 under the title *Harmonie des formes et des couleurs*; in April 1889, Signac wrote to

Van Gogh expressing his desire to equip workers with Neo-Impressionist theory (*Complete Letters of Vincent Van Gogh*, III, Greenwich, 1948, no. 584a); on these texts, see R. and E. Herbert, "Artist and Anarchism," p. 481 n. 48.

5 "Extraits du journal inédit de Paul Signac," J. Rewald ed., *Gazette des Beaux-Arts*, 6th per., XXXVI, (July–September, 1949), p. 126 (entry of September 1, 1895).

6 Daniel Henry [Kahnweiler], *Der Weg zum Kubismus*, Munich, 1920, p. 27; for Apollinaire, see texts in E. Fry ed., *Cubism*, New York, 1966, pp. 113, 118.

7 C. Greenberg, "Collage," in *Art and Culture*, Boston, 1961, p. 70.

8 See, for example, C. Owens, "The Allegorical Impulse: Toward a Theory of Postmodernism," *October*, no. 13, (October, 1980), p. 79. Subsequent to this early attempt on his part to theorize a post-modernist condition, Owens has interestingly engaged the present argument in an assessment of the art scene in New York's lower east side: see "The Problem with Puerilism," *Art in America*, LXXII (Summer 1984), pp. 162–3.

9 Originally published in *Partisan Review*, VI, (Fall 1939), pp. 34–39; reprinted in *Art and Culture*, pp. 3–21 [see Text 1].

10 *Partisan Review*, VII, (Fall 1940), pp. 296–310 [see Text 2].

11 "Avant-Garde and Kitsch," p. 9 *[24]*.

12 The historical account contained in this paragraph is based partly on my own research concerning David's pre-Revolutionary painting, the Salon audience, and the intense politicization of culture in Paris during the final crisis of the Old Regime; see T. Crow, "The 'Oath of the Horatii' in 1785: Painting and Pre-Revolutionary Radicalism in France," *Art History*, I, (December, 1978), pp. 424–71. For Courbet in the Salon of 1851, the authoritative interpretation is T. J. Clark *The Image of the People*, passim and especially pp. 130–54.

13 "The Social Bases of Art," proceedings of the First Artists' Congress against War and Fascism, New York, 1936, pp. 31–37; "The Nature of Abstract Art," *The Marxist Quarterly*, I, (January, 1937), pp. 77–98; reprinted in Schapiro, *Modern Art: the Nineteenth and Twentieth Centuries*, New York, pp. 185–211.

14 *Modern Art*, p. 192–3.

15 "Social Bases," p. 33.

16 "Social Bases," p. 37.

17 See the conclusion to "Avant-Garde and Kitsch" (p. 21) *[31–32]*. [. . .]

18 "Avant-Garde and Kitsch," p. 11 *[25]*.

19 See E. Weber, "Gymnastics and Sports in *Fin-de-Siècle* France: Opium of the Classes?", *American Historical Review*, LXXVI, (February, 1971), pp. 70–98; also R. Holt, *Sport and Society in Modern France*, London, 1981.

20 See the recent study by Michael Miller, *The Bon Marché: Bourgeois Culture and the Department Store, 1869–1920*, Princeton, 1981.

21 See K. Thomas, "Work and Leisure in Pre-Industrial Society," *Past and Present*, no. 29, (December, 1964), pp. 50–66; E. P. Thompson, "Time, Work, and Industrial Capitalism," *Past and Present*, no. 38, (December, 1967), pp. 56–97; especially suggestive for the present account is G. Stedman Jones, "Working-Class Culture and Working-Class Politics in London,

1870–1900; Notes on the Remaking of a Working Class," *Journal of Social History*, VII, (Summer 1974), pp. 460–508.

22 Karl Marx, *The Eighteenth Brumaire of Louis Bonaparte*, New York, 1963, p. 104. Recent historical research has documented the virulence of the official campaign against all republican institutions and values during Bonaparte's presidency and following the coup, an ideological scorched-earth policy, driven by fears of a Montagnard electoral victory in 1852; see T. Forstenzer, *French Provincial Police and the Fall of the Second Republic*, Princeton, 1981 [. . .] For a discussion of Marx's interpretation of the aftermath of 1848 in light of the developing logic of mass culture, see J. Brenkman, "Mass Media: From Collective Experience to the Culture of Privatization," *Social Text*, no. 1, (Winter 1979), pp. 94–109.

23 The terminology of this paragraph derives from recent work in the sociology of leisure-based subcultures in post-war Britain. The approach was initially formulated by Philip Cohen in: "Sub-Cultural Conflict and Working-Class Community," *Working Papers in Cultural Studies*, no. 2, (Spring 1972) and has been continued by Stuart Hall and others associated with the Centre for Contemporary Culture Studies at the University of Birmingham. For a collection of their theoretical work and case studies, see S. Hall and T. Jefferson eds., *Resistance through Rituals*, London, 1976. A brief aside in that volume made the first connection between the subcultural response and the historical avant-garde (p. 13): "The bohemian sub-culture of the *avant-garde* which has arisen from time to time in the modern city, is both distinct from its 'parent' culture (the urban culture of the middle class intelligentsia) and yet also part of it (sharing with it a modernising outlook, standards of education, a privileged position vis-a-vis productive labour, and so on.)" The link was first made specific for Second-Empire Paris and pictorial modernism by T. J. Clark in "The Place of Pleasure: Paris in the Painting of the Avant-Garde, 1860–1890," New York, William James Lecture, March 1978.

24 Walter Benjamin, *Charles Baudelaire: A Lyric Poet in the Age of High Capitalism*, H. Zohn trans., London 1973, p. 59 (this is from the first, 1938 version of the Baudelaire essay).

25 Benjamin, *Baudelaire*, p. 106.

26 See Jules Michelet, *L'Etudiant, cours de 1847–8*, Paris, 1877, pp. 129–30. M. Fried has pointed out the importance of Michelet's references to Géricault: see "Thomas Couture and the Theatricalization of Action in 19th-Century French Painting," *Artforum*, VIII, (June, 1970), p. 38. On the uses of Delacroix's "Liberty" in 1848, see T. J. Clark, *The Absolute Bourgeois*, New York, 1972, pp. 16–20. The end of the revolutionary rationale in painting was the subject of recorded reflections by the aging Renoir (A. Vollard, *La Vie et l'oeuvre de P. A. Renoir*, Paris, 1919, p. 42; translated as *Renoir, An Intimate Record*, New York, 1934, p. 47) [. . .]

27 See D. Silverman, "The 1889 Exhibition: The Crisis of Bourgeois Individualism," *Oppositions*, no. 8 (Spring 1977), pp. 71–91.

28 *Modern Art*, p. 192.

29 See S. Guilbaut, "The New Adventures of the Avant-Garde in America: Greenberg, Pollock, or from Trotskyism to the New Liberalism of the 'Vital Center'," *October*, no. 15, (Winter 1980), p. 63–4 [see Text 9, pp. 154–155]; a brief but unsurpassed overview of the trajectory of Schapiro's career

can be found in O.K. Werckmeister, review of Schapiro's *Romanesque Art, Art Quarterly*, new series II, (Spring 1979), pp. 211–18.

30 See "Recent Abstract Painting" originally published as "The Liberating Quality of Abstract Art" (1957) and "On the Humanity of Abstract Art (1960)," in *Modern Art*, pp. 213–32.

31 See note 23 for relevant literature.

32 Hall et al., *Rituals of Resistance*, p. 47.

33 See notes 23 and 32.

34 See P. Mainardi, "Courbet's Second Scandal, 'Les Demoiselles de Village'," *Arts*, LIII, (January, 1979), pp. 96–103.

35 A. Proust, *Edouard Manet, Souvenirs*, Paris, 1913, p. 15: "Quelque effort qu'il fit en exagérant ce déhanchement et en affectant le parler trainant du gamin de Paris, il ne pouvait parvenir à être vulgaire."

36 The most important critical reading of "Olympia" in 1865, that of "Jean Ravenel" (Alfred Sensier), stressed this clash of cultural signifiers in a great deal of detail; see the exposition and interpretation of this text by Clark, "Preliminaries to a Possible Treatment of 'Olympia' in 1865," *Screen*, XXI, (Spring 1980), pp. 18–42 [. . .]

37 See M. Butor, "Monet, or the World Turned Upside-Down," *Art News Annual*, XXXIV, (1968), pp. 21–33. I should mention here that the foregoing discussion of modernist aesthetics is indebted to Charles Rosen's analysis of the origins of modernism in music: see C. Rosen, *Arnold Schoenberg*, New York, 1975, pp. 17–22 and passim.

38 For a summary of the evidence concerning the deliberate pairing of the pictures, see J. House, "Meaning in Seurat's Figure Painting," *Art History*, III, (September, 1980), pp. 346–9.

39 "Georges Seurat," *La Société Nouvelle*, (April, 1891); in Broude, p. 28.

40 See R. Herbert, "Seurat and Jules Chéret," *Art Bulletin*, XL, (March, 1958), pp. 156–8.

41 See R. Rosenblum, "Picasso and the Typography of Cubism," in R. Penrose ed., *Picasso in Retrospect*, New York, 1973, pp. 49–75.

42 See Clark, "Bar," p. 235.

43 The pictures are "Figure Seated in a Café" and "Teacups" (both 1914). In "Figure," a clipping from *Le Matin* describes a new system invented by the criminologist Alphonse Bertillon to prevent the forgery of works of art; one of his suggestions was that artists authenticate their works with their fingerprints. (See Rosenblum, pp. 64–5.)

44 T. W. Adorno, "On Commitment," in A. Arato and E. Gebhardt eds., *The Essential Frankfurt School Reader*, New York, 1978, p. 318.

45 The invocation of Adorno here calls, I think, for explication at some length. As Greenberg does in the American critical tradition, so Adorno stands in his as the preeminent defender of removed, inward, self-critical and self-referential artistic practice. Where Greenberg would find visual art answering his criteria in the New York abstract painting of the later 1940's and after, Adorno already had the example of the Vienna school – the liberated dissonance of the work of Schoenberg and his pupils around 1910 and its later codification in twelve-tone technique; his writing, in its thorny style and substance, was in part an effort to make thought adequate to that formal achievement. The parallels between Adorno and Greenberg continue to the present day in the attacks to which the former's account of modernist music has been

subjected. His critics in West Germany, who come primarily from the Left, dismiss as a "dialectic of stagnation" his contention that the truth of an alienated social totality can find form only in the artist's concentration on the inmost cells of enclosed technical problems (see W. V. Blomster, "Sociology of Music: Adorno and Beyond," *Telos*, no. 28, (Summer 1976), pp. 81–112); this they regard as a disguised and unsupportable affirmation of the frozen art-commodity beloved by bourgeois aesthetics. And these attacks have predictably undermined the authority of Schoenberg's modernist practice as well.

Adorno's position is summed up in his essay "On the Fetish Character of Music and the Regression of Listening" (included in Arato and Gebhardt, *The Essential Frankfurt School Reader*, pp. 270–99) published just one year before "Avant-Garde and Kitsch". Like the latter, its defense of modernism is bound up with a critique of mass culture. The austerity and difficulty of modern music is not an internal necessity but one imposed from the outside. "Asceticism," he states ("Fetish" p. 274), "has today become the sign of advanced art: not, to be sure, by an archaizing parsimony of means in which deficiency and poverty are manifested, but by the strict exclusion of all culinary delights which seek to be consumed immediately for their own sake, as if in art the sensory were not the bearer of something intellectual which shows itself only in the whole rather than in isolated topical moments." The culinary has been irretrievably appropriated by the culture industry (that last term is his and Horkheimer's coinage), by the logic of the commodity. Later, he would condense the logic of the autonomous work of art to one line: ". . . in the future, no type of composition is expected to be 'proto' for the purposes of mass production." ("Modern Music is Growing Old," *The Score*, no. 18, (December, 1956) pp. 18–29.) That could stand precisely for Greenberg's original argument as well.

But if both begin from a derivation of modernism in the pervasive conditions of mass-cultural production, Adorno parts company from Greenberg's kind of analysis by keeping the larger cultural landscape continually in view, by according it equal status as an object of inquiry. Greenberg, by taking up the subject of kitsch only at the outset and then bracketing it off, tacitly reestablishes the old opposition between a high culture with all the virtues and a bereft, impoverished low culture. His implication is that modernist art, apart from its reduction in scope, is otherwise unaffected by its origins in the late-capitalist crucible: the line of 'culture' from past to present is, thanks to modernism, unbroken and high art is not implicated in a continuing way with the general culture it evades. Adorno is under no such illusion. In 1936, as he was finishing his essay "Über Jazz," he wrote to Walter Benjamin: "Both bear the stigmata of capitalism, both contain elements of change (naturally never in no way the middle term between Schoenberg and the American film). Both are torn halves of an integral freedom, to which however they do not add up." (in R. Taylor, ed., *Aesthetics and Politics*, London, 1977, p. 123.)

Adorno has come down to us as the dour opponent of all Benjamin's optimism over the technology of mass art (exemplified in the famous essay "The Work of Art in the Age of Mechanical Reproduction"). Though Benjamin himself saw no incompatibility between their positions, Adorno's relentless refusal of all forms of the 'popular' has made him seem the distilled

essence of rationalized snobbery on the Left. His at times extreme and emotional denunciations of jazz as a typically specious commodity of the culture industry are now widely regarded as embarrassing. Susan Buck-Morss, however, in her excellent study of the Adorno–Benjamin axis (*The Origin of Negative Dialectics*, New York, 1977), has provided a timely defense of his account of jazz, one which is directly relevant to our inquiry here. The notorious vehemence of his polemic is directed less against the music itself than against the way it was being heard: there was, first, the perception that the improvised breaks and loose ensemble structure were occasions for free individual expression and thus provided a progressive alternative to academic rigidity and control. There was in this – as there still is – a romantic perception of an upwelling of underclass spontaneity. A second and related reading sought to affiliate jazz with aspects of contemporary modernism, particularly in its constructivist tendencies: as he put it in (*Aesthetics and Politics*, p. 125), "the appearance of montage, collective work, the primacy of reproduction over production." Adorno was intent on unmasking the 'progressive' appearance of jazz and revealing its actual conformist character, "the rigid, almost timeless immobility in the movement, the mask-like stereotype of a fusion between wild agitation which appears to be dynamic and an inflexibility of process which rules over such agitation. Above all, the law which is one of the market as much as myth: it must always be the same and simultaneously feign being always new." ("Über Jazz," in *Moments Musicaux*, Frankfurt, 1964, p. 95; quoted in Buck-Morss, p. 109).

For Adorno, jazz and the collective experience of mass culture in general represent a return of an archaic ritual life in the midst of a disenchanted secular modernity. Like the festive rites in preliterate societies, the apparent release of the individual from normal constraints is automatic and unreflective; in truth it effects a renewed sacrifice of individual life to the overwhelming demands of the collective. And one could not even hope that the return of the primitive might re-ground shattered, deracinated subjectivity in some more elemental strata of experience, because these rituals were thoroughly modern in character – the moments indeed when the individual was most in accord with the demands of capitalism; he ranges himself on the side of the dominating market apparatus best when he does so in postures of enjoyment and undirected leisure. Though the promise of mass culture is one of ever-expanding sensual happiness, what is delivered is always the same – the commodity, infinite in its beckoning guises, but cold and unchanging in its essence, a mockery of desire that the consumer secretly recognizes and is resigned to. It is a realm of fantasy which at the same time enforces the most disabused realism on its participants.

Adorno chooses jazz to stand for this historical development in the realm of music; but it is a mistake to say that he dismisses it. In face, he treats it with the same seriousness and attention that he extends to music from the high-art tradition. The social contradiction which the players and audience of jazz magically resolve – that between helpless individuality and an immoveable social totality – is not resolved in the music itself: jazz is a configuration of opposites, of Salon-music virtuosity and military regimentation, which remain held in contradiction and are therefore apprehendable as such: "If jazz were really listened to, it would lose its power. Then people would no

longer identify with it, but identify it itself." ("Oxforder Nachträge" (1937), in *Moments*, p. 120; quoted in Buck-Morss, p. 110.) In that the mass-cultural form offers a static configuration of the social antinomy its actual consumption suppresses, it offers a potential moment of revelation – or "redemption" – as well. Adorno, however, does not imagine this happening within the confines of mass-cultural practice, that is, for its own audience, but only through an outside intervention like his own. Not so with high culture, where Schoenberg's modernism constitutes an immanent critique of the decayed classicism of the nineteenth century, while preserving and extending that tradition.

But to see this, as many have, as a recuperation of a sterile high-culture/low-culture opposition would be a mistake. The best way to demonstrate this would be to bring in his contemporaneous essay on Wagner, written between 1937 and 1938 in London during his first years of exile. Like many others since, Adorno locates Schoenberg's liberated dissonance as latent in Wagner's compositional practice – in its atomization of musical material and tonal indeterminacy, the pressure of an independent expressive polyphony against the strict four-part harmonic scheme, the contextualization of the dissonance-consonance or antecedent-consequent relationship, the displacement of that relationship away from tonality into the unsystematic realm of orchestral color. Given that much of musical modernism develops directly from problems posed by Wagner, it is striking to read Adorno summing up his argument midway through the essays in this way (*In Search of Wagner*, R. Livingstone, trans., London, 1981, p. 62): "The contradictions underlying the formal and melodic structure of Wagner's music – the necessary precondition of the failure at the level of technique – may be generally located in the fact that eternal sameness presents itself as the eternally new, the static as the dynamic, or that conversely, intrinsically dynamic categories are projected onto unhistorical, pre-subjective characters." We could substitute the word "jazz" for "Wagner's music" and the resulting statement would be fully consistent with Adorno's analysis. The last clause refers to the emptied mythological ciphers who inhabit the Wagnerian stage, but could just as well be interpreted to mean the modern archaic man, the jazz "subject". The seed-bed of modernism is describable in the same terms as mass music. "For this reason," he states, "the really productive moment in Wagner is seen at the moments when the individual abandons sovereignty and passively abandons itself to the archaic, the instinctual" Near the end of his life, he would make the same point in more general terms ("On Commitment," p. 315): "Works of art which by their existence take the side of the victims of a rationality that subjugates nature are even in their protest constitutively implicated in the process of rationalization itself. Were they to try to disown it, they would become both esthetically and socially powerless: mere clay. The organizing, unifying principle of each and every work of art is borrowed from that very rationality whose claim to totality it seeks to defy." Quite obviously, the present essay takes issue with Adorno's undifferentiated view of mass culture, but that last quotation could stand as a three-sentence summation of its central argument.

46 "The Impressionists and Edouard Manet."

47 C. Pissarro, *Letters to his Son Lucien*, J. Rewald ed., New York, 1943: entry of January 9, 1887.

48 "Extraits du journal inédit de Paul Signac," p. 126; Signac wrote on July 5,

1895 (p. 124), "Toujours à la recherche d'une facture plus libre, tout en conservant les bénéfices de la division et du contraste." Those two aims were to prove largely incompatible.

49 See J. P. Crespelle, *The Fauves*, New York, 1962, p. 112.

50 See Ellen C. Oppler, *Fauvism Reexamined*, New York, 1976, p. 13–38.

51 A. Derain, *Lettres à Vlaminck*, Paris, 1955, pp. 146–7. [. . .]

52 "Synthetisches Cino der Malerei," 1918, quoted in R. Haussmann, *Courrier Dada*, Paris, 1948, p. 40; also in H. Wescher, *Collage*, New York, 1968, p. 136. For a Dada reading of Cubist collage in specific terms, see R. Huelsenbeck, "En Avant Dada," in R. Motherwell ed., *Dada Painters and Poets*, New York, 1951, p. 36.

53 W. Weber (*Music and the Middle Class*, New York, 1975, pp. 105–6) describes how artisan-class, radical choral groups emerged from the Revolution of 1830 and in 1832 were sufficiently organized to give a massed concert which included twenty singing clubs and 600 singers. Subsequently, several of the clubs began to perform at commercial theaters and promenade concerts. This improvised form of communal artistic life was suppressed by the state in the political crack-down of 1833–5, but the form was resurrected by an entrepreneur named William Wilhem who began receiving state subsidies for his singing classes in 1836. Called the Orphéon societies, they remained primarily lower-class in their membership, but the audience at the well-attended and fairly expensive concerts was middle-class and aristocratic. The climax of this development occurred in 1859 when the Orphéon societies were called on to perform in the new Palace of Industry of Napoleon III.

54 For a photograph of the booth, see P. Huisman and M. G. Dortu, *Lautrec by Lautrec*, New York, 1964, p. 84.

55 For a discussion of Surrealism in these terms, see F. Jameson, *Marxism and Form*, Princeton, 1971, pp. 96–106.

56 Quoted in Vollard, pp. 45–6. [. . .]

Index

Aaron, D., *Writers on the Left*, 105 n16, 181 n9, 181 n10
Abel, L., 49
abstract art, abstraction, 4, 9, 23, 35, 40, 41, 45, 47, 62 n10, 62–63 n11, 110, 120–21, 131, 154, 155, 176, 172
'abstractness'/'literalness', 68, 73, 79 n21
'abstractionists'/'literalists', 17, 86, 87, 120
Abstract Expressionism 5, 7, 55 author's note, 91–93, 96, 98–102, 107–122 *passim*, 118, 119, 137, 138, 139, 142, 144, 145, 147, 148, 161, 162, 175, 224–225, 227
Abstract Expressionists, 91, 99, 119, 140, 143, 145, 153, 163, 168
academies, 38, 125
Academicism, 12, 22, 24, 176, 178
'academicism', 159, 234, 239, 242, 248
Acconci, V., 78 n17
Acheson, D., 109
Ackerman, J.S., 'The Demise of the Avant Garde: Notes on the Sociology of Recent American Art' 150–151 n30 and n31
Adams, R., 231 n23
Addison Gallery of American Art, 141
Adorno, T.W., 15, 239, 252, 258–259, 265–269 n45; 'On Commitment', 262 n44, 265 n45; 'On the Fetish Character of Music and the Regression of Listening', 263 n45; 'Modern Music is Growing Old', 263 n45; 'Über Jazz', *Moments Musicaux*, 263–264 n45; 'Oxforder Nachträge', 265 n45; *In Search of Wagner*, 265 n45
aesthetic (s), 17, 37, 93, 98, 118, 139, 148, 205; -activity, 4, 9; -'American', 163; -dialecticians, 258; -experience, 4, 21, 76–77 n13, 187, 194, 197–198, 206, 220, 237; -judgement, 17, 193, 219–220; -ideology, 168; -'leftist', 235; -Modernist, 9, 93, 98; -order, 153; -validity, 23
Alexandrianism, 22, 24, 60, 156
'alienation', 97, 101, 111, 157, 174
Alloway, L., 118, 223, 231 n21, 226, 227; 'Popular Culture and Pop Art', 118, 123 n21; *Nine Abstract Artists; their work and theory*, 226, 231 n23.
Althusser, L., 13, 19 n37.
Ambrose, S., 122 n2, 123 n17.
American Abstract Artists, 136, 139, 156, 159, 164 n9, 170
American Artists Congress, 95, 129, 135, 157
American Committee for Cultural Freedom, 94, 130
American Federation of Arts, 130, 141, 142, 145, 161; '100 American Artists of the Twentieth Century' exhibition, 145
American Historical Review, 103 n2, 150 n31, 260 n19
'American Left', 154, 158
American Magazine of Art, 149 n3
American Mercury, The, 166 n33

'American Scene', 98, 136, 139, 158, 180
Antal, F., *Classicism and Romanticism*, 18 n2
Antioch Review, 150 n14
Apollinaire, G., 153, 236, 260 n6
Arato, A., and Gebhardt, I., *The Essential Frankfurt School Reader*, 212 n8, 262 n44, 263
Aristotle, 23, 32 n1
Arp, H., 44, 45, 83
art, critics/criticism, 3, 6, 10, 11, 12, 14, 16, 17, 47–60, 65–75, 81–87, 191–211 *passim*, 217–230; history/historians, 3, 4, 7, 10, 11, 12, 14, 16, 17, 47–60, 65–75, 81–87, 191–211, 217–30, 233–259; 'good'/'bad', 27, 68–69, 76–77 n13, 217–30 *passim*; -'literature' in, 35, 38–41 *passim*, 45; -and life, 28, 60, 108, 129, 76–77 n13; -medium, see 'medium'; 'non-objective', 23, 35, 62, n10, 132, 177; -'non-representational', 8, 9, 23, 176; -'representational', 8, 9, 40, 45 see also representation
Art and Language, 19 n20, 17, 188
Art and Literature, 47, 62 n7
Art Deco, 257
Art Digest, 148 n2
Art Bulletin, 262 n40
'art for art's sake', 12, 23, 98, 100, 148, 174, 176, 181, 230 n2
Artforum, 20 n50, 75 n2, 79 n17, 88 n6, 91, 100, 103 n2, 126, 150 n16, 151 n32, 166 n34, 189 n1, 212 n4, 261 n26
Art Front, The, 148 n2
Art History, 61 n2, 104 n2, 232 n28, 260 n12, 262 n38
Art Institute of Chicago, 142
Art International, 78 n17, 104 n3, 119, 149 n9, 212 n10
Art Language, 'Abstract Expression' 212 n9; 'A Portrait of V.I. Lenin', 211 n1, 230 n11; 'Abstract Expression' 230 n11
art market, see dealers and galleries
'Artists Sessions at Studio 35', 166 n31
L'Art Moderne, 259 n3
Art Monthly, 17, 105 n14, 213 n23
Art Monthly Review, 259 n1
Art in America, 79 n17, 149 n9, 260 n8
Art News, 98, 139, 149 n9, 141, 166 n28, 166 n29, 183 n42, 224
Art News Annual, 266 n37
Artists for Victory, 165 n13
Artists Peace Tower, 120
Artists Union, 136, 148 n2, 148 n3
Arts, 79 n18, 231 n20, 262 n34
Arts and Architecture, 150 n13
Arts Council of Great Britain, 214 n25
Arts Club of Chicago, 142
Arts Yearbook, 18 n5, 104 n3, 212 n12, 230 n1
Assiter, Alison, 'Philosophical Materialism or the

Materialist Conception of History', 215–16 n37
Athene, 32 n5, 52
Atlantic Alliance, 109
atomic bomb, 58, 99, 100, 109, 159, 161
audience, 37, 57, 60, 78–79 n17, 96, 138, 140, 169, 239, 240
Auerbach, F., 214 n25
autonomy, 4, 9, 17, 39, 55 author's note, 70, 83, 93, 99, 200, 209, 218, 220, 227–8, 235, 237, 252, 255, *see also* relative autonomy
avant-garde, 21–33, 39, 55, 93, 95, 96, 101, 102, 118, 125, 129, 138, 148, 153–183 *passim*, 222, 233–266 *passim*; cinema, 27; culture, 24, 47, 137; 'mainstream', 102; and New Liberalism, 162–3; poetry, 43; 'popular' 78 n17; 'spirit', 108
avant-gardism, 167, 169
avant-*gardism*, 75 n3, 78 n17
Avery, M., 165 n13
Ayres, G., 231 n21

Babbit, I., 45 n1
Bacon, F., 110, 197, 201, 214 n25, 225
Banham, Rayner, 223, 224; 'This is Tomorrow', 231 n18
Bahr, H., 8
Baldwin, M. and Harrison, C. and Ramsden, M., 'Art History, Art Criticism and Explanation', 14, 19 n20, 187, 189 n2, 231 n13; 'Manet's *Olympia* and Contradiction: apropos T.J. Clark's and Peter Wollen's recent articles', 215 n36
Balthus, 214 n25
Balzac, H., 53, 61 n6
Barasch, M. and Sandler, L., (eds.), *Art the Ape of Nature,* 259 n3
Barnes, Barry, 205, 219; *Interests and the Growth of Knowledge*, 213 n18, 230 n6
Barr, Alfred H. Barr Jnr., 8, 9, 10, 11, 12, 14, 16, 91, 100, 131, 132, 142, 143, 154, 160, 163; *Cubism and Abstract Art*, 4, 7, 104 n4, 154, 164 n4; 'Flow diagram', 7, 8; *Picasso: Forty Years of His Art*, 10, 19 n22; *Picasso: Fifty Years of his Art*, 19 n22, 104 n4; paradigm 16; *Matisse: His Art and His Public*, 104 n4; 'Is Modern Art Communistic', 131
base/superstructure, 6, 13, 14, 48, 96, 155, 203
Baselitz, G., 202, 214 n25
Battcock, G., *Minimal Art: a Critical Anthology*, 20 n50, 76 n9
Baudelaire, C., 47, 57, 62 n10, 70, 76 n11, 148, 153, 233, 244; 'The Salon of 1846', 76 n11; 'The Salon of 1849', 76 n11
Baur, John I.H., *Revolution and Tradition in Modern American Art*, 141
Bay of Pigs, 116, 132
Baxandall, M., 196, 205; *Painting and Experience in Fifteenth Century Italy: A Primer in the Social History of Pictorial Style*, 212 n13; *The Limewood Sculptors of Renaissance Germany*, 214 n29
Baziotes, William, 110, 129, 141, 142, 166 n27
Beauroy, J., Bertrand M. and Gargan E., (eds.),

The Wolf and the Lamb: Popular Culture in France, 259 n1
'beholder', 75 n2, 93
Bell, Clive, 8, 193, 204, 218, 219, 221; *Art*, 204, 212 n3, 214 n27
Bell, Daniel, 132
Bell, Quentin, 208; *Vision and Design: the Life, Work and Influence of Roger Fry*, 208, 215 n34
Pengelsdorf, Rosalind, 164 n9
Benjamin, Walter, 96, 244, 263–4 n45, 259; 'The Author as Producer', 96, 105 n24, 212 n8, 215 n35, 216 n38; *Charles Baudelaire: A Lyric Poet in the Age of High Capitalism*, 244, 261 n24, n25; 'The Work of Art in the Age of Mechanical Reproduction', 263 n45
Benn, Gottfried, 31
Benton, T. Hart, 84 author's note, 136, 148 n2
Béraud, Jean, 56
Berlin, Isaiah, 211 n2
Berman, Greta, *The Lost Years, Mural Painting in N.Y. City under the W.P.A. Federal Art Project 1935–1943*, 103 n1; and Wechster, J., Realism and Realities: the Other Side of American Painting 1940–1960, 106 n38
Bernstein, Barton J., *Towards a New Past, Dissenting Essays in American History*, 105 n12, 122 n3, 150 n21
Bertillion, Alphonse, 262 n43
Bertrand, M., *see* Beauroy, J.
Bhaskar, Roy, 202; 'Scientific Explanation and Human Emancipation', 214 n24
Bikini explosion, 95
Biographia Literaria, 88 n7
Blake, Peter, 201
Blisses, the, 126
Block, 215 n36
Blomster, W.V., 'Sociology of Music: Adorno and Beyond', 263 n45
Bloom, Hyman, 143
Blunt, A., 205; 'The Realism Quarrel', 205, 214 n31
Böcklin, A., 38
bohemia, 22, 38, 119; bohemian enclaves, 125; bohemian retreat, 178
Bonaparte, Napoleon, 182 n23; Louis-Napoleon (Napoleon III), 243–4, 261 n22
Bon Marché, (Boucicault's), 242
Bosanquet, B., 37
Boston Symphony Orchestra, 128
bourgeoisie, the, 25, 36, 52, 53, 54, 58, 62, 86–7, 96, 101, 102, 119, 153, 155, 169, 173, 178, 203–4, 210, 220, 240, 243–4, 251; bourgeois authors, 169; art, 39, 54, 72, 101; audience, 169; civilization, 50, 82–3; culture, 12, 21–33, 35–45, 48, 51, 53, 99, 157, 175, 242–3; élite, 61–2 n6, 102; idealism, 205; ideology, 75, 204, 210; individualism, 17; society, 7, 22, 29, 38, 39, 48, 50, 51, 54, 125, 155, 172, 176–7, 178; revolution, 201; 'white collar', 119
Bouvard et Pécuchet, 84
Braden, Thomas W., 128, 129, 132, 145; 'I'm Glad the C.I.A. is Immoral', 128, 145, 150 n18–20
Brancusi, C., 12, 23

Brandt, Mortimer (Gallery), 158
Braque, G., 9, 12, 21, 23, 70, 96, 98, 136, 141, 161, 222, 236, 251–2, 254
Brecht, Bertolt, 49, 50, 51, 55, 60, 61 n4, 72
Brenkman, J., 'Mass Media: from Collective Experience to the Culture of Privatization', 261 n22
Breton, A., 8, 49, 138, 155, 156, 164 n8, 171, 228, 257; and Rivera, D., 69, 149 n6, n8; 'Manifesto: Towards a Free Revolutionary Art', 49, 149 n6, n8, 164 n5, 171, 172, 182 n16; *La Clé des Champs*, 149 n6
Brown, B., 161, 165 n13, 166 n27
Broude, N., *Seurat in Perspective*, 259 n3, 262 n39
Brüning, H., 182 n23
Buchloh, B.H.D., Guilbaut, S., Solkin, D., *Modernism and Modernity: The Vancouver Conference Papers*, 189 n5
Buck-Morss, Susan, *The Origin of Negative Dialectics*, 264 n45
Burchfield, Charles, 136
Burgin, V., 'Modernism and the *Work* of Art;, 103 n2
Burlington Magazine, 259 n2
Burlin, P., 165 n16
Burke, E., 42
Butor, M., 'Monet or the World Turned Upside-down', 262 n37

C.I.A., 115, 120, 127, 128, 129, 130, 131, 132, 145, 146, 147, 150 n18, n24
C.O.R.E., 120
'cabinet picture', 96
Cage, John, 117, 141
Cahill, Holger, fn5, 149
Calzolari, P.P., 214 n25
Canaday, John, 143–4; 'A Critic's Valedictory: The Americanization of Modern Art and Other Upheavals', 143–4, 150 n15; *Embattled Critic*, 150 n15
Canadian Art, 212 n10
capitalism, 12, 15, 22, 28, 31, 39, 47, 48, 49, 51, 52, 54, 61–2 n6, 56, 59, 60, 81, 98, 103, 108–123 *passim*, 125, 129, 136, 147, 148, 157, 171, 172–4, 177, 189, 203, 220, 235, 238, 242, 246, 248, 249, 255–6, 250, 259
Caro, Anthony, 65, 66, 67, 70, 73–5, 79 n18, n21, n22, 85–6, 231 n21; *Prairie* 66; *Table Piece XXII*, 74–5
Carter, B.A.R., 197; and Wittkower, R., 'The Perspective of Piero della Francesca's *Flagellation*', 213 n15
Castelli, Leo, 119
Catholicism, 171
cause, 187, 193, 194, 198, 206; cause/effect, 28, 193
causal conditions, 7, 17, 92, 99, 100, 101, 187, 199, 219; causal determination, 209; causal inquiry and explanation, 191–211
connoisseur, 194–5
Cavell, Stanley, 76 n9; *Must We Mean What We Say*, 76 n9; *The Claim of Reason*, 76 n9
Celantano, F., *The Origins and Development of*

Abstract Expressionism in the United States, 164 n11
Center for Inter-American Relations, 132
Cézanne, P., 12, 23, 55 author's note, 57, 66, 208, 221; *Gulf of Marseilles seen from L'Estaque*, 66
Chadwick, L., 223
Chardin, J.B.S., 53
Charlton, Alan, 202
Chase Manhattan Bank, 126
Cheney, S., 8
Chéret, Jules, 251, 257
Chia, S., 214 n24
China, 37; Chinese poetry, 37; Mandarin, 50
Chipp, Herschel B., 149 n6; 149 n8
de Chirico, G., 31
Chomsky, N., 6, 7, 16, 93; 'Politics', *Language and Responsibility*, 6, 7, 18 n7, n8, 18 n10, 18 n13, n14; *American Power and the New Mandarins*, 105 n12; *Problems of Knowledge and Freedom*, 105 n12; *For Reasons of State*, 105 n12
Churchill, W., 147
Christian Science, 113
cinema, 180; Soviet, 26, 27, 49; avant-garde, 27
Clark, T.J., 6, 18 n11, 12, 16, 17, 65–79 *passim*, 102, 188, 230 n3; *Image of the People*, 6, 75 n1, 260 n12; *Absolute Bourgeois*, 6, 75 n1, 261 n26; *The Painting of Modern Life in the Art of Manet and his followers*, 88 n5; 'Clement Greenberg's Theory of Art', 104 n2; 'Contribution to "general panel discussion" ', 189 n5; 'Preliminaries to a Possible Treatment of Manet's Olympia in 1865', 210, 216 n39, 262 n36; 'The Bar at the Folies-Bergère', 259 n1, 262 n42; 'The Place of Pleasure: Paris in the Painting of the Avant-Garde 1860–1890', 261 n23
class, 6, 24, 48, 51, 52, 53, 54, 57, 59, 60, 61–2 n6, 95, 101, 102, 126, 129, 135–6, 138, 140, 156, 158, 163, 169, 170, 172, 173, 174, 176, 178, 188, 189, 200–1, 203, 204, 211, 220, 233, 239–40, 242, 243, 244, 246–7, 248, 251, 255–6
Clemenceau, Georges, 55
'The Club', 131
Cockcroft, Eva, 93, 101, 102; 'Abstraction Expressionism, Weapon of the Cold War', 103 n2, 150 n26, 166 n37
cognition, 4, 8, 68, 187, 188, 194, 209, 211, 219, 222, 249; and art, 17, 68, 181, 219, 222; 'cognitive style', 205; 'non-cognitive conditions', 202, 209
Cohen, Bernard, 231 n21
Cohen, Harold, 231 n21
Cohen, Philip, 'Sub-Cultural Conflict and Working-Class Community', 261 n23
'Cold War', 5, 7, 86, 91, 93, 100, 103 n1, 109, 111, 114–15, 118, 120, 122, 125–33, 146, 160, 162, 163, 227
Coleman, Roger, 231 n21; Introduction to the first 'situation' Exhibition, 232 n24
Coleridge, S., 42, 85, 88 n7

Commentary, 61 n5, 94
communism, 94–5, 100, 109, 111, 114, 103 n1, 129, 130, 131, 144, 146, 155, 157, 158, 159, 161, 165n 13, 170, 182 n23; anti-communism, 94, 95, 103 n1, 126, 129, 146, 147, 161, 175
Communist Party, 133 n2, 135, 136, 137, 154, 158, 161, 165 n24
community, art, 11, 12, 61–2, n6, 199, 202
Congressional Record, 94, 105 n18
Congress for Cultural Freedom, 115, 145
consciousness, 32 n2, 41, 42, 48, 86, 96, 97, 113, 144, 108, 176, 181; 'false consciousness', 113, 194, 245–6
Constable, J., 53
Constant, G., 165 n13
Constructivism, 223; 'neo-constructivist left', 218
consumption, mass, 52
'content', 39, 92, 98, 176, 178, 187, 193, 219, 241
convention, 9, 67, 68, 71, 73, 81, 82, 101
Corot, J.B., 38
Corvi, Ferdinand, 235
Cox, Annette, 102; *Art-as-Politics: The Abstract Expressionist Avant-Garde and society*, 94, 96, 104 n2, 105 n17
Council of the Americas, 132
Council of Foreign Relations (CFR), 18 n14, 132
Courbet, G., 39, 40, 47, 57, 117, 178, 205, 240, 247, 248, 258, 260 n12; *Burial at Ornans* authors note, 55, 240; 'Young Ladies on the Banks of the Seine', 248
Coviello, P., 231 n21
Coward, R., and Ellis, J., *Language and Materialism: Development in the Theory of the Subject*, 214 n32
Crane, Hart, 23
Creffield, Dennis, 201
Creole Petroleum, 127
Critical Inquiry, 61 n6, 62 n10, 104 n2
Cross, H.G., 253
Crow, Thomas, 7, 15; 'Modernism and Mass Culture in the Visual Arts', 188; 'The "Oath of the Horatii" in 1785: Painting and Pre-Revolutionary Radicalism in France', 260 n12
Cuban missile crisis, 117, 132
Cubism, 8, 9, 10, 44, 84 authors note, 91, 93, 94, 96, 97, 98, 99, 104 n5, 160, 165 n24, 177, 179, 236, 251–2, 255, 257; cubist collage, 52, 233, 236, 251–2, 255
Cubism and Abstract Art (1936) exhibition, 8
culture, 5, 9, 21–33, 35–45 *passim*, 49, 60, 84, 96, 119, 137–8, 155–6, 161, 169, 170, 209; 'avant-garde', 22, 24, 47, 175; commodification of, 15, 21–33 *passim*, 47–60 *passim*; 'formal', 25, 29, 32 n5, 53; 'folk', 25, 26, 238; sub-culture, 9, 261 n23, 246–7, 248, 255, 233–59 *passim*; mass culture, 15, 25, 156, 233–259; popular, 26, 118–19, 201, 234, 238
curators, 8, 96, 147
curatorial validation, 8
Curry, John Stewart, 136

Dada, 58, 66, 78 n17, 83, 111, 117, 223, 233;

'neo-Dada', 116; collage 233; Berlin dadaists, 255
Daix, P., *Le Cubisme de Picasso*, 87 n2
Daladier, E., 182 n23; government, 172
Dali, S., 32 n2
Dallas Museu, 144–5
Dalou, J., 205
Daumier, H., 38, 205
David, J-L., 26 n12, 240, 245, 247; *The Oath of the Horatii*, 53, 240, 245, 260 n12; *Brutus*, 245
Davie, Alan, 225
Davis, Stuart, 108, 148 n2, n3
dealers, 56, 115, 117–19, 125 ff, 140–1 142–3, 158, 202, 222, 227–8
Degas, E., 56, 209
Debussy, C., 40, 41
'decorative', 45, 121; 'non-decorative', 42
Defoe, Daniel, 53
Delacroix, E., 38, 76 n11, 245, 247; *Liberty guiding the People*, 245
Denny, Robyn, 231 n21
'depth', 43, 44, 92–93, 179, 228
Der Ventilator, 83
Dérain, A., 84 authors note, 254; *Lettres à Vlaminck*, 266 n51
determinism, 6
Denis, Maurice, 8
Devree, H., 103
Dictionaire des Idées Reçues, 83
Diderot, D., 57, 78 n17, 85; *Rameau's Nephew*, 88 n7
Dies Committee, 103 n1
Diller, Burgoyne, 136
'disinterestedness', 9, 62 n10, 93, 94, 219, 220, 229
discourse, second order, 209–211, 215 n36
Dondero, George A., 94, 130, 133 n3, 131, 132, 163; 'Modern Art Shackled to Communism', 94
Dortu, M.G. and Huisman, P., *Lautrec by Lautrec*, 266 n54
Dove, Arthur, 136
Dubuffet, Jean, 110, 159
Dulles, John Foster, 114, 123 n17, 128
Duchamp, M., 59, 66, 78 n17, 83, 117, 142
Dupee, Fred, 170
Dupuy, 56, 57
Durand-Ruel, P., 253
Duthuit, George, 140
Dyn, 164 n5

Eagleton, Terry, 61–2 n6
'easel' painting, 36, 101, 232 n29, 257
Ecce Homo, 83
Economism, 51
Egan, Charles, 141, 158
Egbert, Donald, 'The Idea of the Avant-Garde in Art and Politics', 151 n31
Egypt, hellenistic, 52
Eisenhower, D.D., 113, 114, 128
Eliot, T.S., 21, 24, 28, 50, 55, 62 n10, 66, 85, 87, 88 n7; *The Waste Land*, 84
'Eliotic Trotskyism', 50, 54
Ellis, J., *see* Coward, R.

El Lissitsky, 84 authors note
Eluard, Paul, 23, 49
Emerson, Ralph Waldo, 76–7 n13
Emmerich, Gallery, n 16
Encounter, 115, 128, 145, 149 n9
Engels, F., 13, 14, 19, n39, 19–20 n40, 171; and Hegelian Left, 171; and Marx, K., *German Ideology*, 212 n7
epistemology, 194, 195
Epstein, J., 231 n21
Ernst, Max, 142
European Recovery Plan, 161
Evergood, Philip, 136
'existentialism', 97, 112, 126, 131; existentialist-individualist, 126, 163
experience, 4, 25, 56, 57, 85, 93, 176, 248; of art, 56, 85, 171, 193; 'common', 23; contemporary, 95, 96, 97, 111; 'pure', 37; social, 111, 237; 'visual', 40, 178, 250; urban, 235; of 'work itself', 187
expression, 4, 24, 40, 42, 45, 144, 162, 178, 195–99, 206; cultural, 65, 99; theories, 195 ff; 'expressive image', 160; -means, 4, 5, 40, 45, 93, 96, 178; -possibilities, 66, 99, 229; -resources, 178, 200, 228; qualities, 45, 93, 228
Expressionism, 31, 163

Fair Deal, 161
Fantastic Art, Dada and Surrealism (exhibition), 8
Farrell, J.T., 155; 'Note on Literary Criticism', 155, 164 n6
fascism, ists, 30, 31, 48, 76–7 n13, 84, authors note, 95, 101, 111, 142–3, 169, 172–3, 182 n23, 257
Faulkner, W., 58, 143
Fauves, 8, 55, authors note, 254
Federal Art Project (FAP), 103 n1, 149 n5
Federal Power Commission, 121
Federation of American Printers and Sculptors, 95, 157
Federation of Modern Printers and Sculptors, 129
Fénéon, Félix, 57
Feragil (Gallery), 158
Festival of Britain, 223
Fetting, R., 214 n25
Fillmore East, 121
Finland; invasion of, 157
First American Artist's Congress Against War and Fascism, 19 n3, 164 n2; 'flatness', 5, 6, 39, 43, 57–8, 68–9, 78 n16, 104 n5, 179, 219, 221; see also surface
form, 39, 41, 62 n10, 60, 66, 733; significant, 221
formalism, 11, 12, 24, 27, 71, 92, 97, 101, 122, 154, 159, 169, 187; idealist, 155; Russian, 138
Forstenzer, T.; *French Provincial Policy and the fall of the second Republic*, 261 n22
FORTUNE, 170
Foucault, Michel, *Les mots et les choses*, 87 n1
Fourier, C.S.M., 151 n30
della Francesca, Piero, *Flagellation*, 196–7

Francis, Sam, 224
Frankenthaler, Helen, 70, 75, 92
Frankfurter, Alfred, M., 140–1, 143
Frascina, F., and Harrison, C., *Modern Art and Modernism: A Critical Anthology*, 18 n1, n2, n5, n11, n17, 19 n19, 104 n3, n4, 105 n25, 216 n39, 230 n1, 259 n1
Freeland, Richard, M., 93; *The Truman Doctrine and the Origins of McCarthyism*, 105 n12, 165–6 n25
Freeman, Joseph, *Proletarian Literature in the United States*, 183 n33
Free Speech movement, 120
Freud, L., 214 n25
Fried, M., 17, 81–88, 92, 97, 98, 100; *Art and objecthood*, 20 n50, 69, 76 n9, 77 n16, 78–9 n17, 79 n21, 86, 88 n6; *Manet's sources: aspects of his art 1859–1865*, 75 n2, 79 n17; *Shape as form: Frank Stella's new paintings*, 68–9, 76 n8, 79 n21; 'Morris Louis', 77 n15, 79 n20; *Absorption and Theatricality: Painting and Beholder in the Age of Diderot*, 79 n17; 'Thomas Couture and the theatricalization of action in nineteenth century French painting', 79 n17, 216 n26; 'The beholder in Courbet: His Early Self Portraits And Their Place In His Art', 79 n17; 'Representing representation: on the central group in Courbet's *studio*', 79 n17; 'Painter into painting; on Courbet's *After dinner at Ornans* and *Stonebreakers*, 79 n17; *Anthony Caro*, 79 n18; *Anthony Caro: table sculptures 1966–77*, 79 n18; 'Two sculptures by Anthony Caro', 79 n21; 'Caro's abstractness', 79 n21
Frost, T., 223, 225, 231 n23
Fry, Edward (ed.), *Cubism*, 260 n6
Fry, Roger, 8, 195, 196, 214, 208, 218, 219, 221
Fulbright, Senator; foreign relations committee, 130
Fulbright (scholarship), 115
Fuller, Peter, 196; 'Towards a Theory of Expressionism', 213 n23
Futurism, 84, authors note
Futurists, 31

galleries *see also* dealers, 140–1, 142, 143, 147, 158, 159; gallery system, 125, 227–8
Gambetta, Léon, 54
Gargan, E., *see* Beauroy, J.
Gatch, Lee, 143
Gebhardt, I., *see* Arato, A.
Gazette des Beaux-Arts, 260 n5
Germany, 30, 31, 36; Federal Republic of, 214 n25
Gautier, T., 40
Gear, W., 223
Geldzahler, H., *New York painting and sculpture*, 76 n4, 76 n8, 104 n3
General Motors, 115
Géricault, T., 38, 53, 247; *Raft of the Medusa*, 245
Germany, 116, 142, 157; German-Soviet alliance, 157; culture, 182 n23
Gérôme, J.L., 38
Giacometti, A., 223

G.I. Bill for veterans, 115, 144
Gide, A., 24
Gilbert, J.B., *Writers and partisans: a history of literary radicalism in America*, 105 n6, 164 n7, 181 n9, 181 n10
Gimbels department store, 166 n27
Giotto, 27
Glyph, 79 n17
Goebbels, 31
Gomulka, 132
Goncourts, 39
Gombrich, Ernst, 205; *The story of art*, 194; *Art and Illusion*, 194; 'Art history and the social sciences' *Ideals and idols; essays on values on history and in art*, 212 n6
Goodman, Nelson, 205; *Languages of Art*, 192, fn1, 211 n1; 'Art and inquiry' *Problems and projects*, 194, 207, 212 n5, 214–5 n33
Goodman, Paul, *Growing up absurd*, 114
Gorky, A., 91, 98, 109, 129, 141, 142, 161, 166 n27, 227
Gothic, 58, 97, 101
Gottlieb, A., 91, 95, 109, 141, 142, 148, 157, 165 n13, 166 n27
Goya, F., 111, 247
Graham, J., 165 n13
Gramsci, A., 4; Gramscian, 65
Graubner, G., 214 n25
Grave, B., 235
Graves, M., 166 n27
great depression, 54, 103 n1, 136, 156, 157, 257
Green, A., 231 n21
Green B., 165 n13
Green, G., 165 n13
Greenberg, C., 5, 7, 11, 15, 16, 17, 47–60 *passim*, 60 n1, 65–75 *passim*, 91, 92, 93, 96–103, 122, 138–41, 145, 147, 150 n14, 153–7, 159, 160–3, 165 n17, 169, 174–181, 181 n5, 187, 193, 195, 217–19, 225, 226–7, 232 n26, 236–9, 241–3, 248, 258–9, 260 n7, 262–3 n45; 'Avant-Garde and Kitsch', 7, 12, 14, 15, 47–60, 81–87 *passim*, 99, 136–9, 149 n7, 156–7, 164 n10, 169, 174–181, 181 n6, 182 n31, 32, 237, 238, 239, 242, 243, 260 n17, 18; 'Towards a Newer Laocoon', 7, 12, 47–60, 81–87 *passim*, 169, 174–81, 181 n7, 18/ n34–n41, 238; —notion of 'modern specialization', 11, 12, 17, 91; 'Collage', 11, 47, 236, 260 n7; 'Modernist painting', 5, 6, 11, 12, 18 n5, n6, 47, 58, 62 n7, 67, 76 n4, n5, 76 n10, 104 n3, 188, 196, 212 n12, 217, 230 n1, 230 n4; —notion of 'art for arts sake', 12, 98; 'The Pasted Paper Revolution', 19 n25; *Art and Culture*, 12, 19 n25, 47, 98, 104 n3, 106 n32, 135, 149 n7, 164 n1, 180, 183 n44, 230 n2, 260 n7, 260 n9; 'Cézanne', 47; 'Abstract, Representational, and so Forth', 47; 'Present Prospects of American Painting and Sculpture', 58, 62 n8, 96, 106 n27, n28, n29, 146; 'Art (*nation*)', 58, 12 n9; 'After Abstract Expressionism', 68, 76 n4, n5, 76 n12, 104 n3, 149 n9; 'Intermedia', 77 n16; 'Avant-Garde Attitudes: New Art in the Sixties', 78 n17; 'Counter Avant-Garde', 78 n17; 'Anthony Caro', 79 n21; ' "American-type" Painting',

104 n5, 146, 149 n9; 'The Situation at the Moment', 96, 97; 'Jane Street Group, Rufino Tamayo', 97, 106 n30; 'New York Painting Only Yesterday', 98, 100, 106 n32, 180, 183 n42 & n43, 183 n44; 'Art Chronicle: The Decline of Cubism', 98–9, 102, 147, 150 n29, 160, 161, 166 n26, 231 n15; 'The Late Thirties in New York', 98, 100, 106 n32, 135, 154, 164 n1, 230 n2; 'The Crisis of the Easel Picture', 101, 106 n42; 'How Art Writing Earns Its Bad Name', 149 n9; 'Art Chronicle: A Season of Art', 145, 150 n22; 'Art' (1.2.47), 165 n18; 'Art' (8.3.47), 159, 165 n20; —Greenbergian formalism, 153, 161; —notion of post painterly abstraction, 195–6; 'Problems of Criticism II: Complaints of an Art Critic', 187, 188 n1, 193, 212 n4, 230 n3, 230 n10; 'Louis and Noland', 212 n10; 'Three American Painters: Louis, Noland, Olitski', 212 n10
Green Berets, 116
Greenblatt, Stephen, J., (ed), *Allegory and representation: selected papers from the English Institute 1979–80*
Greuze, J-B., 38
Gris, J., 251; '*Figure seated in a cafe*'; '*teacups*', 262 n43
Grosz, G., 205
Gropper, William, 136
Groupe Espace, 223
Groupe de Recherche d'art visuel, 223
Group Zero, 223
Guardian, The, 231 n14
Guest, Eddie, 21, 28
Guggenheim museum, 83, authors note
Guggenheim, Peggy, 101, 131, 158; 'Art of this century gallery', 131, 141–2; 'Spring salon for young artists', 142 (exhibition)
Guilbaut, S., 7, 95, 96, 99, 100, 101, 162; 'The New Adventures of the Avant-garde in America', 60 n2, 103–4 n2, 261 n29; 'Création et Développement d'une Avant-Garde: New York 1946–51', 103–4 n2, 165 n19; *How New York Stole the Idea of Modern Art: Abstract Expression, Freedom and the Cold War*, 104 n2, 105 n20, 106 n26
Guilbaut, S., Solkin, D., Buchloh, B.H.D., *see* Buchloh, B.H.D.
Gulf of Tonkin, 119
Guston, Philip, 113, 123 n15, 129, 214 n25
Gwathmey, R., 165 n16

Hacker, H., 214 n25
Hacker, Andrew, *The End of the American era*, 121, 123 n28
Hadjinicolaou, Nicos, 'Sur l'Idéologie de l'Avant-gardisme', 181 n1
Hall, S., Jefferson, T., (eds), *Resistance through rituals*, 247, 261 n23, 262 n32
Hamilton, Richard, 201, 223, 225
d'Harnoncourt, René, 127, 161, 162; 'Challenge and Promise: Modern Art and Society', 162, 166 n29, n30
Harper's Bazaar, 142, 150 n13
Harrison, C., 14, 17, 19 n20; — and Baldwin, M., and Ramsden, M., *see* Baldwin, M.

Harrison, C., and Frascina, F., *see* Frascina, F.
Harrison, C., and Orton, F., *Modernism, criticism, realism*, 50 n21, 189 n3, n4, 211 n1, 212 n9, 230 n3, 230 n5, n7, n9, n11; 'Jasper Johns', 'Meaning what you see', 232 n28
Harrison, Wallace, 127
de Hart Mathews, Jane, 102; 'Art and politics in cold war America', 103 n2, 105 n18
Hartigan, G., 129
Hauptman, W., 'The Suppression of Art in the McCarthy Decade', 103 n2, 105 n18, 133 n3, 150 n16, 150 n17
Hauser, Arnold, 3, 4; 'The Sociological Approach: the Concept of Ideology in the History of Art, *the philosophy of art history*, 3, 4, 18 n2
Haussmann, Raoul, 255; *Courrier Dada*, 266 n52
Heath, Adrian, 231 n23
Hegel, F., 88, 209; *Phenomenology*, 88
Hélion, J., 214 n25
Hemmingway, E., 143
Henry, Charles, 235, 251; *Harmonie des forms et des couleurs*, 259 n4
Herbert, R., ' 'Parade du cirque' de Seurat et l'esthetique scientifique de Charles Henry,' 259 n3; 'Seurat and Jules Chéret', fn 40, 262 n40
Herbert, R., and E., 'Artists and anarchism: unpublished letters of Pissaro, Signac and others', 259 n2, 260 n4
Heron, Patrick, 222, 225, 226, 229, 231 n14, n20; 'The ascendancy of London in the sixties', 231 n22; 'A Kind of Cultural Imperialism', 213 n22
Hess, Thomas B., *abstract painting*, 141; *Barnett Newman*, 232 n25
Hill, Anthony, 231 n23
Hilton, Roger, 223, 225, 231 n23
Hiroshima, 95
Histoire et critique des arts, 104 n2, 165 n19, 181 n1
historicism, ist, 9, 91, 191, 229
Hitler, A., 30, 31, 131, 182 n23
Hobbs, P., 231 n21
Hockney, D., 205, 214 n25, 226
Hodgkin, H., 214 n25
Hodicke, K.H., 214 n25
Hofmann, H., 32 n2, 92, 131, 141, 142, 158, 166 n27; — school, 175
Hogarth, W., 53
Hokusai, 27
Holt, R., *Sport and Society in Modern France*, 260 n19
Holty, Carl, 136, 161, 166 n27
Hook, Sidney, 'Communism and the intellectuals', 166 n33
Hopper, Edward, 84 authors note, 108, 136
Hollywood, movies, 25, 27
Horizon, 62 n8, 106 n27, 141, 150 n12
House, Gordon, 231 n21
House, J., 'Meaning in Seurat's Figure Painting', 262 n38
Horkheimer, M., 263 n45
Hoyland, J., 205, 231 n21
H.U.A.C., 166 n33
Huelsenbeck, R., 'en avant Dada', 266 n52
Huisman, P., *see* Dortu, M.G.

Hurd, Peter, 136
Icon, Icon art, 27, 28; Iconic, 117; Iconoclasm, 35
illusion, ism, 36, 43, 44, 52, 96, 110, 117, 178, 255
I.C.A., 223, 232 n27
ideology, 3, 4, 5, 6, 7, 14, 15, 16, 17, 18, 22, 39, 50, 51, 61–2 n6, 67, 75, 86, 91, 93, 95, 101, 102, 108, 114, 125 ff, 153, 155, 159, 161–62, 163, 166 n28, 167, 168, 170, 188, 202–4, 206, 210, 236, 238, 240
imagists, 40
imitation, imitiating, 23, 24, 29, 32 n1, 36, 40, 41, 42, 43, 177, 179, 180; imitation of imitating, 23, 24; realistic, 29, 37, 43, 45, 178, 179; of nature, 45, 180
imperialism, American, 7, 102; cultural, 130; imperialist ideology, 7, 163
impressionism, ists, 40, 55 authors note, 70, 91, 178, 233, 236, 240–1, 242, 246, 248, 249, 250, 252, 253, 257
industrialism, 26, 2
independent group, 223–224, 226
Ingres, J.A.D., 38
Institute for the Study of Fascism, 105 n24
Institute of Labour Research, 145
intellectuals, 95, 132, 145–6, 156, 159, 168, 174; bourgeois, 61–2 n6; marxist, 61–2 n6; American, 94, 145–6, 172, 173
intelligentsia, 6, 54, 115, 126, 154, 156, 167, 169, 173, 174, 180, 188; as a social class, 6, 173, 188, 189
internationalist art, 158, 159, 161
intuition, 17, 75, 76–7 n13, 85, 88 n7, 93, 98
iron curtain, 113, 132, 158
Irwin, R., 120
'Is abstraction, Unamerican?', 146
'Isolationist Art', 158
'Ivory Tower', 24, 159

Jameson, F., *Marxism and form*, 266 n55
Janis, Sidney (Gallery), 117, 142
Jansenism, ist, 35
Janson, H.W., 140
Jefferson T., *see* Hall, S.
Jena school, 84
Jesus, 28
Jewell, Edward, Alden, 123 n4, 163
Joachimides, Christos M., 214 n25
jazz, 263–5 n45
John Birch Society, 128, 145
Johns, Jasper, 55 authors note, 117, 234
Jones, Allen, 226
Journal of Social History, 261 n21
Joseph, Keith, 192, 193
Joyce, J., 23; *Ulysees*, 23; *Finegan's Wake*, 23
Judd, Don, 17, 86
judgement, 3, 76–7 n13, 249; value, 16, 17, 224
Kafka, F., 61 n5; *The Trial*, 84
Kahn, Gustave; 'Seurat', 259 n3
Kahn, Herman, 117
Kahnweiler, D.H., 236; *Der Weg zum Kubismus*, 260 n6
Kandinsky, W., 12, 23, 83, 97, 200; *Kandinsky:*

Russian and Bauhaus Years, 83–4, authors note

Kant, I., 73, 219; Kantianism, 61 n6, 229

Kantor, Tadeusz, 132

Kaprow, Allan, 119; 'should the artist become a man of the world', 119, 123 n24 & 25

Karp, Ivan, 118; 'anti-sensibility painting', 123 n22

Kelly, E., 120

Kennedy (President), 117, 118, 120; Youth Corps & Alliance for Progress, 116

King, Martin Luther, 120

Kissinger, Henry, 132

Kirkeby, P., 214 n25

Kitaj, R.B., 214 n25

'kitsch', 15, 25ff, 53, 137, 138, 148, 155, 156, 157, 176, 238–9, 242, 243, 248, 263 n45, 257

Klée, P., 12, 23, 45, 52, 205

Kline, Franz, 92, 129, 142, 224, 225

knowledge, 9, 10, 16, 57–8, 84–5, 96, 194, 204, 206, 209, 211, 222

Koberling, B., 214 n25

Kolakowski, Lezek, 6; *Main currents of Marxism*, 6, 18 n12

Kolko, G., 93; *The Roots of American Foreign Policy*, 105 n12; *Wealth and Power in America: An Analysis of Social Class and Income Distribution*, 105 n12; and Kolko, Joyce, 93; *The Politics of War 1939–45*, 105 n12; *The Limits of Power: The world and United States foreign policy*, 105 n12

de Kooning, W., 92, 109, 129, 141, 142, 160, 163, 166 n27, 168, 214 n25, 224, 227, 229

Kootz, Samuel (gallery), 141, 158, 161; 'The Intrasubjectives' Show, 166 n27

Korea, 109

Kossof, Leon, 201

Kozloff, M., 93, 95, 100, 101, 102, 126, 129, 148; 'American Painting During the Cold War', 91, 103 n2, 108, 126, 151 n32, 166 n34; 'An Interview with Robert Motherwell', 123 n9

Kounellis, Y., 214 n25

Kramer, Hilton, 120; 'Art: United States' Exhibition dominates São Paulo's 9th Biennial', 120, 123 n27

Krasner, Lee, 165 n13

Krushchev, President, 114

Kuhn, Thomas, S., 10, 11, 17, 219, 222; *The Structure of Scientific Revolutions*, 10, 11, 19 n23, 105 n15, 230 n6; 'paradigms', 10, 11, 12, 17, 94, 105 n15, 188

Kuspit, Donald, 76–7 n13; *Clement Greenberg: A critic*, 104 n3

Lakatos, I. and Musgrave, A., *Criticism and the Growth of Knowledge*, 19 n23, 231 n16

Lanyon, Peter, 229

Lasch, C., 93, 94; 'The Cultural Cold War: A Short History of the Congress for Cultural Freedom', 105 n12, 115, 123 n18; 145–6, 150 n21, n23, n24; *The New Radicalism in America: The Intellectual as a Social Type*, 105 n12; *The Agony of the American Left*, 105 n12

Latin America, 127, 129, 132

Latin American Affairs;(Secretary of State for), 126

LautréamonT, Comte de, 49

Laverdant, Gabriel-Desiré, 150 n30

Law, R., 231 n21

League of American Writers, 170, 181 n10

Leavis, F.R., 55, 61 n5, 62 n10, 66, 85; *New Bearings*, 62 n10

Lebrun, Rico, 143

Lee, Sherman E., *On Understanding Art Museums*, 150 n27 & n28

'left', leftist, 94, 158, 258; art history, 245; New York and East Coast, 175; 'ultra leftist', 61 n2

Left Review, 214 n31

Léger, F., 98, 110, 161, 222

Leighton, 38

Lenin, V.I., 49, 137

Lessing, G.E., 37; *Laokoon*, 37

Leider, Philip, 'Abstraction and Literalism: Reflections on Stella at the Modern', 20 n50

Lewishons (the), 126

Liberals, ism, 170, 175; American, 94–5; 'new liberalism', 95

Library of Congress, 127

Lichtenberg, 215 n35

Lichtenstein, R., 55, 107, 118; *Torpedo Los*, 118

Life, 140, 150 n10, 165 n12

Lilburne, John, 201

Lippman, Walter, 54

'literalness/abstractionists', 17, 86, 87, 120

'literalists/abstractionists', 17, 86, 87, 120

literature, 23, 28, 36, 39, 40, 41, 172, 173, 176, 177, 178, 179, 180, 219; proletarian, 169, 170

Little Rock, 114

London, Kurt, 27; *The Seven Soviet Arts*, 26

Los Angeles City Council, 144

Louis, Morris, 70, 75, 79 n20, 92, 120

Luce, Henry, 146, 165 n12; 'American Century', 146, 165 n12

Lukács, George, 61 n6

Lynes, R., *Good Old Modern: An Intimate Portrait of the Museum of Modern Art*, 19 n18, 133 n1, 127, 150 n25

Lüpertz, M., 214 n25

MacDonald, D., 26, 27, 49, 100–1, 115, 149 n6, 154, 158, 160, 164 n7, 170, 175, 182 n16; National Defense: the case for socialism, 49; Ten propositions on the war, 49; 'Truman's Doctrine, Abroad and at Home', *Memoirs of a Revolutionist*, 158–9, 165 n15; Looking at the war, 160, 165 n23; This quarter – war and the intellectuals: Act two, 172–3, 182 n24–28

MacIntyre, Alasdair, 199; 'The Idea of a Social Science', 213 n19; *Against the Self-Images of the Age: Essays on Ideology and Philosophy*, 213 n19

MacPherson, C.B., 200; *The Political Theory of Possessive Individualism: Hobbes to Locke*, 213 n21

MacKinac (resolution), 165 n12

Mailer, Norman, 121; *Of a Fire on the Moon*,

121, 123 n29
Magazine of Art, 141
Mainardi, P., 'Courbet's Second Scandal, "Les Desmoiselles de Village" ', 262 n34
Malevich, K., 83, 205
Mallarmé, S., 23, 42, 58, 66, 234, 235, 236, 237, 252; 'The Impressionists and Edouard Manet', 252, 259 n1, 265 n46
Manet, E., 11, 40, 55 authors note, 66, 67, 68, 71, 75 n2, 92, 178, 218, 233, 234, 235, 239, 240, 242, 248; *Dejeuner sur l'herbe*, 66, 75 n2, 248; *Olympia*, 227, 233, 248; *Bar at the Folies-Bergere*, 251
Marcuse, Herbert, 246
Margo, B., 165 n13
Marden, B., 214 n25
Marinetti, F., 31
Marsh, Reginald, 136
Marshall Plan, 95, 127, 159
Martin, Kenneth, 231 n23
Martin, Mary, 231 n23
de Martini, J., 165 n16
Marx, K., 32, 48, 49, 51, 171, 175, 195, 215–16 n37, 229, 243, 244, 261n22; and Hegelian Left, 171; and Engels, F., *German Ideology*, 212 n7
Marxism, ists, 7, 9 n2, 12, 13, 48ff, 61–2 n6, 95ff, 135 ff, 153 ff, 169, 170, 181, 201, 211, 215–6 n37; criticism, 61–2 n6, 75, 92, 99; vulgar, 155, 211; anti, 94–5; 'de-Marxification', 154, 155, 158; tradition, 49, 61–2 n6, 229
Marxist Quarterly, 7, 154, 155, 164 n3, 260
masses, the, 24, 25, 27, 29, 30, 52, 118, 137, 138, 157, 171, 173, 174, 176, 239; urban, 25, 243; 'culture of', 30
Masterman, Margaret, 'The Nature of a Paradigm', 19 n23
materialism, ist, 220; historical, 17, 18, 98, 102–3, 188, 194–5, 203–4, 216 n37, 210–11; conception of history, 13, 14, 15, 72, 98, 99, 102–3; objectivity, 40, 178
Matisse, H., 12, 23, 57, 58–9, 66, 83, 84, authors note, 91, 92, 97, 136, 141, 159, 222, 254; *Joie de Vivre*, 10; *Blue Nude*, 66
Matsu, 114
Matta, R., 142, 214 n25
Matthieu, G., 224
Mauvais Sang, 83
Mayakovsky, V., 83; *The Cloud in Trousers*, 83, 88 n3; *Bedbug and Selected Poetry*, 88
Mayor, A. Hyatt, 141
McCarthy, Mary, 139, 170
McCarthy, Senator Joe, 144
McCray, Porter A., 127, 128, 129, 130, 131
McCarthy Committee, 103 n1
McCarthyism, 86, 94–5, 114, 128, 144, 147
McLean, B., 214 n25
McLuhan, M., 119, 223
McNamara, Senator, 116
'meaning', 58–9, 60, 195, 198–9, 201–2, 206, 209, 234; 'imitative', 32 n1; 'meanings of the dominated', 210–11, 216 n39, 216
'medium', 23, 29, 32 n2, 29, 35, 36, 37, 38, 40, 41, 50, 52, 55, 58–9, 63 n11, 67, 75, 81, 177, 178, 179, 235, 238, 241

Melville, S., 'Notes on the re-emergence of Allegory, the Forgetting of Modernism, the Necessity of Rhetoric and the conditions of Publicity in Art and Criticism, 76 n9, 78 n17
Melville, H., 58
Merleau-Ponty, M., 86
Merz, M., 214 n25
metaphysics, 86–7, 88 n7
'Metaphysics of Despair', 97, 101
Metropolitan Museum of Art, New York, 107, 122, 145
Metz, Christian, 198, 213 n17
Meunier, 205
Michelangelo, 27
Michelet, Jules, 245; *L'Etudiant, cours de 1847–8*, 261 n26
'Middle Generation' group, 223–4, 225, 226
Miller, Michael, *The Bon Marché: Bourgeois Culture and the Department Store*, 260 n20
Miró, J., 12, 23, 45, 59, 83, 97
misrepresentation, 211–12 n2
Modern Art & Modernism: Manet to Pollock, Open University Course A315, 16, 18–19 n17
'Modern Art in the United States' exhibition, 231 n19
Modern Artists in America, 141
Modernism, ist, 3, 5, 6, 7, 9, 10, 12, 13, 15, 17, 53, 54, 68, 82–3, 84 authors note, 92, 93–5, 97, 98, 99, 100, 101, 102, 167, 187, 188, 191, 196, 202–6, 207, 208, 218, 217–30, 233
modernism, ist, 16, 28, 31, 51, 53, 55, 58–9, 62 n10, 67, 68, 70, 72, 75 n3, 87, 148, 155, 156, 158, 160, 163, 188, 233ff
modernity, 55 authors note, 57, 109, 158, 236
Mondrian, P., 12, 23, 91, 110, 142, 233; *Boogie-Woogie Series*, 234
Monet, Claude, 55, 59, 66, 205, 228, 248, 253, 254; at La Grenouillère, 228, 232 n30; *Nymphéas*, 59, 66
More, Herman, 143
Moreau, G., 38
Morland, G., 38
Morley, M., 214 n25
Morris, George, L.K., 136, 165 n24, 170; 'Morris on critics and Greenberg: A Communication', 165 n24
Morris, Robert, 17, 86
Morrow, Dwight, 127
Mortimer, Raymond, 140
Motherwell, Robert, 92, 111, 119, 123 n6, 129, 131, 141, 142, 155, 166 n27, 224, 225; 'The Modern Painters World', 164 n5; *Modern Artists in America* (editor), 166 n31; *Dada Painters and Poets*, 266 n52
Mundy, Henry, 231 n21
mural art, 95, 96, 100, 101, 137, 232 n29; Mexican muralists, 103 n1, 126
Museum of Modern Art, New York (MOMA), 5, 7, 18 n3, 100, 101, 102, 126–32, 136, 140, 141, 142, 145, 146, 147, 150 n25, 163; International Council of, 115, 127, 130, 146; 'New American Painting' exhibition, 116, 131, 146, 231 n19; and American foreign policy, 126–7; as minor war contractor, 127; 'Twelve Contem-

porary American Painters', 142; 'Fourteen Americans' (exhibition), 142
Musgrave, A. *see* Lakatos, I.
music, 32 n1, 35, 36, 40, 41, 42, 179; Greek, 32 n1
Mussolini, B., 30, 31

Nagasaki, 95
N.A.S.A., 120
Nation, 62 n9, 94, 159, 165 n17, 175
National Collection of Fine Arts, 120
National Council of Churches, 145
National Security Council, 109
National Student Association (NSA), 128
Nazis, 31, 118; Nazi Germany, 131, 176
Neo-Impressionism, 15, 56, 235, 236, 252, 253, 254; colour theory, 235; theory, 259–60 n4
'Negation', 52, 58–9, 62 n10, 60, 66, 67, 70, 81–3; 'Practices of', 55, 59, 60, 65, 66
New American Painting (exhibition), 116, 131, 146, 231 n19
New Bearings, 62 n10
'New Deal', 93, 95
New Left Review, 8, 230 n8
'New Liberalism', 161, 162, 163, 166 n36
New London Gallery, 'New London Situation', (exhibition), 231 n21
Newman, Barnett, 68, 76 n7, 92, 109, 112, 142, 158, 162, 165 n13, 221, 224, 227
New Masses, 170
'A New Spirit in Painting' (exhibition), 201, 202, 214 n25
'New Realist' (exhibition), 117–18
New York School, 107, 110, 143, 168, 234
New York School, The First Generation, 123 n5
New Yorker, 26
New York Times, 105 n20, 127, 130, 131, 143, 150 n15
Niall, S., 'Paris Letter Christmas Day 1938', 182 n23
Nichols, Dale, 136
Nicholson, Ben, 225
Nietzsche, Friedrich, 230
Noland, Kenneth, 70, 75, 107, 120, 122
Nouvelle Realists, 223
November Group, 83

O'Brien, Conor Cruise, 145
O'Connor, F.V., *Federal Support for the Visual Arts: The New Deal and Now*, 103 n1; *Arts for the Millions: Essay from the 1930s by Artists and Administrators of the W.P.A. Federal Arts Project*, 103, n1; *Jackson Pollock*, 133 n2, 150 n13, 232 n29
O'Connor, F.V., and Thaw, E.V., *Jackson Pollock: A Catalogue Raisonné of Paintings, Drawings and Other Works*, 106 n34
October, 76 n9, 104 n2, 260 n8, 261 n29
'of' genetic, 192–5, 206
Office of Inter-American Affairs, 126, 127
Office of Strategic Services (OSS), 127
O'Keefe, Georgia, 108, 136
Oldenburg, Claes, 119, 234; 'America: War and Sex etc.,' 119, 123 n26

Old Masters, 22, 27, 70, 76 n11
Olitski, J., 70, 75, 86, 120, 122
ontology, 74, 86, 194, 198, 206, 210, 229; Modernist, 221
Oppler, Ellen, C., *Fauvism Re-examined*, 226 n5
Oppositions, 261 n27
'Opticality', 92, 97, 121, 222, 228
Ordre Moral, 54
Orozco, J.C., 103 n1; Murals at New School for Social Research, 145
Orton, F., and Harrison, C., *Modernism, Criticism, Realism*, 17 n51, 189 n3, n4, 211 n1, 212 n9, 236 n5, n7, n9, n11; 'Jasper Johns: Meaning What You See', 232 n8; and Pollock, Griselda, *Avant-Gardes and Partisans Reviewed*, 61 n2, 95, 99, 101, 102, 104 n2, 230 n2 & 3
Overton, Richard, 201
Owen, David, 201
Owens, C., 'The Allegorical Impulse: Toward a Theory of Postmodernism', 260 n8; 'The Problems of Puerilism', 260 n8

painting, abstract, *see* abstraction; academic, 39, *see also* academicism; 'color field', 71–2, 120, 121, 122; easel, 36, 101, 232 n29, 257; 'essence', 68–9, 71; landscape, 37; and literature, 35–45, *see also* literature; 'pure', 42, 43, 44, 45; and sculpture, 36ff, 43, 179
Paladino, M., 214 n25
Paleys (the), 126
Paolozzi, Eduardo, 223
paradigm, 10, 11, 13, 17, 18, 96, 105 n15, 188, 209; 'metaphysical', 10; 'sociological', 10; theory, 10; in modern art, 14, 96; Modernist, 15, 17, 91, 95, 97, 188; criticism, 104 n5, 97, 168, 169
'Paris 37–57' (exhibition), 222
Parnassians, 40
Parrish, Maxfield, 27
Parsons, Betty, 141, 158, 160, 165 n14 & n22; gallery, 158, 232 n26; papers, 165 n22
Partisan Review, 7, 26, 47, 48, 49, 81, 94, 96, 98, 104 n5, 137, 138, 141, 146, 149 n6, n7, n9, 150 n22, n24, n29, 154, 155, 156–7, 160, 164 n5, 164 n10, 165 n24, 166 n26, 169, 170–2, 173, 174–5, 180, 181 n6, n7, 182 n12, n16, n18, n23–30, 231 n15, 232 n26, 260 n9, n10
Partisan Reader, 149 n7
'This Quarter – The Crisis in France', 172, 182 n21, n22; 'What is Alive and What is Dead in Marxism, 170
Pascal, B., 35
Passmore, Victor, 223, 231 n23
Past and Present, 260 n21
Pater, W., *The School of Giorgione*, 46 n2
Patriotic Council, 130
patronage, 22, 54, 56–7, 60, 115, 118–9, 125ff, 132, 135–7, 239, 241; institutional/corporate, 118–121; government, 136–7
peasantry, 25, 27, 28, 30; Russian, 27–28, 30
Pelez, Fernand, 259 n3
Penck, A.R., 214 n25
Penrose, R., (editor) *Picasso in Retrospect*, 262 n41

Pentagon Papers, 18 n14
Pepsi-Cola Company, 159
perception, 'Priority of Perception Thesis', 85, 98
Phillips, William, 169, 170
Picasso, P., 9, 10, 12, 23, 24, 27, 28, 30, 45, 52, 59, 70, 86, 87–8 n2, 91, 96, 97, 98, 136, 141, 161, 165 n24, 202, 236, 214 n25, 222, 251, 254, 255; *Les Desmoiselles d'Avignon*, 10; *Ma Jolie*, 66, 82; *Glass of Absinthe*, 74; *Guernica*, 92; work of 1911–12, 87–84 n2
Pisarro, Camille, 56, 205, 253
Plato, 32 n1; platonic mimesis, 138
Plumb, J., 231 n21
Poe, E.A., 40, 42, 251
poetry, 21, 32 n1, 37, 40, 41, 179; 'pure', 23, 43; 'true', 40; avant-garde, 43; epic, 58; poetic effects, 37, 177
Poggioli, Renato, *Theory of the Avant-Garde*, 150–51 n30
Pohl, Frances, K., 'An American in Venice; Ben Shahn and American Foriegn Policy at the 1954 Venice Bienhale', 104 n2
Polaris, 118
Poliakoff, S., 223
Polke, S., 214 n25
Pollock, Charles, 150 n13
Pollock, Griselda, and Orton, F., see Orton, F.
Pollock, Jackson, 11, 12, 13, 17, 58, 59, 67, 70, 72, 75, 83, 91, 92, 93, 96, 97, 98, 99, 100–3, 103 n1, 104 n5, 109, 112, 129, 131, 133 n2, 132, 141, 142, 150 n13, 158, 159, 160, 161, 163, 166 n27, 168, 221, 224, 225, 227, 228–9, 232 n26, 232 n29; *Lavender Mist*, 66, 82; *Wooden Horse*, 83; *Number One 1948*, 92, 93; *She Wolf*, 142
Poons, Larry, 70, 75, 78 n16, 120
Pop Art, 117–19, 120–1, 148, 201, 223, 224
Popper, Karl, 3, 207, 219, 222; *The Poverty of Historicism*, 18 n1; *The Logic of Scientific Discovery*, 230 n6
Popular front, 95, 101, 154, 155, 157, 163, 169, 170
Porter, David (gallery), 142
Porter, Fairfield, 117, 123 n20
positivism, 97, 61 n6
Possibilities, 141, 165 n21
'post-impressionism', 195
'post-modernism', 78 n17, 205, 217, 220, 237, 259
'post-painterly abstraction', 195–6
point four, 109
Pound, E., 23
Pousette-Dart, R., 157
practice, of art, 5, 8, 10, 12, 13, 17, 59, 83, 85, 95, 96, 98, 99, 102, 167, 168, 171, 181, 191ff, 203, 207, 208, 222, 225; of art history, 5, 13, 102, 167, 168, 191ff, 206, 207, 208; 'avant-garde', 55, 96, 167, 168; of criticism, 11, 191ff, 207, 222, 225; social, 6, 57, 62–3 n11, 72, 203, 233, 246, 257
Praxis, 103 n2
Pre-Raphaelites, 38
Prospects, 103 n2
primitivism, 55 authors note

producer, artist as, 4, 15, 125, 195, 203, 206
production, conditions of, 32 n5, 91, 93, 94, 96, 99, 101, 167, 175, 188, 191, 194, 196, 201, 204, 206, 209, 210–4, 222; means of, 5, 96, 204; modes of, 14, 96; pictures/art as produced, 4, 17, 18, 94, 101, 187, 191–3, 198–9, 208, 210, 211, 227; cultural, 238; mass, 229
Productivists (Russian), 83
proletariat, 174; art and, 154–6
propaganda,, 6, 30, 95, 115, 129, 132, 145, 146, 155, 156, 158, 160, 188
protestantism, 171
Proust, Antonin, 54, 248; *Edouard Manet, Souvenirs*, 262 n35
Ptolemy, 60; Ptolomy Patriciate, 60
purists, 218
puritanism, 30
purity, ism, see also art, pure, 15, 23, 24, 35ff, 41, 42, 43, 44, 50, 52, 55, 60, 67, 108, 171, 177, 196, 218, 219, 237

'Quality', 15, 17, 122, 156, 192, 220, 222, 238, 256; in art, 68–9, 71, 77 n16, 78 n17, 98, 122, 140, 238
Quemoy, 114

Radical Philosophy, 213 n17, 214 n24
Rahv, Philip, 49, 169, 170, 173–4, 177; 'Twilight of the Thirties', 173, 174, 182 n29, n30
Ramsden, M., and Baldwin, M. and Harrison, C., see Baldwin, M.
Raphael, 27
rationalism, 38, 56
Rauschenberg, R., 78 n17, 117, 120, 234
Ravenel, Jean (Alfred Sensier), 262 n36
RBA Galleries, 'situation' exhibition, 226, 227
Read, Herbert, 218
'Reading-in', 92, 187, 220
Refregier, Anton, Mural for Rincon Annex Post Office in San Francisco, 145
Realism, 117, 131
realism, 9, 38, 45, 62–3 n11, 72, 93, 96, 97, 143, 229, 249; immature, 45, 52
reductionism, 6, 67, 68, 101, 102, 209, 211, 221; reductionist conception of Modernist painting, 68ff, 221
'Red conspiracy', 109
Redfern Gallery 'Metavisual, Abstract, Tachiste' exhibition, 224
Rée, Jonathan, 'Marxist Modes', 213 n17, 214 n32
Reed, John, 181 n9; John Reed Clubs, 135, 169, 170, 181 n9
Reflectionism, 6, 35
Reformation, 35
regionalism, 95, 100, 110, 116, 136, 158, 173
Reinhardt, Ad, 62 n10, 66, 83, 142, 157, 158, 164 n11, 166 n27, 224; 'Art as Art Dogma', 232 n27; 'Ad Reinhardt on his art', 232 n27
relative autonomy, 13, 94, 96, 102, 171, 172, 181, 222
relativism, 3, 194; epistemological, 220
'relevance', 93, 98, 102, 187, 218, 220
religion, 86, 87, 88 n7; 'Religious Attitude in Criticism', 88 n7; Modernism as, 204
Rembrandt, 26, 27, 45

Renaissance, 29, 43, 96, 99, 125, 135, 179, 191
Renoir, A., 248, 258, 261 n26
Réné, Denise (Gallerie), 223
Repin, I., 27, 28, 33
representation, 4, 8, 9, 14, 45, 192–3; art as, 4, 8, 9, 28, 55 authors note, 82, 91, 92, 94, 95, 96, 99, 103, 167, 197, 198, 218, 238; art history/criticism as, 4, 16, 103, 188; materials of, 82; means of, 96; photographic, 4; practice of, 4, 28, 62–3 n11, 72, 96, 99; systems of, 5
resemblance, 4, 8, 192–3, 218
'resistance', 59–60, 72, 102
Reston, James, 123 n16
revivalism, 30
La Révolte, 235
Revue de l'Art, 259 n3
Rewald, J., 91; *The History of Impressionism, 104 n4; Post-Impressionism: from Van Gogh to Gauguin*, 104 n4; 'Extraits due journal inédit de Paul Signac', 260 n5, 265–6 n48; (ed.) *C. Pissarro, Letters to his son Lucien*, 265 n47
Rich, Daniel Catton, 143, 147; 'Management, Power and Integrity', 150 n28
Richardson, Samuel, 53
Richter, G., 214 n25
Rilke, R., 23
Rimbaud, A., 23, 59, 66
Ritchie, Andrew C., *Abstract Painting and Sculpture in America*, 141
Rivera, D., 84 authors note, 103 n1; Murals in Detroit, 145; and Breton, see Breton, A.
Riverside Museum, 165 n13
romantic, 37, 38, 39, 45 n1, 112, 178
Roosevelt, F.D., 93, 103 n1, 126
Rockefellers, the, 126, 129, 130, 132, 147; Rockefeller Brother's Fund, 127
Rockefeller, David, 126, 132
Rockefeller, John D., 126
Rockefeller, 3rd, John D., 130, 132; Fund for Asia, 130, 132
Rockefeller 3rd, Mrs John D., 126
Rockefeller, Nelson, 126, 131, 132
Rockwell, Norman, 28
Rodman, Sheldon, *Conversations with Artists*, 151 n33
Rose, Barbara, 123 n6
Rosen, C., *Arnold Schoenberg*, 262 n37
Rosenberg, Harold, 97, 119, 133 n2, 139, 140, 141, 150 n14, 162, 163, 227; 'The American Action Painters', 111, 112, 113, 123 n8, 139, 146, 149 n9, 166 n28, 224, 232 n24; 'Action Painting; A Decade of Distortion', 149 n9; 'After Next, What?', 149 n9
Rosenblum, Robert, 112; 'Fernand Pelez, or the Other side of the Post-Impressionist Coin', 259 n3; 'Picasso and the Typography of Cubism', 262 n41, n43
Rosenquist, J., 118; *F-111*, 120
Rosenthal, Norman, 214 n25
Rostow, Walt Whitman, 127
Rothko, Mark, 68, 92, 95, 109, 112, 129, 131, 141, 142, 157, 158, 160, 162, 165 n13, 165 n21, 166 n27, 168, 197, 221, 224

Rouault, G., 141
Rousseau, Theodore, 38
Rubin, William, 93, 100; *Anthony Caro*, 79 n18; 'Jackson Pollock and the Modern Tradition', 91, 104 n6
Rumney, R., 231 n21
Russell, John, 79 n18
Russia (Soviet), 26, 27, 109, 127, 138, 157, 176; Russian Productivists, 83; Stalinist-, 171; October Revolution, 171
Ryman, R., 214 n25

Sahl, Mort, 114
Said, Edward, 61 n6; 'Opponents, Audiences, Constituencies and Community', 61 n6
Saint-Simon, Henri de, 148
São Paulo Biennial, 120, 128, 129
Sample, Paul, 136
Sandler, I., 93, 168, 169; *Abstract Expressionism: The Triumph of American Painting*, 105 n11, 107, 123 n4, 149 n4, 150 n11, 150 n13, 169, 181 n4, 181 n5; *The New York School: The Painters and Sculptors of the Fifties* 105 n11, 168, 181 n2; *The Triumph of American Painting: A History of Abstract Expressionism*, 181 n3
Sandler, L., see Barasch, M.
Sartre, J.P., 112
Sassetta, S., 196
Saturday Evening Post, 21, 128
Schapiro, M., 4, 7, 8, 9, 11, 14, 15, 49, 140, 154, 155, 156, 157, 164, 240–8, 259; 'The Nature of Abstract Art', 4, 7, 9, 13, 15, 16, 18 n4, 154, 155, 164 n3, 240, 241, 246, 260 n13; *Modern Art: 19th and 20th Centuries*, 18 n4, 260 n13, n14, 262 n30; 'The Social Bases of Art', 13, 14, 15, 16, 19 n33, 154, 164 n2, 240, 241–2, 260 n13, n15, n16; 'Recent Abstract Painting', 262 n30; 'The Liberating Quality of Abstract Art', 262 n30; 'On the Humanity of Abstract Art', 262 n30
Schlesinger, A., 161, 163, 166 n36; *The Vital Center, Our Purposes and Perils on the Tightrope of American Liberalism*, 161, 162, 163, 166 n32, n35, n36
Schnabel, J., 214 n25
Schoenberg, A., 59, 66, 262–5
School of Paris, 122, 159, 166 n27
Schwarts, Arturo, *Breton/Trotsky*, 164 n8
Schwartz, Delmore, 49, 109 n3
Scientific American, 223
Scott, William, 225, 231 n23
Scrutiny, 54
sculpture, 22, 36ff, 42, 43, 44, 73–5, 86–7, 179
Semiology, 205–6
semiotics, 248
Seneca, 54
Serge, Victor, 49
Selz, Peter, 149 n6
Serota, Nicholas, 214 n25
Seurat, Georges, 56, 234, 235, 250, 253, 257; 'La Parade', 235; 'Le Chahut', 235, 259 n3; 'Sunday Afternoon on the Island of the Grande Jatte', 250; 'Bathers at Asnières', 250

Shahn, Ben, 136, 147
Shakespeare, W., 28, 54, 88 n7
Shapiro, D., *Social Realism: Art as a Weapon*, 19 n33, 148 n1, n2, n3; and Shapiro, Cecile, 95, 100, 101; 'Abstract Expressionism: The Politics of Apolitical Painting', 103 n2
Shaw, Hugh, 231 n21
Shelly, P.B., 'Defense of Poetry', 37
Siegel, P.N. (ed.), *Leon Trotsky on Literature and Art*, 181–2 n11, 182 n15
Signac, Paul, 235, 236, 237, 239, 253, 266 n48; 'Impressionists and Revolutionaries', 235, 259 n2, 259–60 n4
signifiers, 9
signifying systems, 5, 96, 198; practices, 240
Silone, Ignazio, 50, 61 n3
Silverman, D., 'The 1889 Exhibition: The Crisis of Bourgeois Individualism', 261 n27
Simenon, G., 26
Siqueros, D.A., 103 n1
Sisley, A., 248
Smith, David, 67, 70, 75, 92, 98, 161; *ZIG IV*, 66
Smith, Richard, 226, 231 n21
Smithsonian Institution, national collection, 147
Soby, James Thrall, 141, 142, 160, 163; *Contemporary Painters*, 141
social anthropology, 84, 194–202
'social base', 59, 98, 99, 172, 239
social history of art, 6, 13, 17, 102, 203, 220, 222, 227
social iconography, 258
'social realism', 19 n33, 27, 84 authors note, 95, 98, 100, 101, 129, 131, 136, 137, 139, 146, 155, 180
socialist realism, 132, 138
social sciences, 199, 203, 207
socialism, 31, 48, 50, 156, 157, 173, 177, 242; " 'socialist' artists", 148
Social Text, 261 n22
society, bourgeois, 7, 22, 29, 38, 39, 48, 50, 51, 54, 125, 155, 172, 176–7, 178; capitalist, 51, 70; mass, 53; art as expression of, 148; liberal, 162–3
Solkin, D., *see* Buchloh, B.H.D.
Soulages, P., 224
Souvarine, Boris, 49
Soviet, state, 30; cinema, 26 ff, 49; anti-, 194; -Union, 128, 131, 137, 157, 158, 170; -'camp', 161; -system, 163; policy of Popular Front, 169, 178; art, 171
space, 'realistic', 43; pictorial, 43
spectator, 37, 40, 42, 187; 'cultivated', 28
Sports Illustrated, 130; *Sport in Art* (Exhibition), 130
Sputnik, 116
de Stael, N., 223
Stalin, J., 30, 31, 49, 131, 132
Stalinism, 13, 30, 84 authors note, 95, 137, 146, 147, 153, 157, 164 n7, 170, 171–2, 174; anti-, 49, 98, 100, 135, 154, 155, 175, 180–1, 230 n2; 'Moscow Trials', 170
Stamos, T., 129, 158
Standard Oil, New Jersey, 121, 127

Steadman Jones, G., 'Working-Class Culture and Working-Class Politics in London 1870–1900: Notes on the Remaking of the Working Class', 260–1 n21
Steinbeck, J., 26
Stella, Frank, 68, 120, 122, 214 n25
Stendhal, 53; *Le Rouge et le Noir*, 53
Stevens, Wallace, 49
Stevenson, A., 114
Still, Clyfford, 68, 92, 100, 107, 109, 112, 129, 141, 142, 158, 160, 165 n22, 221, 224
stoicism, 54
Stone, I.F., 114
Streibert, Theodore, 130
Stroud, P., 231 n21
Studio International, 230 n5, 231 n22, 232 n27
Structuralism, Marxist-Structuralist analysis, 61–2 n6
'subject', 95, 96
'subjective', 95, 96, 101
'subject-matter', 23, 29, 35, 37, 39, 132, 138, 176, 177, 178; 'out-side' 32 n2; literary, 178
'sublime', 111, 121
Suez, 227
'surface', 44, 57–8, 78 n16, 221, 229, 253; 'possessing of a surface', 219
Surrealism, 32 n2, 45, 83, 91, 95, 110, 179, 223, 257; surrealists, 45, 97; 'pseudo'/'mock', 45
Sutherland, G., 225
Sutton, Denys, 'The Challenge of American Art', 141, 150 n12
Sweeney, James Johnson, 141, 142; 'Five American Painters', 142
Symbolists, 218

Tachistes, 223, 224
Tagg, John, 'American Power and American Painting: The Development of Vanguard Painting in the United States since 1945', 103 n2
taste, 27, 113, 119, 126, 147, 239; 'politics of', 45
Tate, Allen, 49
Tate Gallery, 224, 227
Tatlin, V., authors note, 84, 205
Taylor, Francis Henry, 140, 143, 163
Taylor, Joshua, 147; 'The Art Museum in the United States', 150 n27
Taylor, R. (ed.) *Aesthetics and Politics*, 263 n45, 264
'theatre', 77 n16, 87, 159
'theatricality', 78–9 n17, 86
Third Communist International, Seventh World Congress, 169
Thomas, K., 'Work and Leisure in Pre-Industrial Society', 260 n21
Thompson, E.P., 'Time, Work and Industrial Capitalism', 260 n21
Thomson, James, 37
Tiger's Eye, 141
Times, The, 143
Timpanaro, Sebastiano, 196, 220; *On Materialism*, 212 n11; 'Considerations on Materialism', 230 n8

Tin Pan Alley, 21, 25
Titian, 37; *Prodigal Son*, 37; *Venus of Urbino*, 233
Tobey, Mark, 108, 166 n27
Tomlin, B.W., 129, 166 n27
Toulouse-Lautrec, H., 257
Transition, 140
Tretyakov, 27
Trobriand Island, 199–202, 204–5, 206, 210
Trotsky, L., 8, 13, 50, 55, 96, 98, 137, 138, 139, 149 n6, 149 n8, 155, 156, 170, 171, 181, 164 n8; *Literature and Revolution*, 13, 19 n36, 105 n24, 149 n8, 182 n14, 182 n15; 'Art and Politics', 164 n5, n7, 170–1, 182 n12, n13; 'Letter to Dwight MacDonald', 170, 181–2 n11; 'Leon Trotsky to André Breton', 172, 182 n18, 182 n19, 120; and Breton *see* Breton, A.
Trotskyism, 81, 94, 95, 100, 101, 137, 153, 154, 155, 165 n24, 170, 174, 175, 181, 230 n2
Truman, H., 109, 161; Doctrine, 109; Administration, 158, 163; 's America, 158
'truth', 16, 32 n1, 63 n11, 88 n7, 96, 141; discovery of, 3; Truthful Statement, 4; 'of seeing', 57; artistic, 172
Tuchman, Phyllis, 79 n18
Turnbull, William, 223, 231 n21
Turner, J., 111
Twombley, C., 214 n25

U-2 incident, 116
Uncle Sam, 126–7
United States Information Agency (USIA), 115, 129, 131, 144; '100 American artists' show, 130

Valéry, P., 23, 32 n3, 43, 179
value(s), 28, 39, 55, 59, 77 n16, 139, 174, 192, 208; of visual art, 43, 45, 54, 55, 56, 59, 68, 71, 91, 93, 178; abstract, 45; artistic, 54
Vaneigem, R., *Traité de savoir-vivre a l'usage des jeunes générations*, 88 n4
Van Gogh, 45, 52, 205, 260 n4; *complete letters of Vincent Van Gogh*, 260 n4
Vaux, M., 231 n21
Vauxcelles, L., 254
Velvet Underground, 116
Venice Viennale, 119, 128, 129, 142, 227
Venturi, L., 45
Verhaeren, Emile, 39; (Georges Seurat), 34, 262 n39
Verlaine, P., 41
Vernet, C.J., 38
Vietnam war, 93, 118, 120
Vigée-Lebrun, M-L, E., 38
VkhUTEMAS, 83
Vlaminck, Maurice, 254
Voice of America, 108
Vollard, A., 254
La vie et l'oeuvre de P A Renoir (Renoir, an Intimate Record), 261 n26, 266 n56

Wagner, Geoffrey, The New American Painting, 143, ff 14, 150
Wagner, R., 265 n45

Wallace, Henry, 159, 161
Warhol, Andy, 107, 117, 118, 214 n25, 234
Warburgs, the, 126
Watts, G.F., 38
Weber, Alfred, 4; Weberism, 61 n6
Weber, E., 'Gymnastics and sports in *fin de siecle* France: Opium of the classes', 260 n19
Weber, W., *music and the middle class*, 266 n53
Webern, 59, 66
Wechster, J., and Berman, Greta, *Realism and realities: the other side of American painting 1940–1960*, 106 n38
Werckmeister, O.K., 20 n46, 261–2 n29
Wescher, H., *collage*, 266 n52
'Westkunst – zeitgenossische Kunst Seit 1939', 222, 231 n17
Whelan, Richard, *Anthony Caro*, 79 n18, 79 n21
Whitechapel Art gallery; 'This is Tomorrow' exhibition, 223, 227
Whitman, W., 113
Whitney Gallery, 143
Whitneys, the, 126, 132; John Hay Whitney, 127
Whyte, William, 114; *The Organizational Man*, 114
Wilenski, R.H., 8
Wilkie, Wendell, *One World*, 157, 164–5 n12
Williams, Shirley, 201
Wilson, Edmund, 49
Wittgenstein, L., 72, 73, 76 n9, 79 n19; Wittgensteinian, 55, 56, 76 n9; *Philosophical investigations*, 72; *remarks on the foundations of mathematics*, 79 n19
Winch, Peter, 199; *The Idea of a Social Science*, 213 n19; 'Winchian', 199–201, 202, 204, 208
Wingate, W., and Johnson (Fine Arts Ltd), 214 n25
Wittkower, R., 197; and Carter, B.A.R. *see* Carter
Wolfe, Bertram, 49
Wollheim, Richard, 219, 221, 229; 'The Work of Art as Object' *On Art and the Mind*, 230 n5
Wood, Grant, 136
Working Papers in Cultural Studies, 261 n23
Works Progress Administration/Work Projects Administration (WPA), 91, 103 n1, 110, 137, 149 n5, 157
Worringer, W., 8
Wright, William, 106 n34

Yeats, W.B., 23, 144
Yost, Charles, 113–4
Young, B., 231 n21
Young Contemporaries (exhibition), 226

zeitgeist, 173
Zeuxes, 29
Zinnser, William, *Pop Goes America*, 119, 123 n23
Zola, Emile, 7, 39